SENSUALIST

The

The SENSUALIST

A Novel

Barbara Hodgson

CHRONICLE BOOKS
SAN FRANCISCO

Printed in Singapore.

Library of Congress Cataloging-in-Publication Data available.

ISBN 0-8118-1906-X

Book and cover design: Byzantium Books
Composition: Byzantium Books
Cover design and photograph: Barbara Hodgson

10 9 8 7 6 5 4 3 2 1

Chronicle Books
85 Second Street
San Francisco, CA 94105
Web Site: www.chronbooks.com

The author is grateful for the help from the following people and institutions:
The Woodward Biomedical Library at the University of British Columbia for permission to
 reproduce the woodcuts from Andreas Vesalius's *Fabrica*.
Greg Morton of the Biomedical Communications Department at the University of British
 Columbia for the photography of the woodcuts from the *Fabrica*.
Mike Smith of Smith Photo for the photography of the art on pages 1, 75, 122, 131, 160, 169, 183,
 184, 187, 235, 260, and 271.
Gamma Pro Imaging for the photography of the art on pages 108, 110, and 263.
Kristin Sjaarda for the photography of the art on pages 14, 26, 29, 31, 33, 39, 47, 59, 84, and 215.

Thanks also to: Helge Windisch of Cologne, for researching and translating details concerning the
Munich University Library; Dr Wolfgang Müller of the Munich University Library, for the detailed
notes pertaining to the loss of the Vesalius woodblocks; Dr Manfred Skopec of the Institut Für
Geschichte der Medizin der Universtät Wien, for information on the Josephinum; Don Stewart of
MacLeod's Books in Vancouver, for the loan of the Maggs Brothers and Thomas Thorpe book-
sellers' catalogues; Lee Perry of the Woodward Biomedical Library at the University of British
Columbia, for her interest in the project and for allowing me to have pages from their copy of the
first edition of the *Fabrica* photographed; Nick Bantock, for his support and invaluable comments;
Saeko Usukawa and Erika Berg, for alerting me to unusual anatomical curiosities; Annie Barrows,
my editor, for her relentlessly tough questions and comments, and for her constant support; Karen
Silver, for her encouragement; Erin Van Rheenan, copyeditor; Madame M. Girov-Swiderski, for
the Latin translation; Natascha Dreger, for the German translations; Lisa Jensen and Steve Hepburn,
for their help; Todd Belcher, for the photography assistance; Liz Darhansoff, my agent; and Isabelle
Swiderski, for keeping pressing work at bay.

The skeleton on the flap of page 26 comes from the *Encyclopædia Britannica*, 9th edition,
 London: 1878.
The flap art on page 122 was created by L.W. Yaggy and James J. West in 1885.
The quote on page 184 comes from *Hall's Encyclopædia*, London (18th century).
The 19th-century anatomical figure on the same page is a lithograph by Ludovic after
 Léveillé, printed in Paris by Lemercier.
The facsimile of the book page on page 215 is adapted from Harvey Cushing's *A Bio-
 Biography of Andreas Vesalius*. New York: Schuman's, 1943.
All images, unless otherwise credited, are from private collections.

TO DAVID

2677

14/5

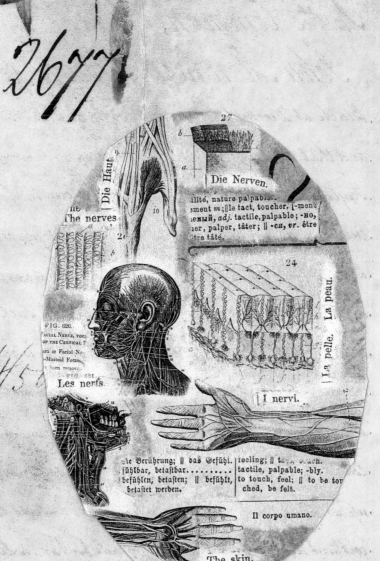

TOUCH

ROSA

Helen woke up in the middle of the night wearing someone else's breasts. Not her own insignificant, almost non-existent bumps, but huge, pendulous, full ones. Breasts whose only master was gravity, whose creases ached in bands across her ribs, whose weight cascaded irrepressibly onto her lap. Breasts that could round shoulders and cave in chests.

"Damn," she murmured to herself, "it's begun," and then went back to sleep.

She woke up again several hours later, her neck stiff, her right foot buzzing with sleep and her ears pounding from nearby clacks and screeches of mutinous machinery. Semi-conscious, eyes still tightly shut to preserve the safety of her darkness, her hands groped about her body hoping to deny the memory of the disquieting alteration. Her body was her own, not another's, she felt with relief. Then she remembered that she was on the train to Vienna and opened her eyes. A mountainous, old, mustached, bewigged, bespectacled woman occupying the aisle seat in the opposite corner of the train compartment, perched precariously, chins and jowls askew, staring and smiling intently.

"God, she's grotesque," Helen said to herself. And so she was. Her head, arms, legs, all stuck on in some parody of humanity—lumps of fleshy dough fashioned by talentless hands.

"Good morning," said the woman. She spoke in English, but her

accent was German. Her piercing eyes were magnified well beyond
their plausible size.

The greeting put Helen into the quandary that repeated itself daily
during her travels and left her craving the safety and solitude of her
work. She often studied and admired practitioners of indifference and
believed that refusing to respond to the advances of strangers was to
fulfill an almost divine duty. This admiration, however, was powerless
against the considerable influences of female forces from her past:
mother, aunts, and teachers, all as inflexible as their foundation gar-
ments; all insistent that, if one had the misfortune to be thrown amongst
foreigners, then politeness and pleasant conversation were not only
marks of quality, but were the sole reliable survival techniques available
to women. Helen was consequently torn between her desire to ignore
the greeting and her need to please even this stranger. She managed to
satisfy the conflict by mumbling "Good morning." And although
uncomfortable at the thought of having been watched, of still being
watched, her upbringing also prohibited her from demanding that the
woman stop. She had to retreat, either through departure or through
indifference, so she withdrew into her corner and concentrated on
trying to reorient her body.

She rubbed her eyes, dry in their sockets, and ran her hands
through her hair in an attempt to subdue the pandemonium that night
had inflicted on it. Each fine strand abraded her fingers as though spun
of steel. She wiped away the faint silver path of dried saliva that had
escaped from the corner of her mouth. Her foot was still asleep so she
wriggled it and tapped it vigorously to rid it of its pins and needles. Her
throat was parched and her mouth felt dusty and abandoned as if left
open all night. She put the back of her hand to her forehead to see if she
had a fever and was distressed to feel the hot skin of an impending cold—
the last thing she needed, especially now, en route to a foreign city and
in the middle of winter. Her fingers ached to touch her raw throat, and
so she let them caress and press the swelling glands. Pulling the collar
of her shirt up around her neck, she swallowed several times, wincing
against the discomfort reverberating into her ears, willing the dry

heaviness to go away, but electrified by the starched caress of the collar against the lobes of her ears.

Smothering in the incredible heat and mustiness of the compartment, she looked around, attempting to reacquaint herself with her surroundings. As it was early still with no sign of day, the only light came from a single incandescent bulb inset into the ceiling between the two banquettes. Accustomed to moving from city to city in sterile, impersonal transportation—jet planes, bullet trains—waking up in the antiquated, almost moldering train had disconcerted her for a few moments, and she fought against the urge to ask the woman, to reassure herself, that this was still the train to Vienna. She shifted her legs, easing a dawning cramp in her buttocks, and it suddenly occurred to her that her body was a festering orchestra of twinges, itches, and spasms. Her hands were conducting this disharmonious symphony—never resting in their travels from hair to throat, eyes to mouth, nose to flanks. She looked over again at the Gargantuan figure opposite, inconsiderately displacing essential air. Lack of air. That was the problem. She was suffocating, sealed in time with a woman consuming more than her fair share of precious oxygen. The woman was wearing a tightly fitted, buttoned-up, malodorous astrakhan wool coat, and on her feet were leather boots that reached up to just below the vague evidence of her ankles.

"It's hot in here, isn't it?" Helen asked.

"No, it is quite cold," replied the woman.

Helen nodded, absently wiping sweat from along her upper lip, and sat back, focusing her eyes on random objects in the compartment. In the dim light everything seemed rather grey and constructed out of shadows: the maroon upholstery that had worn into a darkish stained grey, the enameled metal walls that were covered with light grey finger prints, even the colored tourist picture of the Alps on the wall opposite that had faded to a monotone ashy-grey. She gazed upon her restless hands navigating the banquette's stiff bristly fabric and then elbowed the armrest down and flung her left arm onto it. The bare wrist peeking out from under the frayed cuff of her sweater reminded her that she had taken her watch off the night before and had put it in her pocket. She

pulled it out, wound it, and slipped it back around her wrist, taking an unaccountable pleasure in permitting the retracting joints of the bracelet to pinch her skin as she did so. It was 7:25 A.M.

Aggravated by the unflinching regard of the woman and in an effort to stop fidgeting, she pushed back the vinyl blind that covered the exterior window and hid her face from view. She started to rub away some of the condensation fogging the glass, but the icy cold moisture numbed the tips of her fingers and rivulets of water ran along her hand and down her wrist and arm. She stopped clearing the window and looked at her hand in disbelief, as if seeing it for the first time. When had she experienced such cold before? This was a chill that penetrated to the core of each finger, stiffening the joints, tightening the tendons. Protected from the woman's scrutiny, she leaned her hot forehead against the window—instantly relieved by the cold—and put her now icy hand under her sweater to cool her body. She again felt her breasts. This body does feel different, she thought, but she was interrupted by the woman.

"What do you see out there?"

"Nothing, it's still too dark."

"You must see something—if only snow, my dear."

"Yes, snow."

"And perhaps a frozen lover?" The woman chuckled gently to herself then let a docile but jangling warble escape through the gap between her parted lips.

Helen closed her eyes, exasperated by this senseless string of questions, and kept her forehead resting against the glass.

The woman's physical appearance and cloying stares were suddenly utterly defeating. Helen had been refusing to admit her vexation, preferring to blame, instead, her insane dream, her budding cold, her disturbed sleep—anything. What could she say in response? How could she stop the woman from continuing to plague her? She sighed out loud.

"Look hard and look fast. You might find him here, but you won't find him in Austria." The woman laughed again, louder this time as if to

clarify her desire to share her broad-minded drollery. "There are no lovers in Austria, frozen or otherwise!"

Helen raised the blind slowly and deliberately. The sky had lightened marginally, enough to show endless whiteness outside, whiteness as far as she could see. A frozen lover would have no trouble hiding out there, she thought to herself. He'd want to hide. Someone like me wouldn't warm him, ever. She looked at her watch again. 7:30. Still in Germany.

"You are yourself once again." The woman resumed speaking in a stilted but pleasant voice.

"Pardon?" She was pulled from her thoughts by how extraordinarily apt the statement was, but the woman simply smiled, nodded, and shoved the glasses that had been slowly creeping down her nose back up flat against her eyes.

Helen looked at the racks above the seats, mentally cataloguing the large quantity of luggage heaped up on both sides. When had this woman come in, and how did she arrange all of these bags without a commotion? Perhaps that was when she had first woken up, disturbed by the arrival. Tasteful luggage—including a hat box, terribly beautiful with a glossy black case and a black and red floral lid. She instantly wanted this hat box very much; she had always wanted to travel with a hat, to pretend that she was a part of an earlier time. "Heidecker's" claimed the elegant script on the creamy label. "Berlin," she read to herself, squinting.

"Go ahead, please, take it down and have a look in it," the woman said, her pride barely masked.

Helen demurred.

"No, please, take the hat box down. I want you to look at it." Helen pushed herself steadily into the seat back. She reached out with both her hands and clasped her knees, stretched her arms taut and with a burst of energy jumped up, and then, off guard from a sudden dizziness, nearly collapsed, but managed to grab the luggage rack before her knees gave way beneath her. Pausing for a few seconds while the blackness rippled before her eyes, she was finally able to maneuver the hat box to within

reach of both hands. The film of perspiration turned to beads of sweat that crept slowly along the ridge of her eyebrows and clung to the corners of her eyes. Moisture dripped from her armpits and rolled down her sides. "I really am sick," she thought.

"I don't live in Berlin anymore," said the woman, mistaking the concentrated look on Helen's face. "It's no fun since the wall came down, and it is such a bother to get there from Vienna. Do you know Berlin?"

"No," said Helen, grimly focused on moving the fragile box. She wiped her eyes on her shoulder, and finally succeeding, sat back down, set the box on her lap, and looked over at the woman.

"So, open it."

Helen gingerly lifted off the top and set it aside. She then peered into the box and saw an enormous black wig with some of the hair pinned into neat little curls and the rest teased into a frenzy of knots and split ends.

Helen didn't know what to say. She had expected a hat.

The woman, smiling expansively, looked at her. "Take it out," she urged.

Helen went rigid with distaste. "No, I'd rather not." She pronounced the five syllables with infantile precision. She reached for the lid and firmly shut away the repugnant object. Time to get out of here, wash the night away, pray for this pest to disappear.

The woman sank back in her seat, shrinking and fading as if deflated by disappointment. Ignoring the woman's sullen look, Helen replaced the box upon the luggage rack and then squatted down between the two seats, blindly patting the floor around her, looking for her shoes. She found one of them stuck in the corner near the window and the other on the opposite side, next to the woman's feet. Hesitating for a moment before grabbing this shoe, as if worried she'd seize the wrong one, she noticed the placement of the woman's feet was one of prudery, humility even, with the toes turned in to face each other; the feet themselves angled to rest on their arches; the low, functional heels raised slightly as if resisting contact with the floor. The flesh, crammed

and miserable in the tight black boots, fought against the modesty of the angles, creasing the leather and threatening at all points to escape and roll unrestrained onto the floor.

A sudden jerk of the train nearly threw Helen to her knees and broke her reverie. She scooped up her shoes, squeezed her feet into them without bothering to untie the laces, crushing the backs as she did so.

"We all lose parts of ourselves from time to time, you know," the woman commented, contentedly removing pins from the wig on her head, throwing them one by one onto the floor. "You just have to be careful what you replace them with."

"I'm sorry," said Helen, "I don't follow you."

The woman leaned towards Helen. "Parts of ourselves, you know." She patted her own huge bosom, sagging in spite of the assistance of the tightly buttoned coat, and blinked meaningfully. She then sat back and burped lightly, a smile resting on her lips. The pins continued to drop and skid about.

Helen averted her eyes, remotely disgusted by the burp, and assembled her soap, washcloth, and toothbrush. She was about to stand up when the woman asked, "What are you here for?"

"On the train, you mean? Going to Vienna," Helen snapped, stifled by her revulsion, yet mortified by her rudeness. This insolence surged out of nowhere, without reason—the worst sort of reaction—unassailable in its lack of logic.

"No, I mean what is your reason for being here?" The woman frowned to herself, concentrating on the foreign phrases. "What do you do?" She took her glasses off and steamed them up with a blast of foggy breath, wiping them off with the cuff of her coat. Whatever had been on the glasses now joined a complex array of detritus already clinging to the sleeve.

"I'm visiting." Helen's clipped reply should have repulsed further inquiry.

"Ah, how interesting, visiting friends!" exclaimed the woman. "My name is Rosa Kovslovsky, and since we have no one else to formally introduce us, I will tell you myself that I am a medical doctor, but in

truth I haven't practiced professionally for years. What is your name?"
She offered her hand.

Helen shook hands reluctantly, taken aback by the clamminess, imagining the creases of the woman's palm imprinting themselves upon her own, sensing the whorls of the fingerprints impress themselves into her fingers, and dreaming that her sweat was Rosa Kovslovsky's sweat—just as damp, just as cold, but graver, more fever laden, oozing. "Helen," she said, dropping the hand.

"Helen what, and what do you do?"

"I'm an art historian," she said, ignoring the first part of the question.

"Ah, how interesting. On what style do you concentrate? Is that the correct way to pose such a question?"

"Yes, certainly it's correct. But I study a topic, not a style—medical illustration, anatomical art." She winced inwardly—was there no part of her that could suppress this honesty? You don't have to answer! she screamed at herself.

The woman was silent for a moment and then declared, "We're all experts on anatomy, you know—you only need to have one broken heart to be an expert on anatomy."

"Hmm, yes," Helen sighed pointedly and stood up. "Excuse me," she said and stepped carefully around Rosa's outstretched legs, noting that the thick hose that conspired with the boots to imprison her flesh was failing and ripping along the twisted seams. Reaching to open the sliding door, needing to leave as quickly as possible—this woman was absorbing her now along with the air—she paused in spite of herself as the woman excused herself and drew her legs back towards the seat.

"But, please, before you go," Rosa said. The smile was briefly replaced by a look of pleading.

"Yes?" said Helen, hesitating. The glasses were really thick, the refraction displaced the woman's eyes. Helen didn't know where to look.

"It has begun, you know," the woman finished. And with that she waved Helen a cheery goodbye, her squat fingers splayed in a childish fan. As she left, Helen could see Rosa had begun frantically tormenting her hair with jerky, hacking yanks.

Helen turned away, let the door slide halfway back, and walked unsteadily down the aisle of the rocking train, aware that this Rosa person would be leaning out of the compartment watching her. She willed herself not to turn around, not to take another look. How disagreeable, she lamented, her stomach churning. How many hours will I be confined to this woman's company? She resolved to move the minute she got back.

The toilet was occupied, so Helen waited in the corridor, leaning against the cold window of the outer wall, closing her eyes, thinking about having exposed herself so ridiculously to a stranger. And what if there had been a man there instead of a woman? I've really got to stop dozing in the sitting compartments of night trains. Better to spend the money and get a sleeper. What an insane conversation! She suddenly inspected the hand that had shaken Rosa's. What did she expect? It was all there, it was all hers. She wiped its palm furiously against her trousers.

The latch of the door snapped. The sign now read 'libre' and the door slowly opened inward, revealing parts of a flowered shoulder, the shuffling tip of an orthopedic shoe, the muzzle of a very timid short-haired terrier, and finally the apple-red cheeks of a jolly, grinning woman. The dog, however, wasn't at all happy. It was cowering with its tail between its legs, its eyes rolled up high to compensate for its lowered head, and it quivered in spasms. Helen looked the pair up and down several times as they continued trying to extricate themselves from the narrow doorway.

Finally free, the woman, still grinning, put a finger to her lips, supplicating silence. Pointing to the dog and whispering, *"Verboten, weißt du,"* she giggled, bent down and scooped the poor mutt up and stuffed him unceremoniously into her canvas shoulder bag. Helen, more confused than ever, was uncertain if it was forbidden to have a dog on the train or in the train washroom.

The woman and her still-shivering bundle squeezed past Helen and through the doors to the adjoining car, leaving behind heavy wafts of bath and flea soap. Helen watched them go, wondering to herself why she didn't find any of this amusing.

She stepped into the washroom, locked the door, stood in front of the distorted mirror, and then took off her sweater and pulled her shirt up quickly to have a peek at her body. Shamefaced and perplexed, she traced the outline of the imaginary breasts she had felt so clearly in the compartment. Over and over, at times running the tips of her fingers along the surface of her skin, at times the edges of her fingernails, she etched an ever-darkening red line low along the bottom ridge of her ribs. The nerves of her fingers had never been so alive. Helen felt as though layers of damaged skin had been removed—not just from her hands but from her entire self—stripped to reveal a discomfort that should have remained contained. What did this Rosa mean, "It has begun." What has begun? Why did she feel as though she already knew that whatever it was had begun, that the woman had merely been repeating her own words? She weighed the imaginary breasts in her hands, weighed the persistent fragments of the illusion. She'd go back, she'd ask, she'd find the answers.

The train slowed down and then lurched to a standstill. Which stop would this be? It was reassuring to hear the normal commotion of a station—elbows hitting the bathroom door, luggage being dumped at the top of the stairs, passengers yelling and porters whistling. She dropped her shirt back down, tucked it in, and then quickly washed and dried her hands and face.

Fighting against the boisterous mob plugging the corridor, Helen squeezed into her compartment, momentarily relieved but disconcerted to find that not only had the odd woman and her luggage departed, but that, better yet, no one had taken her place. Instead, along with the hairpins lying thick on the floor, there was a rather worn wooden box left lying on the seat. The note attached to it read "For your search." After a quick, bewildered glance at the box, she flew to the window, unlatched its stiff lock, and struggled to slide it down low enough to lean out. Seeing no trace of the woman, letting the questions subside, she squinted to read the platform signs. "München," she said aloud, the soft *ch* shushing along her palate—a pleasant tickle; "Munich," she repeated, the hard *ch* grabbed at the back of her mouth, irritating her worsening

sore throat. A city she had always meant to visit. Another time. Particles of snow drifted down through the gap between the platform roof and the train, and a cold draft sauntered into the compartment.

Rosa had disappeared along with her wig, her bags, and her outrageousness, and moments later the conductors were blowing on their whistles and closing the doors to the cars. At the last minute the woman with the dog came running from somewhere at the end of the platform —unmistakable even from a distance—panting audibly, her inadequate summer shoes flapping against the concrete. Her heavy burden, still safely hidden in the cloth bag, was banging against her side, a hopeless antithesis to her sideways rolling trot. Helen imagined she could hear the pathetic dog yelping with each bump against its mistress's body, but somehow knew that it would never consciously give itself away, that it knew its mistress too well, knew that the most jovial people could be the cruelest. The conductor opened the door to the car adjacent to Helen's and hoisted the woman up the stairs. The door shut again with a pneumatic poof and a bang and the train jerked ahead.

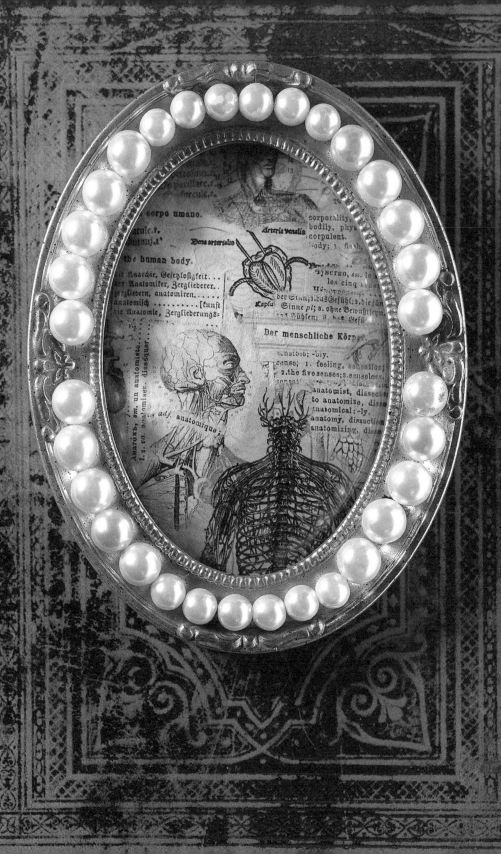

F R A U K E H L

Raising the window was only a token seal against the grinding wheels and gears. And the frozen air, so insolent and pernicious, had settled in for the duration. Helen chaffed her arms, cupped her hands over her ears, and then went to stand at the door, to watch the usual compliment of travelers lingering in the corridor, talking or leaning out the windows, smoking.

She then carefully and silently slid the door shut, concerned that the action not be perceived as an insult to those in the corridor. She decided against raising the blinds now flapping limply against the windows. Back in her seat, she turned the box over and over, looking for the latch. It was heavy and sturdy, and its contents shifted with muffled tones. It was decorated on the top panel with an oval, glass-covered plaque, the surface of which was scratched and nicked, protecting paper printed with aged and complex diagrams of the human body. Its ornate frame was inset with large, round beads that looked like pearls. The lid of the box was ornately tooled, but the box itself was nondescript, of polished wood, maybe mahogany, and worn—the veneer was scarred and chipping away in places; worm-holes speckled its surface. Except for the rather perverse subject matter chosen for its decoration, it could, at one time, have been fitting for an ordinary jewelry collection.

Helen tapped the box with her fingernail, musing over the coincidence between the artwork and her profession—a colleague couldn't

have chosen a better gift. She tried to open the box—the latch was not evident—by variously squeezing the sides and then the front of the lid, then by pressing the top down and releasing it quickly, and then by ramming the stiff note-card that had been left with the box in the crack between the lid and the bottom. Stubborn resistance. She balanced it on the edge of her knees and looked at it through the distance of her myopia. She tried pressing down on the plaque. She held it to her ears and rapped it with her knuckles, and then wedged her fingernail into the crack; the nail split. Mindlessly putting her finger in her mouth to chew off the hanging remnant, she picked up the note again. Nothing else was written on it except, "For your search."

She turned the card over and spat the nail end onto the floor. Just a thick piece of textured paper, neither white nor colored, neither new nor old; just a piece of paper. She turned it over again and looked at the handwriting. Old-fashioned style but inscribed with a ball-point pen. Writing like her grandmother's. Nothing distinctive, just the copperplate taught in schools around the world when clear, legible script was paramount. Her grandmother could make a disposable pen write like a million dollars. She held the paper up to the light of the window and could make out the corner of a watermark, an animal. A greyhound? Some kind of rodent? Two of them. More precisely, an animal and a half, running inside a crest, the other half cut off by the edge of the paper. Contemplating these details helped to pass the time.

Rosa's questions about who she was and why she was here nagged like a vexing itch. It seemed like this was the first time in weeks that she'd had even a ghost of a break to think about the purpose of her trip to Vienna. And what caused this Rosa to assume that she was here to search? Would there be something in the box showing that Rosa guessed that she was here to collar a truant husband no less?

Helen was a woman with a great capacity for disappointment; the bitter gall of fallen aspirations taunted her from waking to sleeping. Her husband, her marriage, and now this trip—all embarked upon with great enthusiasm and promise and all so quickly languishing in defeat and indifference, especially now that she was having such grave

second thoughts about coming to confront him.

Helen's husband's name was Martin Evans. He was a free-lance journalist who spent a good part of each year anywhere but home. She retaliated by abandoning the spaces empty from his absences, and wound her way along the academic speaking circuit, trotted out in front of drowsy students as an expert in medical art. Whether lecturing in classrooms harshly illuminated by fluorescent light, sensing instinctively the collective pressure of the hard plastic on her audience's aching ischiums; or eulogizing in the gentle wombs of darkened lecture halls, being drawn to join the spectators, to drown in vast upholstery, to watch herself tease layers of skin, muscle, and bone off of numberless men and nameless women; she had the impression that she was exposing more of herself than of the art. She was a freak in the art world and an intruder in the medical one, and as such seemed to invite probing, intimate questions.

If only Martin took such personal interest. Well, at least they didn't actively dislike each other—that would have taken too much effort.

Helen had convinced herself that she would sacrifice elements of her career if he showed any signs of doing the same, but that sign never came. And now that he seemed to have dumped her, she felt obliged to at least try to find out why.

During their long absences from each other, Helen would write him constantly as if by not doing so they would completely forget about each other's existence. He would dispatch the occasional letter or postcard—from Jeddah, Beijing, Milan, Miami—wherever stories took him. He usually worked on feature articles rather than fast-breaking news items, so research on one story might take him several months and thousands of miles. His letters never communicated much—a sentence about the weather, a description of the latest airline outrage, a trite "wish you were here,"—and they were usually scribbled on complimentary stationery from second-class international hotels, the kinds of hotels that dragged exhausted maids down long corridors until well after dusk, that had the same dark wood-paneled bars piping in music that bordered on offensive, if only for its inoffensiveness. She pictured Martin sitting

in these bars night after night, drinking too much, scribbling justifications, eavesdropping, meeting men in suits who had tips for this story or that or who just had their own sordid tales to sell. The work paid for the drinks, the airline tickets, and the hotel bills, but beyond that? She bought the house they never lived in, she owned the car that was rusting in the driveway. "Ah, resentment!" Helen half smiled to herself. Resentment held her hand, resentment stroked her hair, resentment shared her bed.

Aside from the sparse mail, she would avidly read his articles when they appeared or when she stumbled across them. Here she found disappointment as well. What fascination did a poisoned well in a village in northern India hold that their marriage did not? What was worthwhile about a ten-year-old arrested for corruption in Moscow? What difference in the world did these stories make? Who the hell cared?

But when she wrote to him she took care not to express her antipathy. She would agonize over the contents of his articles to show him that she read them carefully. She would also describe in detail what she was doing: her lectures, her travels, her day-to-day concerns. She tried to keep him up to date with the house and its constant need for attention and money. He would never refer to these letters, either in his own writing to her or when they were at·home together. And because of his silence, she would say nothing as well—as if the letters never existed, as if she never wrote to him at all. The more she wrote the more it seemed a foolish thing to do, and so the more she wrote, as if to find vindication in the written words, vilification in the spaces between the lines.

Helen thought back to her first awareness that he had cut and run, escaped, so to speak. His parents had phoned her to tell her that they had a message from him announcing that he would be home for Christmas. This "home" was back east—not exactly nearby but closer than he'd been for months. So she flew out, stayed with his parents—they were okay—and waited to surprise him. Christmas Day came and went, free time dragged heavily through the following week to New Year's Eve with no sign of him. Not even a phone call or a card. A good part of the holiday was spent repeating phrases of regret and chagrin, his parents

embarrassed for their son's behavior and for the possibility that they might have misunderstood his message, Helen ashamed for not having the power to bring him back herself.

She returned home on New Year's Day, not surprised to find neither card nor message waiting. He had been in Vienna the last time she heard from him, so she wrote to him frequently over the next few weeks care of the *poste restante*, the American Express, the associated newspaper offices, and the hotels that he had stayed at in Vienna over the years. They had had a tacit agreement that she wasn't to call him unless there was an emergency. Didn't this constitute an emergency? What would other people do? She had no idea. "Why didn't we just divorce?" she asked herself.

Her reveries had interrupted her inventory of signs of illness, but the now unbearable discomfort in her throat demanded her undivided attention. Never before had a sore throat possessed so much surface area—from the steel wool lodged in her gullet, to the knives that poked with every swallow into her inner ears. Through these sensations the entire interior of her head seemed as tangible and knowable as the back of her hand. She contemplated going out to the restaurant car to at least get a bottle of water. Didn't they send around men with carts? The desire for water suddenly became overwhelming.

Just as she was about ready to heave herself up, the door slid open and the severely manicured face of a disapprovingly elderly woman poked itself into the compartment. She blinked furiously as though taken aback by Helen's mere presence, scanned the racks and the other seats, and then barked a command at an unseen third party. Her head vanished and was replaced by a fussy but stylish young man who was burdened down with elegant, overstuffed luggage. As he shuffled in, holding two suitcases under each arm and pushing a fifth with his foot, Helen automatically slid the box out of sight. The hairpins, still littering the floor, skittered and snapped, knocked about by his feet and the bag. She watched him as he dropped the bags, first from his left arm onto the seat opposite and then from his right onto the floor. Then with a great deal of tortuous breathing and groaning he managed to hoist them, one

by one, onto the racks, squeezing Helen's small pack into even less space
than it had occupied before. Each effort produced gusts of perfume that
blasted her nostrils and seared her sinuses. Her eyes watered lamentably.
He stood up straight, brushed off his sleeves with efficient, undulating
fingers and squared his already square shoulders. And then, catching
sight of the tarnished mirror on the wall opposite her, he bent down
slightly to scrutinize himself, running his hand back over his hair which
fell in a brown-blonde cascade beginning at his high forehead, ending in
a blunt edge at the top of his collar. She noticed with a jolt that he wore
cosmetics—mascara caked his eyelashes, heavy kohl framed his eyes,
and outrageous spots of color perched high upon his cheek. As he
rotated his head to inspect each and every aspect of his appearance, he
observed her studying his reflection and smiled without turning around.
She rearranged herself to face the window, but not before glancing
towards the corridor and the woman waiting outside with knotted hands
impatiently kneading the air. He followed Helen's eyes to the corridor,
and then with a hastily muttered "Pardon," brushed off the seat previ-
ously occupied by Rosa, and gallantly motioned for the woman to enter
and take her place. She marched in, crushing more of the pins. Brushing
past the young man, causing him to lose his balance momentarily, she sat
down in the seat opposite, making Helen rearrange herself again, to
straighten up and tuck her feet in.

 "God," thought Helen, "what's the matter with the other seats?
What's the matter with the other compartments?" Clouds of perfume and
cologne competed viciously in the cramped space, making Helen's already
watering eyes flood. The young man settled into the far corner, giving
Helen the feeling that both were looking at her. And they both were. The
woman sniffed lightly. Helen threw her a brief glance and then reached for
her book. The young man played absently with the blind over the door.
The blind shot up with a snap. He grinned to himself, left the blind up, then
started tapping the window, alternating the sharp rap of a fingernail with
the dull but reverberating thud of a fingertip. Click-thump-click-thump-
thump-click. The toe of the polished boot of his right foot began to skip
about as if anxious to join in. Hairpins danced in unison.

The woman sniffed again, this time more heartily. Helen flipped through the pages, agitatedly searching for her place, but she was thinking about the woman—this ancient woman who was probably about seventy-five years old, around the right age to be the young man's grandmother. Dressed very extravagantly, garnished with jewelry, and lots of it: a filigreed gold broach affixed to her coat, heavy pendulous earrings dripping from her elongated earlobes, necklaces draping around her crepey neck, bracelets stacked up the arms, numerous rings on the fingers of both hands, but . . . a finger was missing from her right hand! The gap was almost perfectly concealed by the glittering baubles. Helen gaped at the mutilated hand from under her lowered eyes then shifted away, sensing that the woman was aware of her gaze. Perhaps she was a bit older than seventy-five—the backs of her hands seemed very gnarled and blemished; her legs were tortured with varicose veins. Her jet-black hair was coiffured and sprayed into a helmet of waves around her forehead and swept back in such a way to show off her earrings, and pathetically, to show the skin at her hairline, stained by a clumsy dye job. Her clothing from her fur collar down screamed money: immaculate fit, luxurious fabrics, exacting finish, impeccable accessories. But for all of the ornamentation, it really was her face that struck Helen the most. She had the face of someone who had been honed and tuned and sculpted into a mockery of a rich woman. Her eyes and mouth were voracious: her eyes ferret-like—wary and assessing—her mouth working and reworking itself as if trying to decide what to devour next. Her nose was pinched into permanent disdain, and one could see that even liberal doses of the best perfumes would be insufficient to mask the sour odor of her greed. Her chin had the sharpened zeal of a tool worn into the habit of gouging. "Really, this is too much," Helen thought, "but I'm not going to move."

She finally managed to focus on the page of her book, only to be wrenched away from it by an unpleasant, very deep sniff. This sniff, snort rather, had substance and reached back into the throat. Helen glared, renouncing her attempt to read but still cradling her open book; the woman's lips smacked, rolling the sniff about her mouth rapaciously. The ring-laden hands that had been smoothing her skirt over

her knees suddenly leapt to her throat as she pulled her collar tight together. Helen, peeking at the dandy in the corner, wondered what his part in all of this was. He straightened himself and cleared his throat to speak.

"Could you please change seats with Frau Kehl?" he said in English. "She dislikes riding with her back to the front of the train. You do speak English, don't you?"

"No, I'm afraid I couldn't," Helen replied. Surely Frau Kehl, if that was her name, was capable of speaking for herself. As a gesture of cooperation she pointed to the free seat by the corridor on the same side of the banquette, opposite the young man.

Frau Kehl responded with a soft cough that she prolonged by once again smacking her lips as if the cough were a spoonful of caviar.

"Frau Kehl must have a window seat. The air in the trains, you understand, is quite intolerable."

"You'll have to find another compartment then," said Helen with discriminate maliciousness. "Perhaps if Frau Kehl were to travel first class she would find a better selection of seats."

The old woman motioned sharply to the young man who pulled out a ticket from his breast pocket. He studied it for a moment before handing it over to Helen. She looked at it, turned it over, shrugged, and gave it back. So what? It was the same as hers: an ordinary second-class ticket with no seat numbers or compartment reserved.

The young man became visibly distressed, his cheeks flushed, his voice rose and cracked, "Don't you see? You really ought to change seats with Frau Kehl. I don't think I'm making myself clear enough."

"No, you aren't," Helen agreed. "Perhaps you'd like to call the conductor and explain to him what your problem is." Appalled at her own behavior, she urged herself to give in. Another look at the woman dissuaded her. Let the old witch fight her own wars.

He got up from his seat, shook his legs to unwrinkle the already crease-free cloth of his trousers, smoothed his lapels, and vanished soundlessly, not forgetting to shut the door behind him.

Helen and the old woman, for by now Helen had decided that the

woman was much older than she first seemed, were stuck in the com-
partment alone together. Helen gave up any pretense at reading and
looked directly at her. She asked in German, "May I ask where are you
traveling to?" There. A conciliatory question.

"I've seen you before," came the unexpected response.

"I don't believe so; I've never been to Germany or Austria."

"Nevertheless, your face is very familiar. It does not bring me
happy memories." The old woman wrung her hands. "You ask me
where I am going. I'm going to Vienna." Her voice was strained and
strangled. "It is a 4 hour and 55 minute trip. We have 4 hours and 17
minutes left, and I refuse to spend the entire trip flying backwards. I am
looking forward to revisiting Vienna and I must not arrive backside
first." She pulled her leather handbag towards her, released the clasp,
dug about inside, and eventually extracted a pocket mirror. Holding the
mirror up to block out Helen's face, she made motions to straighten the
rigid perfection of her hair and her features, shifting the mirror about
this way and that in a bird-like darting fashion. Her voice continued
from behind the glass. "You, on the other hand, can have no memory of
Vienna, and it can have no memory of you. Whether you arrive there
forwards or backwards is immaterial. Whether you arrive there or not
is immaterial, for that matter." She inspected her nostrils, glancing first
into the left and then into the right, gave them both a vicious pinch with
her thumb and forefinger, and then ran the long nail of her index finger
down the lines bordering each side of her mouth, as if to deepen the
already cavernous furrows etched into her skin. She ended by yanking
down on her chin and tossing the mirror back into her bag which she
closed with a firm snap.

"Well, perhaps your grandson will find another compartment more
suitable for you," said Helen consolingly.

"My grandson!" the woman howled in a burst of carmine lipstick
and badly stained, chipped teeth. Her face fell back into place, letting
her vulturish demeanor rule once again.

Helen twitched and fidgeted, restless now that she was unable to
stretch her legs out and regretful that she could no longer give in to her

illness. In doing so she knocked her bag over, causing the box to slip partway onto the upholstered seat of the banquette. Frau Kehl's eyes immediately fixed upon it, and she grabbed it faster than Helen could react. "How lovely!" she exclaimed but was visibly taken aback by its weight. Her expression changed when she examined the artwork. With a cry of disgust she dropped the box onto the seat next to her and pushed it away. "Revolting. What would possess you to own such a repulsive object?" But she again picked it up, held it to her ear—just as Helen herself had done—and shook it vigorously, listening to its muffled contents. Then she shook herself almost as violently and threw it down again.

Helen stuffed it back into her bag just before the door opened. The young man and a conductor appeared at the threshold. Frau Kehl stood up and said, "I refuse to stay in this compartment." She sneered disapprovingly in Helen's direction and turned on her heels, knocking both men out of the way.

The conductor helped the young man with the luggage; the two of them disappeared down the corridor, leaving the door wide open.

She hoped that the silence following their departure signaled the end of the parade. That Rosa woman had been bad enough, but no one deserved an encounter with Frau Kehl. They all seemed like characters out of someone's disorganized memory: oddly out of time, vaguely alarming, definitely disorienting. Suffused by the relief of her solitude and the absolute pleasure of the unaccompanied rhythm of the train, Helen sprawled on the seat and felt her forehead yet again. Then a glitter from the corner of the seat opposite caught her eye. It was a ring caught in the crease between the back and the seat. It had a gold band with a large, rather vulgar, diamond. Helen looked at the inside of the band and found it was engraved "To Helen." She tried it on but it was so tiny that it wouldn't fit past the first knuckle, even on her little fingers. "Not for this Helen, not for my fingers, obviously," she sighed. With the bag on her lap and the ring cradled in her tightly closed fist, she

stretched her leg out and shut the door with the flick of her toe, then curled up on the seat and, trying to resurrect her thoughts of Martin, fell asleep.

She woke with a start a short while later, still clutching the ring, suddenly frantic with the idea that she must return it. Without thinking she slid the door open and stood in the hallway, first turning left and then right. Which direction did they go? She scampered to the right, hoping to at least run into the conductor. She glanced into each compartment she passed, then went through into the next car. The train ended three cars down without a sign of Frau Kehl, her companion, or the conductor. Helen retraced her steps, passed her own compartment heading towards the front of the train, but she stopped in her tracks halfway through the next car. She didn't want the slightest thing to do with the voracious Frau Kehl and her pretty boy. If she gave back the ring what else would she relinquish? Helen turned and went back to her compartment. She'd give the ring to the conductor next time she saw him.

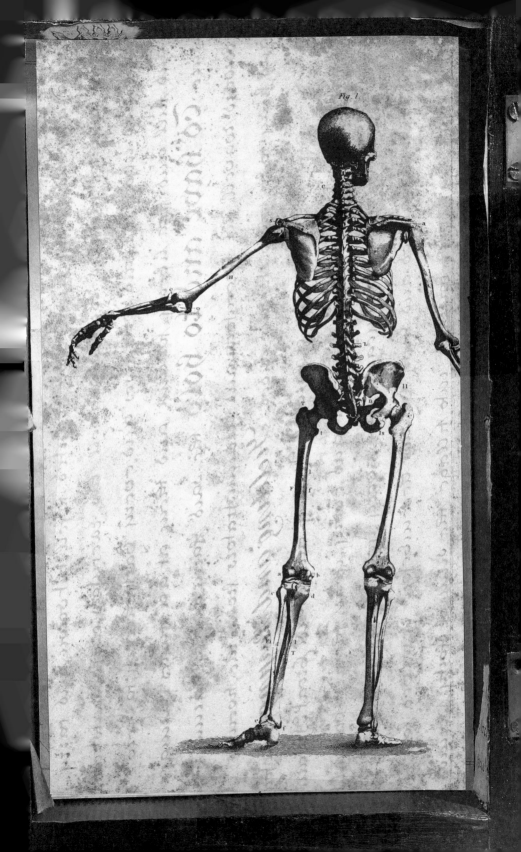

Fig. 1.

ANNA

Helen sat back with legs stretched out onto the seat opposite, absently popping the ring onto the tip of this finger or that, then raising the back of her hand to feel her burning forehead. The heat of her skin provided a solace in its presence and consistency—it was real, it was understandable, and in a perverse way it helped to explain the bizarre tumult exploding around her. She was sick, sick and demented. These people weren't unusual; it was her. Ever since she had woken up, she had been dreaming, hallucinating, staring wildly at each poor soul who tried to sit in her compartment. God knows what they thought of her. She pulled the box over to her and held it tightly to her chest, stroking the rippling surface of the frame, running her fingers along the smooth tops of the beads, then allowing her hands to wander through the space vacated by the breasts that had intruded so shockingly. Then, giddy from the lingering smell of the perfume, she shoved the box aside and stood up to let in a quick blast of cleansing air. Turning back to sit down, she could see that the lid had opened up. The plaque on the top panel had pivoted on a pin inset at one end and had inadvertently slid to one side when she had set the box down. When the pin rotated with the movement of the plaque, it released a catch inside opening the top.

The box contained, of all things, a book. Facing the book, lining the inside of the box's lid, was a flap of paper printed with a diagram of

a human skeleton. She folded it back and revealed an engraving of the bones of the hand, labeled with italicized letters. On the back of the first flap was a document entitled "The Fabric," showing a diagram of skin tissue and with a legend for the engraving opposite. She lifted up the second flap: below it was another flap upon which someone had drawn a crude, almost medieval, diagram of six tiny bottles surrounded by plants. The back of the flap was text presumably pertaining to the engraving.

She turned her attention to the book itself; a thick, bound stack of paper, musty and decaying, the edges deckled and fragile. The first page was a title page, remarkable not so much for what it said but for the quantity of handwriting on it, running not only over the blank, unprinted stretches of the page but over the words as well, and in turn, over itself. The title—*Anatomica*—clearly indicated a treatise on anatomy. She turned the pages one by one—it was all in Latin—until she came to about the 6th page and a small magnifying glass, the metal frame of which was inscribed with medical words, set into a hole carved into the pages. Looking back at the inside of the lid she could see that its placement matched that of the diagram on the flap. She tried to remove it, but finding it tightly wedged into the hole, instead estimated its depth and turned over a thick clump of pages, careful not to dislodge it. She came to a group of labeled bottles, similar to those also recorded on the flaps. They looked like medicine bottles, vials rather, but their contents were desiccated and blackened, appearing to be anything but efficacious. They were inset into what appeared to be an engraving of hearts.

Again she cautiously turned back another batch of pages to a page with a large hole carved into it. The shape suggested a hand. There was room for all the bones: carpals, metacarpals, phalanges, but it contained only a single finger bone, firmly lodged into its appropriate place. She painstakingly extracted the bone. It was thin, about two inches long, and deep brown as if it had been resting in a rich loam for eons and had taken on the color of the surrounding earth. It had been placed in the box very much like an anatomical specimen, or no, more like a religious

ANATOMICA

OPUS

IN UNO VOLUMINO

MYSTICA

CONJUNCTIO

IN QUINQUE SENSIBUS

Tactus libentia, Videndi miraculum, Odorandi potentia, Audiendi delectatio, Gustandi gratulatio

ANDREÆ VESALII

BRUXELLENSIS

ET

CONTEMPORALIUM

Opera referenda & gratulata

EX LIBRIS

R.I.K. Dr. Med.

Handwritten annotations:

1574 - Andreas Vesalius born
1538 - Tabulae Anatomicae sex published
1539 - Venesection Letter published
1542 - Woodblocks cut in Venice for the Fabrica & the Epitome
1543 - 1st edition of De Humani Corporis Fabrica printed by Johannes Oporinus of Bâle
1564 - Vesalius dies on Zante, Greece
1568 - Oporinus dies
1583? - Fabrica woodblocks passed on to Froben's printing house
1603 - Woodblocks go from Froben to König - Still in Bâle
1604 - Venice edition by Antonium & Jacobum de Franciscis?
1706 - Abridged edition of the Fabrica printed by Andreas Maschenbauer in Augsburg - ATTRIBUTED TO TITIAN
1781 - Abridged edition printed by H.P. Leveling of Ingolstadt "Anat. Erklärung" using ORIGINAL WOODBLOCKS
1783 - Leveling publishes 2nd edition, also in Ingolstadt
1800 - Woodblocks are moved from Ingolstadt to Landshut when university moves
1808 - Fragment (?) Asiatic Society of Japan tr. from Dutch (?) into Japanese
1826 - Woodblocks are moved again from Landshut to Munich
1893 - 159 blocks are discovered in the Munich Library
1914 French edition started (never completed) in Haarlem "La Structure du Corps"
1925 - Title page for the 2nd edition Discovered in Antwerp - donated to the University of Louvain where Vesalius studied medicine
1932 - Woodblocks rediscovered this time total is 227. All initial capital blocks have disappeared along with some others
1934 - publication of the icones Anatomicae by University of Munich & New York Academy of Medicine. By Bremer Press of Munich
1943 - 400 year celebration of the publication of the Fabrica
1944 - July 13 - University of Munich bombed - Woodblocks survive
1944 - July 16 - 2nd bombing - Woodblocks destroyed - reputedly

1543 - 1st edition of the Epitome also published (only edition)?
1546 - Letter on the China Root published
1547? - Jan Stephan van Kalkar dies 1555. 2nd edition of the Fabrica published
1607 Johannes Oporinus Frans Kalkar 1592?
1568 - edition printed in Venice by Francesco Senense copied NOT USING ORIGINAL BLOCKS
1606 - 1608 - Venice - plagiarism - Valverde and 1682
FELIX PLATTER - De corporis humani structura et usu - Vesalius images recut (smaller - on copper)
1723 - 2nd abridged edition of Maschenbauer 1706 printing
1771 - Von Wolter tries to reprint

reproductions NOT ORIGINALS

SOME BLOCKS REVISED & SET the F. BLOCKS ALREADY REPRINTED 1592

relic. Helen, who had kept Frau Kehl's ring stored on the tip of her left hand baby finger, slipped it onto the bone. It went on easily but was difficult to remove. Helen was pleased with the effect and left it there. She dropped the bone onto the seat beside her.

Further exploration of the book revealed two pieces of paper stuck between two of the pages. One was a sheet torn from an appointment book and the other, more immediately interesting, was an old woodcut folded in two. Carefully removing the pliant but discolored paper, she was amazed to find it was of a sturdy, well-proportioned man, stripped of his skin, exhibiting his muscles against the backdrop of a peaceful Italian countryside. She immediately recognized it as the work of the sixteenth-century anatomist Andreas Vesalius. Running the tips of her fingers along the surface of the supple, lightly foxed paper, she could feel the impression made by the pressure of the woodblock. And judging by the evidence of stitching on its left hand side and the wear and discoloration on the other edges, she suspected that it had been removed from a book, but definitely not this one; it was too large.

She'd seen an original once but at that time hadn't had any reason to examine it closely. Specializing in later works of French and English anatomists, she had let her knowledge of Vesalius slip too far to the back of her brain. Born in Belgium, became a doctor at some incredibly young age, published a monumental work called the *Fabrica* in the mid 1500s, nearly displaced Galen as the father of anatomy, largely unknown outside the medical world.

She held the paper up to the light to see if a watermark was evident, but the cloudy skies and dim incandescent bulb were insufficient illumination. She flipped the box's pages back to where the magnifying glass lay, and with great difficulty pried it out. Peering at the woodcut through the glass, first focusing on the inked surfaces, then on the laid texture of the paper, and then moving along to the woodgrain of the box and then to the hairy surface of the upholstery—no matter where she looked, the word *Sohle* appeared. Curious, she held the glass up to the light and examined its surface, discovering that the word had been etched right into the glass itself. *Sohle* means "soul," she guessed,

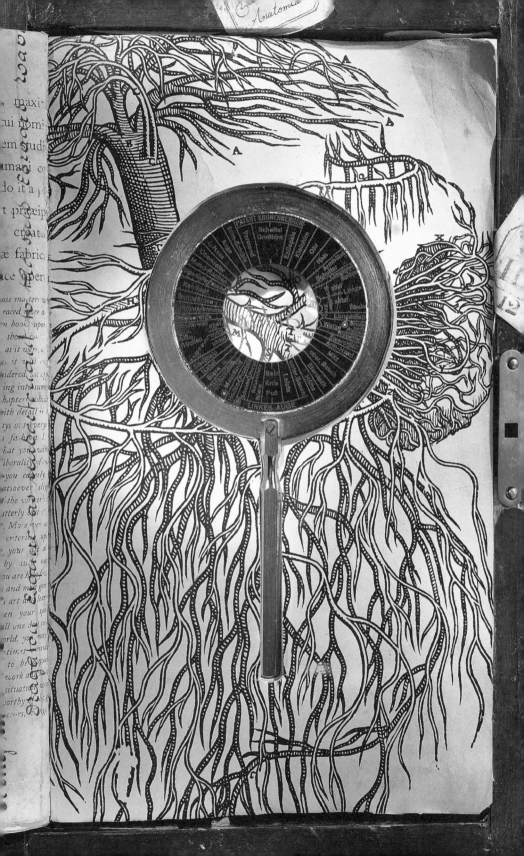

promising to look it up. What was even more interesting than the woodcut itself was, why was she even given it? Helen set it and the magnifying glass next to the finger.

The last item in the box was the single page neatly torn from a small date book. It was ruled with light blue ink and one side of the page was densely covered with the same style handwriting found on the note. The ink from the pen had smeared here and there but everything was legible nonetheless. The date printed at the top of the page, in German, was for Thursday the 24th—two days away. Ten o'clock had been circled and the name Dr L. von Ehrlach of Türkenstrasse in Vienna was written down.

She turned again to the vials and one by one tried prying them out. All of them were wedged in tightly and would barely move. The last one shifted promisingly, but gave in to the pressure and shattered between her thumb and finger, piercing her skin. Blood dripped from the cut, barely missing landing onto the page.

Swearing softly, she wrapped her finger with a cloth handkerchief and gingerly lifted the broken pieces out of the box. The blackened contents of the smashed vial—fortunately dried into flakes—fell onto her lap and into the book. Holding the broken pieces of glass in her hand, at a loss for what to do with them, she gave up and put them into a little pile beside her.

Helen pulled a pen and a pad of paper out of her bag and sat back with her feet balanced on the edge of the seat and her knees up like an artist's easel. She turned back the stiff cover and read through a half-finished letter to Martin she had started the day before. Then, resting the pad on her legs, she started to describe the contents of the box and her encounters with Rosa and Frau Kehl. She wrote steadily and care-fully, pausing every once in a while to pick up this object or that, or to think about the best way to describe the two strange women, taking care to phrase the characterizations as phenomena related to her state of illness. She knew that Martin would ignore the lengthy preamble about her fever and her concern for his well-being, and would delight in her descriptions of the singular appearances and behaviors of the

ANATOMICAL. *a.* Anatomicus.
ANATOMICALLY. *ad.* E regulis inci-
sionis corporum ; e regulis (præscriptis)
anatomiæ.

To ANATOMISE. *v. a.* Incidere or se-
care corpus (corpori).
ANATOMIST. *s.* Cicatus (peritus inci-
dendi et perscrutandi corporis) peritus
anatomiæ.
ANATOMY. *s.* 1. *The art of dissecting
the body* ; anatomia ; anatomice; ars in-

people she'd met. She knew what Martin liked to read; his respect for
the human race would barely register on any scale. Too bad her letters
didn't contain more of this sort of stuff.

She couldn't stop thinking about Martin. Who knows how long
she would have ignored his absence if it hadn't been for a phone call
from the editor of one of the New York papers he regularly contributed
to. Helen had never met this editor, although she had spoken to him
from time to time. She had a good idea of what he was like, mostly
because Martin had enumerated his various quirks, telling her of the
high pitch of his voice, the nervous disintegration of sentences before
they reached their endings, and the audible clicks and shudders, almost
like the language of the Kung Bushmen. She could place him as being
a cautious man, not prone to speaking his mind in one emphatic sweep,
but accustomed to breaking and pausing, allowing other thoughts to
detour the original subject. Martin said he was very slight, quite
underweight, a real feather, in fact—Helen was positive that was
because he would be unsure of what to eat. He was in his late forties,
apparently, and was never seen without a vest no matter how hot the
summers got.

"Helen! I've been trying to figure out if I should call you or," the
sentence had trailed.

"What can I do for you, Mr Singleton?" Everyone called him
Jimmy but never to his face. She herself couldn't call a man who always
wore a vest by his first name.

"Have you heard from Martin lately?"

"No, not since his parents got a telephone message around mid-
December. He told them he'd be at their place for Christmas but never
showed up. Is anything the matter?" The alarm bells were ringing.

By prodding and being patient and by answering her own ques-
tions, Helen had finally grasped the fact that Martin had not submitted
an article that he had promised for an early January edition.
Furthermore, Jimmy Singleton had called the Vienna paper and then
the hotel, the Eugen, and had discovered that Martin had left just before
Christmas with the intention of returning to Canada. He'd gotten

another journalist looking into Martin's departure but that reporter had had to leave Vienna on another job before he could find anything out.

She had asked what the article had been about. The answer was a vague muttering about art thievery. Helen felt on familiar ground and questioned him further, but he really didn't know much. They had agreed to run the article; it seemed timely if one could judge by the number of thefts reported from western and central Europe, and that was it. Martin wasn't obliged to keep them up to date with drafts and outlines.

Helen, in turn, telephoned the Vienna newspaper and then the hotel, receiving the same answer that Jimmy Singleton had received: that Martin had left and wasn't expected back.

"And, so, why am I here?" she asked out loud. "Because I'm his wife and this is what a wife should do? Because I've always wanted to see Vienna? Because I'm selfish and actually quite interested in the article he's writing and in the anatomical art collections in Vienna? Because I want to know whether or not I have to go on writing him these crazy letters?"

The door of the compartment opened up once more. She looked up, startled to be disturbed again so soon, but it was only the conductor. He was standing at the door, his gaze riveted by the finger bone on the seat. With an apologetic hesitation, he picked it up and measured it methodically against his own stout fingers. Shaking his head with each evidence of poor fit, he put it back down and started removing objects from his own pockets. While he did so, he perched on the edge of the seat, his knees stretched wide apart for balance and his jacket bunched up untidily around his hips. He extracted a silver whistle with a dark, worn leather neck strap, a foot or so of dental floss (which he quickly stuck back), a ticket, a set of keys, and a candy bar wrapper with some of the chocolate still left in it. He put the objects on the seat next to him and spread everything out so that Helen could see what he had. She watched him with dismay, wondering what was expected of her. The conductor smiled expectantly and then invited her to take her pick. She sighed

inwardly but leaned over to better look over his treasures. She chose the ticket. He nodded approvingly, put the remaining objects back into his pockets, stood up and departed, closing the door behind him.

She'd forgotten to give him the ring.

The door opened again almost immediately, this time admitting the woman with the dog. So, thought Helen, the parade isn't over, after all. The woman panted and huffed, still laboring perhaps from her run for the train, but more likely from a chronic shortness of breath.

"Ah, here you are. I've been looking all over for you," gasped the woman as she dropped the bag onto the seat opposite. It landed with a justifiable squeak. She herself sat down heavily onto the middle seat. The dog's nose emerged from the bag, but the woman stuffed it back in and jumped up to close the door. She then upended the bag, dumping the terrier out head first. He was a café-au-lait color with big black eyes, serious eyebrows, and tufts of hair sprouting randomly about his body. Helen, convinced that he was about to shiver himself off of the seat, offered her hand to try to show that she was a friend. He ducked the hand and eyed her suspiciously.

"He loves to travel on trains," announced the woman. "My name is Anna." She shook Helen's hand vigorously. "My dog does not have a name. Please do not give him one; I don't want to spoil him. I would like to ask you if you found anything in the toilet earlier this morning. Something that I may have left."

"What might you have left?" asked Helen, "I didn't see anything, but it would help if I knew what you were looking for."

"Oh, it makes no difference, I probably didn't even bring it with me. It's so easy to forget essentials, don't you agree? It really must be in here somewhere." She opened up her purse and dug around, cooing to her dog intermittently. "Ah, here it is! I had it all the time." She flourished a large battery-operated men's shaver, flicked it on, raised her dress to above her knees, and bent over to shave her legs which, Helen noticed, had likely never been shaven. After the first pass of the shaver Anna sat back up and blew the hair off of the end with a big puff.

"Do you mind?" snapped Helen, aghast yet intrigued. Anna

reminded her of one of her aunts—Gertrude—her father's only sister. Aunt Gertrude had tried desperately to join the league of women formed by her mother and her mother's sisters but they steadfastly refused her admission. She wasn't serious enough; she talked to herself; she smelled too often of overexertion; she knitted uncomplimentary socks of castoff unraveled green wool. Gertrude had believed that she qualified if only because of her Christian name. The issue became a thorn in the family's side, not because Gertrude truly wanted to belong, but because she realized that no one wanted her. Helen could remember the conversations between her mother, aunts, and their friends, held in the otherwise unused living room on sunny afternoons, curtains drawn tight as armor against the sun. The living room anything but. Gertrude did this outrage and Gertrude caused that offense. The horror these women had for Gertrude had everything to do with the fact that she wasn't married, that she lived alone. Helen's Aunt Tessa never married, she lived alone, but at least she didn't act like she missed it; she didn't carry her state of solitude like a disease. Gertrude, on the other hand, was a living walking breathing reproach to spinsterhood, and she drove everybody crazy. Yes, this Anna was like her Aunt Gertrude.

"I do beg your pardon. When one lives alone one often forgets oneself." Well, that was the first part of Helen's assessment verified. She was relieved, for she had liked her Aunt Gertrude. Anna put the shaver back in her purse and clamped it shut, then swept her dress back down over her knees.

"Oh, I see you've cut your hand. How did you do that?"

Helen gestured to the shards of glass beside her, but then noticed that the dog had been staring intently at the objects. She placed her hand over them protectively before he could be tempted to take off with the bone. He stood up on the seat on all four legs and shook himself grandly until all of his hairs stood on end.

"May I see that?" asked Anna, pointing to the box.

"Sure." Helen passed it over, awkwardly balancing it with her one free hand.

While Anna inspected the box, Helen managed to get the dog to sit
down again and to accept a couple of pats on the head. She reached out
towards his paws and quietly asked him to shake hands with her. He
lifted his paw, rested it lightly in her outstretched hand, and nuzzled her
ear. "I could get you a new pair of shoes," he whispered.

Helen sat back with a thud. "Can your dog talk?" she asked Anna.

"Don't be absurd," laughed the woman. "What else have you got
here?" She put the box down on the seat on Helen's side of the compart-
ment and reached for the woodcut. Holding it carefully by the corners,
she crowed with delight. "Ah, Andreas Vesalius, the *Fabrica*, the
Epitome, the *Tabulæ*, what a wizard!"

"Oh, so you're familiar with the history of anatomy?" asked Helen.
The *Epitome* and the *Tabulæ* were the names of his other books. Anna's
outburst had jarred her memory.

"Anatomy? No way," Anna shrieked. "Vesalius is a collector of
important books, and he is, needless to say," she said it anyway, "always
dusty."

"But you just mentioned three of his important books," said Helen.

"Yes, I told you," Anna sighed, "he is a collector. He lives in
Munich. My sister knows someone who goes to Munich all the time to get
books from Vesalius. She's told me all about these particular books; they
are very rare, you know. You'd like my sister; you have a lot in common."
She draped the paper back onto the seat, delicately took hold of the end
of the finger with its ring, smiled and leaned towards the dog, waving it
temptingly in front of his nose. The terrier rotated his head following the
rhythm of her dancing hand, his eyes glued to the bone. "Ah," she said,
"how he loves jewelry."

"Don't you think it's the bone that's attracting him?" asked Helen.

"The bone? What'd you take him for, a carnivore?"

"Isn't that what dogs usually are?"

"This dog happens to be an *artiste*."

Anna dropped the finger back onto the seat. She picked up the
magnifying glass and put it under the feeble ray of sunshine now waver-
ing through the window. In seconds the concentrated beam burnt a dark

VESALII BRVXELLENSIS

streak down the floor between the two banquettes. Anna screamed with laughter. Helen jumped up and opened up the window, thinking only of dissipating the stink of singed linoleum before it crept out to the corridor. She grabbed both the magnifying glass and the box, embracing them in a formidable stranglehold.

"I've been helping my sister follow Vesalius for many years, you know. Did she give you this box?"

"Who's your sister?"

"Oh, you'd recognize her if you saw her," Anna said evasively, distracting herself by playing with the ends of her hair. She refocused suddenly. "Will you give me the box? She never gives me anything."

"I don't think so." Exasperation had comandeered Helen's voice.

"I see. Well, will you give me a piece of glass?"

"I don't see why not," said Helen, relenting, "take two."

"Thanks, I will." Slipping the glass into her dress pocket, Anna stood up and ordered the dog back into the bag. He buried himself headfirst, leaving only his scruffy tail showing. He had at least stopped shivering.

"But, how rude of me!" screeched Anna suddenly. Helen started up in a fright. "I must give you something in exchange," she prattled on as she looked around the compartment all the while patting hips, tummy, buttocks. Her eye lit on the sack. She grabbed the dog's collar with such force that it wrenched the clip and tore away from the poor animal's neck, reducing the dog to a whimpering, cowering mutt. She ignored its pathetic snivels and detached the tag with great difficulty, panting furiously as she did so. Finally succeeding, she cried out in triumph and tossed it over to Helen who caught it just as it was about to fly over her right shoulder. The dog, traumatized without his collar, would not come out of the bag again.

Anna stood up. "If you see my sister, tell her that I need to talk to her. You'll know her—she doesn't resemble me at all." Before she turned to leave, she stuck the tip of her finger in her mouth, chewed on it coquettishly, then waved it in a gesture of farewell.

Helen was alone again in the compartment. The dog had spoken to

her; she was sure she hadn't imagined it. She looked down at her feet and saw immediately why he had offered to get her a new pair of shoes—hers seemed to be burnt to cinders. She brushed away the ash; it fluttered into the air and disappeared, leaving her shoes, at least, intact.

IN VIENNA

D o men still wink? This one did. His name was Herlsberg. First name? Who knows. If he had one no one was letting on, least of all him. The wink could have passed for a spasm, anywhere else but here. Here was the editorial offices of Vienna's largest daily newspaper where Herlsberg held the post of editorial assistant. The wink was an excuse for not speaking English and for pretending not to understand Helen's dusted-off textbook German. The managing editor had spoken English—and he wasn't parting with any of his name—but Herlsberg spoke next to none, and thus the wink.

Helen the martyr spending her first full Viennese day at the newspaper, finding out more about Martin's research, going through the contents of the mailbox that he had retained there. The editor had described the article that Martin was writing as an exposé on anatomical art thefts. He didn't know any particulars, nor did he seem interested; after a cursory conversation he left her in Herlsberg's care.

That Martin had been working on something to do with anatomical art was a striking coincidence. Helen tried to explain how astonishing this was to Herlsberg, but, realizing the futility of doing so, she turned her attention to the overflowing mailbox as he spun about and went into his own office. Her brain filled with confusion and blood flushed her face, leaving her momentarily blinded and dizzy, when she realized that a good number of the letters in the box were from her, none of them opened.

She separated her letters out from the rest and looked at the envelopes one by one, furious and saddened. They dated as far back as October. She went to the door of Herlsberg's office. "When did you last see Martin?" she asked.

"December 12th," was his reply. She nodded and went back to stare at the box. Contemplating momentarily the idea of opening the envelopes and rereading her letters, she decided instead to bury them into the depths of her bag. Left on the desk she'd been provided were a much-diminished pile of mail and telephone messages from other people.

Before going through these, however, she fished about in her bag and pulled out a bottle of water. The sore throat and fever that had started on the train had not gone away and in the stuffy, overheated editorial offices she felt more ill than ever. The still coolish water helped relieve the burning, and so she began the task of organizing the remaining letters.

"I feel like a jealous wife," she muttered to herself.

"Was?" Herlsberg's voice startled her. She looked up and saw that he was watching her from the door to his office.

"Sorry," she replied in German, "I was talking to myself." He stared at her for a few seconds more and then went off through another door. He came back a few minutes later balancing a saucer and a glass of steaming amber liquid. He set them down onto her desk and pointed to them. "Tea," he said unnecessarily and returned to his office.

The telephone messages were from art galleries and museums in Vienna, a museum in Budapest, and a library in Munich. "It would have been interesting to work with him on this one," she thought to herself as she picked up the telephone to call the name written down on the first message slip on her pile—the director of Vienna's Josephinum museum.

"Herr Direktor Ganz, bitte," she practiced to herself while she dialed the number. *"Können Sie. . . ."*

A man's garbled voice on the other end of the line interrupted, identifying himself incoherently.

"Herr Direktor Ganz, bitte." A precise stab in the lingua obscura. While waiting for the connection she tried to put into order what she

knew of the museum called the Josephinum. She had never visited it but knew it vividly and intimately as if she had put the collection together herself. It was an anatomist's dream, full of wax models of the human body in various stages of dissection. Gruesome, perhaps, but they were works of art, crafted in eighteenth-century Italy. Had something been stolen from the Josephinum?

The telephone buzzed and clicked several times, and then a voice announced that she had reached the Director's office. She introduced herself, explained tortuously why she was calling, and asked to speak to Herr Ganz. The secretary said that the director was not in but would be free the following afternoon. Helen made an appointment, hung up, took a sip of the tea, and went on to try the next name.

Why was Martin looking into theft of medical art? The topic was important to her, but it wouldn't be easy to get the public's attention or sympathy over that one. She imagined gangs of doctors dressed in their white laboratory coats plotting to break into obscure museums full of ancient stethoscopes and scalpels, jars of leeches and brains, and skeletons of abnormal human specimens.

She tipped the dregs of the now tepid tea down her pained throat, stuffed the rest of Martin's correspondence in her bag along with her own letters, and walked over to Herlsberg's office.

"Where is the Josephinum?" she asked.

"A medical museum," he replied.

"No, sorry. *Where* is it?" she corrected herself.

Herlsberg shrugged. "They have wax models. Interesting, if you can stand that sort of thing."

She gave up. "Why would Martin be calling them? Have they had something stolen?"

Herlsberg swiveled in his seat and began typing into his computer. Helen remained standing at his door, hoping that she hadn't just been dismissed. He read from the screen, squinting, moving his lips, then typed some more. She set down her bag and the mailbox and leaned against the door jamb, giddy from the heat. She waited for a few minutes, then shifted her weight. And shifted it back again.

"I'm going to pass out," she thought, alarmed.

"Thefts," confirmed Herlsberg.

"What?" she asked.

"Thefts. Art thefts,"

"Is that all? No details?"

He squinted even more deeply and frowned. "No," was his clipped reply.

"Just thefts? There must be more information."

"No." He blinked and smiled. "I will return the mailbox if that is all." She was dismissed.

"Yes, that's all," said Helen. "Thanks for the tea." And she left.

Her hotel radiated an incandescent warmth that had nothing to do with anything but the color temperature of the light bulbs. After the hours spent roasting in the editorial offices, Helen had walked in the cold, betrayed by her overheated body into believing that the harsh Vienna dusk was benignly temperate. By the time she reached the hotel she was chilled to the bone. The hotel radiators lacked the will to even try to battle the cold drafts. So, bundled up with sweater, scarf and extra socks, Helen sat on her bed cross-legged, cradled by the thick duvet, with the teapot she had brought up from the kitchen nestled between her legs like a hot water bottle.

She sorted through the letters, tossing them into penitential piles on the floor. She would glance at the handwriting, "This one was a bellyache." It landed on the pile on the left. "This one was chagrin." It went in the middle. "This was," she looked at the return address scribbled on the back, "jealousy." It got tossed on the pile on the right. And so it went. Piles of discontent, mortification, and criticism. She sighed and fell on her back, her legs still crossed, her arms spread out beside her, her hands kneading the quilt cover, her mind wandering from Martin to the women on the train. Especially Rosa. Had she been dreaming?

She doubted it. Every so often the straps of her brassiere dug into her shoulders, the folds of skin and fat encircling her tummy itched

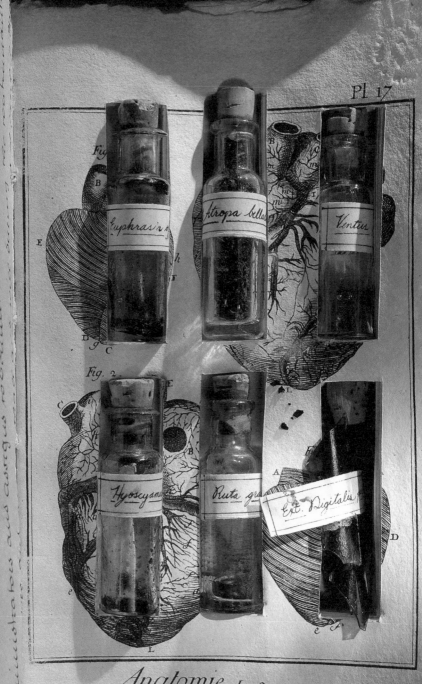

Anatomie, Le Cœur.

Pl. 17

and flamed, her thighs—the bruisers!—her thighs ricocheted off each
other, chaffing and wobbling all the while. A horrid feeling. She would
pull up on the straps to relieve them of their non-existent burdens;
she'd rub her flat belly, smoothing out the imaginary folds; she'd
grasp the loose fabric of her trousers and stretch it further to accom-
modate the fantastical haunches. Something about this was real. Not
the weight—any mirror did the favor of belying that concern—but
the substance, containing, absorbing, assimilating. She was devouring
or being devoured by another's essence and that other could only be
Rosa.

She wrestled herself back up, moved the teapot to the bedside table,
and pulled the box closer. Picking through the stuff again. Not dreaming;
here it was. The magnifying glass, the woodcut, the torn-out page, the
finger bone, the vials. The page into which the vials were stuck caught her
eye again. She ran her finger along the roughened surface of the paper,
contemplating the fragments of hearts, picked up one of the flakes of
dried medicine from the broken bottle and absently put it in her mouth.
When she realized what she had done she tried to scratch it off of her
tongue, but her picking only broke it up into smaller fragments. Appalled
by her stupidity and hoping that whatever was in the bottle no longer
worked, she washed it down with the rest of her tea. The label still clung
to one of the remnants of broken glass. *Ext. digitalis purpurea*. Digitalis.
Heart stimulant. As if on cue, her heart started beating crazily. Why
hadn't she read the label before swallowing the stuff? Why had she stuck
it in her mouth in the first place? She grabbed the magnifying glass and
stared through it—cockeyed sickening sensation in the gut—read the
label again, read the notebook page, the appointment with Dr von
Ehrlach. Why not go see him after all?

Resolutions made at ten o'clock at night can seem pretty ridiculous at
ten o'clock in the morning. However, at five minutes to the hour she
found herself standing in front of a bland, turn-of-the-century building
on Türkenstrasse, preparing to keep the rather dubious appointment

with Dr L. von Ehrlach and grateful that her reaction to the dried-out old medicine had been nothing but panic.

A morose doorman sporting dense glasses with heavy translucent sky-blue frames let Helen into the building. While she told him she was there to see Dr von Ehrlach, she couldn't help but notice his moth-eaten uniform with frayed cuffs, the strands of gold braid trailing from the sleeves, and the holes developing along the seams. He shrugged both to dismiss the poor state of his once dignified clothing—her scrutiny was unmistakable—and to let her know that, although it was none of his business who she was there to see, he would be so kind as to point out the lift to her. As she waited for the car to descend, she watched him walk away, noting that he squirmed and tugged at his shoulders, trying to straighten out the epaulettes which were in bad need of repair. He let himself into a cloakroom just off the lobby, shut the bottom half of the double-dutch door and stood ramrod straight, at attention. Helen punched the button again, but could hear no sound coming from the elevator shaft. She looked inquiringly over towards the doorman. Regarding her with his expressionless face, he held up a schilling coin between gloved finger and thumb, and demonstrated inserting it into a slot. Helen looked around the door of the elevator and located the slot. She found a schilling in her pocket, stuck it in the slot, and immediately heard the sound of the elevator descending. She turned towards the doorman to acknowledge his help, but he was now leaning with his elbows on the shelf, surveying other dimensions of his empty domain.

Helen's gaze followed the slow descent of the lit elevator car. Its arrival was punctuated by a whine and bump; the heavy cage door screeched in pain as she slid it back, redoubling its cries of agony when she shut it. She was surprised to see a small man tucked away in the corner hunched on a stool, legs hanging, feet swinging to the beat of imaginary elevator music. He was wearing a uniform identical to that of the doorman.

"Oh," exclaimed Helen. "You startled me."

"*Was?*" asked the elevator man.

"You startled me," she repeated in German. "Are you the elevator

man?" He obviously was, but then why hadn't he opened the door for her?

"*Ja,*" he replied.

"*Dritter Stock, bitte,*" she commanded.

He pointed to the buttons.

Helen stared at him for a second and then pressed 3. The elevator began its rise up to the third floor with a terminal slowness that gave Helen the opportunity to scrutinize the cramped interior. The car was dimly but warmly lit with a series of five suspended lamps, delicately shaded with smoky glass made even more opaque with the accumulation of years of dust. The walls were decorated with floor-to-ceiling strips of fretworked brass, alternating with tarnished glass panels. The elevator's interior had been buffed time and again, and one could see that every crevice was caked with the white powder of dried polish. Helen rubbed her eyes until they watered, as if tears would bring light to the dimness. She then asked the man petulantly, "If you're the elevator man, then why don't you do your job?"

The man reached first into his breast pocket, dashingly offered her a soiled handkerchief, and then into the palm side of his left-hand glove. A somewhat stained card, creased into the shape of his palm, emerged. "Wilhelm Stukmeyer, *Aufzugsfachmann/Elevator Professional,*" read Helen dumbstruck. *By appointment only.* That was ridiculous. Who had ever heard of such a thing? She tried to hand him back the card, but he demurred with lowered eyes and a raised hand. He did, however, accept the return of the handkerchief.

The elevator finally reached the third floor and groaned to a stop. She opened up the still complaining door, leaving Wilhelm sitting in his corner. "I'm taking the stairs down," she muttered to herself as she walked down the hall, looking for the doctor's office.

Helen knocked on the door that displayed the sign, "Dr. med. L. von Ehrlach." Not hearing any footsteps or voices inside, she turned the knob, and, finding it unlocked, stepped into a modest, functional waiting room. It was incongruously furnished with five dark green, molded plastic chairs arranged around a heavy polished oak coffee table.

There was no receptionist, but there was another door with a yellowed, hand-written sign on it that read, in German, "Please have the kindness to wait."

She sat down on the edge of one of the chairs, finding little in the room to catch her attention. She glanced at her watch: 9:58. Contemplating the room's bareness, she noted the pale green of the walls and the absence of windows. The floor was the same as the floor of the hallway—a dark green marble laid in three-foot squares with the veins painstakingly matched from square to square.

At precisely ten o'clock the inner door opened up, and a tall man in his late fifties or early sixties sporting a long white lab coat over a hairy tweed jacket peered out. His face was thin, almost ravaged, and the brilliant silver and red hairs of his goatee, mustache, and eyebrows added voltage to his rather electric appearance. As this was clearly Dr von Ehrlach, Helen stood up and took a step towards him, reaching out to shake his hand and introduce herself. The doctor took a step forward, both arms outstretched, his eyes and mouth unable to control themselves.

"Rosa! My dear, how remarkable to see you again," he exclaimed in German. "How the years have melted you away!" He clasped her in his arms and drew her to him in a massive embrace. The rough wool of his suit coat tickled her nose and cheek.

"I'm sorry," answered Helen, flustered, in English. "My name is Helen Martin." She pushed against his chest to free herself from his grasp.

Stepping back and releasing her, the doctor gesticulated incoherently and clumsily wrestled a notebook out of his jacket pocket. He flipped to a page and then consulted his watch. "It *is* ten o'clock, isn't it?" he asked, continuing the conversation in English.

"Yes, it is. Is your appointment with Rosa?"

"Of course. I have here, please take a look for yourself, an appointment with Rosa Kovslovsky at ten o'clock." He offered his datebook to Helen, staring at her intently. She leaned over to look at his spidery handwriting then showed him the page she'd been given.

"I don't know what to say. Your name, your address, this time was written down here, so I just showed up; I don't know why. It seems foolish I guess, but I hoped I might be able to find out something. About her, perhaps." Her voice trailed off. This was not going well.

"Yes, yes," he said. "That's fine. Please come in and forgive my confusion." The doctor led the way into his inner office. He pointed to an uncomfortable but authentic looking Empire chair placed in front of a huge office desk. Helen removed her coat, set her bag down on the floor, and then sat down. The doctor went to the other side of the desk and stood there for a few moments looking at her. "Are you sure you aren't Rosa Kovlovsky?" he asked, mystified.

"Yes, quite sure," Helen replied. "Besides, you said nice to see you again, or something like that. You must know what she looks like if you've seen her before."

"Yes, of course. You're nothing like her, and yet. No, she's rather, you know . . . " he gestured helplessly then sighed, ". . . large," he finished. He rubbed his eyebrows till the hair stood out in a static frenzy, then he came back around from behind the desk and stood close. "Yet there is something about you." Without warning he grabbed her shirt and pulled it out towards him, dipping his neck to give him a bird's-eye view down her front. Helen stood up quickly, jerked her shirt out of his paws, and pushed him away.

"How dare you do *that!*" she exclaimed, not only turning red from anger and mortification but frozen to the spot.

"Please forgive me," he muttered. "Professional interest. No, you can't possibly be Rosa. Yes, there is something about you—your earrings, yes, but more than that, hmm," he paused, "your hair, is it yours?" Helen nodded, nervously twisting a strand.

She then sat back down into the chair and burst out crying. Searching for the elevator man's handkerchief, forgetting that she'd given it back to him, embarrassed by her own behavior, her chagrin increased when all she could find was a tattered length of toilet paper. She blew her nose quickly, the ends of the snotty paper dragging against her sleeve, and hastily reburied the humiliating rag in her pocket. It was

all too much; the nightmare of the train hadn't gone away after all. This Rosa person was back to haunt her only it was worse; now there was Dr von Ehrlach.

The doctor, unmoved, went back behind the desk, slid into his oak chair, and swiveled rhythmically as he accurately described the woman that Helen met on the train, the woman who had given her the box. Betraying her with details of a certain intimacy, perhaps professional, perhaps not, Helen couldn't help but wonder why he was confused about her identity. There were no characteristics in common between them: height, weight, hair color, hair style, age, walk, language; it was all as different as could be.

"I've met this woman," said Helen hesitantly, her equilibrium sufficiently restored, allowing her to speak. "She gave me some things that you should see." She handed the box over to him and watched as he instinctively swung the oval plaque aside. He knew how this worked. He'd seen the box before. He didn't comment about how curious the decorations were.

"Yes, this is Rosa!" he exclaimed, flipping through the book to the page with the finger bone, noticing the ring that had been placed on it. "But where did you get this?" he asked, twirling the ring around the bone. Without waiting for an answer he replaced the finger and picked up the ticket that had been slipped in. "Rosa loves Berlin," he said, noting the city name marked on the face of the ticket. "Did she show you her wigs?" Still not expecting a reply, he tucked the ticket into the book's gutter, and then noticed the dog tag that Helen had jammed down the gap between the book and the box. "This dog tag has no name on it," he murmured. He leaned forward over the desk, looking at Helen's shoes. "No," he said to himself, "can't be the same dog. Those aren't new."

He found the magnifying glass and held it up close to his right eye. "Ha!" he cried out. With serious concentration furrowing his already galvanized brow he glared at the dog tag through the glass. Squinting, he exclaimed, "It is the right dog!" His face puckered up in confusion. "But where did you get those shoes?"

Helen started to speak, but he interrupted her, "Why is the glass broken?" She hadn't noticed his attention swing back to the box; he was moving too fast for her.

"Well," she said, "the bottle was wedged in too tightly. . . ."

"And you broke it," he finished for her.

"Yes, that's it exactly."

"Did Rosa show you her wigs?" he asked again in an innocent tone. Helen shook her head. "No," she lied.

"Are you sure that that's your own hair?" he asked, pointing to her head. "Are you sure that isn't a wig? How is it you've managed to arrive here looking exactly the way Rosa promised she would look? Why are you carrying Rosa's Vesalius?" He had removed the woodcut. "What does she want you to do?"

"How do you know this is Rosa's Vesalius?" she asked, deciding to respond only to the one question.

"Just look at it," he said.

She did. She could see nothing to indicate whose piece of paper it was. She put it back onto his desk.

He flipped it over and then pointed a long bony finger at a line of writing in the upper right-hand corner: "To Rosa," she read.

"Okay, so it's Rosa's," she shrugged. "I only just met her on a train, I know nothing of her except that she gave me this box. We exchanged maybe ten words. Oh yes," she added, "she seemed to think that I was going to be coming here this morning. And yes, I am sure that this is my own hair."

"May I touch it?"

"No!"

"May I give you something for your box?" he asked brightly. "Something fitting?"

"Well, I guess," said Helen, "but, you know, I'm really here in Vienna because I'm looking for my husband, Martin Evans. These other things, like Rosa and this drawing, are incidental."

"A drawing! That's just the thing." The doctor got up and walked over to a tall, narrow wooden cabinet stacked with flat drawers. One

after the other, he wrenched them open and then rapidly slammed them shut. Dust flew about, which he waved away as if swatting at wasps. Helen rushed over, hoping to get a glimpse of the contents inside the drawers, but he shot her such a scowl of disapproval that she stood back. Finally, about two-thirds of the way down the cabinet he drew out a piece of paper and trotted back over to the desk beaming idiotically. It was an engraving of a tooth extraction executed on heavy rag paper. He handed it to Helen and motioned for her to place it in between the pages, to try it for size. To his satisfaction, it fit perfectly.

Dr von Ehrlach put his arm around Helen's shoulders and shepherded her towards the door.

"But, I haven't had a chance to find out about why you were meeting Rosa this morning. And why she sent me in her place," she protested, unwinding herself from his clutch. Such nonsense. No one sent her. She came on her own.

"Please, make another appointment," he replied, suddenly stiff and distant. "I've run out of time. I make appointments for 45 minutes, only. That is how it is done in Vienna."

"Do you have a patient waiting now?" Helen asked. "I could come back later today, if that would be more convenient. I'm only here for a few days," she added desperately.

"I am so sorry," he said. "Go see Rosa. She will be able to tell you. I'm afraid that I won't be able to help you at all."

The doctor hustled her into the outer room. Seeing no one else waiting, she said, "Couldn't I talk to you until your next patient arrives? I don't need much time and besides, I don't know how to get in touch with Rosa, Rosa Kov-, Rosa Kovosky." She was struggling hard to maintain her academic professionalism in the face of this maniac.

"Kovslovsky," corrected the doctor as he slammed his office door in her face.

Helen stood in the empty waiting room at a loss for what to do next. She could hear the doctor stomping about in his office and was startled to

hear him bellow out, "Rosa, why have you sent me this imbecile?!"

Hurt and dismayed, Helen left the office. In a gesture of revenge she neglected to close the door, and as she drifted down the hallway towards the stairs and the elevator she could hear the door slam shut with great force.

"How dare you do *that!*" she repeated the words gleefully. How often do you have the chance to say that! "How *dare* you do that! *How* dare you do that!" The words sounded impressive, and with no doubt the last version was the best. Too bad she hadn't put the emphasis on the right word in the first place.

Helen could see from the distance that the door to the elevator car was open. "Nonetheless," she said to herself, "I'm taking the stairs." As she got closer she noticed Wilhelm, the elevator man, standing, holding the door open for her. Her resolve weakened in the face of his exertions, and she was lured into the elevator by the little man as if he were a magnet. He closed the door effortlessly and soundlessly, then politely inquired, "Which floor, please?"

"The ground floor, thank you," she said.

Wilhelm pushed the button, turned around, and hoisted himself onto the stool. "So, tell me," he beamed at her. "What did he give you?"

"Who?" asked Helen coldly.

"The doctor. What did the doctor give you? Please tell me. I worked for his father, you know."

Helen, who was less certain than ever that her understanding of the language was doing her any service, responded hesitantly, "What does that have to do with anything?"

"It gives me the right to ask," was Wilhelm's reply.

Helen looked up at the lit number above the elevator door that showed they were still at the third floor. The elevator seemed to be moving more slowly down than it did up.

"Are we moving?" she asked.

Wilhelm ignored her question.

"Oh, all right," she said. "He gave me a drawing."

"What is it of?"

"A tooth extraction."

"Whose?"

"Do you mean whose drawing? It was the doctor's drawing."

"No, I mean whose tooth?"

"I don't know whose tooth!" Helen was exasperated.

"Let me see."

"It's too difficult. I've put it away. I don't think the elevator is moving." There was now no light illuminating any of the floor numbers.

"Don't be impatient," said Wilhelm. "This is an *Aufzug,* that is to say, an elevate-or, an *ascenseur,* it is meant to go up. We are presently taxing its talents." He spoke to her as if she were a child. "You have plenty of time to show me the drawing," he added quickly.

Helen gave up and pulled the box out of her bag. She flipped up the top and showed the engraving to the little man.

"Goodness," he exclaimed. "That's the illustration of my tooth extraction!"

"Impossible," she said curtly, "this engraving is probably from the mid-nineteenth century."

"Like I said, that's my extraction," and he pulled back his mouth with his finger, revealing a massive gap in the identical spot—the second premolar on the bottom left side.

Helen averted her eyes, embarrassed by the display. "Look," he gurgled, his voice distorted by the contortions of his mouth. She shot him a quick glance then looked away again, agitated by the close proximity of this periodontal exhibition. "Look," he commanded again. *"Sehen Sie!"* The imperative sibilants lingered and bubbled. She gave up and inspected his mouth and then the drawing. "Remarkable similarity," she admitted, putting the engraving back into the box. "If this is an illustration of your tooth extraction, then it has been done as a copy of an earlier style. I don't see why anyone would go to the bother." She'd assimilated his clinical approach. "And besides, what would be so special about your tooth and your mouth?"

"It was done in the perfectly authentic style of the century, the decade even; it was the extraction of an impacted lower PM2 and was

unusual for the amount of pain it caused its patient." Wilhelm spoke with the authoritative voice of a university dental lecturer. "Part of the jaw had adhered to the root, which is why you see this incision here," he pointed to a stitched seam indicated in the engraving, "and here," he then pointed to a scar visible on the surface of his jaw below the gap.

"Where is your tooth now?" Helen asked, against her will.

"Why, it's right here," Wilhelm produced an extremely large molar from the same glove that had relinquished the business card. "I lost the bit of bone a long time ago."

Helen automatically put out her hand to receive the tooth. "This is a wisdom tooth," she declared. "It has four cusps. Your mouth couldn't possibly produce a second premolar of this size."

"Are you a dentist?"

"Well, no, but I have studied anatomy, and I know that this is not a second premolar."

Wilhelm pursed his lips and turned his face so that Helen could see the other side. He then rolled back his lip and showed her the matching right side second premolar. It also looked like a wisdom tooth. "Satisfied?" he asked.

"How do you fit such large teeth into such a tiny jaw?" Helen asked him.

Wilhelm beamed proudly. "Good genes," he announced. "If you studied anatomy then perhaps you could tell me what that bone is from." She hadn't noticed him turning the pages to the hand.

"It's a human phalange," she answered with certainty.

"From which finger? From which hand? Okay, so you know from the diagram!" But how old was the owner of the finger at the time of death? Male or female? How was the finger removed from the body? You haven't studied anatomy," he declared. "An anatomist could identify the very hand that possessed that very finger."

"I suppose you're going to tell me that it was your finger." Her sarcasm was not lost on him.

"Listen to me," said Wilhelm seriously, "we are in a city crawling with anatomists. Just be careful to whom you say you studied anatomy.

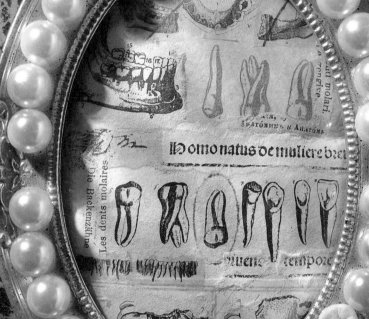

And by the way, it is the first phalange of the right hand third finger, the
ring finger here, probably off of a woman of about the age of twenty to
thirty, and removed with some violence." He added tersely, "before
death."

She picked the finger bone out of the box and looked at it more
closely. There were faint grooves of a sharp knife or file around the
joint.

"Will you give me something from that box? In exchange for the
tooth, that is," Wilhelm asked. "And the business card," he added, aware
that Helen would be a hard bargainer.

"I don't want your tooth, and besides, everyone is asking me to give
them things from this box. What is in here that could possibly interest
you?" She realized after asking the question that probably everything in
the box interested him. The light indicated that they were passing the
first floor. Helen tapped her foot impatiently.

Wilhelm looked at the now shut box still cradled in Helen's arms
and reached out to stroke the frame. A pearl came off in his fingers.

"This!" he shouted. Before Helen could protest he opened up his
mouth and popped the pearl into the cavity left by the extracted tooth. It
fit perfectly. Wilhelm was as surprised as Helen. He laughed joyfully
until he caught his reflection in the polished brass panel in front of him.

"Thank you very much," he mumbled humbly, running the tip of
his tongue tentatively around the new, smooth surface, while at the same
time continuing to vainly inspect his newly completed reflection.

Helen was speechless.

The elevator slid to the ground floor, stopping silently and gently.
Wilhelm opened the docile door for her and then sat back onto his stool.
She stepped out, then turned back to wave goodbye, but the door had
already closed.

The doorman was still standing in his cubbyhole, holding the same posi-
tion, elbows on the shelf, that he had held when Helen first went up. She
looked at her watch and saw that it was 12:30. Somewhere between

being shoved out of Dr von Ehrlach's office and that moment, nearly two hours had passed.

Standing by the front door, she removed Wilhelm's business card from her coat pocket. Balancing that and the tooth with the box, she managed to flip the top up and toss the card in. She closed it again, reluctant for some reason to add the tooth. At that moment she happened to look up. The doorman was standing next to her, watching her movements intently.

"I suppose you'll be wanting something from here, as well," she said in English.

The doorman didn't respond but kept on looking at the box.

Helen decided to ignore him. Rolling the molar absently between her thumb and her first finger, she was about to slip it into her pocket when she felt the doorman's gloved hand rest lightly on her arm. He gestured for the tooth, which she passed to him. He deftly snapped it into the gap left by the missing pearl. Helen smiled.

"I like your glasses," she said.

The doorman nodded, stepped over to the door, and opened it up. Helen emerged into a blustery Vienna winter day.

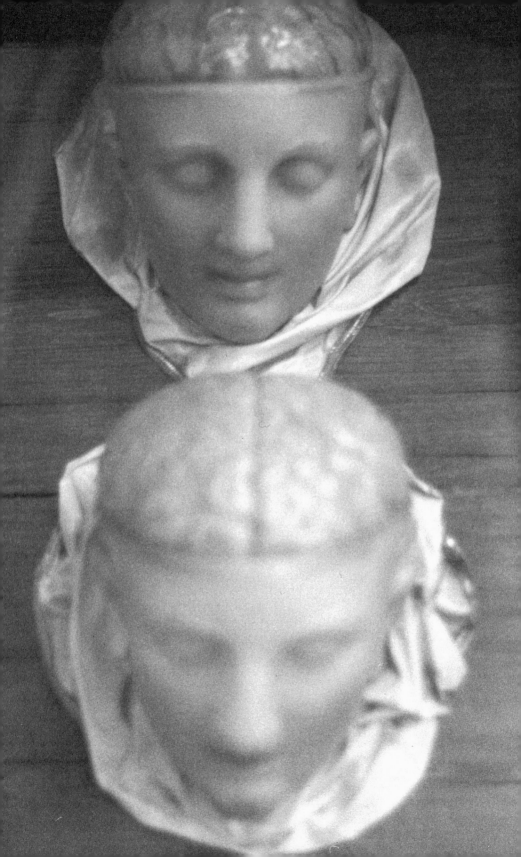

THE JOSEPHINUM

Who needs to eat? Thinking always of eating only because of the watch on her arm. One o'clock. The crowds should have gone, but here she was waiting at the door of a swamped restaurant. Helen was reminded of the jungle—the waitresses were sweating torrents, flinging themselves from table to table with arms loaded, creeping in the undergrowth of table legs and nasty boots, snatching finished plates from under tongues still searching for remaining drips and crumbs. The diners were obeying the laws of the animal kingdom—hooting, howling, croaking—to get their bread and butter.

This fierce competition among those already seated excluded the tantalized spectators, who were only allowed to watch meekly from the sidelines, a zone of safety where Helen was content to remain. The management teased the latecomers beyond their hunger by standing them parallel to the dining room, rather than snaking them perpendicularly away. Only the occasional swallow—physically impossible, after all, to resist the seductions of fragrant gravy and savory roasts—was permitted; open staring and salivating met with clucks of disapproval from passing staff who delighted in parading their overloaded platters along the line in a salacious tasty tango. One-twenty ticked into place and the screeching harmony of dozens of chairs being pushed back sent a shuddering appetite through the motley line of tardy arrivals. The constraints of discipline were taxed as the stampede of satiated diners

thundered away through the exit and those waiting resisted the urge to hurl themselves upon the abandoned cutlery, to forage for overlooked dribbles and scraps. Helen was not much of an eater—she had to be reminded of hunger—she had to be told how good tasting food could be—she was unaccustomed to the display of unfettered appetites; it confused and upset her, but it gnawed a hole in the pit of her stomach.

A weary waitress finally beckoned, seating Helen on a still warmly sagging rattan chair at a table for four where two other women were engaged in their own solitary mastications. Her presence acknowledged only by the nod of loaded mouths, she was left alone. Her own curtain dropped as she sat down; sharing a table with strangers demanded purdah. Another legacy from the matrilineal empire. They appeared at the oddest times, these long departed kinswomen. A fragment of her aunt Tessa now eased herself into the chair opposite—Helen could hear the wood squeak under her aunt's formidable weight; her mother stood behind her, resting her languid hands on her shoulders, leaning over to whisper in her ear. Helen stared at the memory of her nodding aunt while listening to her mother's murmurs of disapproval. In spite of the many years that had passed since their deaths, their tongues were never distant, even though her mother had rarely raised her voice above a sigh and her aunt had seldom spoken. But her mother had never really stopped talking and her aunt's mute opposition always manifested itself at volumes louder than speech. They reviled eating with outsiders; their contempt for working was congenital; they ridiculed the manners, clothing, expressions of anyone so unwise as to appear in public; and they mourned Helen's ignominious rejection of their teachings. They never showed up to tell her that they missed her, to tell her that they loved her; their appearances were meant to torment. Helen brushed the insinuation of her mother's fingers away from the nape of her neck and raised the menu to block off the shadow of her aunt. They'd go away sooner or later.

Completely baffled, she ordered what she thought must be the smallest meal on the menu—what appeared to be a sandwich—and was horrified a few minutes later to see a platter arrive heaped not only with a

bun of gigantic proportions along with a huge slab of thickly-cut beef, but masses of gravy-smothered french-fried potatoes as well. As the plate was put down in front of her, a blast of hot air rose up from the steaming food, and she broke out into another sweat. She looked around the restaurant and saw that the windows were fogged and that the waitresses, who were wearing thin cotton uniforms with their sleeves rolled up high, would frequently pause to wipe the moisture off their brows with the greasy aprons wrapped around their middles.

Helen shed layers of clothing, dropping scarf, sweater, vest to the floor. She called waitresses over and asked for glasses of water that she downed the instant they arrived. Still the huge plate of food stared at her; it wasn't going to go away without her help. She speared a french fry and stuck it in her mouth. As she chewed it an overwhelming sensation flooded into her mouth and down her throat—the french fry felt incredible. She took another one and, holding it on the fork, nibbled in darting reconnaissance bites. The texture, from the crispness of its exterior where the gravy hadn't smothered it, to the light fleshiness of the inside, astonished her. Grains of salt melted in provocating bursts upon her tongue, or hid in toothy crannies and slowly spread their briny magic, or better still, landed full square between incisors and exploded into intoxicating splinters. This was not just salt—this was spice. And the gravy, so rich and smooth, cloaking the inside of her mouth with the luxuriance of velvet, flowed down her throat and eased her soreness. And the sandwich—the crispy bun cracking between her teeth, the shards of the crust pushing pleasurably into her gums; the lacy fringe of lettuce grazing lightly against her lip, the drops of cool water sliding down from the newly-washed leaves onto her chin; the thick mustard oozing out to the corners of her mouth stinging the shallow winter cracks. She looked at the food with new respect. Since when had food felt so good?

She recalled the hundreds of meals she had shared with Martin, not remembering them one by one, of course, just their collective blandness, their unmemorableness, for Martin's chastisement of her disinterest. "Look," he'd say, wagging a fork capped with an exotic mushroom or

yet another kind of twisted pasta, "*this* is food. Try this!" She'd duti-
fully put the new discovery in her mouth and shrug away its unimpor-
tance with a nonchalant swallow. Martin would do the cooking when he
was home—steaming up the kitchen with new recipes from his travels,
buying new utensils as insurance against failure, matching the meals
with the appropriate music, setting the table with new dishes if need be.
Helen would sit in the corner of the kitchen watching his devotion to
cuisine, amused but placid, unable to taste his passion. When Martin put
food into his mouth, no matter how insignificant the morsel, he would
ensure that each molecule collided with his taste buds. And after he had
laid waste to the meal, the gadgets would be crammed into drawers and
forgotten, the discs left in the machine till the next time he returned, and
the half-empty packets of bewildering ingredients—couscous, massala,
wasabi—would decay in cupboards already full of rotting food.

Thinking of taste buds. For Helen, this meal was actually just as
bland as any other. It was the sensation of eating that was so remarkable.
She licked another drop of mustard seeping out of the bun. Again there
was that incredible tangibility, but as for taste, it could have been flour
and water. Helen shrugged and finished the meal, happy to get whatever
she could from it.

The appointment with the medical museum's director, Herr Ganz, was
for 3:30. She arrived with just over an hour to spare. The museum was
housed in a building called the Josephinum, a spare, elegant edifice, set
back from the street and somewhat camouflaged by a tall iron fence and
a mature garden. Compared with the buildings within Vienna's center,
the Josephinum was positively modest. Built around 1784 as a medical
college, there were none of the medieval saints, baroque angels, or
neo-classical caryatids that graced the more elaborate churches and
museums of the inner city.

The museum's displays were both repelling and fascinating. Surely
this was something that astounded everyone. Her guidebook had been
nonchalant: "A museum of the medical arts, noted for its collection of

eighteenth-century anatomical wax models. Open 900 to 1500 Monday through Friday."

The collection of wax models, called the *Anatomia Plastica,* had been commissioned in the late 1700s by the Emperor Joseph II from the Florentine artist Paolo Mascagni. Cast in classical poses, they were reminiscent of Greek and Roman statues, but instead of being clothed in the white marble that made nudity so acceptable, they were stripped of all covering, including their skin. This absolute nakedness—the exposition of muscle, sinew, vein—made them appear both formidable and vulnerable, repulsive and mesmerizing, more ultimately human in power and in weakness than any living being. The aged tawniness of the wax comforted the eye and magnetized the hands, pulling them in a willful and irresponsible invitation to approach, to caress, to carry away a coating of the 200-year-old wax on the tips of fingers. Helen was still so hot from her fever that she imagined the wax sizzling and melting under her touch. She could see the rivulets of wax, at first slow and tentative, then uncontrollable and torrential, running down the torsos of the figures. The heads would collapse on weakened necks, limbs would drop, pools of wax would eddy at her feet and then, as her fever subsided, would harden and lock her in, a prisoner within this intoxicating collection. The dimness of the hall protected Helen's total absorption, but it was only the glass cases imprisoning each of the figures that protected them from her touch.

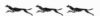

She waited for a good half hour in the director's outer office, alternately idly flipping through a magazine, continuing her unfinished letter to Martin, and watching the secretary read through some papers in a file. Discovering Martin's pile of unopened mail from her had not deterred her from writing, but it did force her to ask herself where to mail it to. In a fit of hubris she decided to mail it to his parents.

In the hush within the office, she was reminded of the absolute silence within their marriage. They both had realized that they were lodged firmly on the rocks the day he had teased her Walkman earphones off her head.

It was about half a year before he'd quit his full-time job at the
paper and started taking on free-lance assignments. She'd become
exhausted by his incessant talking and had put the earphones on as a
kind of protection. For days, except during dinner, she'd been listening,
she claimed, to a series of lectures, very important, couldn't be inter-
rupted.

Martin, who lived to talk—but only to an audience—was driven
round the bend by Helen's auditory armor. If he tried to say something
she would first look startled, then yell "What?" then impatiently yank
one of the earpieces away from her ear, and in mock patience ask him to
repeat what he had said. He always gave up but would forget a short
while later and try to engage her once again in conversation.

When he finally could endure it no longer, he snuck up behind her,
grabbed the headset, and popped it onto his own head. Instead of the
expected droning voice of a lecturer, there was only silence. He wrestled
the cassette unit off of her belt before she had a chance to stop him and
discovered that it was completely empty. She'd worn the Walkman as a
devious means to block him out. In spite of her contrition, his response
was to return the gesture, accomplished by ever-increasing absences.
Helen told herself for the hundredth time that she hadn't meant to hurt
his feelings, but. There was always the but. His talking had been driving
her crazy.

The tap of hard leather soles advanced along the marble floor of
the outer corridor. The door opened and the director, Peter Ganz, the
palest man that Helen had ever seen, stepped into the office. As he
passed through, the secretary gestured towards Helen. Ganz turned
around and with an easy naturalness shook her hand and invited her
into his office. He took off his coat, apologizing for his tardiness, and
excused himself while shuffling his messages. This gave Helen, who
was seated on the opposite side of his desk, an opportunity to study him.

For a start, Peter Ganz couldn't have been more different from von
Ehrlach, if he had been born on another planet. He was relatively
young, probably in his early forties, although his blue-black hair and
mustache made him seem younger still. He was stylishly dressed in a

tailored three-piece suit and his groomed body looked as well-tended as his clothing. This care and expense made the pallor of his skin even more of a surprise. She perversely compared him with his collection, although most of those figures had acquired a tanned and mellow patina resulting from their lengthy life spans. Again the urge to reach out and touch came over her. She blinked and swallowed and then sat on her hands, looking around at the disorderly bookshelves and the art on the walls.

The telephone rang several times while she waited. While focusing on the cracked spines of a well-thumbed set of encyclopedias, she strained to follow the brief conversations about mundane issues such as lack of janitors and missing budget reports. His voice was like his complexion—smooth and colorless. Just as Helen decided that she'd rather wait in the outer office, Ganz picked up the phone one last time and asked the secretary not to put through any more calls. Then he looked at her directly and asked her in English what she expected from him.

"I haven't heard from my husband, Martin Evans, for close to three months. He had an appointment with you in early December and I'm hoping that you'll be able to tell me why he visited you."

Ganz flipped through his appointment book, muttered in frustration, then called the secretary to come in. They had a rapid conversation, ending with the secretary pointing to a file on his desk. Ganz, while scanning the file, motioned for the secretary to remain.

She continued speaking, filling the silence. "I'm an art historian, Herr Ganz, in fact my area of study is medical art, but I haven't got the faintest idea why someone would steal such art."

"If I am not mistaken, your husband is doing a story on art forgeries in central and eastern Europe," Ganz said, looking up. Herlsberg at the newspaper had said thefts, thefts in western and central Europe. These seemed like important distinctions.

"Not thefts?" she asked.

"Thefts?" Ganz repeated. "No. Forgeries. Forgeries of medical art. We had several long interviews during which I gave him a great deal of information about the subject. He has a fine command of the German

language," Ganz continued admiringly. "But I would expect that the article has already appeared. As you know, these interviews took place several months ago." He looked expectantly at Helen, who shook her head.

"I spoke with the editor of his paper and they presumed it would run at the start of this month, but they received nothing, not even a draft, and he hasn't been in touch with them at all."

"Have you called the police?" Ganz asked.

"Not yet," said Helen. "He's often away for long stretches at a time. We usually don't worry about him."

"We?"

"Me, his parents, his newspaper, you know."

Ganz rubbed his cheek with the flat of his hand, leaving an unreasonably red welt on the white skin. He fired off an indecipherable comment to his secretary, who sat poker straight, his hands bound around one slightly raised knee. The secretary inclined his head slightly, let a smile slide across his face, and shrugged fatalistically.

"I was just saying that it would be sorrow to be missing for three months and not to be wanted," said Ganz.

Helen protested, claiming that wasn't the exact situation, but left off in defeat. She knew it was true, and also knew that her own absence would provoke even less attention. Both her parents were long dead; she had no brothers or sisters. And as for Martin's parents, time had little meaning. No matter how long it had been since she got in touch with them, they would just assume that she was away somewhere, for some reason. Perhaps at some point his mother would wonder what she was doing, would look up from some magazine or television program and say, "Whatever could Helen be up to?" Sending them her letters to Martin was beginning to make sense.

"I don't remember the specifics of our two interviews, but I do remember that he questioned me at some length about the subject of the Vesalius woodblocks from Munich. I must tell you that before I developed an interest in anatomical art I was a curator at the Munich University Library and had met a gentleman who had worked at the library before it was destroyed in the bombing during World War II. He

told me about a set of woodblocks, not prints, but original blocks, that had been housed in the library since sometime after 1826. These were the original woodblocks that had been used to illustrate an anatomical treatise by the Belgian physician, or anatomist, I should say, Andreas Vesalius. You're familiar with him?" He waited for her nod then continued. "Before 1826, their history went back to 1542 in Venice when they were first struck. I was amazed to hear that they had been lost and found and moved many times, and it was only after they were rediscovered during this century that they were destroyed during the bombing I just mentioned. This story intrigued me, so having found out about these woodblocks, I set out to find out about the work. They were extraordinary for their time, the interpretation being attributed to an artist called Jan Stefan van Kalkar, based, naturally, on the anatomical findings of Vesalius." He stopped, sensing Helen's impatience.

"Please don't pay attention to me. Go ahead, continue," she said. "But I must remember to show you something before I leave."

"I haven't much more to add. This subject seemed to be your husband's area of concentration. I asked him if he was interested in any of Vesalius's contemporaries, Eustachius or Fallopius, or with any of the other anatomists from other epochs, Galen, da Vinci, William Harvey. I talked about the improbability of forgery. I'm not an expert. You understand?"

She nodded.

"I'm only an interested amateur. However, it seems to me that to counterfeit, after all, that is what we are talking about here, are we not, counterfeiting? To counterfeit a print is a waste of time. What do prints sell for in general? A few hundred schillings up to a few thousand? This is not a fortune. So, we're not speaking of Dürer—perhaps a rare Dürer print would sell for a great deal of money—we're speaking of Vesalius. Scarce but not rare. Respected but not venerated. And the time involved to make the paper, to print, to find a buyer. Furthermore, any self-respecting purchaser of prints would take one look at the paper, hold it up to the light, run the fingers along the surface, and would be able to tell immediately that it was contemporary."

"But what if it was printed on old paper? I'm sure there are means of finding old papers, even today."

"Okay. Yes. This is possible. But it still would not be financially rewarding. Also, I am simply not aware of any Vesalius forgeries." He paused, reflecting. "It would be possible; there have been so many editions." They sat in silence. "No," he finally said, "I just do not see the point of it. One could simply not make enough money. However, I suggested to your husband that if he must persist, that he go to Munich, to the library."

"Do you know if he followed your advice?"

Ganz shrugged. "He said he would. I can't think of a more appropriate starting point. Of course there are the other medical museums such as the Wellcome in London, the Semmelweis in Budapest, to name a few. Paris, Berlin, Bologna, Florence—really there are museums all over. I did suggest the Semmelweis, specifically. They just bought a Vesalius."

"Who else would buy these prints?"

"It is a very specialized field of collecting, I'll admit that. Most of the connoisseurs are doctors, or retired doctors, or they are large companies such as the pharmaceuticals. And of course there are the museums. And then there are people like me who run the museums and galleries and who have a personal love for this form of art.

"You can see just from my own poor showing on these walls," he gestured to the framed engravings that Helen had noticed earlier, "that the art spans many styles and has several layers of appeal. Of course, through your own studies you will understand the scope of this specialty." He paused. "You said you had something to show me."

She pulled the box out and displayed it on the table. Opening it and extracting the woodcut, she held it so Ganz could see it properly. He took the piece of paper circumspectly, went over to the window, and held it to the light. When he came back he looked at her with curiosity. "So you too are a collector?" He set the paper down onto the desk.

"A strange woman, a stranger on the train, that is, gave me that, along with these other things." She pushed the box over to him. He

SECVNDA
MVSCVLO.
RVM TA.
BVLA.

picked the objects out one by one, much as von Ehrlach had done that morning.

"How did you say you met this woman?"

"On the train coming to Vienna."

"Why did she give you this box?" He had just noticed the drawing on the outside and was turning the box around in awe.

"I have no idea. I have no idea why all of these things are coinciding like this."

"Well," said Ganz, looking once more at the woodcut, "it could be an original Vesalius, but I doubt it. You should be careful with it, just in case. If you don't mind I'd like to have this authenticated. Would you leave it with me?" She picked up the woodcut and held it tightly, possessively. His contradictions did not inspire confidence.

Ganz coaxed the paper back into his waiting hands. He may have been skeptical, but it didn't mean he wasn't interested.

SIGHT

R O S A

Helen woke up wearing someone else's eyes. Eyes that shattered her orbs into a thousand piercing splinters, that shook her balance off its pivot and flung her headlong into a mercurial fog.

Darkness is immobility, yet here she was in a room as black as the other side of the moon, shooting through the air at a million miles an hour with confetti whipping her eyeballs. She managed to find the bedside lamp and turn it on; the sudden light bringing the terrifying plunge to an excruciating stop.

Helen lay on her back, gasping, shuttered and blotted—hands gripped to either side of the bed as if nailed in place—urging her eyes to open. Then the bed began to tip, first this way then the other; she held her breath, willing the motion to cease. Flickering light from the lamp added to the sense of dislocation, but more than that, everything seemed much further away, as if she were looking at the room through the wrong side of a pair of binoculars. She got out of the bed and groped helplessly at the chair, the wall, the air, making her way to the bathroom. With each step the floor gave way to a paralyzing chasm; with each step she felt her heart rip through her, her skin denounce her, her breath deflate her. Nearly senseless with nausea and fright, she switched on the bathroom light and tried to confront herself in the mirror. There were two of her staring back. She looked closer; there were dozens of her staring back.

Aghast, she clamped her hands into fists and stuck them into each eye. Slowly spreading her fingers back out she peered through them to the mirror. Still multiples. She then noticed that the two end doors of the three-way mirror were angled open—shutting them returned the room to normal.

"But I had someone else's eyes in my head," she moaned, now clutching her abdomen in the hope that the support of her hands would suppress the pervading inner upheaval. Eyes incapable of vision, eyes in motion, eyes in chaos. She pressed her hands tighter against her gut, feeling the ridges of the abdominal muscles straining against the pressure of her hands but no longer straining to rebel. "I must be sicker than I thought. I should go see a doctor." She looked in the mirror and saw herself, a stranger, laughing hysterically. What's so funny? Go see a doctor. How about Dr von Ehrlach? She joined the laughing reflection.

She turned on the taps and splashed her face. Letting the water stream down her forehead and cheeks and chin, she crept back into the room. She picked up her watch, holding its face close to her own, her cavernous irises marking the jerking spasms of the second hand, then focusing on the time—it was 4:30 in the morning—and suddenly noticing wisps of smoke coming from a cigarette butt in the ashtray beside the bed. She wiped her face with a brush of her sleeve and quietly pivoted around to inspect the room.

"It's a terrible habit, one that I should eliminate as soon as possible," said a familiar woman's voice from a dark corner of the room. Thick spectacles caught the light and threw it back into Helen's battered eyes.

Helen thought to herself, "Rosa." It was the woman who had been on the train.

Questions charged through Helen's brain, "What are you doing here?" "How did you get in here?" But all she asked was, "Were those your eyes?"

"Please sit down, my dear," begged Rosa. "Seeing people standing about in what they call their sleeping gear makes me uneasy. Get back into bed, if you like. Don't mind me," she added. "My, this chair is

uncomfortable." She waited for Helen to sit back on the bed, and when Helen drew the covers over herself she visibly relaxed. "Yes, those were my eyes just as those breasts were my breasts. My vision was much clearer, like yours." She removed her glasses and offered them to Helen, who ignored the gesture with a deliberate stare to an unseeable remote point. Rosa let them dangle in the air for a moment, then slapped them back in place. "Ah, you were so happy a minute ago. I do like jolly company; it does help to pass the time." Rosa glanced down to her wrist, automatically checking the time, but her watch was deeply buried in the folds of flesh, capable only of informing a serious inquiry. She yawned, flattening her features back against the curve of her skull. "But I'd like you to meet the owner of a much worse pair of eyes. He is a gentleman with an impressive collection of optical studies. In fact, you could say that his collection has drained him of that which is most precious to him, his eyesight." Now that Helen's own eyes were becoming more accustomed to the dim light of the room, she could see that Rosa had opened the purse that perched on her ample lap.

While Helen watched her rifle through the pages of a well-worn notebook, licking her finger with each turn of the page, Rosa chattered away. "You must be wondering how I got into your room. I'm not a ghost, you know." She set aside the notebook for a minute and searched in her bag again. Not finding what she was looking for she raised herself up slightly from the chair and produced, from the pockets of the voluminous cape that she wore, a long wire hook and a set of keys. "The hook is to lift the chain once the door is unlocked. Very useful. You should get one." This confused Helen even more, as there was no chain on the door. Rosa picked the notebook up again. "Here," she announced, "is the address," and with a flourish ripped the page out of the book, folding it into a paper plane and aiming it at Helen, letting it fly with effortless accuracy. "Delightful," she said, "I haven't lost my touch. Excuse me for not getting up, by the way; I'm committed to saving energy."

Helen picked the paper out of the undulating folds of the rumpled quilt and spread it open, surmising, from the lovely script that had

graced its twin, that it was from the same book as the page she had
found in the box. An appointment was listed for that same day at 11:15 at
the home of Herr F. Anselm.

"I'm sorry," said Helen, "I have appointments lined up already. I
can't just change my plans to suit you." She felt suitably rude. Rosa's
presence demanded bad behavior, and Helen, her hackles up, was ready
to deliver it.

"Oh, but you'll appreciate meeting Herr Anselm. Friedrich and I go
back a long way."

"Why do I need you to tell me who my appointments are with when
I am quite capable of making my own? And who was Dr von Ehrlach
and why was he convinced that I was you? Who are you anyway?"

Rosa was beside herself with laughter. "He mistook you for me?"
she chortled. "That man is such a nincompoop, an old friend, but really!
Did you see his collection?" she asked more seriously.

"No," said Helen, "he spent most of the time looking through the
box you gave me. He seemed to be quite familiar with it."

"Ah, he looked through the box. That must mean that he gave you
something. What was it?"

Helen slid down to the end of the bed and handed the box over to
Rosa, who flicked the reading lamp on beside her, giving Helen a better
opportunity to study her. Rosa wasn't just overweight; she was huge in a
grand manner, and her clothing and hair reinforced this. More startling
than the fat were the angles. Rosa had more angles than anybody Helen
had ever known—the 45° of the elbow, the 90° of the chin, the isometric
projection of one eyebrow, the axonometric projection of the other. She
was a veritable obese polygon grappling with flowing clothing, self-
deforming both within and without. Helen yearned to coax the angles
into round soft surfaces so that Rosa would conform to her idea of fat.

The long, gold satin cape fell in deep flounces from a white ruffled
collar. The luxurious material straddled the pointed corners of her
shoulders and flowed along the ridges of her knobby arms and looked as
though, at any time, it would be sliced into ribbons by the sharp edges.
Her hair (this was an altogether different wig to that which Helen had

first seen her wearing and different as well to the one that had been in the hat box) was a deep amber color and leapt out in many hazardous directions. Her upright posture, combined with the formality of the chair, evoked an imposing nobility; her robust mustache commanded respect and was impossible to miss, especially as Rosa moved her mouth in silent motion as she talked to herself.

"No need to thank me, by the way, for the box, and stop staring at my mustache; you're growing one too." Helen's hand flew to her upper lip. Rosa then said, "I see you've been around. Where did you get this charming item?" She pointed regally to Wilhelm's tooth, lodged into the frame. "No, don't tell me. Anybody who thinks that a second premolar is more valuable than a pearl will not be able to supply me with a rational answer." She continued her inspection.

"A real pearl?" asked Helen.

Disbelief disfigured Rosa's mouth. "On second thought, tell me where you got it." She sighed when she heard it was from the elevator man. "I see you have already broken the glass." She pulled out the shards and tried to fit them together. "And lost some of it as well." She wrenched one of the bottles out of its hole. "Here, try some of this," she said, undoing the cork. "It's *Euphrasia*—good for your eyesight."

Helen waved the outstretched hand away.

"What did you do with the glass?" persisted Rosa, tucking the bottle back into its slot.

"I gave it to a woman with a terrier," objected Helen, "I didn't lose it."

Rosa shook her head. "She only had to ask me. There was no need for her to badger you. Well, what's this," she said approvingly. She was rolling the finger bone like a cigar, admiring the ring. "Now *this* is something." She tried to yank the ring off but discovered, as Helen had, that it wasn't to be removed. She tossed it back and pulled out the dog tag, asking if it had come from the terrier.

"Yes, it did," said Helen. "Well, the woman who owned the terrier gave it to me."

"What was its name?" asked Rosa.

"It didn't have a name," replied Helen, "But Dr von Ehrlach held the magnifying glass up to the dog tag, read the word etched onto the glass, and announced that he knew the dog."

"And what word is etched onto the glass?" asked Rosa, squinting through the glass, trying to read it herself.

"*Sohle*," answered Helen. "It means soul or spirit, I think."

"It means shoe sole, idiot," snapped Rosa, who then looked surprised at herself. "I'm sorry, I didn't mean to say that. I hope I haven't hurt your feelings."

"No, that's alright," said Helen. "My command of German is quite limited. I'm used to making mistakes. But that does explain one thing. . . ."

"What is that?" asked Rosa.

"He offered to find me a new pair of shoes," said Helen.

"Who did, the doctor?"

"No," replied Helen, "the dog."

"Well, you should have taken him up on it," said Rosa, "if only to be able to judge his talents. In spite of his standoffishness, he has great taste."

She ferreted around some more. "Aha, here is Louis's gift to you," she pried the engraving out from its place between the pages then glared at it. "*This* is supposed to be a good reason for exchanging the pearl for a tooth?!" she fumed.

Helen remained silent.

"A very bad sign," Rosa sighed. "Either that," she said, brightening up, "or a very good one. Ask Herr Anselm to show you the secret of the box." She replaced the objects, slammed the box shut, and struggled up out of the chair, wrenching herself free of its confining arms with a faint hiccup and a crack of splintering wood. "I must go." She pinched the folds of her cape into obedient pleats and fluffed up her hair.

"But you haven't explained to me what you are doing here or why you've made this appointment for me."

"We can work together, if you'll permit it. We're both prisoners— I'm caught in a parody of humanity; you, you're a frozen wasteland. We'll see each other again, dear." She stood caught in the warp of the

distinctively Viennese doubled doors. "In the meantime the world will look as lost to you as it does to me. Goodbye." And with that she turned the knob of the outer door and quietly escaped.

Helen crept over to where Rosa had been sitting and slid into the chair, as if trying it out for size. Where Rosa had been confined by its arms, Helen rattled loosely, but it wasn't really the fit she was curious about; it was the view. From Rosa's former throne she looked at the room, her bed, the deep indentations her body had left in the soft mattress. The view was as familiar to her as if their roles had been reversed.

It was now quarter to seven and the cigarette butt was cold. Helen dropped it into the box, pressing it like a blossom between two engravings, slid back under the covers, and turned over to go back to sleep.

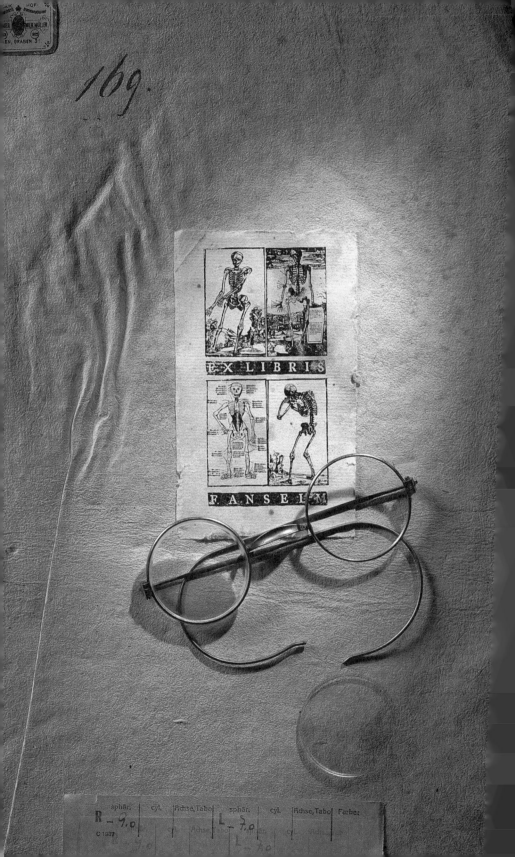

FRIEDRICH ANSELM

The sight of Herr Friedrich Anselm didn't so much as soothe Helen's eyes as capture them. He was withered and yellowed—not jaundiced but aged—absorbing light and surroundings; he was about seventy years of age with wavy, flowing, shoulder-length white hair. He could've been Jesus had Jesus lived to be an old man. Clearly proud of his crowning glory, he drew attention to it with the flight of his hands and the toss of his head. In a younger man the gestures would have been affected, but with him they were enchanting. Helen was captive from the second she crossed the threshold.

In Anselm's presence the watering of her eyes abated, the tension eased, the intense glow that had followed her from her hotel faded as her irises shrank back to normal. The walk out from the hotel to the wealthy residential quarter had been frightening and perilous. She'd started out fine, no apparent vestige of the night's torment. But a ray of sun reflecting off a window pane branded her with its piercing light—a condemnation, she sensed instantly—a damnation to never-ending wakefulness, to the loss of night. Oh well, she thought, who needs sleep when there are still so many days to perfect? Her eyes admitted the entire world, all of the illuminations, reflections, movements; this heightened vision overloaded her senses and ravaged her balance. She squinted, her eyelids open only a sliver, attempting to filter out as much as possible, but with these eyes her world was 360 degrees, and as sharp at the edges as in the

center. Black was as intense as white, no relief in the shadows, no com-
fort to hide her head in the heavy woolen coats of passersby. No relief
except with Friedrich Anselm.

He greeted her so naturally, helping her off with her coat, his papery
hands rustling against her sweater; he handed her a daintily mono-
grammed handkerchief to wipe her still-streaming eyes; he treated
her like a seldom seen but fondly regarded relative, a niece perhaps, a
goddaughter. The more agreeable he was, the more confused she
became. Just what was she doing here anyway? It was as if they shared
a history—a long history—filled with love, secrets, pleasures, and
emptied by recriminations, suspicions, jealousy. It was a complex
history, unspoken yet immediately recognizable. She clumsily offered
him a box of chocolates that she had bought for herself the day before,
bought not because she desired them but because she didn't want to
disappoint the shopkeeper. He accepted them, first inspecting the box
then whispering gratefully, "Belgian!" He immediately untied the ribbon,
pried open the lid, and ate three chocolates, one after the other, before
Helen could even remove her shoes. His naturalness gave her a chance
to get her bearings and to recover from her traumatic walk.

Anselm popped two more chocolates into his mouth and led her
through the house to his study, talking while chewing. As they walked
along the corridor, Helen craned her neck this way and that, trying to
take it all in. There were Turkish rugs (she could hear her mother
exclaim, "Turkey carpets!" approvingly) spread about on the polished
wood floors, vases full of fresh flowers tucked away in unexpected but
perfect corners; smug, indulgent chairs lolled here and there, ready to
seduce the indolent idler. It was the art on the walls, though, that was
most enthralling. There were paintings and engravings of bodies: skele-
tons in postures of philosophical musing, muscle charts of the healthy
and the diseased, blood circulation studies, cut-aways of bone, and
details of surgical procedures. She absorbed as much as possible without
actually pausing at any of the pictures. She wanted to interrupt Anselm

and beg him to let her look but acquiesced to move on, ever the dutiful guest. He was talking non-stop about the weather, the neighborhood, the style of architecture, the architect of his block. When they reached the study, Anselm held the door open to let her pass through. It was the most astonishing room that she had ever seen.

The ceilings elsewhere had appeared to be eleven or twelve feet high; in this room the walls stretched up at least twice that. Two stories of glassed-in library shelves were separated midway up by a balustraded passageway that ran along two adjacent sides of the room, but Helen could see no way to get up to the walkway. Along the other two sides, the walls were literally covered with framed paintings and reproductions of parts of the human body. Some of the pictures were packed in so tightly that they were actually overlapping. The effect was like a giant collage, heightened rather than diminished by the chaotic eclecticism of frame styles, sizes, and colors. Several tall ladders on runners leaned against the walls, their rungs stacked with more books and their supports sporting fluttering pieces of paper taped on helter-skelter. Helen stood gaping at the expanse of books and pictures. The room was windowless and yet softly lit with even, natural light. She threw her head back further and saw that the illumination came from a large skylight.

Anselm stood by his desk, watching her with amusement. "Stunning, isn't it?" he asked proudly. "Please sit down. Perhaps you'll have a chance to explore after our conversation."

Helen took a seat next to his desk.

After her discussion with Rosa early that morning, Helen had expected to meet someone who was blind, or nearly so, but Herr Anselm appeared to have no problems seeing. He wasn't wearing glasses, although he did have a pair stuck in his breast pocket, didn't walk with a cane, didn't squint, and looked Helen squarely in the eye. Helen also noticed that when he put the box of chocolates down on the desk, there was only one left.

"So, Rosa has suggested to you that I may be able to reveal the secret of the box, has she? Hmm. I haven't got a clue what she's talking

about; I've never seen this box before. Did she say anything else about it? I don't even know how to open this thing." While they had been chatting about his house, his collections, Rosa and various other things, he had been idly trying to raise the lid.

"No, she didn't," replied Helen, watching his long thin hands alternate between pressing panels of the box and smoothing back his hair. She was about to point out to him that he needed to swing back the plaque when he inadvertently did so himself. But rather than look inside the box he looked inside the plaque, the underside of which was exposed when it swung back, and removed the paper nestling under the glass. It was more than just an engraving—it was a booklet. Anselm opened it up—it appeared to be about 8 pages or so, cut into an oval just like its frame—and slowly started turning the pages. He ran his fingers down each page as he did so.

"Remarkable," he said. "Truly remarkable. I suppose you realize what you have here?"

"No, actually," said Helen. "I had no idea that the picture could be removed. What do I have?" Was this the secret?

"What picture?" he asked, as he handed the booklet to Helen.

"Why the picture on the top of the box, of course," she said. "The one you removed."

"Is there a picture there? Marvelous. What is it of?"

Helen opened the booklet to the first page and found on the left-hand page an illustration of the anatomy of sight and on the right-hand page, the regular punctures of braille.

"Do you mean you can't see?" she asked, astounded.

"But of course I can't see. I was under the impression that you were quite aware of that. However, I believe I can understand your confusion." He plucked the last chocolate out of the box and stuffed it in his mouth.

"But your collection? How do you know what you have? And you move around so assuredly; you look straight at me."

Anselm, still chewing, ran his fingers through his hair again, pushing it back away from either side of his face. "That was caramel," he said

finally. "I have coded every piece in my collection. The codes refer to episodes in my life that have special meaning, and by being reminded again of these particular moments I can recall the pleasures that the individual pieces of my collection have given me and continue to give me. It is an elementary but effective means of allowing me to appreciate what otherwise would have been stolen from me.

"As for moving about in my own house, I have had decades of practice, and I assure you that it is by no means a special feat. Lastly, as for looking straight at you, my eyes may lack vision but they are not weak—I have no reason to fear scrutiny nor do I fear scrutinizing. You realize, I hope, that the eyes are capable of picking up more than just the visible.

"This booklet you have shown me has done the very same thing even though I have never seen it before in my life. But you really must excuse me for talking so much. Since my eyesight has failed, talking is one of my few recourses to words."

"But you can read braille," said Helen.

"No, I can't," said Anselm. "The braille I read shows me pictures not words. I've never learnt how to read words in braille." He smiled at her, a disarming, disingenuous smile, a deceptive smile; for he was lying; his lips had moved, barely, but they did move, as his fingers swept across the bumpy surface of the paper. "And besides, with so many languages floating through my head, clearing space for the philological aspects of braille would be a burden."

She was not in the position to challenge him so instead asked, "How many languages do you speak? English, German, Dutch . . . ?"

"Oh, I'm not speaking of linguistics," replied Anselm, twirling a lock of hair around his index finger. "I'm talking about voices. The individuals who conspire to talk to me, through me, in spite of me."

"Do you mean voices in your head?" asked Helen hesitantly. She didn't want him to think that she considered him deranged.

"Yes, I do mean voices in my head," he replied firmly. "And if you don't have voices in your head it's because your voices are in your body."

"I beg your pardon?"

"Where were you raised?"

"Well, in Canada."

"I should have known," he sighed. "A typical North American edu-
cation. Prepares you for nothing. It is a miracle that you've come this
far. What else do you want to ask me?" He picked up the chocolate box,
held it to his nose and took a deep breath, and then shook it and turned it
over, dumping the few remaining crumbs onto his desk. He swept them
up and tossed them into his mouth.

Helen hesitated. "I have so many questions. I don't want to waste
your time, but I find that I've lost my sense of order. I mentioned to
you that I study anatomical art?" Anselm nodded. "Well, there's a lot I
would like to ask you about your collection, and I'd like the chance to
study it as well, if there's a chance we could discuss that . . . ?" Her
voice trailed off, in anticipation of a response. He nodded again.

"But, I guess, more importantly, there's my husband."

She faltered. Anselm sat up straight and put both hands on the
table. "I so rarely have anything to do with other people's husbands. I'm
intrigued."

"My husband was, is, Martin Evans, a journalist. He came to
Vienna in December. Early in the month. He was doing a story about
stolen anatomical art, no, sorry," she remembered Ganz's version,
"about art forgeries." Anselm's sightless eyes were fixed on a distant
corner of her face. She paused, searching for something else to say, then
added, "He's taken off without notifying me or his papers. I mean the
editors at his papers. I'm trying to track him down." She faltered again
and let the silence absorb them both.

Anselm had been twisting his hair around his index finger through-
out their conversation, but now dropped the lock of hair and held the
finger in front of his eyes, moving it back and forth, the only movement
in the room. Helen was fascinated. What did he see? Shadows? Motion?

"I never met your husband," he said finally.

"No, I didn't imagine you had." She had no reason to doubt him.
"But since he was trying to track down this story, I thought you might
have some ideas about the forgeries."

"Where did you find out about me?"

"From Rosa Kovslovsky."

"Yes, of course! You just showed me that box. Did she tell you I'd be able to help you find your husband?"

"No, I haven't discussed him with her."

"Then why did you come here?"

"I don't know, Herr Anselm. But now that I'm here and see your incredible collection I can't help but think that you might have some suggestions. According to the director of the medical museum, Martin was particularly interested in the Vesalius woodcuts. Do you know anything about them?"

"Oh, so you've met Peter Ganz?" The fact that Anselm's voice was level didn't make the fact that his lip curled maliciously any less shocking.

"Yesterday." The malevolence marching across his face was mesmerizing.

"What did he have to say?" Always the even, detached voice.

"Just that my husband had met with him and that the original woodblocks had been destroyed in a bombing in Munich."

"That's correct. They were destroyed. They no longer exist."

"But, you see, Rosa Kovslovsky also gave me a reproduction of a Vesalius woodcut. It looks quite convincing—faded, a bit worn, you know. I showed it to Peter Ganz. He's kept it to be authenticated."

"Kept it? Too bad. I would have liked to have seen it." The irony of the statement was lost on Helen, who took his words at face value. The trust that she had already developed for Friedrich Anselm disturbed her but was unshakable.

"Could somebody be producing forgeries? Would there be a market for fakes?"

"Fakes? What is a fake? There have been countless editions of Vesalius produced over the centuries. Which of those would be fakes, might I ask?"

Helen shrugged; it was just a question.

"Do you speak German?" he asked sharply, finally letting his voice

betray some hidden hostility. They had been conversing in English.

"Yes, I speak some German and some French."

"I don't care about French. I can speak French perfectly, and yet when I do I am never so misunderstood. Useless language."

"Herr Anselm," said Helen, unable to follow Anselm's sharp verbal turns. She was frustrated by her incapacity and felt like an idiot child. The distress showed in her voice, in her words, "is my visit disturbing you?"

"Not at all, my dear," he replied, suddenly reassuring. "You remind me of someone."

"Well, do you have any ideas at all why Martin might be investigating the blocks?"

"Your husband, you say? Don't women keep track of their husbands these days? I never was a husband but that would have been my expectation. To be kept track of, that is." He looked off into an even further distance, leading Helen's eyes on another exploration of the room. The reflecting glare of the glass doors bounced back, shutting her irises down stop by stop like an aperture closing in a camera.

"I can't help you." Anselm frowned, referring back to Helen's question. "I am so distant from the art world. The humanities—men like your Herr Ganz—have forgotten about me, and that is how I prefer it. But that's not to say that I don't keep my ear to the ground, so to speak, that I don't know what's going on." He seemed unaware that he was contradicting himself. "Perhaps you could go to the library in Munich. Ask there. Or go to Venice. Or go see Stefan Arany at the Semmelweis in Budapest. Yes, go to Budapest, after all, this is their sort of thing. It's a small museum but very respectable. In fact," Anselm's voice was picking up speed, "I could write you an introduction. But don't mail it expecting a response. No one in Budapest ever replies to letters." He opened a drawer and chose a crisp sheet of letterhead. Selecting a pen standing in a crystal glass, he started to write. Helen followed the nib gliding along its trail of ink, watched him guide his fingers along a straight path using his thumb to measure the drops to the next line. Without knowing that he was virtually blind she would never

have been able to tell by watching him write. He finished the note quickly, blew on it to dry the ink, passed it first in front of his eyes and then to her. It was in Hungarian.

She folded the letter and slid it into her bag. "Thank you. You know, I don't quite see the point of going to Budapest. I have had no indication that he ever left Vienna."

"Have you any indication that he stayed in Vienna?"

"No," she said.

"Well, then, what's the harm of going?"

"It seems like even more of a wild goose chase then coming to Vienna. He could be anywhere. He could have become tired of this story and moved on to do something else. It wouldn't be the first time that a journalist had lost interest in something. Here, Vienna, is the last place that anyone has heard from him."

"If you were your husband, if you were researching this story, I would also suggest that you go to Venice and Padua and then to Bologna."

"Why Padua? Why Bologna?"

"You would come closer to finding the very foundations of anatomical art. And I would also say go to Greece—to Samos, and to Syria—to Damascus. If you want to understand what motivates a collector, start at the source."

"Herr Anselm," interrupted Helen. "Sources and foundations are all very well for scholars, but Martin was just a journalist sniffing out a story. He wouldn't have gone traipsing around looking for fundamental inspiration. He'd want to find the here and now. Thanks for the suggestions," she stood up, feeling ungracious and rude, "and for the letter. I'll go to Budapest and try to meet with Mr Arany, but I'll not be able to go to Italy or Syria."

"Ah," he smiled at her, "you have the mind and the voice of a pragmatist who knows just what to do. I suppose you'd like me to pat you on the head," he added sarcastically. "Why are you looking for your husband? Have you no personal self-respect? Let him come back to you if he wants to. And didn't you say you were an art historian?

Perhaps you are a decorator? A historian would know how to delve below the surface. Do you want me to give you a primer on how to find Mr Martin Evans, his missing body, his invisible flesh? Go to the post office, get a telephone directory, call the police. Copy his picture from some fuzzy newspaper reunion picnic and paste it to lamp posts around the city with the big headline 'MISSING.' Read Miss Christie and walk around with a magnifying glass. I see you have one already." He picked up the glass from the box and banged its steel rim against the table a couple of times. "Talk to journalists, to hacks, but don't talk to me, through whom the blood you see on these crumbling charts flows. From me you'll not get what you're looking for, you'll get questions and mazes, contradictions and blemishes, but most of all you'll get the terrible truths that you need to find a man who not only has an identity on paper but who also has muscle, nerve, tendon, and bone." The firmness and stillness of his face indicated that he'd finished his tirade.

Helen sat back down. "Why Padua?"

"Because Vesalius taught there for many years."

"What does Vesalius in particular have to do with all of this?"

Anselm frowned again, grabbed his lower lip, and rolled it around between his thumb and index finger. "Nothing," he said, "nothing at all." If he hadn't suddenly changed his mind about revealing these "terrible truths" then he'd certainly postponed the moment. He turned his attention back to the box still lying open on his desk.

"Now, what else do you have in here." He slid the booklet back into place. Helen noticed that it was the right way round and oriented the same way it had been originally. "Your finger?" he asked waggishly, waving the bone about; his abrupt mood swing left Helen adrift and a bit unhinged. Like the train conductor many days before, he tried it out against his own. "Do you know who this belongs to?" he asked.

"No, no," said Helen. "Do you?"

"Oh yes, I do have an idea. It's just a guess but if I'm correct I really ought to be angry, very angry. Exhuming the past. Yes, ought to be very angry. Been jewelry shopping, have you?" he said, pointing to the ring. Helen suspected that Anselm was trying to make up for his

outburst with what was probably uncharacteristic joviality. He flipped quickly through the rest of the stuff, ignoring the dog tag, running his hands across the engraving of the tooth extraction, and wincing with disgust at the feel of the butt. "Yes, we all know that Rosa smokes too much. Must we be reminded of it at all turns?" He picked up the butt and tossed it into the garbage can beside his desk. Helen was about to protest but realized that it really was disgusting: it had left a yellowed ashy stain on both pages.

He slammed the lid shut and pushed the box back towards her. "Yes, lovely, now call on me in a couple of days, and let me know how you're getting on."

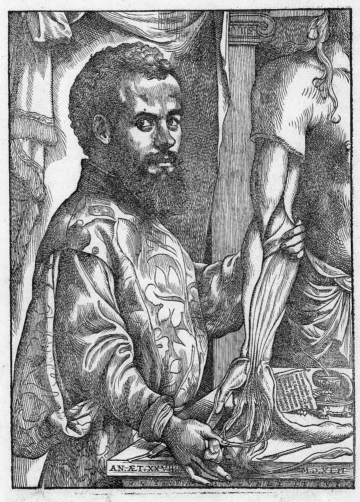

AN. ÆT. XXVIII. M.D.XLII.

VESALIUS

Vesalius, always Vesalius," the fluid name coiled around Helen's mind, interweaving itself through her other thoughts. During the long walk back, marked by detours to shops, carried along by crowds, down peculiar little streets, through the deepening cold and intruding dusk. She always came back to Vesalius. The hotel, at last, and its falsely welcome glow of warmth and light, the mat at the entrance dotted with crusts of dirty snow stamped off of boots and not yet melted.

Speculation about Vesalius was replaced by a preoccupation with Friedrich Anselm. Old men were unknown territory for Helen. For that matter, so were young men. All men. But she felt that she knew Herr Anselm already and knew him well. He was like a familiar book one finds in an old book shop, a book that had once been on an often-contemplated shelf in someone's home, in some library: often held, often opened, but never read—the contents, foreign territory; but never mind, the thing itself, an old friend. She felt so comfortable in his presence, yet on guard, afraid that—like the book—once read, once revealed, he would betray that intimacy by telling her something? Or nothing? Which would be worse? He had welcomed her in to his house, showed her his remarkable collection, shared his blindness with her, flaunted his independence from its sightless grip. She feared that his intellect was illusory, that his words spun a magic that deceived her. Seduced her. She feared this—to be seduced by illusion—but she

refused to admit it. When he had helped her off with her coat, she had nearly leaned against him, the way a child will lean against a trusted parent. Not collapsed, just leaned. But neither, really, and just in time. And a good thing, she smiled to herself, thinking of his frailness, the bones almost visible, barely covered by thin skin. Her own build, not much heftier, was saddled with the vestiges of a phantom girth, seemingly immense.

Had he ever been anyone's lover? Had he ever been anyone's father? He couldn't have only been a scholar. At least he hadn't mistaken her for Rosa like that idiot Ehrlach. But then, he couldn't see, could he?

The next morning, hoping to get her Vesalius print back, Helen telephoned Herr Ganz again. She spoke to his secretary, who suggested she come in and meet with the director the following morning, leaving Helen with a free day. She called the Semmelweis, and although she was told that the director was away for three weeks, made an appointment with him anyway for the day immediately following his return. In the meantime, she'd find something to do, she told herself.

When Helen arrived at the Josephinum she discovered a museum surrounded by police cars and ambulances, the winter air heavy with panic and concern. A cordon had been erected around the entrance; the police were not allowing anyone into the grounds. She stood around for a short while, stamping her feet, rubbing her hands, in the company of a few other hardy bystanders, but finally gave up and went to find a café from which she could get a cup of coffee and telephone the director's office. She was again put through to the secretary, whose smothered, breaking voice had the damp muteness of someone who had been crying. She repeated her name several times to the distraught man, but it wasn't until she mentioned the Vesalius woodcut that he recalled who she was. The dam in his throat broke, and his news hit Helen like a malevolent wave.

The director had been murdered the night before, his body left in the museum, stumbled upon only that morning. Stunned, she pleaded for details. The secretary idiotically repeated the word wax, over and over, nothing else. She asked if she could come by sometime that afternoon, to talk to him, to at least pick up her print. She knew this was insensitive, but the director had been her only real link to information. By the time she hung up she still wasn't sure if the secretary realized that she intended to come, but decided to hazard the chance that he would see her anyway.

Her coffee had cooled into an expensive puddle of lukewarm brown milk when she remembered it sitting on the table next to her. She drank it anyway, barely noticing the coagulating skin of cream forming along the rim of the cup, scarcely registering the waste of heat. Death wasn't such a stranger to Helen's life; other people, closer people, had died. She had only met Ganz once, so his death meant nothing personal to her. But it was hard all the same, in a foreign city where the few people you know make up your entire world, even if only for a short while. And he was, as she had observed when she met with him, so normal, so steady. His death removed the only vestiges of sanity that she had been able to secure since that dreadful morning with Rosa on the train. Draining the last of the coffee, she spooned the dregs of unmelted sugar crystals into her mouth.

Three o'clock found her back at the museum. Most of the police cars were gone, the blockade removed, but the door was shut and locked. She rang the bell and waited impatiently for someone to come. A guard finally opened the door a sliver and peered out. She motioned to him to open it wider; he shook his head. She pulled out her notebook, flapping it meaninglessly in front of his eyes. He asked her what she wanted, eventually letting her talk her way into the building. As he led her up the stairs to the director's office, she could see a large group of people clustered in one of the display rooms, near where a figure had been knocked over and smashed.

The secretary's office was a scene of chaos, stuffed full of police officers. Any pretense of answering the telephone had been abandoned—it was left to ring unceasingly—the clamoring peals echoing all

the way down the hall. Papers were strewn about, giving the many uniformed men crowded into the tiny room no choice but to tread on them. Filing cabinets hung open, their contents disgorged like the entrails of slaughtered animals; framed drawings had been knocked off the wall, the glass shattered, the drawings ripped out and left as litter amongst the other papers; bookcases had been overturned, the helpless books torn at the spines, left gasping where they had fallen.

Helen squeezed into the maelstrom, catching a glimpse of Ganz's office through the open door. The destruction within was, if possible, even worse. She stood open-mouthed, struggling to make sense of the vandalism, when one of the men noticed her and tried to maneuver her out the door. She wrenched her arm away from his grasp and called out to the secretary, unable to remember his name, making a fool of herself trying to get him to turn around. When he finally pivoted in her direction, more in a response to the frenzy surrounding him, than as an answering gesture, she could see that her impression of his distress was correct; his eyes were red and swollen, he looked like he himself wanted to die. He told the man to leave her be and turned his back. She retreated to the corner to be the unnoticed witness of this requiem to an inexplicable shambles.

While she stood slumped against the wall, she thought about her mother and her aunt and what they'd make of her involvement in such a scene. She hadn't been bothered by their phantom appearances for several days; they must have been frightened off by Rosa. Rosa had ousted them. Rosa, the vanquisher of stray guilts. Great, thought Helen. I exchange two annoying old dears for a foul wreck; two nagging consciences for a weak-kneed dance with evil. Evil. Where did that word pop out of? Since when had she regarded Rosa as evil? Malicious, deranged, disturbing, but evil? Helen felt foolish cataloguing Rosa's iniquities: she broke into hotel rooms (although she fully admitted this); she was a liar (or was this just an assumption? No, she'd lied about the door chain); she had manipulated Helen (but maybe this was Helen's fault); she looked soiled, unwashed (since when did squeamishness justify sanctimonious judgments, anyway?).

Rosa hadn't said anything about Ganz. She thought back to where she'd first encountered his name. It was from a message slip in Martin's box at the newspaper. Did Rosa know Ganz? She seemed to know everyone in this game.

It wasn't until hours later when the office was cleared of men and equipment that Helen emerged, rigid yet shaky, out into the center of the room. She stood beside the secretary, who was deeply rooted to his desk, and asked him what had happened. Her faltering German, so subdued, so innocent, caught him off guard, and he began to explain, telling her the chain of events, as if she were a young child and he, the teller of fairy stories. She was becoming accustomed to feeling like a child.

Ganz, it appeared, had been murdered the night before. He had apparently been working late, the cleaning staff had already finished for the night, the lone night shift guard was eating his dinner somewhere in another wing. The poor guard was as sick at heart as the secretary himself. He had already resigned. No one knew yet whether or not the murderer had been in the building during opening hours, staying on, hiding out of sight after closing. Not, after all, an impossible thing to do in an institution like the Josephinum. No one knew whether or not Ganz was acquainted with the murderer. No one knew if robbery was the motivation, but from appearances it seemed highly likely. The death, however—

"The death," moaned the secretary. "A man shouldn't die such a death."

"Tell me how it happened," Helen encouraged him gently.

"They don't know exactly, yet. Do I want to know the little truths when they find out?" he asked himself as an aside. "However it was that he died, he was found covered in wax and propped up as one of the displays."

"Covered in wax?" Helen shivered; she had imagined him as a wax effigy. "Do you mean that someone had smeared wax on him?"

"No, he was covered in wax as if he had been dropped into a vat." The secretary broke down. "It's too, too terrible. No one deserves such a fate, least of all him."

Helen's mind raced wildly. "But there aren't any vats of wax in this building, are there? You don't make wax effigies here?"

"No, they must have somehow moved him and then brought him back. It seems so unlikely. The guard has already resigned," he repeated, this time a little less regretfully.

Helen looked around at the ruins of the office and asked, "Can I help you put things back in order? Have you noticed if anything is missing?"

The secretary looked at her coldly, some of the fever in his eyes drained, leaving behind a frigid barrier. "You are thinking no doubt of your precious woodcut."

"Not at all," she objected. "I mean, I meant to ask at some time, but for now, I am thinking only of you and the museum and the disaster this represents." This was laying it on a bit thickly, but she had to break through that wall.

The secretary softened. "I have no idea if anything is missing," he said. "And thank you for your offer, but it is best if I work alone; only then I will be able to tell if something has been stolen. I will call you," he added, "if I discover your woodcut."

"Well, I should go then and not take up any more of your time." Helen drifted towards the door, scattering paper as she went. "I'll be in Vienna for the next three weeks, but I'll be difficult to get a hold of. May I call you in a couple of days? To see how you are doing?" The secretary nodded. She left.

In two days, without fully knowing how or why, Helen was completely installed in Friedrich Anselm's house, cataloguing his latest acquisitions, and furthering her pursuit of Martin. After she had left the museum she had attempted to call Anselm, to ask him if he had heard of Ganz's death. Not finding his number in the phone book, she asked the hotel receptionist to try for her, but he too could find nothing. He explained that many older Viennese were not subscribers to the telephone service, and that perhaps it was the case for Herr Anselm. So she found herself

knocking at his door, being invited in again, discussing Ganz and revealing that she had almost three weeks to wait before she could see the director of the Budapest museum. Anselm had unequivocally welcomed her into his house. She could be valuable, she could stay for nothing in exchange for her work, she could pursue her husband. She was confused by his offer—it sounded reasonable and practical—but it was ridiculous that he would invite a complete stranger to come live in his home. Unless. Helen couldn't dismiss the nagging possibilities. Unless he shared Helen's sense of familiarity.

She had spent the last night at her hotel inspecting the booklet lodged inside the plaque on the lid of the box. There were twelve pages, each spread with a drawing on the left and a page of braille on the right. The first spread showed cut-aways of fingers and masses of nerves; the second, engravings of the eyes from all angles; the third, a descriptively repulsive examination of the nose, nasal passages, and sinuses; the fourth, relatively benign diagrams of the workings of the ear; and the final one, the fifth, a truly revolting representation of the tongue and taste buds. The back page was blank. Suddenly it dawned on her that this group of illustrations represented the five senses and she chastised herself for taking so long to comprehend it. Was this the secret that Rosa was hinting about? If so, what was so secret about it? She replaced the booklet, and turned her attention to the book inside the box itself.

The book was a rich, eclectic, but seriously haphazard collection of anatomical illustrations through the ages. Some were reproductions of early woodcuts, others were of more recent engravings. In all they represented the entire history of the art form, at least up to the turn of this century. Helen was more confused than ever.

Her fever had gone away, but her relief was short lived as the burning, arid agony was replaced with an annoying ache behind her eyes. She placed cold wet face cloths over her eyes at intervals, tried keeping the light in the room low, even tried the light bright; nothing seemed to help. The anguish came from a new-found acuity—her vision had cleared up remarkably. It had always been fine for reading, although lately type

danced on the page rather more often than usual. What was really worrisome was the rate that her distance vision had deteriorated. She had bought glasses for driving five years earlier and now, if she didn't wear them for walking, could not count on seeing more than a half a city block. She was aware that without them she walked with her nose in the air, her eyes half shut in a squint that helped her vision not one bit. Vain and forgetful, she rarely wore the glasses.

Which was worse—the sudden return of piercing clarity or the steady downward slide into misty myopia? Helen wasn't sure, but she knew she just didn't want to see everything around her, didn't want to have to acknowledge the complex layers and obligations. Comfortable in her nearsightedness, she'd had more sight than she needed for her world of two-dimensional images.

That night she finished her letter to Martin and immediately began the next one. In addition to the details of meeting Rosa and the box, her first letter had contained details of her trip—the cost of the tickets, the time it took to get from one place to another. And then, remembering that Martin liked to discuss eating, she had commented on how good she found the food—if he ever read this letter that would surprise him. The second letter was a great deal more difficult. She began by telling him that she would be moving into the house of a seventy-year-old art collector. As she paused to consider how to phrase just why she was doing this, she realized that she really had no idea. It just seemed so natural. The money, too. She'd save so much money. Okay, so it seemed natural to her to be able to save on hotel bills, to work with a celebrated collector, to have the run of his library. What was in it for him? She wore out his patience, she knew that, with her parochial education; on the other hand, her missing husband entertained him; she didn't flaunt her youth, yet her youth was a respite from the cares of being old; and she intrigued him, with her endless questions about Vesalius. He didn't like the questions, that was evident, but he was intrigued. Or something. She scratched out all references to Friedrich Anselm and moved on to asking Martin why he hadn't read her letters, why they accumulated in mocking piles. Then she tore the page out of

her notebook and tossed it out. This tirade would have to be written at another time.

In any case, she had moved out of the hotel and taken up residence in one of the guest rooms on the second floor of his flat. From the window of her room she could look down at the skylight of the study, and if the light was right she could see vague outlines of the books and paintings within. When she had arrived Anselm had asked her if he could run his fingers across her face, to feel what she looked like. As the dry tips traversed her eyelids, nose, chin, brows, he moved his lips. Silently reading the thoughts that had settled onto her face? He said aloud, "You know, Rosa won't visit you here. She dislikes my habits."

What could she say? Her relief was profound. Although she hadn't admitted it to herself, she felt a desperate need to keep her body together. Of the physical discomforts that had lingered from the train; the tangible one, the cold, was pretty much gone; the intangible one, the phantom girth, still surfaced occasionally. She'd catch herself apologizing to non-existent passersby for bumping into them; scouring mirrors, trying to find reflections of herself, not the stranger who resembled her; threatening to tear apart clothing to relieve the ballooning pressure. Yes, three weeks without Rosa, if she could trust Anselm; that was what she needed.

Helen's days were spent alternatively visiting the newspaper and other galleries suggested by the editor of the paper. She also began cataloguing Anselm's drawings and engravings that had been stored in large cabinets located behind his desk in the study. She would pull out a drawing, painstakingly record its description, including medium, artist, size, and condition, in a massive, musty ledger that left its fingerprints on her clothes. She would then take the drawing over to Anselm, describe it to him, and watch while he punched the corner with braille. If the drawing were already framed he would take a label, punch the patterns into it and then affix it to the bottom right hand corner of the frame. Sometimes he would work rapidly and make few perforations, at other times he would

take a considerable length of time, and the braille would extend the entire width of the drawing's surface.

Many of the woodcuts and engravings hanging on his walls were reproduced in her boxed book. This wasn't such a coincidence, she told herself, considering that Anselm's room, even more than her book, was truly a chronicle of the genre. She would spend evenings alone in her room, going through the book and visualizing just where in the room, on which wall, that particular piece of art might be. She had worked her way through the first half of the book and hadn't found one image that she couldn't place, except for the Vesalius woodcut. But then, that hadn't been bound into the book; it was an afterthought.

During her perusals of the study she soon noticed that all of the frames carried similar labels, all done on paper that blended perfectly with the frames. One had to look closely to see that they were there at all. She would run her fingers over the perforated surfaces, at the same time studying the pictures. The braille-like markings held meanings that Anselm would not discuss.

She had access to all of the books: volumes and volumes on anatomy, osteology, physical anthropology, natural history, and medicine. Heavy, dusty books in English, French, Italian, German, Arabic, Persian, Sanskrit, and Chinese. Handwritten, discolored, and frail manuscripts from the Renaissance, the Middle Ages, the Omayyad rule, the T'ang dynasty.

She discovered the means up to the balcony she'd noticed on her first visit. Anselm had refused to tell her, not because he didn't want her up there but because he was teasing her. It was through one of the corner bookcases. The door, disguised in paint as the backs of books, hid a tortuously narrow spiral staircase. The discovery was a delight; Helen had spent that entire morning creating a hundred excuses for going up and down, exhilarating herself in the dizzying ascent and descent.

"May I photograph these?" she asked one day, indicating the entire room with the sweep of her arm.

"No, I'm sorry, Helen. That won't be possible," came Anselm's reply.

"It's your decision," she said, disappointed. "But why not?"

"Because there are two kinds of photographers in the world. There are photographers whose photographs mean nothing and there are photographers whose photographs mean everything. If you are the former you would do no harm; you would only be wasting your own film. If you are the latter then my entire collection is at risk. I know what kind of photographer I am, but I am afraid I can't take the chance to find out what kind of photographer you are."

"What kind of photographer are you?" she asked, frustrated but tantalized.

"My photographs mean everything," said Anselm. "You may think that sounds dramatic, but it's true. Everything that I have ever photographed has been hurt or destroyed soon after. The need to exist disappeared upon being photographed."

"That's silly," she mocked, "photography isn't that powerful. I would expect more from a man with your education and sophistication." She hadn't meant to press the issue; she seemed to have a pretty good record of his collection in her book, but she felt that he was baiting her.

Anselm got up out of his chair and walked over to one of the shelves. He opened up the door and pulled out a leather-bound binder. "I haven't shown anyone this album for years," he said as he returned to his desk.

She sat down beside him and looked down at the open book. He ran his hand along the page—she noticed the now-familiar punctures on the page—and spoke about the people in the first picture. An elderly couple, his grandparents, rigidly clinging to each other as if in dread of the shutter's snap, dead only two weeks after the photograph was taken. The next picture, a building, had burst into flames two days later. He turned the page. The first picture on the left, a woman, diagnosed with chronic syphilis the day after the picture was taken, now in a mental asylum; the next, a picture of a boy and a dog, both dead only hours later, run over by a horse and cart. And so it went, on and on. The

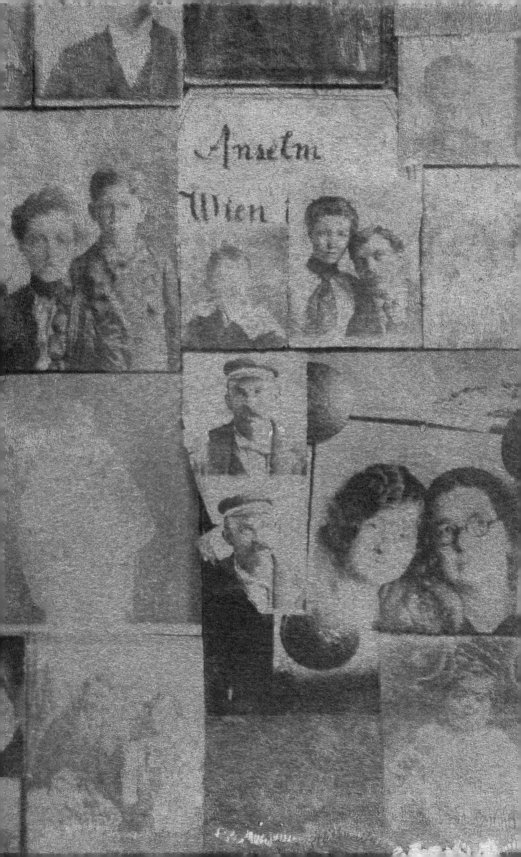

Anselm
Wien

album was a page by page lament of disease, death, and disaster. "You'll note that they are not particularly powerful photographs from an aesthetic standpoint: the compositions are stiff, there seems to be little rapport with the subject, my lighting is adequate but hardly inspired. The aesthetics are irrelevant; the only thing that matters is the outcome. *This* was why I turned to collecting bodies as art," Anselm declared, stabbing with the tip of his index finger a yellowed, dog-eared photograph of a young woman. Helen's heart stopped beating.

Anselm's voice droned on. "I had to stop participating in their destruction."

She grabbed the book away from him and, with a concentration so fierce that the image must have imprinted itself upon her very soul, recognized her own face in the picture.

"And now you see why I can't let you photograph all of this," his hands embraced the room, his voice cut through the fog of her panic. "No one ever has."

She looked at him as if he were mad. The face in the photograph wasn't hers, and yet it was. It wasn't her time, this wasn't her place, how could it be her? "Who is this?" she managed to ask.

"Who? Oh, her. You don't recognize her, I imagine. That's Rosa."

Helen set the album back down on the table and watched aghast as Anselm stroked the faded surface of the print with the same care and concentration that he had shown when he had read her face.

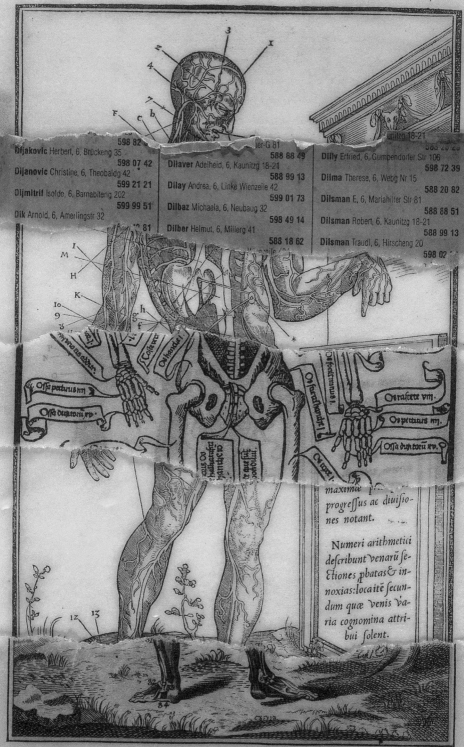

maximæ pro
progreſſus ac diuiſio-
nes notant.

Numeri arithmetici
deſcribunt venarū ſe-
ctiones pbatas & in-
noxias: loca itē ſecun-
dum quæ venis va-
ria cognomina attri-
bui ſolent.

Anatomie, Ecorché vû par le dos.

HERR THÜRING

The face in the album was an unbearable burden. She couldn't tell Anselm, and he couldn't see. Every moment in the study was a challenge and a reproof, so although her work with him fell into a comforting, lulling rhythm, she sought escape and pleasure: trivial, indulgent pleasure, pleasures for her eyes and nerves—she spent her afternoons in coffee houses, consuming the sweets she had always rejected.

After trying out a number of coffee houses, Helen gravitated towards one about a block from Anselm's house. It was very fin-de-siècle, she decided, without really understanding the attributes that made it so. The interior was large, yet dusky and intimate, framed with mirrors lining the walls, leading from the tops of the backs of high banquettes up to the 16-foot high ceilings. The light came from tall arched windows at the front of the café and from ornate glass-shaded lamps hanging from the beautifully painted ceiling. An oak newspaper stand greeted the customers as they came in, the journals theirs to take and to read for as long as they liked. The waiters were quite French in style—her only real European comparison—wearing stiffly starched white shirts, black vests and trousers, and long white aprons. Because the café always bustled, they never seemed to take a break, but they always had time to stop and welcome each customer courteously.

Although coffee houses were expensive, and this one was no exception, Helen couldn't imagine a faster way to work herself into Viennese

life. She tried something different every day, each day ecstatic over her choice and dreamily inclined to order that particular item always for the rest of her life: flaky pastries filled with intensely rich custards and creams; fresh croissants with feathery bodies and crispy, buttery fingers; cakes with the smoothest icing, each slice a work of art. The waiters, to a man, when urged to make the choice for her, would describe their favorites caressingly—their ingredients, their special demands (stirred only clockwise, except when it rains; slow, low temperatures in an oven lined with porcelain; butter only from the Regensfelter farm) as if enumerating the talents and features of their dearest lovers. The obvious enjoyment shown on the faces of the other patrons, too, encouraged her to indulge her newfound pleasure in the texture of food.

One of the waiters, smitten by her—an untimely foreigner drifting through like the snows—had, during rare quiet moments, coaxed her into revealing some of the details of her stay in Vienna. He was especially beguiled by her search for Martin and asked often how it was going. She had briefly described to him her involvement with the murder at the Josephinum. His face went blank. "The museum," she added. His face remained blank. "You must know, the medical museum with the wax models of bodies."

The waiter grimaced and pulled his head back, sticking his chin down into his collar. His disgust could be no plainer. "How could you?" he asked.

"Why? It's a fascinating place."

"They should arrest everyone who works there."

"But why? It's a museum!"

"Do you not know how they got their specimens?" he whispered.

"Yes, I do," she answered, whispering back. Then readjusting to normal volume, "they are wax copies commissioned by your very own Emperor Joseph from a Florentine artist named Paolo Mascagni."

"That's what they want you to think," he said cannily.

"Okay, then, how did they get them?"

"They flayed people alive and dipped them in wax to preserve them!"

Helen was staggered. The waiter's voice had risen and a number of people put down their forks or their cups and looked at him. He bowed to them apologetically and lowered his voice again. "And that is how they got their specimens. That is why they look so lifelike."

"That's what happened to the director," she resumed her whisper.

"You see, I'm right. It's the truth."

One day, arriving at the coffee house later than usual, she saw one of the waiters hesitate and start to say something as she sat down at the table. But he shrugged his shoulders and came over to take her order. She pulled out her books and a catalogue from Florence's Museo de Specola that she had grabbed from Anselm's study. Reading it was tough going, however, and she found her attention wandering from time to time. The waiter brought her coffee and a lovely creation called *Beugeln*, a puff pastry shaped into a cornet and filled with cream, so she put the book to the side on top of the others, propped it open with the sugar bowl, and continued to try to read while eating. As she nibbled, she became aware of someone standing at the front of the table. Looking up at him, taking in the fine cloth of a gentleman's suit, her glance traveled up to the face of a distinguished, clean-shaven, and slightly overweight man in his fifties.

"I am very sorry to disturb you, but may I join you at this table?" He gestured to the room, indicating that all of the tables were taken.

"Yes, please," said Helen, shifting her chair and busily moving her cutlery, plates, and papers.

"Please don't bother to rearrange your things," he said. "My coffee will not take up so much space," he nodded to the waiter who saluted with a light brushing of his index finger along his temple. A cup of coffee with a chocolate on the side quickly appeared, and while the waiter and the man were engaged in an exchange of pleasantries, Helen returned to her book, taking little sips of coffee and scooping fragments of cream, letting them rest in her mouth as long as possible.

"Pardon me," interrupted the man again. Helen looked up at him, her fork suspended in midair. "They have many of those things here, every day; you don't have to eat as though this were the last one." His

face was sincere, but his smiling eyes gave him away. Helen blushed and burst out laughing.

"What are you reading, if you don't mind me asking?" he asked.

"Just a catalogue about a museum," she answered, flipping the pages—a self-conscious gesture.

"A museum in Vienna?"

"No, one in Florence," she replied. "But it has something to do with one of your museums," she added, "the Josephinum, the museum of wax anatomical figures."

"I don't know it, I'm afraid. Amusing, isn't it? I am a native of Vienna, and I don't know this museum. Where is it?"

"Near the School of Medicine, very close to here. Maybe," she calculated out loud, "four blocks away?"

"I see you are taking notes. You don't mind me talking to you, do you?"

"No, not at all," she said.

"Fine. As I said, I see you are taking notes. Are you a writer? Will you be writing something on our museums? And our pastries?" he added mischievously.

She laughed again, "No, I'm not a writer, although I am an art historian. I'm here in Vienna looking for my husband." The honesty. Again.

"Wonderful," he said. He took a sip of coffee. "What is your husband's name?" He flipped open a well-used notebook to which a tiny mechanical pencil had been attached, removed the pencil, licked the end and sat poised to write.

"Martin Evans," she said somewhat cautiously. He wrote down the name.

"Address and telephone number?"

"Oh, he doesn't live in Vienna."

"That's too bad." The gentleman shut his notebook and set it onto the table. "Why are you looking for him here, then?"

"He was working here."

The man picked up the notebook and opened it again. "So he does live here?"

"No, just temporarily. He stayed in a hotel." The notebook snapped shut again.

"Do you know anything about anatomy?" Helen asked him.

"Oh yes. I look for my skeleton every day when I put on my clothes." He chortled and patted his broad belly. "But we haven't confronted each other for many years," he confided. "Wonderful," he said again. "I am a writer."

"What do you write?" she asked.

"Non-fiction."

"That's a very large topic. What kind of non-fiction?"

"People's lives. I have not completed a book, but I am in the process. It is a life's work, if I may call it that. Yes, a lifetime work."

"Which people's lives?"

"Everyone in Vienna."

"But that must be almost impossible. How long have you been working on this?"

"I started when I was twelve years old, at the end of the war, when people could think of other things besides fighting, and I assure you that, although seemingly endless, a project such as this is full of rewards."

"What is the purpose of this book?"

"Purpose? How do I know what the purpose is? It is an interpretation of the telephone directory."

"The telephone directory? You work for the telephone company?"

"Yes, the telephone directory," he smiled, "and no, I work for myself. I think that telephone directories, regardless of the city, are the most astonishing books ever written. They rival the Bible. Particularly for the characters."

"Ah yes," said Helen, "that's an old joke where I come from. Telephone books aren't big on plot or theme but are great on character."

"You think that I am joking," he said indignantly. "I assure you that I'm not. The telephone book would dumbfound you with its complex plots, interwoven intrigues, and highly developed themes. Not a simple book to understand; not a simple book to interpret. May I give you a demonstration?"

"Yes, please." Helen, who finished her cornet without even notic-ing, was enjoying this diversion immensely.

He turned about in his chair and caught one of the waiter's eyes. The waiter hastened over and bent slightly to hear the gentleman's murmured request, then nodded and rushed off. "While we are waiting, may I introduce myself? My name is Herr Thüring." He offered his hand, which Helen took while introducing herself as "Frau Martin."

"Ah, Martin, like your husband's name." Herr Thüring frowned, something wasn't quite right. He opened the notebook again and checked the name he had written. "Is this an unusual custom? The woman takes the husband's first name?" They both laughed.

The waiter returned with a well-thumbed directory, an old dial telephone, and another pastry for Helen. While he cleared the table, Helen put her books down on the seat beside her and held her plate and fork in her hand. The waiter stooped behind the chairs to plug the phone in.

Herr Thüring opened the directory to a page with a bookmark inserted into it and ran his finger down the columns past names with check marks next to them. His finger stopped at the first name without a check mark, one about halfway down the third column of the left-hand page. He turned the pages of the notebook, which was stamped #115 in stencil numbering, and again needlessly licked the end of the pencil before writing down the name, address, and telephone number at the top of the page. While he was doing this Helen asked him how long he had been coming to the café.

"Oh, since the war, at least. I came here as a little boy with my parents," he said, his concentration on his writing.

"That explains why they know you so well here; you didn't even order the coffee from what I could see."

"Hmm?" he asked and then finishing said, "Oh, yes, they know me very well here. This is my mailing address and I make all of my calls from here, not having a telephone myself. In fact, you're sitting at my table. In fact, I would have said something to the waiter if I didn't find you such agreeable company."

"Oh, I beg your pardon," said Helen mortified. "No one said any-
thing. I didn't realize that people had established tables."

"Yes, rather like pews in a church, I suppose," he said. "But as I
said, it is of no consequence. Now, I will give you my demonstration.
First, however, your German is quite good for conversations of this
sort, but will it stand a challenge?"

"No, I don't think so, but I could try," she replied.

"We will try to find someone who can speak English for you. We'll
start here at Dilsman, E. where I left off yesterday. Nine, two, six, nine,
seven, five, one, " he recited as he dialed the number. He waited with the
receiver to his ear, smiling at her.

"*Guten Tag,*" he spoke into the receiver. "*Ich möchte bitte mit Herren
oder Frau Dilsman sprechen.*" He put his hand over the mouthpiece,
"they're asking me to wait. *Hallo? Frau Dilsman? Guten Tag, Mein Name
ist Herr Thüring . . . Ach, Sie kennen meinen Namen?* You've been waiting
for my call? I am honored, dear lady. Do you speak English, by any
chance? You do? Wonderful. I am departing from my usual practice and I
am showing a young . . . " he paused, at a loss for Helen's nationality,
". . . English speaker," he concluded, "how I am developing my book. Do
you have time right at this moment to talk to me? I can always call back
later if this is inconvenient. Thank you, you are very amiable. She can
talk to us right now," he whispered to Helen, his hand once again over the
mouthpiece. He went back to the phone. "Yes, Frau Dilsman, I'll wait.

"She's gone to get the family album. How exciting! I've never done
this in English. While she's gone let me tell you what to do. First of all,"
he moved the notebook and the pencil over to her side of the table and
turned it around so it was oriented correctly for her to write, "ask her
questions about her life and note the details in this book. It doesn't
matter if they are incomplete notes—you can do this in point form—I
can always telephone her back later and fill in the missing parts. Or, better
yet, I can phone her relatives and have their points of view. The first
question you must ask her is if she is related to any of the other
Dilsmans on this page. From there you may question her whatever as
the questions come into your head. I often find that there is no need

from this point on to ask anything; the words just flow out. Everyone
wants to be in my book." His attention was drawn once again to the
telephone. "*Ja,* we are ready. You will be speaking with Frau Martin.
One moment please, and thank you again. No, it is my honor, goodbye."
He passed the phone to Helen.

She took it reluctantly, not quite knowing how she got thrown into
this situation. With a last, helpless smile at Herr Thüring she spoke in
German: *"Guten Tag, Frau Dilsman, Ich bin Helen Martin,"* and then
continued on in English, "yes, I am very well today, and you? Yes, I
agree, the weather is very cold. No, I did not realize that this is an
unusually cold winter. Oh, I think I must be lucky, I don't suffer in that
way." Thüring was gesturing impatiently towards the pencil and the note-
book. She looked at him questioningly and then caught on, scribbling
quickly, detailing the ills of Frau Dilsman's life. She wrote silently,
cradling the receiver in the crook of her neck. When she had filled two
pages she flipped to the next page and moved the telephone to her other
ear. She then asked, obeying Thüring's instructions, "Are you related to
any of the other Dilsmans on this page?" This resulted in another torrent
of words and Helen ended up listening for half an hour, filling eight pages
of the notebook. She finally looked up at Herr Thüring who made a slic-
ing gesture across his neck. Helen interrupted Frau Dilsman as politely as
she could, saying that she needed to transcribe what she had written so
far, otherwise it would make no sense whatsoever, but that undoubtedly
Herr Thüring himself would be calling again with more questions, if she
didn't mind. After a lengthy exchange of thank yous and goodbyes, she
hung up. Rubbing her cramped hand and shoulders, Helen smiled at Herr
Thüring, "Do you do this every day?" she asked him.

"Yes, except when I have to go out of town. I don't want to incur
too much expense." He took the notebook and skimmed through what
she had written. "Not bad, a great quantity of detail. I like your style of
condensing what they say. You have a flair for this sort of thing, you
know. You could write the interpretation of your own telephone direc-
tory; I am not at all proprietorial." He checked off E. Dilsman's name in
the phone book with a flourish.

"I have my hands full with my own work and with trying to find my husband, I think," she said. "But I'll keep it in mind." She looked at her watch.

"Now, let's look for your husband," he said with a glitter in his eye. "Where did he stay last?"

"The Hotel Eugen, but I've been there."

Thüring found the number and had the hotel on the line before Helen finished her sentence.

"Guten Tag," he said into the telephone. *"Mein Name ist Martin Evans. Haben Sie eine Nachricht für mich?"* He poised his pencil, ready to write.

Helen was astonished at his audacity. Why hadn't she thought of that?

"Yes, yes, good. Thank you. Yes. No. I'll call back next week. Thank you. Good-bye." Thüring was scribbling furiously.

"Well," he said, hanging up and rubbing his hands. "It seems that you have left a number of messages!"

"Yes, I suppose I have."

"It also seems that the concierge at the Hotel Gellért in Budapest would like him to call. There is no message, just a telephone number. I've never stayed there, have you? Perhaps that is where he went to next? The message dates from several months ago. In addition, there are messages from a Jimmy Singleton of America—all marked urgent; one from the office of Peter Ganz. Is he from here? I don't know him, not at the *G*s yet, of course." Thüring did not wait for Helen's answers. "The Hotel Eugen took it upon themselves to chastise me for allowing the messages to accumulate. They assured me that they were not my personal secretary. You must undertake to check messages more frequently, if I may give you some advice. You would not need to resort to disguise or deviousness—a wife has the right to demand a husband's telephonic correspondence, no? Now for Herr Ganz." He started flipping the pages in the direction of the *G*s.

"You might find his name, Herr Thüring, but you won't find him. He was murdered."

Thüring glanced at Helen then continued his hunt for Ganz's name. Finding a Peter Ganz, he dialed the number and spoke to the person who had answered. "Wrong number," he said. He dialed another number. This time he spoke at length, heavy with condolence and sympathy. For five minutes his pencil scratched and waltzed across the page. Finally, he hung up and crossed the name off of the list.

"I always appreciate hearing news of deaths. It is extremely important for me, for you see, in order to support myself I write *Nachrufe,* you know, the necrologue?"

"Obituaries?" suggested Helen.

"Yes, obituaries. It is very good luck that we had the occasion to meet; now I will be able to supply a—an obituary—for Herr Ganz. I work for a magazine," he added. "Time isn't really of the essence. Now, it has been my pleasure to meet you. I will put your name in my acknowledgments. Please write it down here at the top of the page for me. And your address, too, so I can send you a copy of the book when it is finally published." Helen did so, grinning to herself at the idea that this man would ever finish such an undertaking.

She stopped on her way out to pay for her coffee and the two pastries, but Herr Thüring had already taken care of the bill. She took a last look at him—he had moved to the side of the table where she had been sitting—and waved. But he didn't notice; he was on the phone to the next person on the list.

Helen asked Anselm if he had ever heard of Herr Thüring.

"Of course I have. Everyone in Vienna has heard of him. You met him? Even I haven't met him. Personally, I mean; of course, my name starting with *A,* I spoke to him many years ago when we still had a telephone. There are two types of people in Vienna: those who have spoken to Herr Thüring and those who are waiting to speak to him. He told you, I hope, about his project?"

"I helped him with it. I interviewed one Evelyn Dilsman for him. He's going to put me in his acknowledgments," she said with mock

pride. "How will he ever finish? He's only on the Ds and less than halfway through them, and he must be in his sixties."

"I don't know," replied Anselm. "It seems, as well, that he feels compelled to go back through new annuals to check on new arrivals, make amendments for births and deaths. Getting to the Ds alone has been an accomplishment. In addition to that, he phones stores, coffee houses, and companies to make sure that there aren't any names there that he has missed due to employees not having a telephone at home. Just going back and double checking takes him half of the year once the new directory is issued. How did you meet him?"

"At the Sauer Coffee House. I inadvertently sat at his table."

Anselm nodded but said nothing.

"He helped me make some inquiries about Martin," she said. "And I told him about Peter Ganz's death. He's going to write Ganz's obituary for some magazine."

"His obituary? It's a great honor to have an obituary by Thüring. To have your death reported only by an impersonal announcement? Why that would be like being buried in an unmarked grave."

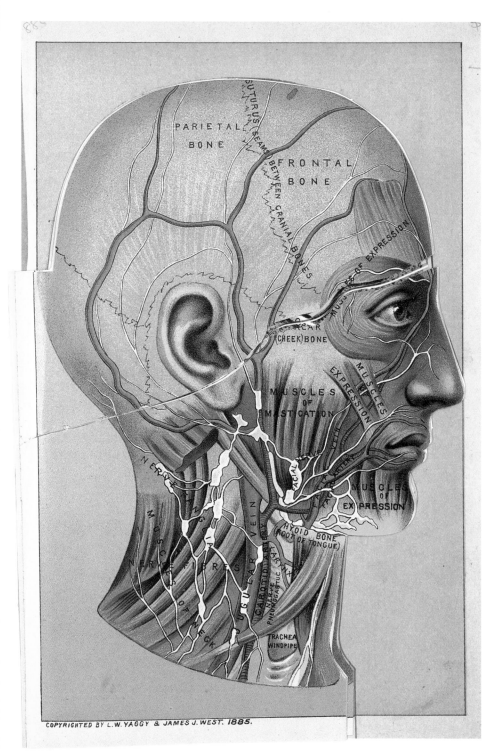

THE SECRETARY

The secretary was not answering his phone. What was his name? Helen wracked her brains. Had she ever known? Were the papers still fluttering away on the floor? Were the chairs and tables still overturned? Was the poor man as she left him that night, head resting despondently in hands, bereft of will, heartbroken beyond repair? It had been nearly a week, time enough to decently show up and ask once more about her Vesalius.

The doors to the Josephinum again welcomed the public. The fallen figure had been removed, the remaining ones rearranged to obliterate the absence of their missing partner. Helen skirted the display—"out for repair" read the tag. The foyer was empty; there was no one to stop her from going up to the offices, so with a quick double check, she climbed the stairs.

The secretary's office was deserted, the door to Ganz's closed; there were no signs of the shambles that had reigned the day after the murder. He must have made a superb effort to pull himself together, thought Helen. Either that or someone else had taken control. Not knowing what to do next, she sat down to wait. It was 11:30. At 11:40 a stout woman carrying several bundles of envelopes walked through the door and over to the desk, ignoring Helen or simply not seeing her. She dropped one of the packages onto the blotter and turned around. Startled, she shrieked and let the others fall to the floor. Helen, apologizing and trying to

explain, helped the woman pick the envelopes up. Both were speaking rapidly at the same time, not pausing to hear what the other was saying.

Eventually Helen stopped talking and started listening. The secretary had been given a leave of absence. He had completely fallen apart. There was no expected date back. Perhaps later in the year; his case was serious. How did Helen get into the office? Who was she? What did she want? She must leave immediately.

Helen was moved to do something she had never done before in her life. She put her hand on the woman's arm to help her to calm down. It worked; the woman took a deep breath, stopped talking, and looked at Helen expectantly. No wonder people do this, she marveled.

She explained about the woodcut, despairing that no one there would be authorized to give it back to her even if they had found it. When she mentioned her name the woman tapped her forehead with the flat of her hand in sudden recognition and, taking Helen by the hand, led her out of the office to another smaller one, two doors down. There she rummaged through a heap of papers and files on her desk from which she extracted a business card.

"This is for you," she announced as she handed the card over. "It's the police." *Die Polizei.* In her throat the words sounded both succulent and threatening. "The officer." *Der Hauptmann.*

Helen took the card and turned it over a couple of times. "What am I supposed to do?" she asked. "Am I supposed to call them?" And what kind of rank was a *Hauptmann?*

"Yes, call them," encouraged the woman. "Go there." In other words, scat, vamoose, get lost. Swell. *Die Polizei.*

"We have been trying to reach you, Frau Marin."

"Martin."

"Yes, of course, Martin. We have been trying to reach you. This is a complicated case, we need to talk to as many people as possible." *Hauptmann* Bauer, of the Vienna homicide division sat impassively behind his desk. An aide perched on a chair beside the desk, poised to

take notes. She was dying to ask him how important he was. Well, he had his own office; that was one clue.

"Perhaps we can start with where you are living. You have left the Hotel Stadtpark and have moved to where?" He took off his jacket and arranged it on the back of his chair.

"I moved to a private residence, the home of Herr Friedrich Anselm." He passed her a form and watched her fill in the details, breathing audibly although not heavily, while she laboriously worked her way through the maze of questions.

"Why did you move, and why not leave a forwarding address at your hotel? You seemed to have moved very soon after Herr Ganz's death." He eased his index finger under his tight collar and strained the cloth away from his neck.

Why did even agreeable policeman seem offensive? Even relatively young ones like Bauer. Had all his hair, no potbelly, no broken veins curling around the tip of his nose. European men were sometimes hard to gauge, but Helen placed him in his late thirties. She deliberated for a moment about how to answer. She assumed cruelly that his lack of mustache indicated his reluctance to break away from the mentality of junior officers who had not yet earned the right to step out of uniform.

"Perhaps you would feel more comfortable if we discussed this in English? I could call an interpreter." So solicitous; he had even had tea brought to his office.

"No, I'm quite alright, it just takes me a little longer to think of how to form my responses." And maybe if you stopped fidgeting, she thought. She explained the series of events that led to her move, but as for leaving her new address at the hotel, she had told anyone who might need to get in touch with her where she was, and that as there wouldn't be a telephone available to take calls, she would check in from time to time.

"And you didn't think that the police might have a reason to get in touch with you, that a murder investigation might be a very good reason. But perhaps being American, murder is not so important. In Austria we don't experience this very often."

"I'm not American, Hauptmann Bauer, I'm Canadian."

He brushed her objection aside in disdain. "It's the same thing, isn't it, the Americas?"

Helen let it drop. "I just didn't think that I would be considered involved. I met Peter Ganz once, had an appointment to meet him again on the day his body was discovered, and when I arrived for that appointment, that was when I found out that he had been murdered. I can't see how I can be of any help."

"What was your first meeting about?"

Helen described her reasons for visiting Ganz, and how the discussion had moved from her husband to her woodcut.

"And why were you to meet again?"

"So he could return the woodcut to me."

While she spoke, Bauer slid a manila envelope out from his top drawer and handed it to her. Turning it over once, she then undid the clip sealing the flap and pulled out the single sheet of paper inside. It was her woodcut. She looked at the officer questioningly.

"Do you recognize the engraving?"

"Yes, it's mine. It's a woodcut. I loaned it to Herr Ganz, at his request, to have it examined. He thought that it could have possibly been an authentic woodcut from the sixteenth century." The questions were racing through Helen's mind. How did he get a hold of it? What has this to do with murder? Take your time, she told herself, don't rush him. She looked at the paper again. What if it really was sixteenth century?

"I have the examination report right here." He rustled a sheet of paper so transparent that Helen could almost distinguish the heavily-penned characters from the other side. "It is a woodcut pulled from a block struck in 1542 for a volume of work printed in 1543 entitled *De Humani Corporis Fabrica Libri Septum* by Andreas Vesalius, a Flemish anatomist. It was utilized again for the printing of a second edition in 1555." He skimmed the report, moving his lips silently as he read. "Blah, blah, blah," he concluded out loud, then said, "here is where we come in. They, the blocks that is, were housed in the library at the University

of Munich where they were destroyed by a bomb, hmm, doesn't say when. Neither the location of the blocks nor their destruction would be of any interest to us, except," he paused, "this print is not from either edition and, although printed onto paper manufactured before 1600, the ink used was manufactured after the war." He looked at Helen with an expectant and triumphant smile on his face.

"So?" she said, "someone could easily have reproduced this by copying from one of the existing prints and then printing it onto old paper. There's enough of it about to keep art forgers busy for decades." She was disappointed; it wasn't real, after all.

"No, you don't understand, do you? This is an authentic print, pulled from the original woodblock. Apparently, they can tell; I don't know how. You have a print made from a supposedly destroyed block!"

"When were they destroyed?"

"*Die Zweiter Weltkrieg*. The Second World War."

"Yes, but *when?* What date?"

"I already said that the exact date is not mentioned." Impatience oozed from his pores.

"Were all of the blocks destroyed?" she persisted.

"It doesn't say, but it implies that they were."

"How many were at the library?"

"I don't know." He softened. "It doesn't say."

"Well, maybe there were others stored elsewhere. They didn't all have to be at the library."

Thus began a long session of questions, more cups of tea, a break for dinner, more questions. Every minute of Helen's stay in Vienna was examined. In detail she described meeting Anna with the dog, Frau Kehl and her pretty boy, Dr von Ehrlach, Friedrich Anselm, Herr Ganz, the editors of the newspaper, the other incidental persons who had crossed her path. She glossed over Rosa, mentioning her only briefly and not by name. Frankly, she didn't know how to describe her without rendering the portrait of a hallucination.

When Helen spoke of her efforts to track her husband down, Hauptmann Bauer interrupted her. "You don't like the police?"

"Why do you ask that?" she in turn asked.

"Why did you not report his disappearance to us?"

"Because he's not really missing; he's avoiding me. I'm not going to bother police over a petty domestic issue."

"You told me that he was investigating an art theft ring?"

"That's what they said at the newspaper. Ganz told me that Martin had told him it was art forgeries he was investigating, not theft. I still don't know who was right, but I think Ganz was."

"What more can you tell me?"

"I've found remarkably little information," she admitted. "He had interviewed Ganz, telephoned some other museums, left no notes. I have an appointment to meet with a Mr Arany, the director of the Semmelweis Museum in Budapest, in two weeks."

"We believe your husband was investigating the mysterious reappearance of the Vesalius woodblocks," the officer announced with satisfaction. "We think he has vanished, not because he is giving you a merry chase, my dear, but because he has found out something he shouldn't have. What I really want to know is, how have you become so inextricably involved, and, as you claim, so unwittingly?"

Helen had to admit the news put her on the spot, not that she had any answers. She could tell him more about Rosa, she supposed. "Yes, do it," suddenly her mother's insistent voice hissed in her ear, "you've never lied in your life." "That's what you think," she shouted silently back. "My life is a lie." Gone, announced a faint whisp of moving air, she's gone.

"I don't know," she said. "I really don't know." A half truth.

Bauer finally let her go. It was nine o'clock in the evening. He offered to have her driven back to Anselm's house, but she preferred to walk.

"Please be available tomorrow from three o'clock," he requested as they parted at the threshold of his door. "I will have more questions for you. I will see you here."

Instead of going straight back to Anselm's, she roamed the old streets of the *Innerstadt,* ending up in the bar of a comfortable hotel from which she could telephone Jimmy Singleton in New York in privacy. She ordered a drink, arranged for a telephone at her table in a quiet corner, and talked to him for the next hour and a half. She told him about the woodcuts, the police and their suspicions; she told him about her worries. If Martin was missing and Ganz murdered over these wood-blocks, that meant that not only she, but perhaps Anselm, and perhaps Herlsberg and the other staff at the Vienna newspaper, were also in danger. But in danger of what? Murder? For what? What did she and the others know? Singleton was pragmatic. She didn't know a thing except what the police told her. If she kept it that way and let them finish their investigation, then there would be no reason for concern. She could leave Vienna tomorrow, well, whenever the police let her go, put Martin's fate in their hands, leave it to them. Yes, she could. She ended the long call by agreeing with him, ringing off, and ordering another drink.

It was very late by the time Helen let herself into the house. Instead of going to her room where she would just lie awake smothered in sheets and abstractions, she crept into the library and read about Vesalius and the woodblocks until her eyes felt as dry and fragile as the pages of the books she plied. What she knew about Vesalius, indeed any of the anatomists that had created the work that she studied, was sketchy and inadequate to say the least. That he had been born in Brussels in 1514, that he died at the age of 50 in 1564, that he had contributed an invaluable wealth of knowl-edge to the study of anatomy, Helen already knew. That he had been a shameful egomaniac; that he had been only 24 years old when the first of his anatomical books, the *Tabulæ Anatomicæ Sex,* was published; that he died on the Greek island of Zanté en route to Venice from a pilgrimage to Jerusalem; these things she hadn't known, and they helped give breath to the dusty lifeless past. And as for the woodblocks themselves, she discov-ered that the collection in Munich that had consisted of about 220 of the

original 270 blocks had moved so many times during their lifetime that it was a miracle they had survived up to the Second World War. The history was interesting to a point, but so specialized, not like the life of someone celebrated—a Michelangelo or a Leonardo da Vinci—someone whose name had made it into everyday language.

The woodblocks were cut following drawings probably made by a Belgian painter, Jan Stefan van Kalkar (although the snipier historians claimed this was impossible given the previous evidence of his mediocre skills in Vesalius's earlier book, *Tabulæ Anatomicæ Sex*), for two elaborate and ambitious books entitled *De Humani Corporis Fabrica Libri Septum* and the *Epitome*, both published in 1543. Helen was fascinated to read that these two books were landmarks of publishing; they cross-referenced the illustrations to the explanations, interweaving the significance of the words with the importance of the pictures. Not only had Kalkar created the artwork for the *Tabulæ Sex* based on Vesalius's studies, he had apparently sponsored or financed the printing of it. So their relationship was much closer than that of employer and employee.

De Humani Corporis Fabrica: On the Fabric of the Human Body. How marvelous to think of the body as some kind of cloth or garment. To be changed at whim. To discard or treasure. To hand down through the generations.

Helen set the books aside and closed her eyes. She pulled her legs up onto the chair, nestled her head upon her knees, letting rounded patellas fit their perfect fit into the orbs of her eyes. The pressure from the bones—such thin skin at the knees, no padding there—pushed her eyes back into her head, creating a lively dance of blackness and explosions of, well, non-blackness. How else could it be described? There were too many whites and too many colors to enumerate. She moved her head back a fraction of an inch and raised the lids. The landscape of her knees presented itself to her—tiny, fine hairs erupted sparsely over the skin's surface. At this distance the shallow crisscrossing lines seemed as deep as crevices, the occasional irritated hair follicles like craters. No, the crisscrossing fissures were the weft and the warp; the hair, the imperfectly spun fibers. The skin. The fabric.

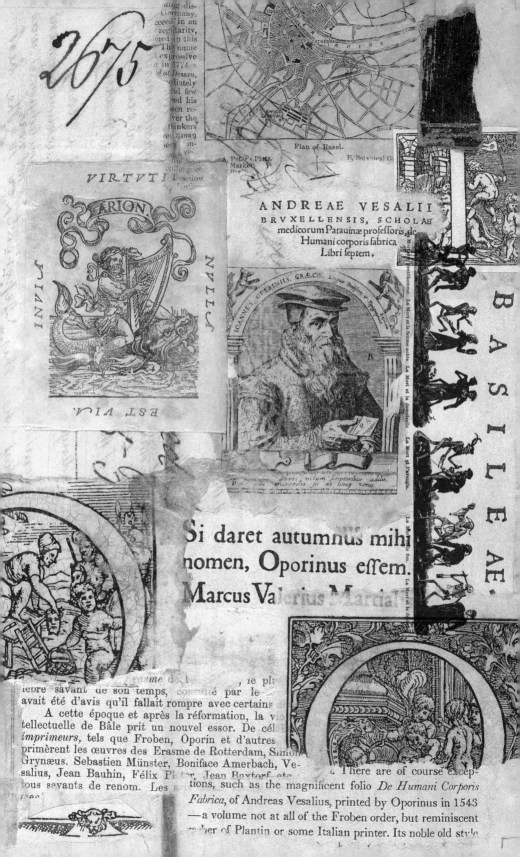

2675

Plan of Basel.

VIRTVTI

ARION.

NVLLA

INVIT

EST VIA.

ANDREAE VESALII
BRVXELLENSIS, SCHOLAE
medicorum Patauinæ professoris, de
Humani corporis fabrica
Libri septem.

IOANNES OPERINUS GRÆCÆ

B A S I L E AE.

La Mort et la femme noble. La Mort et la demoiselle. La Mort et l'aveugle.

Si daret autumnus mihi
nomen, Oporinus essem.
Marcus Valerius Martial.

lebre savant de son temps, condamné par le
avait été d'avis qu'il fallait rompre avec certains

A cette époque et après la réformation, la v
tellectuelle de Bâle prit un nouvel essor. De cél
imprimeurs, tels que Froben, Oporin et d'autres
primèrent les œuvres des Erasme de Rotterdam, Simon
Grynæus. Sebastien Münster, Boniface Amerbach, Ve-
salius, Jean Bauhin, Félix Platter, Jean Buxtorf, etc.
tous savants de renom. Les a

There are of course excep-
tions, such as the magnificent folio *De Humani Corporis
Fabrica*, of Andreas Vesalius, printed by Oporinus in 1543
—a volume not at all of the Froben order, but reminiscent
rather of Plantin or some Italian printer. Its noble old style

Vesalius had been in Venice; Kalkar, if he was the artist, had been in Venice; and the woodblocks had been cut in Venice, but the printing was entrusted to a printer in Basel named Oporinus. Why Basel? Wasn't Venice at the heart of the printing craft at that time? And why the name Oporinus; wasn't that a Latin name? Perhaps this wasn't the name of the printer after all but the name of the firm. Call it something Latin, make it classy and literary sounding. No, thought Helen, printing houses called themselves after the owner in those days. Vesalius apparently knew the printer, this man called Oporinus. He wrote him a letter that was reprinted in one of the books. But what was Oporinus like? A taciturn, humorless craftsman with a love for the press but indifferent to the subject matter? Dissection was a dicey thing in those days—not everyone approved; perhaps it was difficult to find a printer in Venice who would undertake such a project? Was it possible he had a special interest in anatomy, perhaps having suffered from gout and dizzy spells for most of his adult life?

She skipped to another book and found that Basel was a recognized center of printing, thanks to printers such as Oporinus, and that Oporinus was in fact Johannes Herbst, the son of a poor but influential artist. As a young man he had apprenticed as a printer and briefly studied medicine under Paracelsus, a crackpot genius of a physician and alchemist, as influential in his approach to healing as Vesalius had been in anatomy. Oporinus then had become a professor of Latin and Greek. Unable to keep up with changing regulations in the University system— Helen, thinking of her own university, nodded in recognition of a certain historical continuum—he was set up as a full-fledged printer, all of this by the time he reached the age of 32. He led a brilliant life as one of Basel's foremost printers, not only creating beautiful books, but having the distinction of being thrown in jail for printing the first Latin version of the Koran.

The volume that revealed so much about Oporinus drifted off to other irrelevant topics, leaving her to return to the paltry details provided by the first one. It wasn't a big leap to understand why the blocks, upon Oporinus's death, went to the publishing house of Johann Froben.

This Basel printer, Helen had read, was also a well-respected publisher, and in fact, that's where Oporinus had first apprenticed. But Oporinus had a medical background. What about the Frobens? Did they approve of the flayed skins, exposed organs, frayed nerves? Perhaps these things were much more natural a topic than today. Now the reactions were so predictable: clinical interest amongst professionals, disgust amongst lay people. It was rare to find informed interest in the art itself.

Here was mention of an Ambrose Froben, Johann's son? Grandson? Ambrose had printed a book for a Felix Plater in 1583 in which the Vesalius images appeared in reduced form. She dismissed that information; it didn't involve the original blocks. The Frobens went bankrupt in 1603 and their successor, Ludwig König, took the woodblocks next. A common name, König, but not a disreputable one. She could find nothing about printers called König other than the inconsequent detail that they reprinted Plater's book.

An Augsburg printer named Andreas Maschenbauer got his hands on the woodblocks next, and in 1706 and 1723 passed them off as Titian's work in several abridged editions for artists, reviving a rumor that the illustrations had not been done by Kalkar, as Vesalius himself implied. This wasn't, apparently, the work of Maschenbauer's own solitary imagination. The illustrations were so good that for years a number of authorities had claimed they could come from no other hand than that of an artist such as Titian. And it probably helped sales.

Helen studied the reproductions of the Vesalius woodcuts in one of the books, comparing those from the *Tabulæ Sex* with the later *Fabrica*. The book was a badly printed little effort—the ink had filled many of the fine lines, others had disappeared—but mediocre though they were as reproductions, one could see that the art itself was highly developed. The contrast between the Vesalius woodcuts, even in Kalkar's earlier, cruder *Tabulæ Sex*, and other anatomists' work was indeed astonishing. Anselm had books and woodcut prints showing examples of Vesalius's predecessors and contemporaries, names and work that Helen was long familiar with, but who demanded review with a fresh eye under the circumstances. They were a confusing cast not helped by the fact

that each publication gave a different variation on the names of the players: Lorenz Fries, also known as Laurentius Phryesen, who wrote a popular anatomy in 1518 called *The Looking-glass of Medicine;* Giacomo Berengario da Carpi, variously known as Jacopo or James Berengar or Berenger, whose skeletons and muscle men stood in crude yet dramatic relief; Charles Estienne, or Etienne, or Carolus Stephanus as he preferred to be called, a French anatomist from the celebrated family of Parisian printers; Bartholomæus Eustachius, an Italian physician whose work, published posthumously, had a sublime graphic aesethetic that must have been ahead of its time.

Helen scanned the walls, inspecting the complex jumble of old prints and paintings. It seemed so odd that Anselm wouldn't have a Vesalius. She'd been through some of the drawers already, not specifically looking, but certainly keeping an eye out, but nothing had surfaced. It was such an obvious gap in his collection; he must have some examples somewhere. She returned to the inadequate book she'd been reading and studied the illustrations again, concentrating on the woodcuts of the muscle men; they'd only included a few, but perhaps hers had been one of them. The reduced size and bad printing made it difficult, if not impossible, to identify which one, but it was possible to see the progression through the layers of muscles from one woodcut to the next. The first muscle plate was one of the most poignant, with the subject's head thrown back, his arms raised slightly away from his sides, one foot a scant step ahead of the other. The hilly countryside and the silent little town nestled in amongst the trees and contours of the background increased the intensely emotional splendor of the scene. As the views changed in the subsequent plates, the subject rotated to show the sides, the back, and the ever-deepening layers of his body's muscles. The muscles stripped away, hanging down in pathetic shreds, the fields, orchards, and houses continuing to stand in mute testimony to this unrelenting unveiling.

Continuing the search, she found more references to Titian's associations with anatomy. He had lived in Venice during the same period as Vesalius and Kalkar had apprenticed under him. A volume of anatomical

illustrations, called *Notomie di Titiano*, published posthumously in 1670 showed engravings from the *Fabrica* signed with Titian's own initials. She shrugged; she wasn't going to solve the dispute by reading old arguments.

As far as Helen could see, the whole history of Vesalius was fraught with arguments. He himself had published his work with a haughty provocative attitude, an uncontrollable pugilist throwing punches into the air, barking out threats to would-be plagiarists, doubters, critics. She read of how controversy and jealousy exploded the minute the books emerged from the press: Vesalius had dared to contradict Galen; thus he was a heretic. He had stepped on too many toes. The arguments surrounding him continued on through the centuries, leading academics perpetually into scholarly mud-slinging.

Vesalius's frequent admonishments of plagiarists fascinated Helen. As early as 1538, he had written a warning to all copyists and vendors, threatening them with heavy penalties should they try to distribute his work unauthorized. His words fell empty into the air; copyists threw themselves into the task with gusto. In response, in 1546, he published an essay called *Letter on the China Root*. Ostensibly the essay was a discussion of some kind of Chinese herbal medicine used to treat a variety of illnesses ranging from syphillis to gout; in reality it was an opportunity for him to harangue his plagiarists and detractors.

Side-tracked by these details, Helen had forgotten about the chronology of the woodblocks. It seemed that so much had already happened, and yet it wasn't until 1771 that the woodblocks were to surface again, this time in the hands of a surgeon, Herr von Woltter in Ingolstadt. He approached a Bavarian anatomist, a Dr H.P. Leveling, to see if he could print an edition from them. Leveling tried to raise money by subscription, failed, and so Woltter sent them to a Leipzig printer named Crusius. There was no information about Crusius, except perhaps that he misrepresented his capacities, as it turned out he couldn't afford to print a new edition either. To be fair, he sent them back to Woltter in Ingolstadt. Where on earth was Ingolstadt? Dr Leveling finally managed to print a first edition of, he claimed, 1500 copies in

1781. Her source speculated that perhaps only a few hundred were actually bound and sold. He then had a second edition printed in 1783, also purported to consist of 1500 copies.

The blocks remained in Ingolstadt—with Woltter? The history books weren't clear—until 1800, the time of the French invasion, when they were moved to Landshut. The book specified that Landshut was also in Bavaria, implying that Ingolstadt was in Bavaria as well. So that must mean that the two cities were somewhere near Munich. Why were the woodblocks safer in Landshut than in Ingolstadt, who were they with, and who moved 227 of them in 1826 to the library in Munich where they were stuffed in a corner and left until their rediscovery in 1893? The accounts at last reconnected with some facts, reporting that a couple of editions were printed following their last appearance, a notable one being the *Icones Anatomicæ*, a co-publication between the University of Munich and the New York Academy of Medicine.

So, she wondered, was the woodblock used for the printing of her woodcut one of the 227, or was it one of the 50 that never made it as far as the library in Munich? She had to get it back, or at least see it again, to imprint its design upon her memory. Then she had to find a copy of the *Icones Anatomicæ*. Continuing to search through Anselm's library seemed a logical step, but it was already seven o'clock, time to get away before Anselm woke up. She wanted to clear out and stay away for the entire day. No doubt Anselm's house would be invaded by the police, now that she was involved and they knew where she was living. As the rat responsible for this she had to do what all self-respecting rats did: keep herself scarce. She contemplated calling von Ehrlach and warning him to also expect a visit, but decided in the end that it served him right; he warranted none of her pity after the way he had treated her.

She presented herself to the desk clerk at the police station at 2:45, but it wasn't until 3:30 that an officer escorted her to Hauptmann Bauer's office. Without apologizing for keeping her waiting, Bauer pointed to the same chair she had sat in the day before. While guarding what appeared to be a

report, he nodded to the omnipresent aide to commence scribbling, asking her if she had remembered any new details. She had thought long and hard during her wait in the anteroom, hoping to be able to satisfy his craving questions with the scattered morsels she had forgotten, but nothing, except Rosa, had surfaced. And she still wasn't ready to reveal Rosa.

"We've been considering your testimony." Helen sat forward at the word testimony, carefully eyeing his stiff, densely typewritten sheet of paper.

"I thought this was just an informal interview. Are you telling me that I am to regard these as official interrogations, or perhaps I have misinterpreted the word testimony?"

"No, not at all," soothed Bauer, "just an expression. Shall we say, we've been going over yesterday's discussion?"

Helen acquiesced and sat back in her chair.

"And I find that I have many more questions. For instance, when we talked to Herr Gerstner—"

"Who?"

"Gerstner, Herr Albert Gerstner, Ganz's personal secretary. You met him, didn't you?"

"Yes, I did. I just never knew his name. Gerstner. Okay."

"Herr Gerstner mentioned that you had shown Herr Ganz a box and that Herr Ganz was quite struck by it. Perhaps you would like to show me this object?" He looked at her expectantly.

"Yes, I suppose I would." Helen reluctantly reached into her bag and set it onto the desk.

"Open it, please."

Helen obliged.

Bauer and the aide both inclined slightly towards the box, trying to take it all in while maintaining a façade of decorum. "Remove the contents, if you wouldn't mind."

It had never occurred to her to try to take the book out. This astonished her; it seemed like such an obvious thing to do. She carefully tipped the box upside down and maneuvered the entire book onto the desk. The box sat empty.

Helen opened the pages and took out the finger bone, the notebook page, the vials, the magnifying glass, the dog tag, and the other sundry bits of junk and arranged them all on a cleared area of the desk. Bauer lifted each object up, one by one, describing them while the aide scratched away furiously with his pen.

"One magnifying glass, steel, medical inscriptions, seventy-four millimeters radius."

"You're not planning to keep these, are you?" Helen interrupted, a shade vexed.

Bauer's face accordioned in on itself at her intrusion. "One dog tag, brass, inscribed BER-7621. One human phalange . . ." the list droned on.

"Was this where you kept the," he looked at his notes from the previous day, "Vesalius engraving?"

Helen nodded. "Yes. Woodcut."

"Where did you say you acquired it?"

Helen knew it was useless to insist on the irrelevance of these details. Even she could see the connection. "From a woman named Rosa Kovslovsky. I met her on the train."

"Rosa Kovslovsky, Rosa, Rosa, no, there is no mention of Rosa Kovslovsky from your declaration of yesterday. Could you explain this?"

Helen squirmed. And then remembered that she had referred to Rosa, just not named her. "But I did mention her, it's just that we talked about so much that I don't believe I gave you her name."

Bauer went over the notes again. "I see here that you spoke of sharing your compartment with a stranger from some unidentified location until Munich. Is this Rosa Kovslovsky?"

"Yes, it is."

"And you knew her name from before? Or she introduced herself?"

"We only just met. Frankly, I disliked her from the minute I woke up in her presence. She was in my compartment very early in the morning, at least from 6:30, probably earlier. I tried not to talk to her, she gave me the creeps," Helen admitted.

"Why would she give you such a box?" He turned it around, flipped the lid back down, stared at the pearls and the tooth, opened it back up again and examined the ringed finger bone. "And such items? She clearly did not feel the same animosity towards you."

"They weren't all in the box to begin with," Helen said. "Frau Kehl, I told you about her, she gave me the ring." No sense saying it was by accident. "The conductor gave me the ticket to Berlin, the woman named Anna gave me the dog tag, von Ehrlach gave me the engraving of the tooth extraction. You see, things have rather added up since it first came into my possession."

"Are these real pearls?" He had shut the lid again and ran his finger around the frame.

"According to Rosa Kovslovsky they are."

"And the tooth?" He had flipped the lid shut and was trying to pry the tooth out, but his fingers were too clumsy and coarse. She reached over, waited for him to give up, so she could show at least one grace and pluck the tooth out for him. He obliged, so the molar, free but balanced between her thumbs and index finger, was presented to him, proprietorially, a concession to his fall from superiority. This was hers to give him and so she would. His face showed no expression as he cupped his hand below hers, ready to accept her charity. She dropped the tooth onto his palm, then pointed to the book.

"May I?" she asked.

He nodded.

She flipped the pages until she came to the drawing of the tooth extraction. Smoothing it out onto the table she pointed to the tooth in question.

"This is how bizarre my week has been. It may help excuse my apparent lack of cooperation. This molar, premolar, rather, belonged to the elevator operator," she hunted for his card. "Wilhelm Stukmeyer, in Dr von Ehrlach's building. He gave me the tooth when he saw the diagram of the extraction, claiming them to be related." She sighed. "This box is a magnet for every nut case in Vienna—it is not evidence pertaining to either Herr Ganz or to my husband Martin."

"Where did the drawing of the extraction come from?"

"Von Ehrlach. He fobbed it off on me when my questions started to bother him, then he pushed me out of his office."

Bauer nodded again.

"And he mistook me for Rosa Kovslovsky, whom he happens to know quite well."

"Do you resemble Rosa Kovslovsky?"

"Not in the slightest. She's at least seventy years old, is obese, and wears remarkable wigs." Helen toyed with the ends of her hair, thinking about the photo of Rosa that would turn this declaration into an outright lie. The photo lay safely hidden in Anselm's study; there was no chance that Bauer would ever find out about the resemblance between her and Rosa.

"Hmm. Von Ehrlach is recognized to have lightened his grip on the here and now. He seems to spend much time in the past."

"How do you know Dr von Ehrlach?"

"Professional witness."

"Pardon?"

"Testifies on the state of peoples' minds. We call him in for the really odd ones."

Bauer steered them back to Rosa.

"Did she tell you why she was giving this to you?" He cradled the box in both hands.

"No. I had left the compartment just before we arrived in Munich, partly to escape from her and partly to wash up. I was feeling very sick at the time, catching a cold, and I found the compartment stuffy, suffocating in fact. By the time I got back the train had stopped, and Rosa was gone. All that was left was the box and this note," she picked up the piece of paper that said "For your search."

"I see," said Bauer. "Is there anybody else who you've spoken to, met, who you may have forgotten to tell us about?"

Helen thought some more and then remembered Herr Thüring. "Why, yes there is."

"Well," he prompted.

"A Herr Thüring. I met him at the Sauer Coffee House. He's an author."

"You met Herr Thüring!" Bauer was astounded. "You have only been in Vienna for under two weeks and you met Herr Thüring!" Helen could see that his estimation of her rose dramatically, and basked in the relief, even if it was only going to last for a few minutes.

"Yes," she said rather proudly, "and I helped him with one of his phone calls. Haven't you met him?" she asked.

"No." Bauer frowned, "but I have spoken to him. It seems like so long ago." He smiled at some distant memory. His teeth exposed, ripples at the corner of each eye, a new face, a kind face. "Tell me, what letter is he on?"

"*D*s. I called a lady name Dilsman and wrote down the notes. Thüring couldn't think of a better way to describe what he did."

"But how did this come about?" He was genuinely interested, no longer in authority.

"I accidentally sat at his table."

"Ah," he nodded. Everyone acknowledged that it was a tricky business in Vienna, these café tables, skewering the habitué between rudeness and civility, especially when foreigners were involved; here ignorance was an excuse.

The skin smooth once again, the smile stored away for others, questioning proceeded. "Have you met Rosa Kovslovsky since?"

Helen had anticipated this, but it didn't make it easier to answer. "Yes," she said finally.

"Where?"

"My hotel room, the day after I arrived in Vienna. Or rather, the night after I arrived."

Bauer waited for her to continue.

"I woke up and there she was. She'd, uh, broken in. Picked the lock. She showed me her skeleton keys. I woke up out of a, a bad dream, and like I said, there she was. Just sitting there, waiting for me to wake up. She wanted to tell me about someone I should see. Von Ehrlach, as a matter of fact." Helen's head was starting to ache and the officer's stare

was hurting her eyes. He said nothing. "She had already set up an appointment with von Ehrlach. I haven't yet been able to figure it out. That's all. I haven't seen her since. Oh, one more thing, Friedrich Anselm seems to know her quite well, also."

"Do you love your husband, Frau Martin?" Bauer's question came out of the blue.

"He's run away from me, how could I love him?"

"That would make some women love their husbands all the more."

"Don't be ridiculous. That's not love. That's flagellating self-pity."

"What are you doing here then?"

The question made perfect sense, yet every part of Helen revolted against answering it. After a moment's delay she said, "Look, Hauptmann Bauer. Martin, as a husband, has been dead for a long time. I'm sick and tired of living with the deceased. I've come here to bury him, regardless of whether he's dead or alive."

Bauer dismissed Helen after taking down a description of Rosa and suggesting that she get back in touch with him in a couple of days. Sooner, if she had any further information. She reminded him of her plans to go to Budapest, to which he nodded, raising no objections. She gathered up the contents of the box and methodically replaced them one by one. Without so much as a glance at Bauer, but sensing his impatience, she snapped the lid shut and slid the box in her bag.

She hazarded another question. "Can I see my woodcut?"

He shook his head.

"Just for a minute. I'm trying to figure out if it came from one of the supposedly destroyed blocks."

"But it did." He started fanning papers out onto his desk.

"But we don't know for sure. There were 50 unaccounted for. Fifty of the original 270 or so that never made it to Munich back in 1826."

He tapped his pen on his desk. "I don't have it here."

"Will I ever get it back?"

Bauer looked at her coldly, then turned to the papers which now obscured the entire desk top. The aide, grasping her arm, steered her out of the office. Helen realized that there was more than the simple issue of ownership at stake.

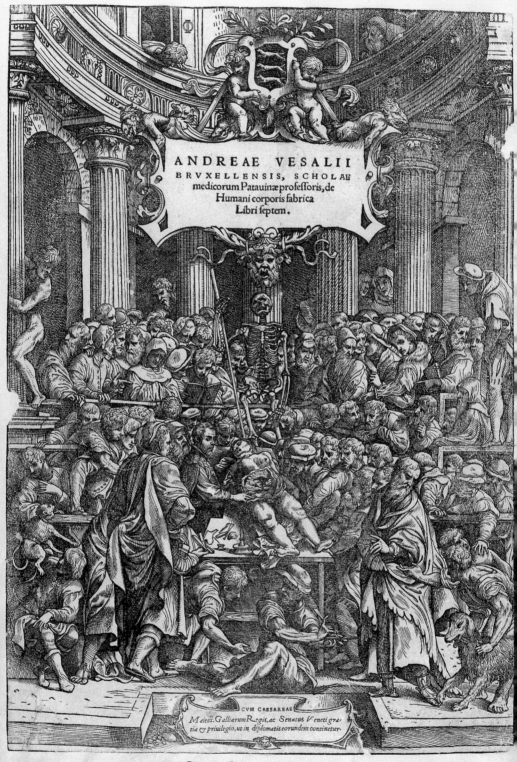

ANDREAE VESALII
BRVXELLENSIS, SCHOLAE
medicorum Patauinæ professoris, de
Humani corporis fabrica
Libri septem.

CVM CAESAREAE
Maiest. Galliarum Regis, ac Senatus Veneti gra-
tia & priuilegio, ut in diplomatis eorundem continetur.

BASILEAE.

LEAVING VIENNA

Anselm's insulated haven had been invaded by police the day of Helen's second interview, but neither Anselm nor the house seemed any worse for it. The old gentleman took it with good humor and had given them a guided tour, even assisting as they sorted through Helen's meager personal effects. This he admitted to quite proudly, congratulating her for traveling neatly and compactly. "It's not everyone who could withstand so firmly the prying eyes of the law and the idle hands of curiosity, you know."

He brushed aside her attempts to apologize for having dragged the police into his life. "Don't worry about it for one bit. They were too circumspect, really, to have done any damage or any real ransacking. But," he added, "they didn't quite explain what they were looking for. Does this concern your husband?"

"Only marginally. It's more to do with the murder of Peter Ganz." Still curious about Bauer's rank, she asked Anselm.

"Hauptmann, hmm? Moderately important. Don't worry, you haven't been fobbed off on some underling. But what has this to do with Peter Ganz?"

She explained why they thought that there might be a link between her, Anselm, and Ganz—it all seemed to come back to Martin and the Vesalius woodcuts. Anselm's nonchalance silenced Helen's dreads, giving

her previous night's conversation with Jimmy Singleton an aura of unreasonable hysteria.

That evening Anselm ordered in a marvelous feast from a neighboring restaurant. A waiter appeared late in the afternoon to set the table and arrange the dining room. By seven o'clock, Anselm was fluttering about as nervous as if he himself had prepared the meal. By 7:30 the waiter was reinstalled, pouring the first wines and serving the first dishes.

Anselm, stubborn as a rusty lock, would not tell her what the occasion was, only saying that it was by way of an apology and leaving it at that. It wasn't a farewell dinner; a week remained before she would leave. It wasn't because he loved to eat; they had never shared a meal in the many days that Helen had been in the house. In fact, she'd never even seen him near food since her first arrival with the chocolates. An apology for what? For letting the police in to pry? For keeping something back, something hidden? She knew that he had so much more to say about Vesalius; what was stopping him? Helen brushed aside the questions and dug in to enjoy the meal of a lifetime, forgetting all about her intention to find out if he had a copy of the *Icones Anatomicæ*.

"You realize, Helen, you have no smell," Anselm announced between sips of wine. He had been drinking a lot and, moving quickly from mere intoxication to total drunkenness, was dragging Helen along with him. The flush of inebriation introduced a tolerant smile to her face. This is my tolerant smile, she told herself, useful for drunken old men who know their own charms. She watched him down another glass of wine. Please don't let him become maudlin, she pleaded silently, her smile plastered on haphazardly now. He continued. "You have no smell, and you have no sounds—you're one of the few people who can approach me without my sensing you. Do you exist? Do you smell things, hear things? Do you make noise?"

She shrugged, serious once again. Her conversations seemed to leave so little room for levity. "What do you expect me to say? I don't understand what you're asking. Of course I do. I smell, I make sounds. Just like everyone else. I'm just like everyone else." Why was he always trying to make her uncomfortable?

"Let me rephrase my question. What do you see in the dark?"

"I've had no darkness since the night I saw through Rosa's eyes, Herr Anselm."

"Friedrich."

"Friedrich." She sighed. An interior sigh—no outward escape of the deflation of the lungs, the expelling of air, no audible evidence of being provoked. She had wanted to giggle, to invite the wine that was rocketing through her head to an exuberant party, a jolly soirée. The frolics would have to wait. "I see so much now that I'm not sure anymore what I smell or hear. Or taste," she added.

"But you know what you see?"

"Oh, yes."

"And what you feel?"

"I must know what I feel. You know this, too. After all, you're the one who told me I have voices in my body. If they don't tell me what I feel, who will?" She looked at him, suddenly embarrassed. "But I don't know what I say. I've had too much to drink and so have you." She nodded to the waiter, standing in the wings. When he came over to the table she looked in Anselm's direction. The young man, who had registered Anselm's drunken state, helped him up and started to lead him off to his room. Anselm turned to her and asked, "What kind of woman are you, Helen? How long will it take for you to realize that it's time to start chasing live bodies, not dead ones."

"But my husband. . . ."

He turned and left, not allowing her to finish. As she stood, ready to thank the waiter and let him out, she finished the sentence for herself. But my husband. Dead in my mind, dead in my heart. She had read somewhere that Leonardo da Vinci had asked how one could describe a heart without filling a book. All she wanted to know was how could she fill a heart. Her heart? Martin's heart? Whose heart needed filling? There was more to that quote. What was it? Something about blindness. That was it. He had asked how to describe the heart to a blind man without filling a book. Anselm the blind man's book of the heart, filled with blank pages that only he could read. She went back to the table and

slowly circled it, picking up tidbits from the various plates and absently stuffing them in her mouth. There was still some of the powerful thick port they had been drinking with dessert. She filled her glass, emptying the bottle, and wandered into the study. With the books and pictures pressing closely in on her she sat down in the most comfortable chair in the room, a leather club chair, and dissected Anselm's behavior. What did he mean she didn't smell? She held the palm of her hand to her nose and took a sniff. Then smelt the tips of her fingers, the ends of her hair, the crook of her arm, her clothes; she even pulled her feet up to her nose and inhaled deeply. She smelt her fingertips again for the repositories of the day's olfactory clues. The alternating dust and polish from stair banisters, the sweat from shaken hands, the unrinsed scum of hand soap, the accumulations from coins and bills, the savory remains of the dinner. Nothing. She dipped her fingers into the dregs of the port and slid them along the end of her nose. Nothing. What constitutes smell or smelling? She'd never thought about it, except she supposed, when something was truly fetid.

Everyone has a smell, whether it's the fragrance of soap and shampoo or the stink of sweat and scurf. She gathered her hair in her hands and buried her nose and mouth in the fine waves. Wisps tickled her nostrils, but there was nothing to smell. She wiped the port off of her nose with her sleeve.

And he said she made no sounds. Everyone comes attached to noises like——. Like what? She thought hard. Like breathing. Like coughing, sneezing, gurgling, panting. Cracking bones, joints. Tapping fingers, toes. Clicking tongues, sucking teeth, scratching scalps. Laughing, chuckling, giggling; the giggling that never came. Humming. Sighing. Crying.

She remembered once walking into the kitchen and finding her mother crying. Weeping. She had never seen her mother cry before. Not even when her grandmother died. Not even when her father. She was sitting on a stool, crying her eyes out, sobbing and snuffling, a book open on her lap. "What is it, Mum? What are you reading?" She'd never seen her mother read before either. Her mother handed her the

book. She had been crying over the dedication, "With love to Charles." Helen turned it over and looked at the cover. It was a cookbook. Her father's name had been Charles. What could she say or do to comfort her mother?

Their home had been sad, subdivided by thin partitions of grief; their sorrows were their own.

The days flew by; the police hounded her at regular intervals; and Hauptmann Bauer, in a weak moment, admitted his thrill at being able to work on such a case, murder, especially an extravagant one—so rare in Austria. Ganz, it appeared, had been stabbed with his own letter opener, an ornate affair that had once belonged to the celebrated eighteenth-century physician, Gerhard van Swieten. The weapon had been discovered under a pile of books, clearly having been discarded before the frenzied searching had begun. When Bauer expressed his reluctance to even hint about the body being dipped in wax, Helen asked him if he preferred that she learn of it from the more scandalous newspaper reports. He conceded and described the terrible blistering effect that molten wax had on human skin. He recounted the efforts that the murderer must have made to pose the body before bringing it back into the museum so that it fit in the exhibit case. Doing so afterwards would have destroyed the wax surface, which was perfectly finished. The police assumed that at least three people were involved, that one of them must have been a museum employee, and that robbery had been one of the motives. As far as Helen was concerned these details were of superficial interest; the murder had nothing to do with her.

The *Icones Anatomicæ* was the last book to be printed with the Vesalius woodblocks. How could she have forgotten? Anselm had to have a copy. Squirreled away somewhere. She'd read that it had only cost $100 when it was first printed in 1934. Not a princely sum. What would it look like? Large, no doubt. Up the stairs, along the packed shelves. Spine out?

Standing up? Lying flat? Back down the stairs. More shelves. Why not ask Anselm himself? Why not, except that the invitation to discuss Vesalius had still not been extended. She looked through the large flat files. It would help to know how large. A box in the bottom drawer under framed prints. A huge book. There it was, the *Icones Anatomicæ*, encased in a sturdy cardboard box, the original delivery slip still attached. She carefully rested it on the top of the filing cabinet and stroked the white leather binding. So fine it could be pigskin. She turned back the cover and skimmed a loose insert entitled "To the Reader." Too long to take it all in; set it aside for photocopying later. This was exciting. Was her woodcut in here? Would she recognize it? She turned to two title pages facing each other, nearly identical except for the rendering skill. A couple of pieces of old paper stuffed in between them. She removed the loose pages and turned them over—they were poorly printed copies of one of the title pages. She replaced them, tucking them into the gutter of the book.

This book had become so important for her, yet she fought herself from speeding through. She forced herself to examine it page by page: the heavy rag paper for the woodblock prints, deckle-edged, water-marked with Vesalius's crest; the thinner, calendered paper for the Latin texts. The watermark looked familiar. She craned her head to better illuminate the paper. Three animals running within a crest. She'd seen this watermark before. She'd have to think.

Almost each turn of the page revealed more loose paper, the images on each corresponding to the woodcuts shown on those pages. Some were very sloppily printed, some were exquisite; some were printed on the backs of paper already printed with unrelated texts, some were on crinkled paper that appeared to have been rescued from trash heaps; they were all like proofs pulled before the actual printing began.

Page by page, she slowly traversed the more than two hundred renderings of the body, fresh and black as if printed days rather than decades ago, from individual organs and bones to full figures of bones, muscles, nerves, veins.

Aha! This one was hers. It was an illustration of the muscles, one of

the muscle men; she flipped the page. No, it was this one. She finally narrowed it down to three; she was positive it was one of these, one of the muscle illustrations, one of the muscle men posed against the classic Italian countryside. She closed the book and hoisted it, assessing its weight. Not a chance to take this out to get photocopied. She measured the dimensions: fifty-four centimeters high by thirty-seven and a half wide.

The colophon stated that 615 copies had been printed, and that it took three years to do.

A cataloguing card had been left between the pages. She read that the blocks had been found in "a Munich attic."

This was a new twist. First it was a "dusty corner of the library," now "a Munich attic." Not only was it impossible to find consensus on Vesalius's history; even recent events were contradictory. No wonder she was confused.

Now she had to find the very first edition, the one of 1543; even more importantly, she had to get her own woodcut back, to compare all of the versions. Time was running out and the answer was so close. She carefully replaced the book, deliberately concealing her discovery of it, then headed out to try to catch Hauptmann Bauer.

Two hours later, still without her precious woodcut and convinced that it would never be returned, she was back in Anselm's library. Bauer had had nothing new to tell her about Peter Ganz or her husband. The secretary, Gerstner, had been briefly under suspicion, but was now exonerated; the night-shift guard who had resigned was in hospital recovering from a botched suicide attempt; von Ehrlach had been cooperative, but since the man was close to being clinically deranged, his cooperation had amounted to little; efforts to track down Frau Kehl, Rosa Kovslovsky, and Anna with the dog had been fruitless. Even the elevator man, Wilhelm Stukmeyer, could add nothing: he had disappeared. Aside from this disturbing detail, Bauer had hit a slump.

The day that Helen left Vienna, she made one last visit to the Sauer

Coffee House. Although she had been back almost every day since meeting Herr Thüring, she had not seen him again. This time, along with her coffee and cake, the waiter handed her an envelope addressed to Frau Martin, c/o The Sauer Coffee House. She pulled a single sheet of paper out of the envelope, a copy of Thüring's obituary of Peter Ganz. The murder had clearly caught the obituarist's imagination. Reading painfully like a plot from a sequel to the horror film, *The House of Wax*, the obituary portrayed Ganz as a man mesmerized by abomination and terror, a purveyor of phobia and panic, and his end a warranted trial and deserving punishment. He quoted the waiter's suspicions that the museum was filled with bodies obtained in the very same criminal fashion, turning this one man's nescience into the learned opinion of the general populace. It was true that Helen had only met Ganz once, but she was personally hurt by Thüring's lurid testimony to a man that he had *never* met.

She was back in the study at Herr Anselm's house that afternoon, reexamining the *Icones Anatomicæ*, noting that it was copy number 406 of the original 615. The more she learned about the history of Vesalius, the more intrigued she became. The two title pages, for example. The one on the left had been created for the very first edition, the one on the right, for the second. They were nearly identical, but not quite, the newer one being cleaned up, in her opinion, rather stiffly. The scene in both was a dissection theater, jammed with onlookers. They portrayed Vesalius in the center of the theater demonstrating a dissection of a human cadaver, along with men clothed in both current garb and classical robes, a monkey, a dog, an articulated skeleton, a couple of charming putti, Vesalius's crest; a circus of activity, no less, not all of which was concentrated on Vesalius's learned lecture.

The second one replaced Vesalius's face with a copy from an existing portrait, reduced the amount of viscera evident in the cadaver, clothed a gent clinging from one of the pillars (he had been naked previously), removed the printer's device, and handed a scythe to the skeleton. Vesalius's crest, three weasels running on a field of black, remained. She read in another book that the weasels were a play on his name—Andreas

Vesalius, that is, Andreas of Wessels, his common name. This was the crest that was repeated as a watermark throughout the book. Now she remembered where she had seen the watermark before. A portion of it was on Rosa's card that came with the box. Why on earth were Rosa's cards watermarked with Vesalius's crest?

In yet another book, she discovered that an old bearded man looking down from the balcony was supposed to be Johannes Oporinus, the printer. A tribute to a craftsman not often expressed in current times.

If the printer attended this hectic mêlée, how about the artist? An earnest young man sat in the third row of seats, book and pencil in hand. Several scholars had assumed this was Kalkar. Trouble was, he was supposed to be in his forties at the time of the publication; this man looked too young. The cadaver was that of a law-breaking woman who had apparently lied about being pregnant to save her neck from the hangman's noose. Vesalius' dissection had confirmed the lie. The perspective of the corpse seemed to be the weakest element of the entire scene.

The inserted paper she had noticed when looking at the book the first time turned out to be a proof of the first title page. She set it aside, then proceeded to remove all of the loose pages. There were nearly a hundred of them.

She flipped through the book again, looking to see if there was any other information and then remembered the notice to the reader that she'd removed earlier. It was lying on top of the desk where she'd left it. Whoops, not a skillful snoop, after all.

As she began to read, the telephone rang. This was a surprise—as far as she knew the phone wasn't connected. It was such a surprise that she had no idea if she should pick it up or let it ring. She was alone in the house; Anselm had gone out for a couple of hours. She scanned the room for the telephone, never having noticed one there before. The ring had a rich, throaty purr to it, but as with most ringing phones the longer she took to find it the more shrill and persistent it became. Finally locating it on the file drawer under a pile of paper, she picked up the receiver, but the ringing continued from elsewhere in the room.

"Hello," said a woman's voice on the other end of the line.

"Excuse me," said Helen, "could you hold the line, another telephone is ringing." She set the receiver down on the top of the drawers and looked around again. She opened drawers in the desk, looked under the chairs, and finally opened the door to the stairs that led to the upper balcony. She found a phone mounted just inside. She picked it up and said, "Hello, one moment please," hearing the ringing continuing from another part of the room. Without waiting for a reply she let the receiver of this phone hang down, taking care not to let it sway and bang against the wall. She was beside herself; where would this next phone be? Why were all of these phones ringing at the same time? She ran to the other side of the room and began removing books from the shelves. She found it behind a large medical encyclopedia that had been displayed face out. She picked up the receiver and said, "Hello?" once more. The ringing finally stopped.

A woman's voice was on the other end, "Hello."

"Herr Anselm is out just at this moment," said Helen. "Could I take a message?" As she spoke she looked for a piece of paper and a pencil.

"Hello?" said the woman's voice.

"My German isn't very good," yelled Helen, "do you speak English?"

"Hello?" repeated the voice. "Hello? Hello?"

Helen stared down the receiver then hung up. She ran over to the first phone on the file drawer. "Hello, sorry to keep you waiting," she said. There was only a dial tone on the other end of the line. She hung that phone up and went over to the one at the foot of the stairs. "Hello," she said but again heard only the dial tone in reply.

The phone calls, if that's what they were, were so unsettling that Helen, unable to concentrate, renounced her reading and restlessly paced the room. The walls were too close—they kept pushing her back to the pile of proofs sitting on the table. She shuffled through them, unable to grasp why they had been stuck in the book, why Anselm had them at all. She stowed them in her bag and replaced the *Icones* in the drawer.

When Anselm came home an hour later Helen met him at the door,

helped him off with his coat, told him about the strange calls, and asked him why he had three telephones in the study. As he removed his scarf and carefully draped it over the coat stand hook, he chewed on the inside of his mouth, absorbed in the echo of the silent phones. "Those telephones were disconnected years ago," he said, "after my parents died, in fact. My father used to work from that study," he added, "that's why there were three phones. I've never had a need for telephones. I don't even have an account."

They walked through the house towards the study, and when they arrived at the door the phones started ringing again. Anselm, without changing pace, entered the room and went straight towards the file cabinet. He picked up the receiver—the ringing in the room stopped—and spoke into it. There was a moment of silence while he listened and then he spoke again, so rapidly that Helen had a hard time keeping up with his words. She did hear her name repeated several times and understood the conversation was largely about her. Anselm hung up.

"Well," he said. "Well."

Helen waited for him to go on.

"That was Frau Kehl, my mother's old companion. Funny, I thought she'd be dead by now. She must be 90 years old. They used to call her my governess, although we knew better. She was asking after you. Tell me, Helen, how is it that you know Frau Kehl?"

Frau Kehl. Mrs Kehl. The woman on the train. This was too bizarre for words. How could there be a connection between Frau Kehl and Friedrich Anselm? It was intolerable enough that she was caught up in the web between Rosa, Anselm, even von Ehrlach, but if Frau Kehl was part of this too it meant that the web was snaring her like a trap. She was suffocating under the tangled slender filaments of coincidence. Her answer to Anselm's question was rushed and incoherent. "I met her on the train to Vienna, if it's the same woman. It must be, I don't know her at all. But if it was the same woman, I don't know how she would know to reach me here. She gave me the ring that you felt in the box."

"Ah, the ring," said Anselm. "Could you describe the ring to me, please?"

Helen told him about the gems, the gold, the petite size, and the name engraved inside of it, that coincidentally said, "To Helen."

Anselm nodded, "That's her first name, too. Helen. Was she traveling by herself when you met her?"

"No," said Helen, "she was with a young man. He was very well dressed and wore mascara!" Nerves jangling, she burst out laughing at the memory. Laughter had finally escaped, but as evidence only of tension, not happiness.

"You don't say," said Anselm, not sharing her amusement. "And just where did she get on the train?"

"I don't know," replied Helen, "the train had been moving for about a half hour before she came into my compartment. She pointed out that she was making a 5-hour trip to Vienna so I guess she must have gotten on at, uh, Salzburg."

"Munich," Anselm corrected. "She would have gotten on in Munich. I made that trip with her very often—Munich to Vienna and back again. It was where she was born, where she called home until she moved in with us. But she was never able to entirely cut her ties there. She always traveled with incredible amounts of luggage and was always rude to everyone."

"Did she have a phobia about traveling with her back to the engine?"

"Indeed. The number of times we had to move compartments in order to avoid this was," he paused, "inconvenient."

"Was she missing a finger?"

"Yes, she was. The third finger of the right hand."

"How would she know that I was here, I wonder," mused Helen.

"Probably because that was me on the train with her." Helen stared at him in disbelief. "Not me personally, you understand. But a substitute. Ever since, well, ever since many years, she has taken to finding young men who look like I did when I was young. She travels with them—they are her traveling companions—until they lose their," he hesitated, "youthful corruption." He was very still, his immobility along with his absurd response clear evidence that Frau Kehl's telephone call had

shaken him up. "Well, Helen," he continued, "I'm sorry I won't be able to say good-bye to you later when you go; I must leave now. Please take these as a parting gift." He handed her his glasses that he always carried with him but that she had never seen removed from his pocket. "And this." He walked to one of the shelves, pulled out a pocket-sized treatise on Vesalius published in Latin, and handed it to her. She watched him leave the room, walk down the hall and turn to go up the stairs that led to his private quarters. "Good-bye, and thank you," she called out to him, tears in her eyes.

Alone again, Helen went to the bookcase that housed Anselm's family photo albums. She put the one that he had shown her onto the desk, along with the other two. All three were quite large and meticulously covered in luxurious dark green leather and were bound at the edge with gold covered rope. There was a cartouche on the front of each binder, and two of them were ornamented with Anselm, the family name; Wien; and a set of dates: the first one read 1900–1925, the second one 1926–1944. The cartouche on the third one, the one containing Anselm's own photographs, lacked the dates.

Helen sat down and opened the earliest one first, feeling somewhat guilty for this invasion of Anselm's privacy. The composition of each page had been done lovingly and carefully—the photographs were placed to complement each other and the script below each, in white ink, was unobtrusive. Helen read them slowly, finding the handwritten German words more difficult to translate than typescript. A family history of grandmothers, cousins, babies, friends, birthdays, weddings, births, even deaths—Anselm's grandfather's corpse resting in his lavish coffin had been dutifully photographed from several angles and labeled—was chronicled in the binder. The second held more of the same, although the handwriting had changed to printing and, though tidy, was less refined. The tenor of the photographs changed as well. The earlier photographs had been stiffly posed; these, although still formal, had a more relaxed quality about them. Frau

Kehl, labeled in the book as Fräulein Kehl, first appeared in the pictures early in 1927, at the age, Helen calculated, of nineteen. The year Anselm was born. She was, if possible, even thinner than when Helen had seen her on the train. Her hair was done up in a similar style, but in these pictures she looked like a Gibson girl, probably, Helen supposed, out-of-date for the times. In the pictures following her arrival she wore what appeared to be the same dress in every picture: dark cotton or silk material, mid-calf length, wide white cloth sash resting low on the formless hips, short sleeves. The change of season from summer to fall brought the addition of a dark, rimmed hat and a sombre overcoat the same length as the dress. Almost whenever she appeared in a photograph she was accompanied by one or more family members. As the years went by Helen could see Fräulein Kehl turning into the woman that she met on the train, her clothing and demeanor becoming gradually more and more extravagant. Towards the end of the album, around 1942, Helen found several photographs of Fräulein Kehl and Anselm together. The first one was taken from far enough back to show that they were prepared to go on a trip. They stood dignified and severe, about a foot apart, and Anselm was grinning contrarily, gesturing to the luggage piled up behind them into a pyramidal heap. The second one showed the two of them closer up—Anselm was wearing mascara and was unmistakably the twin of the young man who had been Frau Kehl's companion in the train. The cascading hair, the clothing, even the faintly smirking look were not only similar; as far as Helen could remember, they were identical.

She flipped to the last page, past years and years of the distant memories that these photos held. On the very last page was the photograph of Rosa, clumsily overexposed yet carefully vignetted. She had no trouble recognizing her although the portrait showed little resemblance to the present-day woman. No, she only had to look in a mirror to see what had been, what still was, what would be. It was Rosa, and it was her.

She sat back in her chair, closed the album, leaving her finger to mark her place, and cradled it in her lap telling herself that it was time for her to start analyzing the extraordinary events that were happening

to her, to put some order into the fragments of nonsense that constantly whirled about her. But in truth, she was afraid; not of answers, but of confrontation with answers, with the demands they would make on her. She reopened the book and again pondered the photograph, running her fingernail along the edge of the print, letting it catch in the glossy, stiff paper's small tears and nicks. A slight crease bisected the lower third: she flipped the lower edge of the print out of its black corners and wiggled the bottom up and down. With this movement she inadvertently slipped the rest of the print free and found herself holding it in her hand. She pocketed it. What else could she do? It was her; it was hers.

WAG

MÚZEUM

Belépőjegy №̸ 001263

2534

№̸ 199862

nem használható fel utazás

Budapest
Wien

...netjegyét gyűjtemény

13¹⁵ 16³⁰ 23³⁰
17⁴⁷ 21⁰¹ 6¹²

VOITU

Z 1320 A Ordnungsnummernzettel (blanko) - A 5 h - DVS - Druckerei Wien - Disc

BUDAPEST

Helen left for Budapest with Rosa's photo burning a hole in her instincts. She would at least go this far, to Budapest, just three and a half hours from Vienna, after all. The trip was uneventful, the train nearly empty, and although the heating worked only sporadically, she was quite comfortable and was left alone except for a brief interlude when the door opened, admitting a bearded, dark-haired young man in rolled-up shirt sleeves and jeans. She'd seen him a short while earlier pacing up and down the corridor in staccato reconnaissance. He sat down on the seat opposite, smiled at her, and said "Hi" in North American English.

"Hello," she replied.

"Where're you going to?" he asked, looking around the compartment, assessing her luggage.

"Budapest," she answered. "Where are you going?"

"Thessaloniki, and then Athens. Why're you going to Budapest?"

"I'm curious to see it, I guess. Why not?"

"Yeah, why not?" he shrugged, sat back and dangled his arms between flopped apart legs. His knees moved towards each other and apart in a kind of restless rhythm.

"What's your name?" he asked suddenly. "Mine's Jeff."

"Helen," she replied.

"Pleased to meet you, Helen." He hopped up and shook her hand.

He sat back down and started tapping the toes of his right foot. Shivering slightly, he rolled his sleeves down and buttoned up the cuffs, covering up tufts of black hair that should have kept him warm.

"Where's your luggage?" she asked him, not really caring.

"It's in my compartment. Up in first class," he winked. "You're from Canada, aren't you?"

"Yes, I am. Where are you from?"

"Nebraska. Seventh Heavenville. At least compared with this dump."

"You mean the train?"

"No, Europe. The place is a dump. Pollution, crap, too many people. You don't think it's a dump?"

"No, actually, I like it."

"You wanna know how come I can tell you're from Canada?"

"Ah, sure," she said, not at all sure she wanted to know.

"First of all, you got hair like wheat." He sat forward and moved closer—inspection time. "Second, you you got eyes like. . . ." He searched her face, lost, at a loss. "Second," he repeated, "you've got," he settled, "nice clean skin, like the sky."

Oh God. A come-on artist, but what had disconcerted him? Helen resisted the magnetism between her hands and her skin. Skin like the sky? It's eyes like the sky. Blue eyes. Sky-blue eyes. But her eyes were brown, forgettable brown, the brown of the earth. What color were her eyes to this guy? She resisted the pull between her hands and her eyes. Goodness knew that her fingers were teaching her so much lately, but they couldn't show her what he saw of her eyes, not even her own eyes.

Jeff had been only momentarily perplexed, it seemed. He was rambling on. "Thirdly," he paused for emphasis, "you're traveling second-class. Me, I got one of those Ur-Rail passes. Lets me go first class. I betchu buy your ticket from station to station. Never know where you're going next. Right? Right." He nodded to himself and then shuddered. "Man, it's cold in here!"

"Mmm, sure is, Jeff." Maybe this was his cue to depart. It was.

"Well, see ya around. I'm going back to where they've got some

heat." He looked at her one more time and left, shaking his head.

"Bye, Jeff," she called out after him and then catapulted herself over to the mirror, but her eyes couldn't teach her any better than her fingers: every way she looked—down, up, sideways—showed a different color, a different shade, a different intensity, a thousand eyes, irises iridescent, kaleidoscopic, eyes to drown in, eyes to go blind in, eyes to go mad in.

Helen had no plans for Budapest beyond her appointment at the Semmelweis—a day, two days, who knew. She hoped for confirmation that Martin had made it this far; then she would plan her next step, whether to return to Vienna or go on to Padua.

She ran the gauntlet of pension hawkers lining the platform at the Budapest train station, regretting the spoken and unspoken *no*s to each and every one of them. Her mother would have told her that they deserved better than her abrupt dismissals, that she should have explained why she preferred to deal with the hotel booking agency, why it was better for all concerned to put a third person in the middle of negotiations for a room, any room, no matter how simple.

Lodgings secured, as she stood outside the booking office, tucking away her money, receipt, map, her general detritus, still they approached, earnest young women, sly old men, a persistent drunk, older kindly women who might have taken her hands in theirs and reassured her.

She took a taxi to the Gellért, the hotel that Martin had gone to, before heading to her pension, noticing the twitching smirk that spread across the driver's face when she announced the name of the hotel.

So much for her idea that Martin stayed at second-rung hotels: this place was stunning. But within minutes she discovered that Martin had never actually spent a night there but had only used it as a mailing address (a journalist's privilege). So with nothing more than a scattering of Martin's telephone message slips, she marched out of the hotel, past her taxi driver who was waiting at the entrance for a fare, and off to find the pension.

Budapest was colder, if possible, than Vienna. Her wardrobe was suited for the vagaries of normal city winter but Budapest surpassed that. There was also the language problem to confront: the idea of learning even a few words of Hungarian to get by for just a night or two seemed overwhelming, especially considering the difficulties she had been having in German, a language that she had taken the pains to study. She hoped that her German would stand her in good stead. Normally she would have prepared herself, would have bought a phrase book, practiced useful words, simple expressions; instead, all she had was a pathetic photocopy of fatuous sentences rendered even more useless by the lack of a pronunciation guide.

Although the pension she was booked into was adequate, operating out of the owner's apartment, the welcome was inauspicious. A dim foyer led to a gloomier stairwell and a positively dark lobby, lit only by the flickering light of a television set sitting on a makeshift receptionist's counter.

There sat a wizened little man with no teeth, wearing a limp, green cardigan and baggy black and white houndstooth trousers held up by frayed suspenders, reading a newspaper by the light of the set. A radio played music in the background; Helen thought she could hear "I'll never be your bodyguard," sung over and over. The horizontal hold of the television set had gone, so bands of grey and black rolled up and down the screen. Helen ignored the TV after glancing at it briefly before filling out the register. The old geezer tossed her passport and booking slip into a drawer, checked his watch and then pressed one of the buttons on the back of the set. He banged the side panel a couple of times and changed channels. The screen sputtered, and the horizontal bands slowed down and steadied out to reveal a butterfly box, only the box wasn't full of butterflies; it was filled with spiders of varying sizes and shapes. The stationary camera position was unwavering, recording with painful detail this single view. Helen stood transfixed, waiting for a change: a switch to a second camera, the voice of a narrator, opening credits, anything.

She couldn't think of a single thing to say.

The man filled the pocket of silence with something in Hungarian, adding a proud smile. She returned the smile, an automaton's gesture. The trance was broken; she rocked on her heels, impatient. As the seconds ticked by even the clerk started to fidget. Then he began clucking rapidly and pointing to one of the spiders in the upper right hand corner, a large one with a diamond-shaped pattern on his back. Helen squinted. Then she saw it; it moved one of its legs. Triumph. She'd seen the film's crowning moment. Now she could leave in good grace, escaping down the hallway towards the rooms.

The hour spent settling in was consumed in front of the mirror, examining each eye, each iris, each retina in the same motionless detail of the camera that had recorded the spiders, searching for fragments of the brown they had once been. Giving up, she retrieved her passport, was given keys to doors; and for the rest of the evening pursued a warmer layer of clothing, a Hungarian dictionary, and a café or restaurant where she could recuperate from the cold.

By the time she returned, the old man had been replaced by a young, dark-haired boy, probably about fifteen years of age. He had school books spread out on the counter, but the television was blaring and he was watching a wrestling match. As before, there were no other lights on in the lobby except from the television set and even the hallway heading towards the bedrooms was in darkness. Helen asked where the shower was. Without moving his eyes from the screen and with mouth slightly open, he got up and pointed to the end of the darkened hallway.

"Gute Nacht," she said to him in German.

"G' night," he replied in English, then swallowed and jabbed a light switch on the wall into action. The hallway light snapped on and Helen walked towards her room, noting that the boy was now resting his entire upper body on the counter, with his eyes about twelve inches away from the screen, his mouth hanging open.

She walked around her room for a few minutes before taking off her coat, feeling more than the hearing the televised fight reverberating through the walls, picking up a chipped china figurine of a boy and his

Scottie dog that had been placed on the bedside table; lifting up one of the towels on the rack beside the sink and rubbing its scratchiness against her cheek. She ran her finger over the surface of a reproduction oil painting, then flicked the bedside table lamp on and off a couple of times in the futile hope of producing a stronger light. After brushing the memory of dinner out of her mouth, she settled down to start a new letter to Martin.

This time she avoided the touchy issue of the unread letters, finished writing several pages, popped them into an envelope, addressed it, and walked out into the dark corridor to see if the clerk could post it for her. She fumbled along, guided by the blueblack glow at the end of the hallway.

The television set was still blasting, but the program had changed. This was a talk show with three women wearing similar-looking imitation Chanel suits and two men with thick hair firmly cemented into place. They were earnestly debating, sitting in a circle on straight-back, armless plastic chairs. The two cameras alternated between orbiting dizzily around the group and panning in closely to frame each speaker's mouth. The boy had shifted back away from the television set and was now sprawled in his chair behind the counter, his feet up, obscuring the screen from his vision, reading one of his books. Helen coughed to get his attention; he looked up at her without moving his book or lowering his feet. She showed him the letter and asked in German if he could post it for her.

"Sure thing," he said in slangy English, taking the letter and dropping it into a drawer. Just as she was about to ask him where he had learned his English he turned back to his book without another word, so Helen returned to her room.

The poor light reminded her of Anselm's glasses, tempting her to try them on. She walked over to the mirror above the sink and stuck them on, ready to admire the effect. The lens of the left eye was missing, the right one lightly tinted and as thick as a magnifying glass. The room careered around giddily; abandoning her as wildly as that first night in Vienna, when she'd been convinced that she had someone

else's eyes. She grabbed the edge of the sink with one hand and with the other snatched the glasses off her face. She scrunched her eyelids tight a couple of times and finally managed to bring the room into focus. "Boy, if Anselm wore these, no wonder he went blind," she exclaimed out loud.

She discovered amongst her books the insert from the *Icones Anatomicæ* that she had intended to have photocopied. She'd walked out with it! She'd mail it back first thing with an apology. Well, maybe. It did seem like small fish compared to the proofs and the photograph she'd also swiped. By the inadequate bedside lamp, she settled down to finally read it.

The text filled in numerous gaps, particularly the identity of the 41, not 50, missing woodblocks: the illuminated letters, the portrait of Vesalius, the eighth muscle man, and various diagrams. Their fate was still unknown. The muscle man had been lost long ago; the illuminated letters, probably cut in Oporinus's workshop, might have been lost by his heirs; no one knew where the portrait could have gone.

Also recounted was the borrowing of the woodblock of the second edition title page from the University of Louvain, the university where Vesalius had studied before moving to Paris. Louvain had acquired it from a private collector.

The insert mentioned Oporinus, but skipped past the Frobens and the Königs to the man she had previously read about named Felix Plater, who wrote that the blocks had been put up for sale in Basel in 1583. Here, as in her previous sources, the trail was lost, and picked up with Andreas Maschenbauer, in Augsburg. There apparently had been a connection between Vesalius and the city of Augsburg: he, after being appointed imperial physician to the court of Charles V, visited there in 1547 and 1550.

Dr von Woltter of Ingolstadt reappeared in this account as did the doctor H.P. Leveling—Heinrich Palmaz Leveling, as it turned out—a professor at the University of Ingolstadt. The final bit of new information was the name of the librarian at the University of Munich who rediscovered the blocks in 1893, Dr Hans Schnorr von Carolsfeld. The

insert ended with numerous references supporting the idea that Kalkar was indeed the artist, and concluded that there could be no doubt.

These names still meant nothing to Helen. The picture was filling out, but so slowly. Was there no one source that recounted the entire story?

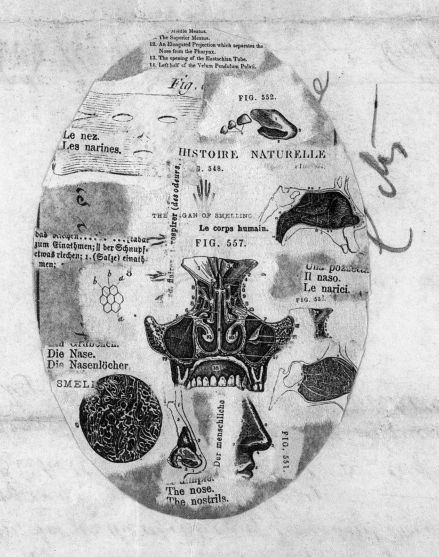

SMELL

ROSA'S HAIR

Helen woke up with an extraordinary odor clogging her nostrils. Its foulness trapped the ever-darkening shadows of her despair tight within her skull: these blackened shrouds, these gloomy hangers-on hammered at the inner walls of her temples, her palate, her sinuses. Panicked, she gasped, drawing the putrid air deep down into her lungs. The poison circulated almost immediately, coursing through her arteries and veins like infectious clots, immobilizing her muscles and her will. She rolled limply over onto her back, grabbed the pillow and smothered her nose and mouth with its rough cotton case and clumps of aging feathers. The night before it had presumably smelt of laundry soap— Helen didn't know, she hadn't noticed—but now it stank of a rotting fermentation. A chemical fermentation. A chemical fermentation and decay. Her nose could pick the smells out the same way her eyes could read a page from a chemistry experiment but lacked the language to decipher, to declare the result harmless or not. Acidic—searing, caustic, wrenching away the fragile membranes from the insides of her nostrils; sulfurous—vitriolic, infernal, clouding the delicate cilia with its bully's punch; bacterial—pestilent, decomposing. She flung the wretched pillow off of her face and sat up clawing at the air, trying to free her breath from its cloying shackles. She slid off the bed and flung the door open. A cool draft rushed in from the hallway, pervaded by the same ghastly stink; Helen realized that she was growing accustomed to it.

This distressed her even more. The corridor was dark except for the sputtering glow from the silent but still-illuminated television set. The hall was silent too, or nearly so, disturbed only by the hint of a restless body turning over in its bed behind one of the closed doors. How could such foulness be so quiet? Where were its bellows of pain? Alerted by the muffled patter of approaching stockinged feet, Helen, now easily breathing in the corrupted air, watched Rosa, waving a lace-edged handkerchief, materialize.

"Hello, hello," she whispered with a wink, of which Helen wanted no part. "I'm so glad to see you up. I wouldn't have liked to have awakened you."

"Why are you here, Rosa?" asked Helen.

"To see you, of course," answered Rosa. "May I come in?"

"But, how did you get in?"

"I'm a guest," she said, tinkling her keys. "Now, may I come in?"

Without another word Helen stepped back to let Rosa pass. She turned the light on, and they both sat down on the edge of the bed.

"This isn't so bad, is it? Of course, it's not the Gellért. But I suppose you realize that they make blue movies at the edge of their delightful swimming pool. A crime, isn't it? As if they couldn't find a thousand places for their smut without polluting that gem. Makes me shudder to think of all of those innocent people swimming in *that* water."

Helen nodded but was having trouble concentrating on anything else but the origin of the nauseating stench.

"That's what death smells like, they say." Rosa's observation was matter-of-fact.

"What?" asked Helen, distress raising her voice several pitches above normal.

"Death—it smells like bleach, I'm told." Noticing the distraught look on Helen's face, she quickly added, "it's all to do with experience, not with actuality, if you see the difference."

"No, I'm afraid I don't." Bleach? Is that what she calls it? *Bleach?*

"It doesn't matter. Oh, I see. You think I've just told you you're dying. No, like I said, it's the experience. You see, when you've smelt

death you've smelt everything. You aren't dying. Feel better?"

"No, I don't. I want you and this revolting stink to go away. I want to go back to sleep. I want peace, privacy. Why are you always around in the middle of the night?"

"Because I am a master of insomnia, that's why. And because nighttime, like foreign languages, gives you a whole new vocabulary, one that you'd be well-advised to start studying, especially since you're in foreign parts. I find that it is night for an inordinate amount of the time in foreign parts.

"So," she continued, "it's been a number of days, weeks, I might say, since we last saw each other. Did Anselm show you the *secret* of the box? Doesn't that sound delicious: *see-cret?*" She rolled the word about, stretching and tasting it. "He could unlock the secret to a bag of flour. That man," she sighed.

"He told me about you, Rosa," said Helen, still not sure what the secret was and not wanting to let on.

"Yes, I know. He takes great pride in his so-called 'powerful photography.' He thinks that he ruined my life by taking my photograph, but he didn't; my life began with that incident, and so did his for that matter."

"He told me that he gave up photography and started collecting anatomical specimens at that point, if that's what you mean."

"That's only a small part of it, my dear. He started collecting minds when he discovered a perfect method of learning, of stepping into other's shoes, so to speak. He wasn't particularly bright when he was young, you know. Rather loose—some might say dissolute—and far too idiosyncratic to be a really good scholar. However, when he began making connections between his photography and the ensuing disasters, something snapped. Did he tell you that he took my picture out of revenge? No? Well, he did. He had already given up photography, it frightened him so. And then one day I did a terrible thing to him. He didn't rebuke me or yell at me, he just asked me, rather sweetly, if I'd like my picture taken. Would you like to know what I did?"

"I'm not sure I should." Helen feared both the subject of the photograph and the teller of the story.

"Don't be silly. I'll tell you whether or not you recognize that you are dying to know. I cut off that witch's finger!" She roared with laughter, losing her balance and falling back on the bed.

"Which witch, I mean what witch?"

"That buzzard Kehl. You met her. Don't deny it." She raised herself up onto her elbows with some difficulty. "Help me up," she floundered, her stout legs kicking the air. Helen got up and, grabbing her by the shoulders, pulled her immense weight forward.

"Easy dear, easy. No need to be so rough." Rosa adjusted her wig and dusted off her sleeves.

"You mentioned Frau Kehl?"

"Frau Kehl, my ass. She's as Frau as I am, and I can guarantee you I'm not. She's a shriveled up old Fräulein, my young lady, and that's why I cut her finger off."

"Because she claimed to be married you did that to her?"

"Bah, so what claiming to be married. I've claimed to be the Pope, and I don't expect anyone to bother over that. No, it was who she claimed to be married to. Friedrich Anselm."

"Oh, so you were jealous?"

"Jealous! Me! I was the most beautiful girl in Vienna. I could have had my pick of any man in the city. They were panting outside my door," she smiled distantly at the memory.

"Well then, why?"

"To protect the dear boy, why else?" She sighed again, sending the resulting upheaval in her mouth and face rippling down through her large torso, aftershocks. "He was hopeless in those days. But he was beautiful too." She rested her chin on her knuckles and stared off into the distance, caught in uncharacteristic sentimental reverie. "You're astonished of course to think that I could love someone, be loved by someone. No, don't object," Helen hadn't protested; Rosa was reciting a well-rehearsed soliloquy—pauses, imperatives all pre-planned. "I can see by the expression on your face," she continued. "Yes, such style, such daring. One had to travel far to find young men brave enough to wear cosmetics then. It rather went out of fashion with the war, you see."

"Protect him from what?"

"From her pretending to be married to him."

"But she didn't call herself Frau Anselm, did she?"

"That was the next step. First the ring, then the change of status, next the change of name. He was very frail after his father died and prey to every money hungry vulture in the city. She was Queen Vulture. We called her *Der Bussardprinzessin von Wien*. The Buzzard Princess of Vienna." Rosa cackled some more. She continued, "So one day I was visiting him at his parent's house, that is to say, the house that he inherited from them, the one he's still in, and there was company. We were sitting in the pretty courtyard—there was my sister Anna, and Louis, Friedrich, myself—and she was showing off her ring as usual. The gardener had left a pair of pruning sheers on the paving stones near to where I was sitting. I picked them up and started to play with them. Buzzard Princess couldn't show it off well enough just sitting, so she got up and went from person to person and stuck it in their faces. When she got to me—we understood each other very well—she thrust it my face too, and I snipped her finger off. There were screams, *ja,* but not from Buzzard Princess. She was cold and still and stared in my eyes while she let the blood spurt onto my clothing and while the others were jumping up and down tearing their hair out." Rosa had stopped chuckling and was recounting this part of the story seriously. "The finger had dropped into my lap, so I grabbed it, pulled the ring off of it and told her to go claim her false marriage with the devil." She spat on the floor.

"A doctor came and took Kehl away. The police came and asked me many questions." Rosa laughed again, "I buried the finger in the courtyard and left it underground for twenty years. Getting the earth ready to welcome the rest of the body one might say. My sister's dog dug the bones up. The two top ones were lost—eaten, rotted, I don't know. The one in your box was the only one I could find. Maybe the dog ate the others." She shuddered delightedly. "If I am not mistaken you yourself have reunited ring with finger.

"But to continue with Friedrich. He put a fresh plate of film into the camera, set the camera onto the tripod, arranged me in the same

courtyard, and then he smiled, asked me to smile, and he took my picture. He had never discussed his phobia about photography with anyone. I discovered afterward that he thought he could be arrested and taken away for exercising such a terrible force against people, so naturally I knew nothing of what was going through his mind when he took the picture. I was visiting a few days later, relieved that he really seemed not to have cared about what I had done, and that everything seemed to be normal. He showed me the developed print, and I asked if I could have a copy to give to my parents—those things were awfully important in those days when having a photograph taken was a real event. He gave me that print, and I took it away with the intention of mailing it to my parents in Berlin; you'll remember, that's where I'm from. I came to Vienna to study medicine.

"Some time passed, and I forgot to mail the print, I'd been so busy. Then one day, a university friend asked me if I was feeling all right. In fact, I hadn't really been feeling well, I was gaining weight at an alarming rate and my clothes weren't fitting anymore, I was tired, and my hair had started falling out. I remembered the photograph a short while later and got an envelope and a piece of paper to write a letter to my parents and to mail it. Then I pulled the print out of the drawer and got a shock. As I looked at it I happened to glance into a mirror and saw myself looking at a caricature of that very woman. I had mushroomed enormously in just two weeks, and with my hair falling out so fast I was indeed hideous. I had to go out and buy a wig to cover the bald patches. It never has grown in." Rosa took her wig off.

Helen had seen bald-headed women before, but bald did not adequately describe Rosa's state of hairlessness. She was totally denuded of hair—not one strand remained—no fuzz, no shadow, nothing. Helen couldn't help but put her fingers out to caress the smoothness of the skin, to look closely, to examine her own face reflected in its shiny surface. The gesture created an intimacy between the two women that Helen was not at all pleased with. Rosa, seemingly oblivious to Helen's discomfort, sighed deeply in mute and soft contentment, letting her alarming mass sink dangerously close into Helen's own slight frame. Helen stood up

before Rosa could crush her and watched her as she replaced the wig, wiggling it back and forth until she got it just right.

She then showed Rosa the photo she had swiped from Anselm's album.

"Why, that's the very picture," she exclaimed. "I'd forgotten just how lovely I was." She grabbed Helen's hand and pulled her back down onto the bed. With her face just inches from Helen's she stroked the younger woman's cheek. "And isn't it just like you? Of course, you're a lot older than I was at the time.

"Before I forget," she added heavily, "I have been meaning to write you a note for when you reach Padua. I may not see you for awhile." She got a piece of paper and a pen out of her bag and sat for a minute with her pen in her mouth, visibly composing the letter. With another longing glance at her photograph, she started to write. She wrote so fast that the letters tripped over each other. She passed the piece of paper over to Helen, who looked at it quizzically.

"I can't read this," she said.

"You aren't reading fast enough," declared Rosa.

Helen tried again and then shook her head, "It's no good, I just can't read this. Read it out to me, please." She handed the paper back to Rosa who took it and crumpled it into a tiny ball.

"I can't read it either," she admitted. "Forget it." She threw the screwed-up ball of paper onto the floor.

"What happened between Anselm and Frau, Fräulein Kehl? In the end. Did they get married?"

"You're such an innocent, aren't you dear?" giggled Rosa. She chucked Helen under the chin and blustered out of the room. Helen fell immediately back asleep as though drowning in the placid asphyxiation still surrounding her.

The next morning Helen rose early, involuntarily sniffing surfaces and corners, finding no traces of the foul night, only the staleness of the newly-awakened morning. A healthy hunger cramped her insides and

drove her out in search of food. The breakfast room was located just off the reception area where the still-silent television continued to flicker. Nobody was at the desk. In the breakfast room itself the smell of baking bread assailed her nostrils with its yeasty wallop; the fragrance of freshly-ground coffee woke up her various dozing parts. A plate of fruit peelings had been abandoned on one of the tables leaving the pungent rind to fill the air with its citrus scent. The freshly laundered curtains were drawn but before she sat down she walked over to the window and, after deeply inhaling the smell of cotton, borax, and soap, peeked out. She could see nothing—although it was 8 o'clock, it was still dark. She turned around from the window and looked about, trying to decide where to sit, vaguely startled that there was one other person in the room, a slight man of about sixty years with an aura of nicotine complementing his brush-cut greying hair and neatly trimmed, greying mustache. He wore polished brown brogues, brown woolen trousers, and a striped knit vest tightly buttoned over a neatly pressed white shirt. When he saw Helen looking at him he patted his mouth with his napkin, stood up and bowed. There was a moment of awkwardness that some-times passes in hotels when two guests have no idea what language the other speaks.

Helen spoke first. *"Guten Morgen,"* she said.

The man smiled at her and said what must have been *Good morn-ing* in Hungarian. She smiled back and took a place at a table nearby. She waited patiently, first of all scrabbling through her Hungarian/English lexicon frantically looking for, finding, and then forgetting the Hungarian words for *Mr, good morning, good-bye,* and *how are you;* absently and needlessly wiping the floral-patterned table-cloth with the edge of her hand, and rearranging the sugar, salt and pepper, and flower vase; then studying her train timetable for the umpteenth time, as if reassuring herself that the schedules would advise her which way to go. Rosa had told her to go to Padua, had given her a note for Padua. She frowned, suddenly, clearly recalling the night's encounter, the hazy details of a forgotten but disturbing dream. What happened to the note? Did she read it, what did it say? Was Rosa really

there? When did she leave? Then she remembered the dreadful smell and realized why she had woken up sniffing the air. She sighed inadvertently, forgetting herself in her thoughts.

The man got up and, mumbling something, went through another door. A minute later he returned with a sturdy youngish woman who was wearing an apron and carrying a tray. Helen smiled again at him and thanked him.

"I am so sorry," said the woman in English, "I did not know that you were here."

"That's okay," said Helen, "I'm not in a hurry." The woman set the table with a coffee cup and saucer, a pot of cream, forks, knives, and spoons. She left and returned carrying a pot of coffee, a basket of buns, pots of jam, and a plate of butter and cheese.

The man asked her a question. She said to Helen, "He wants to know what you are doing in Budapest."

"Could you please tell him that I am traveling."

There was an exchange and the man asked another question. "He says that you must be doing something special, that no one travels at this time of year without a purpose."

"I'm looking for my husband," said Helen while she poured herself a cup of coffee. The woman translated.

"What kind of woman has to look for her husband?"

"A woman who is missing her husband." The woman laughed and thought about how she could translate the phrase. "Hmm, I don't know how I can put that so he'll understand."

"Your English is very good. Where did you learn it?"

"In America. I lived there as a teenager," the woman replied. She deliberated some more and then finally settled on a phrase and repeated it to the man, who began laughing.

"He says that it must be very difficult."

"Is that your brother who was sitting at the reception desk last night?"

"No, my son."

"Did he learn his English in the United States as well?"

"No, he has never been there. He learns it at school, and I give him lessons from time to time. He is an enthusiastic student of slang."

Helen turned her attention once again to the old man who was watching them as they spoke. "I'm also here to study anatomy. Ask him if he knows anything about anatomy. It seems that everyone I talk to these days is an expert on it." The woman asked him, then listened to his lengthy reply.

"He says, 'Why would I know anything about anatomy?' He says, 'twenty years ago I woke up to find that every bone in my body forgot its name and every day since then it has been a struggle to keep each in its rightful place.'"

"Tell him," said Helen, "that if he learned about anatomy maybe he could teach his bones a lesson or two." The woman translated and instead of laughing as Helen had expected, the old man seriously considered what she had said. He then spoke again.

"He asks if you could recommend a book for him to read."

Helen raised both of her hands in a gesture of futility. "I don't know any Hungarian books," she said. The woman translated and the old man pointed to the Latin Vesalius peeking out of Helen's bag. "He asks if he could look at that book."

Helen passed it over to him, praying that he would wipe his hands before he opened it. He did better than that. He cleaned off the table, removed the table cloth, placing each item carefully on the spare chair, wiped his hands, and proceeded to treat the book with more respect than it had probably ever received in its life. As he flipped through the pages the woman and Helen watched him, fascinated with the attention he paid to the drawings. Then Helen noticed that he was moving his lips almost imperceptibly as his eyes moved across the pages. He and the woman carried out a desultory conversation while he perused the book. She began translating.

"He asked me if I knew this author, this Andreas."

"What did you say to him?" asked Helen.

"I said, 'Why? Is he rich? Is he good-looking? Is he single?' These questions are important."

"Why does it look like he is reading the book?"

"You know the answer to that, I'm sure. Can you read that book?"

"No, I can't. It's in Latin, and I can't read Latin."

"There is your answer. He can."

The man shut the book and passed it back to Helen. He spoke again to the woman who said, "He says that this is all wrong, that there are many errors." She paused, waiting for him to speak again. "He says that the liver seems to be based on that of a monkey and that there is a gland shown in the brain that grows in calves and other such animals but not in humans. He's asking you if this is the sort of anatomy that you study? If so, Heaven help your patients!"

Helen laughed and explained, and although the man nodded he didn't look convinced. He got up and left the room quickly. The woman looked at Helen and smiled. She filled her tray with the remains of the man's breakfast, leaving Helen to finish her own.

Helen had just taken her last sip of coffee when the man shuffled back, holding out a leather-bound Latin-English dictionary. Thanking him, she flipped through it, curious about its significance. The type was minuscule but legible; here and there random words stood out like old friends. The margins were heavily annotated with spidery writing and emphatic arrows and brackets. Perhaps annotated was too formal a word. Doodled on was more like it. It was a lovely book bound in crinkly red morocco leather, with marbled endpapers and onion-skin paper, but it was just a dictionary. When Helen returned it, he studiously tore out 4 or 5 pages, which he offered back to her. She had no choice but to accept, although she was dismayed that he had ruined the book for her. She thanked him again and pulled the box out of her bag, intending to put the pages inside. He stood by the side of her table watching her, fascinated by her movements.

When she pivoted the top open, he exclaimed appreciatively and sat down beside her, the distant hint of nicotine she had perceived earlier in reality a thick cloud. A vicarious smoke. He gestured to the box, pointing with his finger, so Helen slid the box closer to him. He read the title page, lingering over the Latin syllables, allowing them to escape one by

one with deliberately chosen emphasis. The words spoken out loud
made sense for the first time: *Tactus,* touch; *Videndi,* sight; *Odorandi,*
smell; *Audiendi,* hearing; *Gustandi,* taste. A compendium of senses; a
complement to the braille booklet.

He pulled out all of the contents: the finger bone, the vials, the mag-
nifying glass, the photograph, everything, arranging them on the table
top. Helen quickly moved her breakfast dishes out of the way and
brushed off crumbs. The man shifted the things about as if trying to fit
together pieces in a jigsaw puzzle, now stroking the finger, now looking
through the magnifying glass. He moved the box itself to the side and in
doing so shut the top. He pried out the tooth lodged into the top, placing
it with the other objects. Helen could now see that tears were running
down his face and that each tear had a different letter reflected in it. Just
as Rosa's letter had been quickly written, these tears, as well, rolled too
fast for Helen to read, and she began to cry herself, not knowing if it was
because of the old man's foolish sentimentality or because the words that
oozed out of his eyes were lost forever as they dripped onto the table.
These individual things could have no meaning for him, this stranger
here in Budapest; they must represent something more than disparate
cast-offs. Possibly a book from the past, never read but sadly missed; a
collection of memories shamefully lost? Or perhaps—Helen allowed
herself the vanity of the thought—it was for her he was crying, as he
saw that she might never learn what it was the box had to teach her. She
hoped he was wrong.

The woman came in from the kitchen and stopped to watch the
young woman and the old man crying over a table top covered with use-
less things.

To Shrug. s. (Humerorum) allevatio.
To Shrug. v. a. (Humeros) alle-
vare.
To Shudder. v. n. Horrere; horres-
cere; exhorrescere; tremere; expaves-
re.
To Shuffle. v. a. I. *To throw into*
sorder; miscere; commiscere; confun-
dere; perturbare; (cards); permiscere.
II. *To remove;* transferre; amovere;
nolire.
To Shuffle. v. n. Vafre et malitiose
acere; non ex fide agere; uti fallacis.
Shuffler. s. Fraudulentus; vafer;
eterator.
Shuffling. s. I. *Crafty, knavish;*
raudulentus; vafer; multiplex et tortuo-
us; subdolus ac versutus. II. *Having*
quick irregular motion.— A shuffling
ait; acceleratus et tremulus gradus.
Shuffling. s. Fraus; dolus; fallacia.
To Shun. v. a. Vitare; devitare; fu-
ere; declinare.
To Shut. v. a. Claudere; occludere
the mouth); comprimere.— *To shut in*
ncludere.— *To shut out;* excludere; se-
cludere.— *To shut up;* concludere.
Shutter. s. (Fenestræ) foricula.
Shuttle. s. Radi...
Shuttlecock. s. Tubulus pennatu...
or pennis instructus.
Shy. a. I. *Cautious; wary;* cousi...
anxius; moderatus; modestus; circum...
spectus; temperatus; verecundia. II.
Disdainful; fastosus; superciliosus.
Shyness. s. Pudor; verecundia.
...ANT. s. Sibilus.

To Sidle. v. n. Transversus incedere;
procedere oblique in latus.
Siege. s. Obsessio; circumsessio; ob-
sidio; obsidium. *To lay siege to;* obsi-
dere. *To raise a siege;* urbis
oppugnationem dimittere; obsidionem
obsidium solvere; obsessionem oppidi re-
linquere.
Sieve. s. Cribrum.
To Sift. v. a. Cribrare ...incer-
nere or succernere.— *To s... matter;*
rem excutere.
Sifting. s. Excretum.
Sigh. s. Suspirium.
Sigh. s. Suspirium; gemitus; ...
suspiratio; gemitus, m.
To Sigh. v. n. Suspirare; suspiria
trahere (or ducere); gemitu edere; ...
mere.
Sight. s. I. *The power of seeing;*
visus, ûs; videndi facultas or sensus, ûs;
oculorum sensus, ûs.— *A good sight;* vi-
sus acer; lyncei oculi.— *A weak sight;*
oculorum infirmitas. II. *View;* oculi,
orum, pl.; aspectus, ûs; prospectus, ûs.
— *To be in sight;* oculis or ante oculos
obversari; esse sub oculis. III. *Spec-*
tacle; spectaculum. IV. *Appearance;*
species.
Sightly. a. Spectabilis; speciosus.
Sign. s. I. *A mark;* signum; nota;
indicium; (*of a disease*); testimonium.
II. *A presage;* signum; prognosticum;
præsagium. III. *Demonstration of one's*
will; (with the head); nutus, ûs; (of
the eyes); nictatio. V. *Constellation*
sidus; cœleste signum. VI. *Signature;*
chirographum. VI. *Picture hung at*
door, &c.; signum; insigne. VII.
miracle; see MIRACLE.
To Sign. To Signify. I. *To mark, to s*
...bum appon...
II. *To s...*

(handwritten: VIDEO VISUM VIDERE)

Significantly. ad. i. e. *In a signifi-*
cant manner; see SIGNIFICANT.
...mean; significare; indic...
notare; indic...
notify; rem...
declarare, or...
Silence, or...
...taciturnitas
conticiniu...
To Sil...
cludere; ...
Silen...
silentio...

To Signify. v. a. I. *To betoken,*
II. *To denote;* de-
...icare. III. *To*
significare.

TOS

To Toss. s. Jacere; agitare; jac-
...are; versa- Agitatio; concussus, ûs;
Toss. s.(et) ludicra alicujus e sago
(In a b)... jactatio.
TOTALITY. s. Totus; universus; tota unus-
ma...
TOTALLY. ad. Prorsus; omni...
plane; plane et omnino.
nitus.
To Totter. v. a. vacillare; titubare...
TOTTERING. s. Titubatio; vacillatio.
TOTEM. s. Taxillus.
To Touch. v. a. d. and n. I. *To*
tangere; (*with the hand*); tangere;
pertractare; manu tractare; contrectare;
tingere.
To touch upon; rem attingere or con-
tingere. *(handwritten: tactus CCLIII)*
Touch. s.; tactus, ûs; tactio; con-
tactus, ûs; tactûs sensus, ûs.
Touchhole. s. Rima; foramen.
Touching. s. Morositas; stomachus...
Touching. prep. De; circa; super.
...vendis animis aptus, idoneus or...
...ndum in modum...
Touchingly. ad. Miserabiliter; mi...
Touch-pan. s. Alveolus.
Touchstone. s. Lapis Lydius or He-
...ractius; coticula; cos.
Touchy. a. Stomachosus;
Tough. a. Durus.
To Tough...

(handwritten: TANGO TETIGI TACTUM TANGERE)

TOWN ...tollere ...tere.
Town.
Town-...
Town-H...
Townsm...
Toy. s.
Toyish...
lator.
TOYMAN. s. ... institor.
...ACE. s. ...
To Trace. ...is persequi
TRACK. s. ...
To Track.
TRACKLESS. a. ...gare.
TRACT. s. *substance;* s...
tractus, ûs; spatiu...
disputatio; comme... dissertatio.
TRACTABLE. a. *A tractable mind;* a...
TRACTABLENESS. s. ...
TRACTATE. s. ...
TRACTILE. a. Duct...
TRACTILITY. s. Duct...
To TRADE. v. a. Mercatur...
mercaturas or mercaturam...
TRADER. s. Negotiato...
TRADESPOLK. s. pl. O...
TRADESMAN. s. ... officinator.

SLU

Sluggard. s. Dormitator; sornicu-
losus; fem. somniculosa.
Sluggish. a. Piger; iners; segnis;
desidiosus.
Sluggishly. ad. Lente; pigre; ...
inerte; desidia; veternus.
Sluggishness. s. Segnities; pigritia;
inertia; desidia; veternus.
Sluice. s. Cataracta.
To Slumber. s. Quies; somnus.
To Slumber. v. n. Requiescere; so-
...se tradere; somno se dare; somnum
capere.
Slur. s. Labes; dedecus.— *To ...*
...stur; maculare; inquinare; lædere ...
aliquem dolis deludere; alicui ...
facere.
Slut. s. Mulier sordida or ...
Sluttish. a. Sordidus ...
spurcus; fœdus.
Sluttishly. ad. Sordide; spurco...
Sly. a. Vafer; astutus; ...
callidus.— *A sly fellow;* veterator ...
CUNNING.
Slyly. ad. Vafre; astute.
Slyness. s. Calliditas; astutia ...
CUNNING.
Smack. s. I. *Taste, savour;* sapor...
of a whip; (flagelli) sonus. ...
ship; scapha.
To Smack. v. n. I. *To taste...*
...labiis strepi...
...segni...

SMELL

Smartly. ad. Acriter; acerbe; vehe-
menter.
Smartness. s. I. *Sharpness of flavour;*
acritudo; acrimonia; vehementia. II.
Vigour; vigor; vis; alacritas; acritudo.
III. *Wittiness;* ingenii acies or acu-
men. IV. *Severity of pain;* doloris
vehementia or acerbitas.
Smatterer. s. Sciolus; semidoctus;
literis leviter tinctus or imbutus.
Smattering. s. Adumbratio; rei in-
choata cognitio.
To Smear. v. a. See To BESMEAR.
Smell. s. I. *The power of smelling;*
odoratus, ûs; olfactus, ûs. II. *Scent*
odor.— *A pleasant smell;* fragrantia;
odor suavis or jucundus.— *An unpleasant*
smell; graveolentia; odor insuavis or
teter.— *Of a pleasant smell;* odore gratus.
— *Of a bad or unpleasant smell;* graveo-
lens; graviter olens.— *That has no smell;*
inolens; inodorus.
To Smell. v. a. I. *Prop.;* olfacere;
odorari; odore tangi. II. *Fig.;* pro-
...cul videre; persentiscere; animadvertere;
...percipere; sentire.
To Smell. v. n. Olere; odorem red-
...olere; suavem odorem reddere.— *To smell*
badly; male olere; graviter olere.
Sweet-smelli...

(handwritten: OLFACERE)

HEAR *(handwritten: hallgatás auditus)*

...tus, ûs; dignitas; auctoritas; pote
imperium.
HEADSMAN. s. Carnifex.
HEAD-STALL. s. Frontale.
HEADSTRONG. a. Capito; pervica...
cerebrosus; pertinax; obstinatus.
HEADY. a. Violentus; vehemens; im
petuosus; iræ impotens; ...
ceps.
To HEAL. v. a. and n. Sanare; me-
num facere; mederi; morbum tollere;
...sanescere.— *To heal up;* coalescere.
HEALER. s. Medicus.
HEALING. s. ...
salutaris; salubris; pacificus.
HEALTH. s. Valetudo. *Good health*
...sanitas; salubris integra; ...
prospera; valetudo integra; *Good health*
...letudo tenuis or incommoda.— *Bad*
health; ...
HEALTHFUL. a. Salubris; ...
validus; integer; Sanus; bene valens; va
salutariter.
HEALTHFULLY. ad. Integre; salubris.
HEALTHINESS. s. Salubritas.
HEALTHLESS. a. Morbosus; ...
or incommoda valetudine est.
HEALTHSOME. a. Sanitas ... lubris.
HEALTHY. ad. Sanus; salutar...
taris; salubris; validus.
HEAP. s. Acervus; cumulus; ...
...coacervatio.
To HEAP. v. a. Acervatim; strues; copia...
...coacervare; acervatim cumulatim...
acervare; acervos construere; aggerere;
HEAPER. s. ...
HEAP. a. Acc... coacervatus.
To HEAR. v. a. and n. Audire; aus-
...excipere; auscultare; II. *To...*
...hendere; intelligere; percipere; compre
HEARER. s. Auditor; auditus.
HEARING. s. Auditio; ...
...sensus, ûs; auditio; auditûs; ...
To HEARKEN. v. n. Audire; audiendi...
aures dare or præbere; aurem admovere.
HEARKENER. s. Auscultator.
HEARSAY. s. Auditio.
HEARSE. s. ... accommodatus.
HEART. s. ...cor...
II. *The...*
III. *The vital part;* sub...
IV. *Courage, spirit;* animi magnitudo or ...
V. *affection;* animus ... excelsitas.

(handwritten: Auditus)

TAN

To Tan. v. a. I. *To imbue with*
...rk; coria corticis quernei pulvere inf...
...or macerare. II. *To burn with*
...sun; cutem adurere or infuscare ...
le colorare.
Tan. s. Cortex querneus in pulver... tenuatus.
Tangible. a. Tactilis; ...
...dens. a. and n. See To ...
To Tangle. v. a. ...ANGLE.
Tangle. s. Nodus.
Tan-house. s. Coriaria officina.
Tank. s. Cisterna.
Tanner. s. Coriarius. ...
To Tantalise. v. a. Par; æqualis.
Tantamount. s. I. *A gentle blow;* inflicta
...lma manu plaga. II. *A pipe at which*
...the liquor in a vessel is let out; fistula.
To Tap. v. a. and n. I. *To strike*
gently; aliquem ferire porrecta palma;
terræ pedem incutere. II. *To broach*
a vessel; dolium vino plenum pertundere.
III. (In botany); radicem ad per-
pendiculum agere.
Tape. s. Tænia textilis.
Tapeworm. s. Tænia.
Taper. s. Cereæ candela.
Taper. a. Turbinatus; in figuram
coni formatus; cono similis.
Tapestry. s. Aulæum; peripetasma...
Tar. s. Pix nautica.
To Tar. v. a. Pice nautica illinere or
inducere.
Tardiness or Tardity. s. Sera fruc-
tuum maturitas; lentitudo.
Tardy. a. Lentus; tardus.

TASTE

Task. s. Pensum; opus imperatm;
mandatum, or præscriptum.
To Task. v. a. Definire alicui quod
faciat.
Tastable. a. Sapidus; in quo est acu-
men saporis.
To Taste. v. a. and n. Gustare; de-
gustare; prægustare; experiri; gustu
explorare.
Taste. s. Gustus, ûs; gustatus, ûs;
sapor.— *Good taste;* sapæ mentis sagaci-
tas.
Tasteful. a. Sapidus.
Tasted. s. Lacer detritusque panni-
culus; cento.— *Covered with tatters;*
pannosus; pannis obsitus.
Tattered. a. Lacer; pannosus.
To Tattle. v. n. Argutari; loqu...
tari; deblaterare; fabulare e garrire.
Tattle. s. Garrulitas; loquacitas.
Tattler. s. Garrulus; loquax ...
giloquus.
Tattoo. s. *The beat of a dr...*
which soldiers are warned to the...
ters; recessus, ûs; receptus, ûs...
Taught. part. a. Doctus; ...
insultare; illudere.
Taunt. s. Contumelia ...
Tauntingly. ad. Cont...
Tautology. s. Tauto...
Tavern. s. Hospitium ... berna; diversorium.
Taverner. Tavern... vern-man. s. Caupo; ...
Tawny. a. Ferrugineus.
Tax. s. Pecuniæ irrogatio; irro...
ditionibus pecunia.
To Tax. v. a. I. *To charge with a*
tax; alicui pecuniæ summam imperare...

(handwritten: Gustus; TASTE)

In the next place, as the mind is t
hold a correspondence with all th
material beings around her, sh
must be supplied with organ fitted
to receive the different kinds o
impressions which they will make
In fact, therefore we see that she i
provided with the organs of sense
as we call them: the eye is adapted
to light; the ear to sound; the nose
to smell; the mouth to taste; and
the skin to touch. She must also
be furnished with organs of com
munication between herself in the
brain and every other part of the
body, fitted to convey her com
mands and influence over the whole

THE SEMMELWEIS

Ignác Fulop Semmelweis, the nineteenth century "savior of mothers," the discoverer of a cure for childbirth fever, was forever immortalized in an idiosyncratic and fitting museum to medical history. The director, Stefan Arany, was, as Peter Ganz had become, a fitting, but mercifully in this instance, living, addition to the collection. His English was astounding, maniacally delivered without concern for tense; his energy bounded like ricocheting bullets. But his demeanor was deceptively frantic—Helen could see through it to a man of perception and composure. The texture of his hand gripped like sandpaper; he looked as though he were carved out of fine-grain wood; he smelled of strength.

When Helen handed him the letter of introduction that Anselm had written for her, he scanned it rapidly, reading aloud in bursts of the dislocated vowels and convoluted consonants that Hungarian seemed to be constructed of. "I am to treat you with care," he announced, throwing the letter onto his desk.

To Helen's great relief, he, like Peter Ganz, remembered Martin clearly. Martin, apparently tired of slamming into so many dead ends by the time he arrived at the Semmelweis, had donned the cloak of a prosecutor, ready to break the fingers of anyone so unwise as not to feed him all he needed to know. As Helen and Arany walked slowly through the exhibits of the unpretentious museum, Arany, joking, imitated Martin's

towering figure looming over him, Arany—a self-confessed cowardly and timid director, yet lord of all he surveyed—he waved his hands towards the displays: primitive microscopes, a trepanned skull, pestles and mortars, faïence apothecary jars, and above all, the Holy Ghost Pharmacy. "What could I tell him, you ask me? He is interrogating me about something happening before I was born even! And in the worst possible Hungarian! Why pester me with your execrable Hungarian when I am speaking to you in the best possible English, I ask him! The scholars agree that Vesalius blocks are destroyed in the bomb. I know nothing to add to that. Go to the Munich University Library or to the New York Academy of Medicine, I recommend. They publish a book together using these woodblocks. Who cares anyway, they are gone! Pow, blown up! He was rude, but then he had a receding hairline. Many balding men are rude!"

Helen assessed the director's full head of hair. "Oh, you can't mean that. He's a journalist."

"Yes? This is his excuse?"

They stopped in front of a cabinet displaying an incomplete torso covered with lesions. "Poor bugger. Greek," he explained. "'I've been to Munich,' your husband tells me." Helen looked at him; she hadn't known, but she should have guessed. "You tell me," he said, assessing her glance, "if I'm not in turn being rude. Why are you looking for your husband in this manner? Is he officially missing? Have you spoken to the police?"

They were now standing in front of a Herbarium display of apothecary jars labeled in Latin, like her own homeopathic vials, with the names of their contents, some of them immediately translatable, others a mystery: *ext. fumariæ, ext. torment rad, sanguis draconis, aqv. anethi.* Arany peppered his conversation with brief explanations: *"extractum digitalis,"* he pointed to one jar, "that's from the common foxglove. We are all now familiar with it for its effect as a stimulant of hearts, but I would not imagine that many people are aware that it comes from such an ordinary plant." Helen leaned her head lightly against the cabinet, clouding the glass with her breath. The digitalis was back, making her heart thump

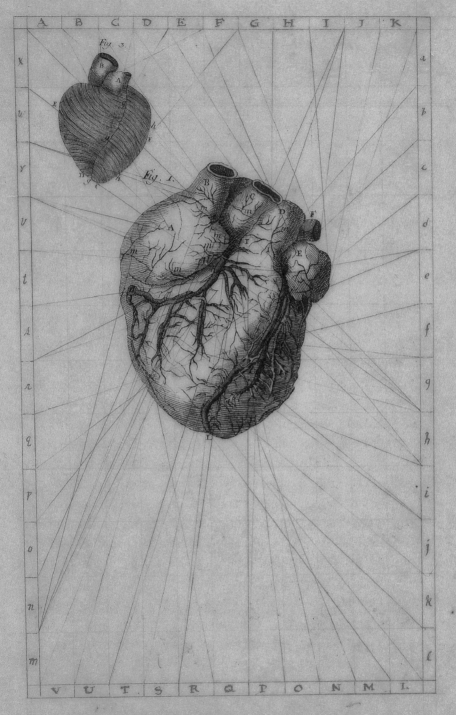

Anatomie, Le Cœur.

and crash against her ribs. A deafening thunder that she could only feel, but couldn't imagine that he couldn't hear. *Ext. digitalis.* The heart again.

The fog on the glass spread. "Oh, pardon me," she said, taking a doubtful paper tissue out of her pocket and wiping the glass.

"No matter, the cleaning staff wipe off the many hand prints and nose prints every day." He absently took her arm—the contact was electric—and led her over to a tiny ivory effigy of a pregnant woman. Helen freed herself from his light grasp; the proximity was unbearable; his warm odor choked her brain; she couldn't concentrate. The belly of the figure was cut away, exposing the organs and fetus inside. Arany was saying, "this is a beauty we are quite proud of. The parts all come out to be useful for instructing midwives.

"Tell me what has happened to Peter Ganz. You are coming from Vienna, so I am presuming you are aware of the incident? I have been absent and seem to be back to some very sad news."

"Herr Ganz was murdered." Helen strained to think about his question and not about him—the way he looked at her, the way he had held her arm, the way he smelled.

"Yes, I read the journals, too." He felt none of this; it was obvious. She pulled her senses into order.

"He was murdered and then dropped into hot wax and displayed in one of the halls of the Josephinum." They were now walking into another room, this one, coincidentally displaying wax figurines and body parts, not unlike those of Vienna's medical museum. A lifelike figure of a young woman reclined on a purple satin cushion. The label read FELICE FONTANA, 1730–1805. The same time period, obviously, as the Viennese collection. They both stared at the figure, her organs pitifully exposed, her fine bedding disintegrating.

"Does this have anything to do with your missing husband?" Arany asked after a pause.

"I thought not, at first. But, yes, they're clearly related. I'm not a person who goes looking for extremes," she searched her mind for the Hungarian word for Mister—an effort to establish grace, formality— then gave up, "Mr Arany. So it has been very difficult for me to even

consider the idea that Martin may have run into trouble." She walked over to the opposite side of the cabinet, as far away from him as possible —an effort to establish distance. "I came here, that is, to Vienna, to confront him, to call it off for good. I mean, to break off our marriage." Helen was conscious that she was butchering her explanation, this queer exhibit was not helping any. "It all seems to concern Andreas Vesalius in some weird sort of way. Peter Ganz's death, Martin's disappearance. Even my meeting Friedrich Anselm."

Arany gestured to her to follow him back into one of the rooms they had already walked through; she knew her distraction agitated him. Could he be more different than Martin? Her mind was wandering. She let it. She didn't often allow people in through her conscience, least of all men. Especially after meeting Martin. After all, that's why couples get together, isn't it? To stop the endless parade of tempting alternatives. To eliminate the need to worry that maybe someone, maybe you, made the wrong choice. Arany strolled on, one step ahead. She wanted to reach forward and slow him down, rest her hand on his arm, his shoulder, test his humanness, open up the possibility that perhaps, somewhere along the line, she had made a mistake, and that she might now take a chance on repairing the mistake. This strong need to touch had been felt in Anselm's presence and now here. With Anselm she had sensed that her proximity fulfilled some sort of continuum; with Arany it came down to a simple basic craving. He stopped suddenly in front of a cabinet they had somehow overlooked.

A large, framed, yellowed engraving on the wall next to the case caught her eye. "This is what all the fuss seems to be about," she said, regathering her wits, recalling the purpose of her visit.

It was an intricate Vesalius woodcut of arteries and veins that she recognized from the *De Humani Corporis Fabrica*.

"Oh yes, the *Fabrica*, or as it is translated into the English language, *About the Fabrication of the Human Body*. Not this one in particular?" Arany asked.

Helen didn't answer right away. Of course, *Fabrica*, fabrication, the making of. Her own translation, fabric, had been too facile.

"Is something the matter?" he asked.

"No, nothing. It's just that I thought *Fabrica* meant fabric as in cloth."

"Sure, why not?" he smiled. "Fabrication, a place of manufacture, fabric, it all has meaning, has it not? What is the difference if there is meaning? So, as I asked, there is no problem with this woodcut?"

"It involves all of the woodblocks supposedly destroyed in the bombing of Munich," she answered. "This possibly would have been pulled from one of them. After the bombing," she added.

"I haven't studied much the early anatomists," Arany said, rubbing his chin. "I specialize with the plastics from the seventeenth century to more recent times."

"Pardon?" She interrupted him. "What do you mean, plastics?"

"The waxes, you saw her."

His English was deteriorating fast, but she caught on. "The wax models?"

He nodded. "I continue with Vesalius. I remember, we add this to our collection last year. It is not authenticate, I don't believe." They both looked at it more closely. *Úr,* that was the word for mister. It didn't sound right. Helen refocused on the conversation, her agitation fading now that they were discussing the woodcut.

"Did Martin explain why he was interested in the destruction of the woodblocks?"

"No, I do not believe he did. It sounds just like digging up old histories. Old, that is, but not old enough to be a fascination. Although he ask me if I buy any Vesalius recently. I show him this."

"What did he say?"

"He asks me exactly when I bought it, from whom, how much I pay for it. Frankly, these are not informations that I can freely give out. I tell him this. I am able to specifically tell him the date, however, 16 March of last year. So we have it almost one full year."

"And he didn't tell you why he was asking?"

"No. I am very busy at the time and did not pursue the matter further." He looked at the piece again, this time even more closely. "It

looks real. There is some question about its authentication?" He looked at her. "I am still not understanding your involvement beyond your concern to find your husband."

"Do you know Friedrich Anselm?" Helen tried another direction.

"But of course! Your introduction is from him!"

"I mean personally. Met with him, had dinner with him. Are you friends?"

"Friends," mused the director. "Perhaps. We certainly share many of the same interests, and I have much respect for his collection. The art world would be a better place, however, if he permitted the photography."

"I stayed with Herr Anselm for three weeks while I looked for what might have happened to Martin, my husband, and I helped him with his cataloguing. It was very eye-opening. I don't believe I mentioned that my area of specialty is anatomical art."

"No, you did not, although I make some assumptions of your knowledge. Is it by accident that Mr Evans is researching anatomical art for his story?"

"It seems to be. I was completely unaware of his assignment until I arrived in Vienna," she thought for a second, "just over four weeks ago. I immediately went to his newspaper's offices and searched through his documents: telephone messages, notes, scraps of paper, anything to give me a hint of where he might be. You see, I'm not the only one wondering what's happened to him. His newspaper editor in New York, his parents, none of us have heard a thing since the beginning of December." She was now drifting through the rest of the exhibit in the wake of Arany's restless stride.

Stefan Arany's sympathies exceeded even his abundant energy. He sloughed off his next appointment—"just bureaucracy!" he laughed, and took Helen out for lunch. At his command the bounty of Hungary appeared, and their heavy wooden table, already crammed with linen, silver, and crystal, smack in the middle of the most raucous restaurant

that Helen had ever been in, groaned under the weight of noodles, sour cream, paprika, peppers, and wine. "We Hungarians are happy only when we're eating," Arany admitted, "so we eat all of the time!" He smacked his lips as the waiter filled Helen's bowl with a thick, succulent *gulyás*.

Aromatic steam rose up from the soup, promising, with its fragrant spices, delicate hints from the east; and with its rich pungent heaviness, comforting sustenance from the west. Hungary's world sprang from its food. Who had any need for culture or intellect, when seduced with such pure physical pleasures? It was the pleasure of a rich presentation and sublime smell. Maybe Anselm had been right when he had claimed that she saw with her body, but it was certainly taking her the long route to find out.

Between mouthfuls of food, sips of wine, and appreciative bleats, Helen and Stefan Arany continued to discuss the missing woodblocks. Although he had professed to know little to nothing about Vesalius, he filled in more details about the anatomist's life and work.

"Vesalius, it seems, pilfers corpses and hiding them in his room for his own perusal when he is a student at the University of Paris. A man with this kind of dedication and knowing the state of anatomy in France, it does not take him long to surpass even his professors, to make enemies of them, perhaps—I am thinking now of the professor Jacobus Sylvius, a bitter fight in later years—and give him his swelled ego. It took even less for him to step on some important feet as he pointed out errors and mocked antique ideas. He has been professor of surgery in Padua and broke tradition by dissection of the bodies for the students rather than, as is the practice up to this point, simply conducting the session from a, uh, high chair, no, elevated throne, leaving the actual dissection to a—" Arany chewed on the missing word.

"To an assistant?"

"Yes, assistant." He traced the oval outlines of a typical dissection theater onto the table cloth. "He published his *Tabulæ Anatomicæ Sex* in 1538 when he had only 24 years, not his first book, but his first anatomical book; an undertaking intending to supply accurate diagrams for his students.

"I won't ask you if you have ever seen a copy; I would not believe you if you said you have. Maybe the only known original is in Glasgow. You know Glasgow? You have not seen this one, have you?" His voice trailed off, doubt mixed with possibility.

"No," Helen shook her head.

"No," he echoed, "of course not. I myself have a fondness for the *Tabulæ Sex*. It was illustrated by the Venetian painter Jan Stephan van Kalkar. I should specify: Kalkar was trained in Venice; he was also a Flemish. We call him Kalkar, but that is wrong. His name is really Jan Stephan—Kalkar is only the name of his town.

"The illustrations were clumsy; no, let us say crude. They remind me of myself." He leaned back in his chair and threw his arms out, a classic specimen awkwardly rendered. "Kalkar had 39 years when he created the *Tabulæ Sex* images. Not a young man by any means. He would have 44, no 43 years, when he completed the drawings for the *Fabrica*. Four years is not a long time to improve your mastery to such degrees. And there was too much jump to breach the stylistic differences between the *Tabulæ* and the *Fabrica*. But, you know perhaps, of the 6 drawings in the book, only 3—the skeletals—are by this Kalkar. The other 3 are by Mr Vesalius himself. He has many talents, yes?

"But I continue. At this time Galen, the Greek anatomist from the second century, remains the invincible authority on the human body, and to question Galen is to challenge the 'Holy Writ' of anatomy. Vesalius, he always vows his dedication of and admiration to Galen's principles, patiently build up a body of work that corrects many of the Galen errors never correct in the interceding 1400 years. It is important to remember," stressed Arany, demonstrating with an expansive and even grin, "that at the time of Vesalius, there are still misconceptions about simple things, like the number of teeth in a human mouth. In spite of the best tries on the parts of anatomists like Leonardo da Vinci to finish the controversy, it is possible to still find physicians declare that the human beings have anywhere from 16 to 28 teeth. Sometimes, it is conceded, they have 32."

Helen ran her tongue around her mouth, taking inventory of her own teeth. When she came to the lower premolars she remembered the

elevator man in von Ehrlach's building. How amazed the anatomists of the 16th century would be to find a man who had a pearl for a tooth! What stories they would have related to an unsuspecting world. Would the example have ended up in an anatomy book as a case study?

Arany spoke on. "I am interesting that the *Tabulæ Sex* perpetuates a number of Galen errors. Perhaps," continued Arany, "Vesalius isn't yet comfortable to contradict anatomy's spiritual father. But by the time the *Fabrica* and the *Epitome* are released he has quietly correcting over 200 mistakes. Although a good many remain."

Helen's mind again wandered, this time to the little old man in the pension. The man whose bones had forgotten their own names; the man who could immediately define Vesalius' errors. She shook her head almost imperceptibly; bones don't need to be put right, bones know where they go. The gesture stopped Arany's patter.

"Do you disagree with me?"

"No, not at all," protested Helen. "You just reminded me of someone who mentioned this very thing to me. Please go on."

He continued. "So, Galen has declared that the heart is full of pores through which blood pass. Vesalius contradicts him, but not until the second edition of the *Fabrica*. Also, Galen has written that the body is full of 'Pneumas,' also named spirits: that is, the brain is filled with the animal spirit, the liver with the natural spirit, the heart with the vital spirit, but when Vesalius cuts open, let us take, for example, a brain, he looks at it and finds it full of grey matter. It appears that no one else, an exception perhaps of Leonardo, has been truly looking. Galen is confused certain processes by those of animals, probably from his dissecting of animals and then projecting the results to the human body. Not that Galen's work is not valuable. We know that he writes perhaps three hundred books, but few survive owing to a fire in the library at Alexandria where they are stored, and the destruction, by his own hand, of countless manuscripts. What we do know lives by the Arabs—physicians and scientists such as Avecenna and Albucasis. On the other hand, because of the high esteem with which his work is held, he is accused of holding off the progress of medicine for over 1300 years.

"Vesalius publishes the *Fabrica* for the serious scholar and the *Epitome* in the same year for anyone. The *Epitome* is now extremely rare," he added, almost as an aside. "You see, it is what is known as a flap book. We cut out the bits and then hinge them on to the base image in order to create a kind of three-dimensional study. Folding back the skin to find the organs; folding back the organs to find the blood vessels; and so on. These books rarely survive as they are so fragile." Whoever had assembled the layers of the human head in her own box had written all about this, but she hadn't taken it in. As with the Latin words on the title page, she needed someone to repeat it, so that she could absorb it through several senses.

"For an observant man like Vesalius it is easy to contradict the errors of the past. But it does not mean that he is popular for it. After the publication of the *Fabrica* and the *Epitome,* he retire from teaching, some say he is chased out; but whatever. He leave Padua and join the court of Charles Five as the imperial physician. Well, he may or may not be *the* imperial physician, I do not remember. The terrible thing, again speculation, is that he seems to have burn his notes, sketches, work in progress, in a fit of rage that follows the publication of his great books. His scholarly peers crucify him—I go too far—call him names, maybe; his work is scorned, old friends renounce him; but his work attracts attention all the same and eventually recognizes for what it is—a landmark in every way. But you know all of this, I am sure; here, have some more wine." As he reached for the nearly empty bottle, a waiter rushed over and poured out the remaining drops. Arany signaled for a new bottle.

Helen starting to demur, checked herself and gave in to the intoxication. It was getting to be a habit. Arany's dizzying use of past and present tense to relate historical events added to the agreeable buzz in her head. "You told me you knew little about Vesalius."

"I do not know very much, but I am interesting in people who are rocking the boat. This is why your husband now is interested me. I have to admit, perhaps I already have, that I have little time for him when we first meet. So demanding. And he talks so much. Is this how journalists work, by asking questions and then to talk so much that there is no

opportunity to supply an answer?" He laughed. "And now it is I who talk so much. How about you, do you ever talk? Remind me what your voice sounds like."

As she started to speak, the waiter arrived with the new bottle of wine. She paused, forming new questions, and watched as the waiter uncorked the bottle, and Arany tasted the fresh wine.

He smacked his lips. "So fat, so nourishing!" Without waiting for her to speak he continued, "You know, of course, that Vesalius is married?" Helen shook her head. "No? How does he find the time to marry, you ask? And to have a child. In 1544 he marries a lovely Flemish lady named Anna van Hamme and not so long after they have a baby, also an Anna. This year that he marries is the year he goes to the court of Charles Five, and then, I think, twelve years later becomes doctor for Philip Two. For this he goes to Spain. I do not know if Anna goes with him. I know they do not live all the time together. He writes in 1561, a critical book on Fallopius. You know Fallopius?" Helen nodded. "Good. He is very important. This is his last book. Then he is run out of Spain. Someone says that as Vesalius dissects a cadaver the heart is still beating. The Inquisitors?"

"The Inquisition?"

"Yes, the Inquisition have problems with this. Vesalius goes to Jerusalem on a pilgrimage without his Annas. He comes back, stops on Zanté and, poof, dies of the plague or some such thing. Not a nice end for such a man."

Helen brought the discussion back to the woodblocks. "Is there any importance to the controversy surrounding the actual cutting of the woodblocks? I understand that a dispute raged for some time about whether the artist was Kalkar or the great Titian himself."

" 'The great Titian, himself!' Yes, you have an opinion, I think? This is where your friend Friedrich would help. He is the authority on artists. Did you not ask him this question?"

"Friedrich Anselm was reluctant to talk about the Vesalius wood-blocks. He would just drift off, or change the subject, or," she laughed, "take the high road and insult me for some petty thing. One thing you

must understand is, I didn't feel altogether comfortable staying at his house. I'm not sure why I agreed to it, except that I couldn't afford to stay at a hotel in Vienna for three weeks, waiting for you to come back." They smiled at each other. "You see how popular you are?" His smile broadened even more. God, she said to herself, I'm flirting. Stop it.

"I don't seem to be doing a very good job of getting to the point. First it was the distractions of the museum, now it's this wine going to my head. What I really need to know are these two things: first, is there any controversy surrounding the Vesalius woodblocks that would warrant an investigation? Something to do with the original artist? Something to do with where they were during the bombing? Something to do with an alteration or alterations done to them during the course of time? And if you don't know, do you know someone who does? Second, where, if anywhere, did you advise Martin to go next?" She picked up her glass, took a sip, then grabbed a piece of bread, swept it ceremoniously across the dregs of cream and gravy on her plate, and stuffed it satisfyingly into her mouth, washing it down with another sip. Not sip, too precious a move, a gulp.

"Such simple questions. Why did you not ask me in the first place? We could have saved all of this nonsense about going to lunch, which is clearly an inconvenience for you!" Arany had been admiring all along her overt appreciation of the meal. "Do you not feed yourself very well? Is this your first meal in some time?"

"Since I arrived in Vienna, I sometimes think, Mr Arany, that I have never eaten in my entire life. That each meal is the very first one. But we're sidetracked again. My answers, please!"

"Okay, to business. First of all, I am not myself aware of any controversy surrounding the woodblocks leading an investigative journalist on a trail crossing Europe. The discussions about whether Kalkar or this great Titian was responsible is a heated one, I can admit, but limited to, at most, a few hundred aging, bald heads in stuffy offices. Just ask yourself, how many people even know his name Vesalius? Come here, one moment, please," he called to the waiter, asking in Hungarian and translating for Helen, "Do you know about Vesalius?"

"Vesalius what, sir?" the waiter asked.

"Andreas Vesalius. I will hint. He is Belgian."

"Hmm, Andreas Vesalius," mused the waiter.

"I have heard of him," said another diner, an earnest young man, eavesdropping from the next table, his buttocks rocking from cheek to cheek at this opportunity to practice English. "He plays out dreams in the newspaper. Every week, a new match in black and white squares."

"You must mean chess, not dreams?"

"He is a chess player, then?"

"No, he is not. He is an anatomist."

"An anatomist? Sprays and perfumes?"

"Not an atomist, an anatomist. Bones and blood vessels . . ."

"Ah, mandibles and maxillas!?"

"Yes! You have got it."

"Hmm, well why does he have a chess column in the paper?"

"It must be another Andreas Vesalius. Thank you," he dismissed the waiter and nodded graciously to the diner. "You see what I mean. I must look that column up." He shook his head in disbelief.

"As for the chance that the woodblocks are moved before the bombing? Is that the next speculation?" Helen nodded. "I cannot know. But it is a provoking idea. So you think that when the library is bombed, that the woodblocks escape destruction and are hidden. What proof have you?"

"None. It's the first time I've thought of it in so many words. But I was given a Vesalius print—the police in Vienna have it now—when I first arrived in Austria. I showed it to Peter Ganz when I met with him; he borrowed it to have it authenticated, and then he died before he could tell me what the results were. The print, along with the report, went to the police, who told me that the woodcut itself was authentic, that the paper was authentic, but that the ink had been manufactured after the war. If true, it can only mean that someone is printing with these again and possibly trying to pass them off as originals."

"It is interesting," mused Arany. "The third speculation is to do with alterations? I do not see any significance. What do *you* think?"

"I haven't had any, I was just grasping at straws. I had read that between the first edition and the second edition there were minor changes made to make it more understandable, opening up the cross-referencing letters positioned beside the different elements, and then an even later edition was printed with the engravings supposedly initialed by Titian. Other than that, no, I have no other reasons for suggesting it."

"Then you want to know what I recommend he do next. Given the little that I know of the subject, I tell him to go to Munich since the originals have been there. As I mention already he is not forthcoming; he evidently did not want to share his suspicions. He tells me, as I have told you, that he has been already. What can I say? I suggest that he go to Padua or Venice. Start tracking the woodblocks down to follow the path that they originally take."

"Venice, then over the Alps to Basel, and so on?"

"Precisely. Though in my eyes, that is not modern journalism, that is old-fashioned detectives, and no one these days has the time for such luxury." The waiter, seeing that the level of the second wine bottle had dropped to within inches of the bottom, wheeled over a precariously overladen dessert tray. Arany looked at his watch. "Speaking of time, will you join me for torte and coffee?" He chose a plate bearing a tempting selection of cakes. The waiter poured two demitasse and placed them on the table.

Helen looked at her watch; it was four o'clock and the restaurant was almost empty. "I've kept you so long from your office . . ." her voice trailed off as she longingly eyed the insanely rich concoctions.

"You are a refreshingly open book, Helen. It is okay with you to call you Helen?" She smiled and nodded, realizing that he had not, until now, ever referred to her by name. "I am sorry for you and for your husband. For me it would be enchanting to live with a woman who so naturally showed her pleasures. Excuse me for being frank."

She flushed a deep red, disarmed by the unexpected intimacy of the remark. This was her chance to be honest about something that could matter. Stefan Arany was not a conventionally attractive man; his face was scarred and pitted, his forehead low and broad, his eyelids thick,

and his long black mustache harvested crumbs and droplets continu-
ously throughout the meal, forcing him to stop at intervals and painstak-
ingly groom it. Stray twists of black hair curled over his collar,
tenaciously escaping from the meticulously combed flock. He was short
for a man, about her height, maybe a touch taller; but his commanding
personality increased his stature substantially. He mesmerized her. How
rare, she thought, are the opportunities to give in to our appreciation of
the opposite sex without being misunderstood. Why can't I just sit back
and admire him, like I admire this cake. To feast my eyes on what may
be a fleeting sensation of beauty. Today, he is all the satisfaction that my
eyes require. He sat watching her, an expectant look on his face.

"Should I tell you that you've offended me?" asked Helen, relieved
that her words didn't betray her. "I can't say that you have, but you did
startle me. Some women may be accustomed to handling compliments;
I'm not. Especially not that kind of compliment. For me," she licked the
last of the cream off of her fork, "I'm here only to find my husband.
This may sound old-fashioned, or pathetic even, but I am nobody until I
disentangle all of this. And as nobody I have no will, no desires except to
free myself." She wanted to say so much more, ask him if he loved some-
one; ask him to do something simple like just touch her hand. She set her
hands on the table, contemplating putting temptation in his way, to see
what he would do. No. She couldn't do it. The hands returned to her lap.

Her bald-faced lie was stated too forcefully for Arany to contradict;
his eyes conceded defeat. Helen submerged further her yearning to
admit her desires and went on, "I haven't even any expectations of what
I'll do once I'm free. That's unimportant. Well," she said, now too
uncomfortable to go on juggling the deception and the honesty, and
attempted a joke, "maybe I have one desire that I'll admit to," she eyed
the cake tray and slid one more slice onto her plate.

"I won't say that you misunderstand me," replied Arany, his wall of
defeat instantly creating a distance between them, "because I believe
that you understand yourself far too well. I wish you the best of luck in
your hunt, and only wish that I could be more help. What do you think
you will do next?"

"I can't really say that I've made up my mind. The way that I see it, I have two choices. Both you and Friedrich Anselm suggested to Martin that he go to Padua. You also advised him to go to Munich. The fact that he had already been is a strong reason for me to go there. Is there anyone you know there that I should see?"

Arany shook his head, "I am afraid not," he said. "Once again, Friedrich would be the best person; he has spent much time in Munich."

"That's right, he mentioned that he went to Munich frequently with his governess, Fräulein Kehl. I didn't realize that he continued to go there after he had left home."

"I don't think that he ever 'left home.' The house where he is currently living is his home all of his life. As far as I am aware he continues to go to Munich until the late sixties, around when he goes blind. It is a matter of some controversy at the time. But perhaps we are more interesting in what is between him and Fräulein Kehl!" The distance between them retracted with his humor.

They both stood up and walked to the restaurant door, where the maître d' waited holding their coats. They stepped out into the now dark and freezing Budapest afternoon; Arany waved a taxi over and asked her if he could drop her at her hotel. She thanked him and declined. They shook hands, Arany got into the cab, and with one last "Good luck," hurled into the wind, drove off. His departure left Helen feeling sadder and more alone than she'd ever felt in her entire life.

TRIGINTA PARI- VM NERVORV
QVAE A DORSALI ME DVLLA DORSI OSSIB
contenta originem ducunt, nuda delineatio ea proportione expressa, qua superius
næ cauæ & magnæ arteriæ delineationes exhibuimus. Hæc trium subsequent
Capitibus communium figura- rum secunda numeratur.

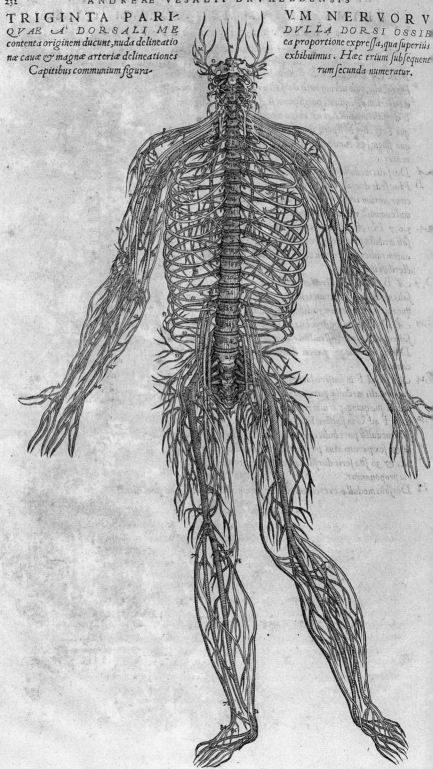

MUNICH

Munich or Padua, Padua or Munich? Sauerbraten or pasta, beer or wine, German or Italian? Freezing winds from the Alps or moderating currents from the Adriatic? Nine-hour train ride or twelve-hour train ride? That settled it. Munich.

Am I seriously pursuing this or am I trying to get out of an extra three hours on the train? She put the question to herself while she flicked the little bedside lamp on and off. "At least there's heat in here," she said aloud, getting up and wandering over to the radiator. She sat down on the heated bars, warming her backside.

Rosa had suggested Padua. Right here in this very room, last night. She had written a note and then thrown it away. Helen got down on her hands and knees and felt under the bed, behind the bedside table, under the wardrobe, behind the radiator. It must have been tossed out this morning when the room was done. Why would Rosa suggest Padua? Rosa was not what Helen considered an integral part of her purpose in Europe. She was a nuisance, an encumbrance, a disturbing distraction. Helen's life was, after all, her business, and Rosa's was her own. If there was ever a compelling reason to go to Munich, it was because Rosa had suggested going to Padua. That really settled it.

The lunch with Stefan Arany had been more disturbing than she wanted to admit. It was her heart that was reacting the most—not the figurative heart, but the physical beating heart. Still beating crazily,

thumping violently, ever since he first took hold of her arm. She opened up her box to the page that contained the old vials. There it was, the *ext. digitalis,* the heart stimulator. She felt as though she'd taken a huge dose. What else was in there? Something else, perhaps, to calm a heart? Here was *ext. atropa belladonna.* Oh great, she thought. Everyone knows about belladonna: the deadly nightshade associated with romance and madness—dilates pupils, brings blushes to cheeks. This one, the one that Rosa had offered to her for her eyes, was *ext. euphrasia officinalis.* She opened the flap in the lid of the box, and for the first time read the description of the medicines in the vials. *Euphrasia,* or eyebright, intended to improve vision and cure eye diseases. *Ext. ruta graveolens,* rue, associated with repentance and sorrow. *Ext. hyoscyamus niger,* the fancy name for the poisonous henbane, a sedative if the patient was lucky, a dizzying, stupifying killer, if not. And the last one, the empty one. She twisted the bottle around, trying to see if there was any evidence of its contents. The flap declared this to be *ext. ventus septentrionalis.* Ha! A wind. She read on. The north wind, the wind that sharpens the senses. This is ridiculous. Heart stimulators, stuff to drive you mad, air. Whoever put this together had a wicked sense of humor.

Helen stepped back over to the bed and fell onto her stomach, bundling herself into the bed's downy arms. She nestled her nose into the pillow and breathed in the competing fragrances of lotion, laundry soap, and years; so different than the previous night, so reassuring. She rubbed her cheek, then her eyelids, then her forehead and mouth against the rough cotton. Her bed at home; their bed. What was it? A prison. A pallet. A no-man's land. At best a battleground liberally salted with devious and shallow traps. What was the mattress? Was it foam or springs, soft or hard, rigid or giving? Was it wide or narrow, wide enough for two or narrow enough for one? Did her feet stick off the end; was she lost in it? Were there blankets or quilts? Wool or down? Were the sheets cotton? Were the pillows feather? Did it smell good? "Why can't I remember?" she asked herself. She rolled onto her back and looked at the cracks in the ceiling.

Could she remember the last time that she and Martin had shared

that bed? Yes, she could. It was like the time before that and the time before that. She on her side, he on his. His back to her. That's what she remembered about their bed: his back. What a mess. What a stupid, screwed-up mess.

Her mother, superstitious as she was, always insisted that Helen's father help her make up their bed when it came time to change the sheets. A weekly ritual, the two of them—tucking, fluffing, stuffing, sheets, quilt, pillows. Always white cotton. Dried into stiff and fragrant parchment on the clothesline out back. Baked by the sun, trailing the scent of grass and clouds. If they didn't make the bed together, her mother had contended, how could they expect to stay together? Of course she meant sleep, sleep together; everyone knew that's what she meant. Helen could smell the memory of her parents' bed, here in her Budapest pension. The memory was a false one; the fragrances were too fresh, too real.

This bed she was lying on now, wide enough for two people in love, narrow enough for one lonely bitter person, beguiled her to sleep.

Late the next morning she found herself alone in the breakfast room. The woman who had brought her breakfast the day before—her name was Krisztina—explained that the old man, Kussák, left for work each morning at 9:00. Helen was surprised that he would still be working and asked how old he was. "Kussák's only seventy," Krisztina replied, "He has plenty of working days ahead of him yet. He watches the mail sorters at the post office to make sure that they don't steal the mail. He used to be a veterinarian."

Helen, wearing all of the clothes she had brought with her, spent the day seeing Budapest and regretting the winter that not only kept her shivering against the gruesome blasts of air but also sent many of the museums and galleries into sporadic hibernation. She went back to the Semmelweis, not to see Stefan Arany again—she couldn't with- stand another encounter, she declared to herself—but to better inspect the displays, particularly the Vesalius woodcut. Followed closely by

one of the attendants, she sketched the print, thinking that at some point she could match it up with the *Icones Anatomicæ* or perhaps one of the proofs she had swiped. She left the building, her wish granted; she hadn't seen even a hint of the director and her spirits suffered accordingly.

Helen escaped into detail: her train schedule booklet, which she assiduously studied during her lunch, promised several direct trains to Munich, all leaving from the Keleti station and all routed through Vienna. She could leave at 3:30 PM, 9 PM or 12:30 AM, meaning she could get into Munich at 12:30 AM, 6 AM or 9:30 AM. Nine-thirty was okay but that meant an overnighter. She shivered at the thought. Or she could go to Vienna and change trains there. There were lots of trains to Vienna; she could leave in the morning at half past eight or at ten to ten. This busy work buoyed her up, gave her something else to concentrate on, eliminated the need to think.

Late in the afternoon, as the shops were closing and before the restaurants started serving dinner, Helen strolled again through the lobby of the Gellért to check if there were any more messages for Martin. A futile chore; she hadn't even looked at the batch she'd picked up when she first arrived. A sign pointing to the thermal baths reminded her of Rosa's wild accusations about the pornographic films. The bitterly cold weather had killed any curiosity she might have had to check out the place first hand, but she wasn't quite ready to leave the hotel for good; she decided to sit down in the sumptuous lounge just off of the lobby and order a glass of wine. When the waiter brought her wine, she asked him in German about the rumor. "Rumor," he replied, "it's not a rumor. They make a lot of money renting the baths out. The extra cash is just too tempting. And besides, there is a strict rule." He looked around at the other tables then whispered, "No sex!" He winked at her and moved on to a table of new arrivals.

The following morning Helen packed and went to the reception desk to pay. The television set: still on and still silent. Neither the old clerk nor

the boy were at the desk, and Krisztina had disappeared—there was no sign of anyone. She went into the dining room, poked her head into the kitchen, and then went back and turned up the volume on the TV, hoping that the noise from the set would attract someone. A musical band, consisting of five chubby young men wearing what looked like cast-off Beatle suits, was playing on a studio stage. They jumped about—three guitarists, a drummer, and a saxophone player—lip-synching and badly at that. The studio set was minimally decorated with a curtain stretched unevenly across the back, two potted palms on either side of the band, and a raised dais for the drummer. They were playing the song she had heard on the radio the first day she arrived—"I'll Never be Your Bodyguard." She listened to it for a few seconds; maybe they were singing, "I Wanna be Your Bodyguard."

Helen looked at her watch impatiently—it was now twenty to eight—and repeated her circuit of the dining room, kitchen, and reception area. She called out down the hall towards the guest rooms. The band was playing a new song, this one sounded like "I am an Onion." She counted out the cost of the room, added a bit more in case there was a tax she didn't know about, left the cash and a quick note scrawled with her name and room number on the reception desk, and rushed out of the pension towards the train station, remembering at the last moment that she had left the television blaring nearly full blast.

She arrived at the train station in good time, in spite of her worries, and seeing no benches, leaned against a wall in a corner of the main hall. It was cold, but at least here the wind only swept through when the doors were open. A malnourished sallow-skinned man of indeterminate age wearing a thin, worn suit, approached her.

"Did you say something?" he asked her in heavily-accented English. She had been reading.

"Pardon? No, I don't think so," she answered, nodding briefly at him and then looking back at her book. She tugged her luggage in closer to her, as if clearing more floor space.

"Are you traveling far?" he persisted. Helen looked back over at him, hoping that he wasn't going to be on the Vienna train.

"To Prague," she said, hazarding an alternative destination.

"I am going to the Dead Sea," he announced.

She looked at him quizzically.

"Yes, I know this route seems unusual, but I don't have very much money."

This justification cleared up none of her confusion. What route?

"I take my train to Subotica. You know Subotica? It is in Romania, just inside the border from Hungary." He could see her knowledge of Balkan geography was weak. "Here, let me show you." Before she knew it he had shifted her bags and was standing even closer, arms spread wide, a map open in front of them. "Pardon me," he said, smiling. "Subotica is right here." He had crowded in very close and was jabbing a badly kept fingernail at a point just across the Hungarian border. "From Subotica I catch a Romanian train to Ruse. Just inside the Bulgarian border. Will you permit me to tell you that you smell very nice? From Ruse I catch a train to . . . but you see what I'm getting at. And it's cheaper that way."

"No, I don't see. Where do you go to from Ruse?" She was determined to ignore the uncalled-for remark, mistaking it for audacious nerve.

"To Istanbul."

"And from there?"

"To the Dead Sea." He inched nearer. She shifted away as best she could, leaning at a ludicrous angle, her feet trapped by the bags on the floor.

"But how?"

"By bus to Aleppo and then Damascus, and then to Amman. And then bus to Israel. Taxi if the buses have stopped working. Now do you see?" He sniffed appreciatively. By this time Helen could smell him: a mixture of cheap cologne, hair oil, tar, tobacco, something alcoholic—distilled, not fermented—laundry soap, and something else, something corporeal.

She kept up the pretense of conversation, of interest. It was better than being locked into his odors. "But why not go to, I don't know, Athens? Take a boat from there right to Tel Aviv?"

"Ah, you do know your geography, after all!" His exclamation sent out a cloud of cinnamon and cavities.

"Well?" She was inexplicably torn between finding out about his reasoning and a now-growing interest in dissecting the smells.

He made a face. "Because of Greece," he said.

"What about Greece?"

"We are not friendly, Greece and I."

Thinking it wise to change the topic, Helen said, "Too bad, I guess. Well, you certainly see a lot of country doing it this way. Why are you going to Tel Aviv?"

"I'm going to move there."

"Ah, you're Jewish?"

"No!" he shouted. Then in a normal tone added, "Not that that is such a problem in these modern times. No, it is because I have dandruff."

"What do Israel and dandruff have to do with each other?"

"I have heard that the Dead Sea climate is a miracle cure. I suppose you are not likewise afflicted?"

"No, not too much," Helen admitted.

"You are lucky. It consumes my entire life. I wash my hair three, four times a day and still, look!" He brushed his hair forward rubbing vigorously. Little flakes fluttered down onto the map. Helen leaned even further away, tempted to brush off the sleeves of her coat, and aware that the elusive odor she had noticed had been the seborrheic scurf in his hair, so bad that it consumed any scent the shampoo might have left. But no, of course, the tar smell, that would be from his shampoo. Surprised and delighted by this new-found acuity, she forgave his brazen proximity.

"Sorry," the man said. "Do you plan to go to Israel?"

"Not during this trip," said Helen. "Maybe. Someday." A gust of engine smoke ensnarled in the bitter wind blew in from the door at the entrance to the station, snapping her concentration. "I should go and see

if my friends have shown up." She scanned around the hall, trying to look convincing.

"Let me write down my address. In Budapest," he added. "I will have my mail forwarded. If you come you will be pleased to stay with me." Helen smiled inwardly at this slip in otherwise perfect English.

"Yes I'm sure I will be," she said, watching him laboriously copy out his name and address. He handed it to her. "Anton Qwerty. What an unusual name. Is this a transliteration from Cyrillic, can you use a *Q* without a *U?* Why, it sounds like the name of the pianist, Anton Kuerti."

"Yes, it is pronounced exactly just the same."

"But why is it spelled differently?" He squirmed. Oh, oh, thought Helen, this is touchier than the Greece issue.

"I am a bastard," he announced.

"I'm sure you aren't *that* bad," she said, taken aback by his abrupt language.

"No, you don't understand. I am illegitimate."

"But that's no big deal, nowadays."

"It's not?" he asked, brightening. "One is always afraid that it will be held against one. Well, my mother worked as a secretary for an English businessman while she was pregnant. And she needed a father's name for her baby, that's me."

"Yes, go on. You did have a father?"

"My mother was not sure who he was."

"Ah, I see."

"So, she gave me the name from your English keys that she typed on. Qwerty!"

The train platform was quite crowded by the time the train to Vienna pulled up. As she walked through the train's familiar corridors she noticed that the standards heading east to west were visibly lower than those coming from the west. The washrooms emitted distinctive odors, the passengers looked more motley—their baggage more abundant and

far less chic. She was comfortable where she was but needed to keep her coat on against the cold.

She shared her compartment with a morose couple who had commandeered the two window seats and a greying, furrow-faced man with his young daughter.

The silent couple got off at Tatabánya, the man and daughter at Györ. Neither city, seen from the disadvantageous railway stations, seemed worth stopping at. She was alone again, at least for awhile.

Helen woke up to the sound of knocking and the strong aroma of tobacco smoke drifting into the compartment. She floundered about groggily, her limbs flapping at twice the speed of her brain. She opened her eyes. She wasn't in her room in Budapest, she was on the train, and it was broad daylight. She remembered: she was on the train to Vienna. She looked in the direction of the knocking.

A conductor, one hand posed to knock again, was standing at the door to the compartment, his mouth fixed into an uncomfortable, authoritative smile. Two taller uniformed men stood behind him. One of them put a hand on each of the conductor's upper arms and pivoted him out of the way. The other, the taller and broader of the two, but surprisingly old, spoke in a quavering voice, demanding in German to see Helen's passport. He took the document and immediately passed it to his sidekick, who opened it up, minutely scrutinizing each page.

"Is there anything the matter?" asked Helen of the man who was now straining to get into the compartment as well.

"No, there is nothing the matter," came the reply.

"May I ask why you're looking at my passport?"

"Border."

"Oh, of course." The customs officer's eyes were rapidly twitching between her and her picture. He nudged his companion who copied him. "Is this your passport?"

"Yes, it is," Helen didn't bother to look over to it.

"What is your name, please."

"Helen Martin."

"Then why is this passport made out to Rosa Kovslovsky?"

"It is? I don't understand." Helen took it back and saw that it was Rosa's. She grabbed her bag off of the floor and started rummaging around in it. To her relief, her own was still there. She pulled it out and handed it to the official. He glanced at the name and the picture and then again passed it along to his fellow officer who examined all of it—her personal information, her visas, the stamps from a trip two years ago— with the same thoroughness with which he had examined Rosa's.

"Why do you travel with two passports?"

"I don't. That one must have been left accidentally by . . ." she groped for a word to describe Rosa, "ah, Rosa Kovslovsky."

"Who is this person? A relative?"

"No, just an acquaintance. I suspect that she'll be quite inconvenienced when she discovers her passport missing."

The official to whom she had been talking turned to the other, an inquiring frown on his face. The second man nodded, pulled a huge rubber stamp out of his pocket, stamped it ferociously, and slapped it shut, passing it back to the first man who, after flashing it open to double check the contents, handed it back to Helen.

"Is that all?"

"Now we must examine your luggage."

She felt her breath contract unreasonably at the notion of these officious men going through her bags but handed them over without a word. The conductor politely pushed past her, zipped open the larger one and motioned for her to stand aside for the officers to look. They cursorily lifted up the few garments, fingered the side pockets, tapped the outside, and then asked if she had any others. She pointed to the shoulder bag leaning desultorily against its companion. While one of the officers looked through it, the conductor tossed the other back up onto the rack. Helen, still standing, felt waves of claustrophobia sweep over her and overcompensated time and again in an effort to keep her balance in the small space available. By this time the official had found the box and was clawing at it to find a way to open it. Helen gestured to

him to hand it to her. He held onto it for a few more moments, unwilling to give up, and then finally passed it to her. She opened it and gave it back to him, her mind darting about, trying to formulate a reason for carrying a human bone around eastern Europe. Both of the customs agents craned their necks to look into the box at the same time. Their interest captivated the conductor, who stood on his tiptoes to see over their shoulders. The older, taller official flipped the pages awkwardly, his face severe until he found the bone. But he wasn't interested in the bone itself; it was the ring that had caught his attention.

"Is this yours?" he asked. Triumph tinged the suspicious tone.

"Yes, it is." Helen lied convincingly.

"Have you declared it?"

"No, it's just a family heirloom," she lied again. "I don't think it has any value."

"It looks like a very precious piece of jewelry to me. Why are you carrying this around with you on a train?"

"As I said, it's from my family. I like to keep something with me to remind me of them."

The shorter official tapped the other on the arm and whispered to him. He nodded.

"Please show me the inside of the ring," he asked handing the finger to Helen.

"It might be stuck here," she said while pulling on the ring, but it came off easily. Helen frowned at it with surprise and then handed it to the official. He squinted to read the writing on the inside of the band. He gave it to his counterpart who did the same and then handed it back to Helen. She remembered with relief that it had been engraved to another Helen.

"You must, in future, please, declare this ring when crossing borders from one country to another," he cautioned. Helen put the bone and then the ring back into the book and was about to close the lid when the official motioned her to pass it back over. He removed the book, handing back the box, flipped through the pages once again, and then said, "May I add something to this collection?"

"If you want," replied Helen slowly. He consulted with the others in a whispered voice, first pointing to the box and then to Helen herself. Then, as though mimicking the conductor on the train she had first taken to Vienna, the two officials started going through their pockets, pulling out coins, bills, toothpicks, lint, nail-clippers, papers, combs— all of the detritus that one could ever expect to find in the pockets of customs officials. The one who had initially asked if he could put something in the box patted his back pocket, cried out something that sounded like "Ah, ha!" and yanked on what turned out to be a five-inch-long tress of auburn hair, bound by a blue ribbon. He waved the tress a couple of times in the air, shaking it free of dust and lint, and then gently and ceremoniously inserted it between two pages. This lock of hair must have represented someone very special. Helen took back the box and opened it to the page where the man had inserted it. He had managed to place it into a perfectly cut oval that she had previously overlooked.

"Why have you given me something so important?" she asked.

"Because this box is much more fitting for it than my back pocket. I have carried this lock of hair with me for almost fifty years and for fifty years I have felt badly every time I sat down. Now I know it will be in a receptacle worthy of it. You must remember to check that the ribbon is secure, otherwise it will slip off and the hair will fly all over."

"May I ask where it is from?"

"A long story," he laughed as if embarrassed to have said such a trite phrase. "Maybe I should say, 'Once upon a time!'" He looked at the other official and at the conductor, both of whom immediately sat down on her coat lying along the edge of the banquette. Helen motioned them to get back up again, pulled away her coat, and then gestured for them to sit down again. This time she joined them. The official with the story stood in the corner facing them, leaning against the wall.

He patted his pockets in the familiar gesture of one searching for cigarettes, and to Helen's dismay he extracted a crumpled packet. She glanced around the compartment looking for a no-smoking symbol. As his eyes followed hers he shrugged as if to declare that he was governed

FABRICA Ed. princeps. Basel, June

Title (*cf.* Fig. 55): [In upper shield] Andreæ Vesalii / Brvxellensis, Scho
medicorum Patauinæ professoris, de / Humani corporis fabrica /
septem. [In lower shield] Cvm Cæsare / Maiest. Galliarum Reg
Senatus Veneti gra— / tia & priuilegio, ut in diplomatis eorundem
tinetur. [Below woodcut] Basileæ.

Colophon: Basileæ, ex offic with 2 woodcuts,
Ioannis Oporini, / An full-page, ending with folded lea
paratæ M. XLIII. / Me io. and second m3 unpaginated.

Collation: ol. (R and italic LIBER IV, m4a-p4, 1 chapte
cancel Z, a 1; with 100 full-page view
canel Mm³; peripheral and 7 m nor w
[6] *ll.,* 663 pp. ong uml d cuts, e ing folded sheet
659), [18 *ll.* showing cerebra periphe
nerves.
Content ntispiece-title 1*b*
blank; 2a reface to Charle LIBER V, p6 chapt
dated P ust 1, 1542; *5 lette on abdominal org 0 min
to Opo d Venice, August illustrations.
24th; *6 (sometimes insert- LIBER VI, Aa4 5 chapt
ed facing blank. on thoracic orga 13 min
LIBER 6*b*, 40 chapters il strations.
(last misnu on bones and LIBER VI 2a, 19 ch
cartilages wit ts, major or ters, 18 of w brain and
minor, includ ll-page cial minor illu
skeletal cuts: p. 1 apter XIX (with
spade; p. 164, "con eals with vivesed
view with skull ("Alas, po Yorick siology which 'ends
p. 165, "lamenting" three-quart our concerning the structure
back view. the human body undertaken in
LIBER II, P1a-g4*b*, 62 chapters on name of the students.' KK2*b* lis
ligaments and muscles, 36 woodcuts errata (which overlooks the misn
including 14 full-page muscle figures. bered Chapter XL for XL at the end
That on p. 181 wrongly marked Prima Liber I); Kk3a-Mm7*b* index foll
for Quarta. by register; Mm8a colophon of pr
LIBER III, g5a-m3, 15 chapters on er; Mm8*b* printer's device.

neither by signs plastered onto walls, nor by fastidious tourists. The acrid sulphur of the match could not compete with the intense smoldering fumes that followed. As he drew deeply on the cigarette, Helen saw for the first time, the yellow, brown, ochre layers of nicotine laminating his fingers, excavatable strata of Turkish, Egyptian, Syrian, and Russian tobacco. By comparison, the old man in the Budapest pension had been a novice smoker, relying on years for his habit, rather than the quantity crammed into those years. The compartment filled with an addictive haze hinting of cloves and forgotten seductions. She no longer objected to his smoking.

"I was a student in Vienna," he began. "I was going to study medicine and be a doctor or, perhaps, a surgeon. I come from Sofia, in Bulgaria—I've changed my name," he confided, "and had just begun my studies at the medical school. I was not doing very well. My earlier studies had been easy; I think most students find this is the case." He looked at the conductor, who nodded solemnly in confirmation. "Plus the war was just finishing and nobody's mind was on studying." He looked again at the others, who nodded vigorously. "I lived in a boarding house on Liebiggasse, close to the medical school. My landlady's name was Frau von Ehrlach, a very nice woman, who fed us . . . pardon, I'll get on with the story." The conductor had poked the official in the shin with the pointed toe of his shiny black shoe. The name von Ehrlach startled Helen into paying closer attention, but it was a common enough name, after all, wasn't it?

"This was a mixed house, not so unusual in Vienna in those days, as all students, men and women, were considered serious and interested in nothing but study. Now it's not so unusual for precisely the opposite reason. Two rooms down from me lived a very beautiful young woman from Berlin; she also studied medicine. Most of the students in our house were in the medical faculty. She was two years further than me in her studies and had lived in Frau von Ehrlach's house for several years. I don't know why I'm telling you this. Maybe you remind me of her."

"What was her name?" asked the conductor.

"I have forgotten her name," said the official sadly, pausing to remove flecks of tobacco from his tongue. "She never sat with us at the table; she took her meals at different times."

"How beautiful was she?" asked the other official. Both men were leaning forward, their elbows on their knees, their chins resting in their cupped palms. Helen suddenly realized that they had heard this story before, perhaps many times.

"Her beauty had no parallel," continued the official. "As a doctor she would have been a ministering angel, but she wanted to be a pathologist." He frowned at the memory.

"What color was her hair, Günther?" asked the conductor.

"Deep gold," he answered. "It matched the flecks of color in her hazel eyes," his voice trailed off. Helen winced at the mawkish sentiment and looked at the dull tress coiled in the still-open book.

Günther read her mind. "It's lost its life," He fell silent.

"Continue, please, Günther," said the second official.

"She took up with another medical student who lived in his own house also near to the medical school. He had inherited this house and was dreadfully rich. One could see why a girl, especially a poor student, would want to be with a rich man. But he wasn't very intelligent. He also was several years ahead of me, but his reputation was well known among all of us students—he was a cad. We often asked ourselves how he got out of the youth brigade, being a couple of years older. Sometimes she would be gone for long stretches of time, weeks. Other times she would be at the house, steadily working until very late, her light on, her pencil scratching away."

"How did you know? Did she leave her door open?"

"Shhh!" This time both other listeners reacted to her question.

Günther shot Helen a look of disapproval, but continued. "Then one day, after she had been away for almost a month, she came back to the house and resumed her normal studies. She had put a photograph of herself in her desk drawer that I would look at from time to time."

"You sneaked into her room!" Helen couldn't help interrupting again. She stuck her knuckles in her mouth. Günther glared at her.

"I still didn't see her very often but this was all right because I could look at the photograph. One day, however, something happened, a little thing, but disturbing all the same. I found strands of her hair in the bathroom and on the hallway carpet. In her room she began often to leave long hairs on her pillow and at her desk. So I started to collect them. As the days passed there were more and more strands until I became quite alarmed. I saw her less and less and it was becoming quite difficult to go into her room because she was staying there more. Frau von Ehrlach's son—he was just as infatuated, the precocious twerp—would bring her trays up to her door and leave them and then take them away when she had finished. Frau von Ehrlach would normally never do that for anyone else unless they were very ill. I would wait outside, hoping to get a chance to ask her if she were all right, but she was very cautious. I would still find hairs in the bathroom in the morning—I think she waited until late at night to leave her room. By the time I had collected all of the hairs that you have seen me put into the box I knew that she was seriously ill. A healthy person does not lose that much hair in the course of so few days." He looked down at the nearly finished cigarette, examined the ash as if certain to find his future revealed in the delicate grey flakes, then, after lighting up a new one with the stub, pulled a rusty tin box from his pocket and dropped the butt carefully inside.

"So I knocked on her door. She told me to go away. I told her that I knew she was ill and that I could take her to a doctor. She flung the door open and stared at me." He paused, looking very morose.

"What happened then, Günther?" asked the second official.

"I was in shock. She had lost all of her hair, she was completely bald. And she was a mountain! Horribly, grotesquely colossal, as though she had been inflated like some kind of . . . no, as if she had been amplified into an infinite megalith. And she screamed at me. That was the worst of all. I ran down the hall and outside the house, my hands over my ears to cut out the sound of her screams. I didn't go back until the next morning. By then she had moved out. I asked Frau von Ehrlach where she had gone, but no one knew. It had happened in the dead of night."

"I know her name," Helen announced quietly.

"What is it? How is that possible?" asked Günther.

"Her name is Rosa. This is her passport." She held it up in her left hand. "She gave me this box. Perhaps she's somewhere on this train; she seems, it seems, that is, that she's so often nearby."

Günther grabbed the passport and ran out of the compartment.

Helen was left with the conductor and the second official, neither of whom showed the slightest inclination to move.

"Aren't you going to follow him?" asked Helen hopefully. "Don't you have to finish checking passports?"

"Oh, we have time," said the official, easing a bottle of amber liquid out of his breast pocket. "My name, by the way, is Franz Ressel. This," he said, pointing to the conductor, "is Andreas Kölderer." He twisted the cap off and took a swig, then pulled a none-too-clean-looking cloth out of his trouser pocket, wiped off the rim and passed the bottle to Helen. Helen took a dainty sip of what turned out to be nothing more than apple juice and passed the bottle to the conductor.

"Pleased to meet both of you," said Helen, shaking their hands. The three of them still sat on the edge of the seat, staring straight ahead. To break the pause, Helen said, "I'm doing some research about a man named Andreas, among others."

"Andreas who?" asked the conductor.

"Andreas Vesalius. Have you ever heard of him?" she said.

"Hmm, Andreas Vesalius," mused the conductor. "I've heard of him."

"I haven't," said the official.

"Here, look at this book." Helen pulled the Vesalius book out of her bag and passed it to the conductor. The official called Ressel looked at it over the conductor's shoulder.

"He didn't draw these pictures," the conductor flatly stated.

"Probably not. Probably a man named Kalkar. But no one knows for sure," Helen replied.

"Then why study Vesalius? Seems to me that it's the pictures that count." The conductor was frowning.

"But I'm not just studying Vesalius, I'm studying the whole subject. Vesalius is just an easy way to show people what I'm doing."

"I see," said the conductor. He turned his head to look at the official who had started dozing and was now leaning on the conductor's shoulder. "You should go to Padua."

"As a matter of fact, I considered it. What do you know about Padua?"

"Everyone knows about Padua. The medical school there is one of the oldest in Europe, founded in 1222. Vesalius himself taught there in 1537. It was at Padua that he gained the experience to write the *Fabrica*."

Helen was dumbfounded. "How do you know this?"

"You are talking to an Austrian. The chances of running into an Austrian who hasn't studied medicine are very slim. Surely, you have already discovered this? Franz here," he pointed to the official, "in flat contradiction to what I have just said, is also Austrian but hasn't had the benefit of studying medicine. He was training to be an architect and got caught in High Baroque. Nothing can kill an architect's career faster than Baroque. Isn't that right, Franz?" He punched Franz gently and looked at him.

Franz nodded grimly without moving his head from the conductor's shoulder, and then closed his eyes again.

"What about you? What made you stop studying medicine?" asked Helen.

"Nothing at all. I completed my studies and became a doctor; in fact, you can call me Herr Doktor Andreas Kölderer. I practiced medicine—I was a family physician—for twenty years. And then one day I was traveling to Vienna from Budapest, it was on this very train, and the conductor fell down stone dead at my feet from a heart attack. As a doctor I could do nothing, the man was already dead. But as a human being I found I could help by carrying out his work until the end of the journey. You don't actually need to be well trained in anything to perform the functions of a conductor, you know." He winked. "Train officials were

waiting to retrieve the dead man's body at Vienna. When they saw my efficiency," tears came to his eyes, "they hired me on the spot. I've been on this train ever since.

"Well," he said, nudging Franz awake, "time to get going. Thank you for the conversation. This is the first time in many years that I have had a chance to reminisce like that." He shook Helen's hand again and pulled the still dozy official up off the seat. "There is less than one hour until we reach Vienna. Sorry to have interrupted your sleep."

Helen stood for a few minutes with her head out the window, clearing her brain. The cold and the wind made her nose run. The scenery flashed past, spectacular really, she supposed, but not inviting. The grey skies and snow-dusted fields made her yearn for sunshine and warmth. "I'm not a northern person," she announced to herself. "I only work hard because somehow, somewhere, someone put a small chunk of ice in my veins."

She had no idea what had happened to the official, Günther, when he left her compartment, nor did she see Rosa get off the train in Vienna, even though she waited on the platform until the train departed, back to Budapest.

S.

ACCIPIES *breui ſimul cum his literis per Mediolanenſes mercatores Danonos,* tabulas ad meos de *Humani corporis fabrica libros, & eorundem Epitomen ſcul-* ptas. V tinam tam integrè ac tutò Baſileam perferantur, atque ſedulò cum ſculpto- re & NICOLAO STOPIO hic Bombergorum negociorum fideliſſimo curatore, in humanioribuſq; ſtudijs apprimè uerſato iuuene, eas compoſui: ne aliqua ex parte atterantur, aliud'ue incommodum ipſis uectura inferat. Inter tabularum ſeriem exemplar fru- ſtatim repoſuimus, ſimul cum impreſſo ſingularum figurarum typo, cui quo quæque loco repo- nenda ueniat aſcripſi: ne fortè illarum ordo ac diſpoſitio tibi tuis ue operis negocium faceſſe- ret, figuræq; non ordinatim imprimerentur. In exemplari promptè diſcernes, ubi genus chara- cterum ſit immutandum. quandoquidem ſcripturæ partem, quæ organorum hiſtoriam comple- ctitur, continuoq; orationis contextu ſingulis capitibus abſoluitur, lineis ab ea diſtinxi, quæ ad characterum qui in tabulis ſculpti occurrunt explicationem iuuat: ob idq; figurarum & chara- cterum Index appellatur. In continua orationis ſerie nuſquam figuris indicandis interrupta, li- terulas expendes, quas in officinis ſuperlineares nuncupatis: quæ illis reſpondent annotationi- bus, quas interiori margini non tanta induſtria, quanto labore & tædio, adhibui, ut lectori ue- lut ſcriptorum eſſent commentarius, exprimens in quànam figura pars, cuius mentio incidit, ſpe- ctari poſſit: uti annotationes in exteriori margine obuiæ, eorum quæ enarrantur argumentum quodammodo proponunt. In interioribus, ne eſſem prolixior, eam rationem obſeruaui, ut quo- tieſcunque figura indicatur, quæ capiti, ubi annotatio ſpectatur, præfixa eſt, nullum capitis nu- merum indicem: quem alioquin appono, ſi figura alteri præponatur capiti. Rurſus, ſi figura in libro ubi annotatio occurrit, inueniatur, libri numerum figuræ haud ſubijcio. Quamobrem ue- rò figuras hoc illo'ue loco collocandas duxerim, in librorum titulis, & characterum indicibus abundè explicatum reperies. Notarum enim, quibus partes in delineatione quapiam inſignien- dæ fuerũt, loco, characteres quorum in officinis perpetuò uſus eſt, in tabulis ſculpſimus: primùm ferè à maiuſculis, & dein alijs Latinorum orſi: inſuper Græcorum minoribus: mox ab eorun- dem grandioribus, qui Latinis non ſunt familiares: quum uerò hi omnes non ſufficerent, numero- rum typos aſſumpſimus, & ſi quæ alia notula in communibus typis occurrebat. In horum indicũ deſcriptione obſeruatum eſt, ut indicans unamq; priuatam explicationem habens character, in margine liber collocetur. Si uerò peculiarem non habeat indicem, ac ueluti cum alio charactere exprimatur, ipſi punctum in margine ſubieci, ut unà cum cæteris lectori in ſerie obuius fieret. Verùm hanc rationem, ac potiſſimùm cur characterum indicem cum partium hiſtoria confun- dendum non putauerim, aliàs adte prolixiùs ſcripſi: nunc uerò ijs quibus poſſum modis hortor, & rogo pariter, ut omnia quàm nitidiſſimè & ocyùs excudantur, utq; in meis conatibus expe- ctationi, quam omnes de tua Officina, nunc primùm magno ſtudioſorum commodo, feliciſq; Mu- ſarum omine inſtituta conceperunt, ſatisfacias. Præcipuum ſtudium in tabularum impreſſione erit impendendum, quòd non uulgariter ac ſcholaſticè, ueluſ que ſimplicibus duntaxat lineis ſint expreſſæ: nuſquam picturæ ratione (ſi interdum locum quo res delineatæ ſuffulcirentur, excipias) neglecta. & quanquã hic iudicio ualeas, nihilq; nõ de tua induſtria & ſedulitate mihi pollicear, hoc unum percuperem, ut inter excudendum id exemplar quàm proximè imitareris, quòd à ſculptore ſpeciminis ſui loco impreſſum, unà cum ligneis formis recluſum inuenies. ita e- nim nullus character, quantumuis etiam in umbra reconditus, oculatum ſedulumq; lectorem lati- tabit. & quod in hac pictura longè eſt artificioſiſſimum, mihiq; ſpectatu perquàm iucundum, li- nearum in quibuſdam partibus craſſities ſimul cum eleganti umbrarum obfuſcatione apparebit. Verùm non eſt quòd hæc tibi perſcribam, quum in papyri lænitate ſoliditateq; ac in primis in ueſtrarum operarum diligentia poſitum ſit, ut ſingula, quale nunc mittimus exemplar, noſq; hic aliquot impreſſimus, ex tua Officina omnibus proponantur, multiſq; fiant communia. Dabo ope- ram, ut non ita multo poſt ad uos proficiſcar, & ſi non toto impreſſionis tempore, ſaltem aliquan- diu Baſileæ cõmorer, mecum formulam decreti Senatus Veneti allaturus, quo cauetur, ne quis

tabularum

ROSA'S WEDDING

The wheels and gears ground and screeched interminably, stretching the last few miles into an agonizing hour. Helen, at odds with her book and trammeled by her agitation, pulled out her map and traced the route with the tip of her finger. The names Ingolstadt, just north of Munich, then Augsburg, just to the west, caught her eye. These were two of the cities where the woodblocks had reposed. "What was the name of the other one?" She scratched her eyelid, then opened up her notebook and looked at her scribbled notes from her research in Anselm's library. Basel, Augsburg, Leipzig—Leipzig was further north—Ingolstadt, Landshut, that was it. Where was Landshut? There it was, barely a finger width from Ingolstadt, a mere detour from Munich. The blocks had moved from Ingolstadt to Landshut in 1800. What was it about Landshut that kept them safe from the French? Her useless guidebook said nothing of interest about the place, implying that the last episode of note occurred in 1592. It had little more to add on the subject of Ingolstadt either. The French invasion had apparently been a non-event in the eyes of tourism.

According to Vesalius himself, Milanese merchants—the agency Danoni—had brought the woodblocks, their proofs, and the letterpress plates for each figure over the Alps from Venice to Basel. When Helen first read this she had thought this seemed like paltry cargo, in light of all else they'd be transporting: oils, spices, cloth, wines. But

further readings revealed that the blocks were each about 42 centimeters long and 28 centimeters wide, which made them just over 16 by 9 inches. Each probably weighed several pounds. Two hundred of them would make at least 400 pounds. Not a second-rate undertaking after all. In Vesalius's letter to the printer Oporinus he mentioned that he and a Nicolaus Stopius, the manager of the Bomberg firm and a friend apparently, took extra special pains to pack the cargo carefully. But what did the Bomberg firm do? Vesalius assumed that Oporinus would know them.

The missing details were further confused by more recent disputes. One scholar claimed that since the Danoni Agency was from Milan, it followed that the blocks would have been transported through the Alps via the Splügen Pass then on to Zurich and Basel; another asserted that they must have gone through the St Gothard pass. And how about from Basel to Augsburg, and so on? Some fifty were missing by the time the library ended up with them. Did blocks slip away on each consecutive journey, somehow just not making it? Helen pictured tired porters abandoning blocks at road-side inns, greedy innkeepers selling them for a few pfennigs, or worse yet, ignorant ones chopping them up for firewood or building them into the walls of their barns.

The detail about Nicholas Stopius being a friend reminded Helen that Stefan Arany had referred to Vesalius's wife Anna. Why were details of this sort—friendships, marriages—so lacking in this history? The historians concentrated on animosities, accusations, and tragedies. Where had Anna come from? How had they met? Why didn't she go with him to Jerusalem? Was she with him when he died? Did his daughter ever marry and have children— more Annas, perhaps? Vesalius's Anna reminded her of her Anna with the dog. Her Anna who was convinced that Vesalius sold books in Munich. No wonder she hadn't thought much about that conversation—it was just too crazy.

Sleet was falling heavily when she arrived in Munich. The skies were dark, and the station was jammed with crowds of people.

She made her way immediately to a hotel that a colleague had recommended. "It's cheap and kind of grotty," he had told her, "but it's clean, safe, and close to the train station. And that's all you can ask for in Munich. Prices are unbelievable."

The hotel, housed in a modest-sized modern building, was rather grim. Compared to its exterior and the exteriors of the neighboring buildings, the lobby was quite inviting—marble floors, aspidistras, over-stuffed easy chairs, impressively contemporary check-in counter with three clocks announcing the time in different parts of the world. After checking in, sadly without looking at the room first, she realized with a sinking feeling that the clocks showed different times because none of them worked, and that the easy chairs were home to single men, all of them silently staring at her. The clerk showed no surprise at the arrival of a lone female traveler; Helen took solace in this fact and decided to tough the night out and move the next morning. Her room was on the second floor, a laborious climb up narrow stairs, necessitated by an out-of-order elevator. The dilapidated room, at the end of a long hall, had an ill-fitting door, was furnished minimally, and yet was still crammed. The inventory included two sorrowful beds, each covered with—Helen counted them—six thin moth-eaten blankets, one rickety painted wooden chair, one matching table with oilcloth glued in patches to the surface, one side table between the two beds, and a free-standing radiator heater, also between the two beds. There was a cracked, stained sink and a tarnished mirror, a towel rack with a single hand towel next to the sink, and under the sink was a pink plastic waste pail molded to look like a woven basket. The floor was covered in a bilious linoleum— the pattern worn away at the entrance to the room—and the walls were painted a hospital green. A framed photograph of Lake Maligne hung crookedly on the wall above the table. She straightened it, but, uncovering a border of grime, restored it to its original jaunty angle. Redecorating the room was not her responsibility.

In addition to the single bare light bulb suspended from the ceiling, there were two shaded reading lamps above each bed and a powerful fluorescent lamp above the mirror over the sink that hummed and

crackled noisily when turned on. Only one of the reading lights worked. She flopped onto one bed and then onto the other, picking the one that sagged the least. Having chosen, she whipped the blankets back, hoping to take any bedbugs by surprise. The sheets were worn but clean, and there were no traces of bugs. The blankets were a disappointment; she had come to expect the fluffy quilts that had covered the beds in Vienna and Budapest.

The tap dripped slightly, resisting Helen's efforts to make it stop. She tried to figure out how the heater operated, for the room was awfully damp and cold. The radiator, as stone cold as the stagnant air in the room, stood mute and unresponsive to her twists of the rusty, uncooperative valves.

The drapes hid a set of dusty venetian blinds, which Helen raised to see the street below and the buildings across the street. The entire block seemed to have been built in the same style, modern on the surface but shoddy in technique. Rather unsettled, she shut the blinds, closed the windows, and then went looking for the bathroom down the hall. The toilet was in a separate room from the shower and seemed clean enough. The hotel on the whole was very clean—Helen couldn't fault that—it was just so cold and depressing.

Back in her room, she turned on the hot water tap, letting it run while she dumped the contents of her bag onto the bed. Testing and retesting the temperature, finally giving up when it seemed that the water could get no colder, she proceeded to put on every article of clothing she possessed, tights under trousers, skirt over trousers, socks over tights, shirt over blouse, sweater over shirt. "I am determined to be warm," she muttered out loud, "no matter how ridiculous I look." With one last look out the window, she locked her door and headed towards the stairs. It was just after seven.

"Is there no hot water?" she asked the clerk.

"Eight o'clock," he replied without looking up. She dropped the key on the counter, automatically checking her watch against the dysfunctional clocks, and strolled past the lounging men who had decided that she was of no interest at all.

The sleet had stopped but water was still dripping off of the awnings. Traffic splashing through the puddles constantly threatened passersby with showers of heavy wet snow. She hadn't taken the time to study the map while still in the hotel, and now found herself lost and disoriented. Not even sure of the direction back to the train station.

Food. Got to eat. Hunger always makes things seem worse than they are. A good meal and the room will look like a suite in the Ritz. She passed hotel after hotel and was struck by the similarity between these and the one she was in—the fancy lobby, in each instance, no doubt masked uninspiring rooms. She was also struck by the sheer quantity of men hanging around. Where were the women? Didn't women travel, too?

Her room, by the time she returned, was suffocatingly hot. Someone had either come in during the evening and had opened the heater, or it was controlled from a central source. Helen could now smell the warm dust molecules dancing faster and faster as the temperature increased. Just as she had tried to turn it on earlier in the day she now tried, even more fervently, to turn it off. Giving up, she threw open one of the windows, leaned out and breathed deeply, savoring the aroma of the city, surveying the now abandoned street below her.

Helen woke up wearing her bones on the outside of her body. "Oh God," she groaned, "now what's happening?" She ran her hands up and down her arms and then along her hips to her thighs, hearing the clacking of bone against bone, feeling the skeletal structure straining against her body underneath. "God," she sobbed, "why me?" and her mind flew immediately to the hallucinating heat of the radiator.

"Helen, Helen, wake up," a voice came from the end of the bed, and her eyes leapt open.

The fluorescent light was on, its harsh glare illuminating every corner of the room. She sat up, first looking down at herself, startled to find the light on, shocked to see skin, not bone, and alarmed, as she raised

her head to look around the room, to see Rosa sitting at the foot of the bed. Behind her, sitting at the table, picking at the oilcloth, smoking a cigarette, was Günther, the customs official.

Rosa was wearing a voluminous white wedding dress, the satin stretching dangerously across the mass of her bosom, the tulle of the veil sprouting wildly from her head, cascading about her body. The hair of her wig was done in tight curls, and her face was made-up into the mask of a young bride.

Helen eased her back against the wall and pulled her knees up close to her chest, putting her arms around them, trying to comfort herself. "Rosa, go away," she cried. The wedding dress was the last straw. Rosa turned to Günther who crushed his cigarette onto the table top, walked over to Helen, and knelt by the side of her bed.

Helen looked over at him. "What do you want?" she snapped. He lifted up his hand to pat her knee consolingly, but she drew away, alarmed.

"We just want to thank you," he said, sadness crumpling his face. "We didn't mean to scare you."

"Thank me for what?" she asked suspiciously.

"For bringing us together again. Without you we both would have spent the rest of our lives alone. We got married. You can see that." He looked over at Rosa, his eyes glowing. "Isn't she beautiful in her lovely dress? I've always dreamed of this moment."

Helen squinted at Rosa, trying to block out some of the fluorescent glare. The spectacle of the old woman in the virginal dress was too much. Helen brushed aside Günther's pacifying hand and slid down to the end of the bed to get a better look. She felt cruel, seeing these two decrepit, pathetic beings so happy and so pleased with themselves. But she felt frightened as well; the impression of the unforgiving bones still lingering upon her skin. She rubbed her arms, anxious to dispel the sensation.

Helen put her face close to Rosa's—much as Rosa had done to her the last time they had met—inspecting minutely the fissures in the caked make-up on her jowls and chins. Flakes from the heavy mascara

around her eyes had tumbled, resting like fruit flies here and there on her cheek. Crusted sleep mixed in with the deep indigo of her eye shadow, nestling in the corners of each eye. Powder clung to the long hairs that grew along her jaw line and on her upper lip. If Helen blew a puff of air, no matter how lightly, the whole room would be aswirl in floury clouds.

Lipstick smeared the far reaches of Rosa's mouth, and as Helen continued her intense survey, Rosa rubbed the plump, waxen lips, smearing the color even more. She looked absently at the tips of her fingers and unconsciously wiped them off on the folds of her dress. Patches of magenta accumulated on the satin near her right thigh. To top it off her hair was tightly curled because she had neglected to take the pins out of the wig. While Helen was studying her Rosa began to chuckle and shake nervously.

"What do you see?" she asked.

Helen frowned. Mean as she felt, she couldn't bring herself to tell Rosa that she was a miserable mockery.

"Doesn't she look wonderful?" Günther's insistent voice from behind her reminded her that she and Rosa were not alone. Seeing his face so pleading and yet so euphoric, she nodded silently to him. Günther was clearly head-over-heels with Rosa, but Helen somehow doubted that Rosa could love him back. No, doubt was too cautious a word. Helen looked Günther over again, but assessingly, wisely, and she knew she could never love him. He was too weak, he loved too deeply, too completely, too surrenderingly. He kept nothing back. And if Helen couldn't love him, neither could Rosa.

"Is there something wrong with my make-up?" Rosa asked imploringly.

"No, Rosa, nothing is wrong, nothing at all," Helen said.

"There is something the matter!" Her hands fluttered about her face like large hummingbirds, lightly touching nose, cheek, chin, earlobe, hair. She grabbed her wig with both hands and shifted it about, rubbing it around her bald head. Günther was watching every movement of his new bride with his rapt look of love and attention.

"I'm always so perruqued! There! Is this better?" Rosa asked, leaving the wig slightly askew. Without waiting for a reply, she popped her bottom denture out of her mouth and mumbled to Helen, "Here, hold this." She stuck the still-wet appliance in Helen's hand. She then removed the top one, looked at it, and zipped it back in. Helen nearly threw up at the sight of the glistening pink and ivory, but managed to notice that the denture had, in the place of its second premolar, a pearl. Too much was happening too fast. As she reached to pick the pearl out of its socket, Rosa grabbed the denture back and replaced it. Helen hopped off the bed and ran to the sink, where she washed her hands over and over, rubbing them vigorously with the tough green laundry soap supplied by the hotel management.

"That's revolting stuff," exclaimed Rosa. "How did you end up in this squalid dive anyway? It's full of Turks!"

That explained the men in the lobby. Helen shrugged.

"You really must celebrate with us, Helen," said Rosa, putting out her hands and drawing Helen back towards her. "Come out with us and celebrate."

"Where, Rosa?" asked Helen coldly, drying her hands. "It's the middle of the night." She would never forgive Rosa for that puerile demonstration.

"Pooh, what does that matter in Munich."

"No, I'm not going with you. You're leaving and I'm going to go back to sleep." She suddenly noticed that under all of the veiling and folds of material Rosa wore a black armband on her right arm. "Who has died, Rosa?"

Rosa looked down at her arm, moving the tulle further out of the way and stretching her arm out fully to better display the armband. "I almost forgot," she said, rearranging her expression into a mourning pout. "Your friend Friedrich Anselm has passed away."

Helen's heart jumped, tripped over itself. An emerging wail was subdued before it had a chance to betray her. "Herr Anselm? But how?" Coming from Rosa, this could be a trick. She had to be on guard, not let her defenses down; to even think of it.

"You tell her, Günther," Rosa sobbed theatrically. "It is too much for me." Helen looked at her in disgust, knowing full well that the histrionics were a sham. Rosa had no tears left. She knew that; she had worn her eyes. She knew every tiny part of Rosa's vision, and it had been decades since her tear ducts had sacrificed their offspring to soothe the hardened surface of her eyes.

Günther hoisted himself up from his kneeling position, groaning and creaking as he did so. "Fire," he said. He walked over to the rickety chair and sat back down with a wheeze. "He caught on fire." To emphasize the situation he lit another cigarette. Maybe it was true; Günther couldn't lie. The panic she could feel rising in her was fanned by Rosa's continued bawling.

Rosa suddenly stopped and pulled a white beaded handbag out from under her. She ferreted about in the bag while Helen waited anxiously for Günther to fill in more details. Rosa, not finding what she was looking for, wiped her tearless eyes with the hem of her dress, leaving a streak of blue and black not only on the dress but across her face. She fussed some more, eventually pulling out a folded newspaper. There were several pages dated from the day previous. Helen scanned the headlines, lurching to a stop at the heading, "DISTINGUISHED SCHOLAR DIES IN FIRE. Herr Friedrich Anselm, distinguished collector of rare anatomical treasures, perished in a fire that consumed his house and his valuable collection yesterday evening at 2300. Fire fighters and emergency crews rushed to the scene but arrived too late to save the collector's life. The fire took two and a half hours to extinguish and caused the evacuation of neighboring houses. Herr Anselm left no survivors. Please see obituary, page 42."

Helen scrambled through the rest of the paper, looking for the obituary. The second page was covered with a full-page advertisement for a fashion show, and the next page had the international weather report and a selection of exclusive houses for sale. She looked at Rosa inquiringly.

"Yes?" said Rosa, her face once again composed.

"The obituary?" asked Helen curtly. She handed the paper to Rosa, who shook it about as if the obituary might be clinging annoyingly to one of the sides.

"Didn't you bring it, my love?" asked Günther solicitously.

"Yes, of course I did," Rosa snarled, "it's here somewhere." She opened up her bag and looked again, turning it upside down and emptying the contents onto the bed. Among the items that fell out was Rosa's passport. As Helen reached out for it, Rosa snatched it away in a voice reinforced by sarcasm, "Thanks so much for seeing to its return." And her expression was unmistakable: "You can see what it's got me," Helen read on the contorted face.

In addition to the passport were several thick rolls of German marks, Austrian schillings, Hungarian forints, and Bulgarian leva, rolled and bound in elastic bands. The money, for some reason, reminded Günther of the lock of hair.

"The hair, Helen, show Rosa the hair!" he cried out.

"Later, Günther, can't you see the poor girl is upset?" Rosa waved him silent. The passport out of sight and forgotten, she unwound the wad of schillings and found the obituary rolled up in with the bills. "There," she said triumphantly, handing the clipping over to Helen. "See, I told you I brought it," she cooed to Günther, throwing him a kiss that brought a boyish blush to his face.

These machinations were lost on Helen, who had buried herself deeply in the obituary.

Friedrich Franz Anselm (1927–1998), illustrious and sublime collector of art, died tragically yesterday in his home in Vienna. The only child of the controversial speculator Franz Hermann Anselm (1890–1965) and leading doyenne of Vienna Society, Helga Louisa Anselm (1892–1991), Herr Anselm began his distinguished career as an expert in anatomical art by studying medicine at Vienna's University. He traveled prodigiously, both to augment his formidable collection and to consult for galleries and museums around the world.

Born in Vienna, he also had strong ties to Munich, home of his governess and close friend Fräulein Helen Kehl (see accompanying obituary). By 1965 he had claimed to have made the circuit

between Vienna to Munich over one hundred times. Never enjoying full vigorous health, Herr Anselm became clinically blind in 1967 but did not permit his condition to interfere with his collecting.

Friedrich Anselm remained single all of his life and leaves no heirs. The unfortunate circumstances of his death, a spectacular fire of unexplained origins, also destroyed his precious collection. It is roughly estimated that approximately 14,000 irreplaceable sketches, paintings, engravings, books, photographs, figures, and instruments were consumed by the blaze.

Funeral services . . .

Helen folded the piece of paper back up and said quietly, "Would you please leave, now?" It *was* true; Rosa hadn't tried to deceive her. How long could she restrain the grief that was pounding against her head, her ribs, pounding to get out? It was so powerful it stopped her breath, it battled with other long-lost griefs. The others she had never acknowledged, the ones that had been weaker. They were still there, not ready to cede their places. They had become too comfortable hiding in empty corners. "Get out!" she yelled suddenly.

Rosa replied evenly, "We wouldn't think of leaving you alone. Besides, you must show me my hair."

"We should go, Rosa." Günther was quietly inching towards the door.

"I want my hair." Rosa's petulant tone held no possibility of compromise.

"If I give you your hair will you go?"

"Oh, Rosa doesn't need her hair back, do you sweetheart? She has such nice hair now." Günther leaned over, gently swept part of the veil away, and carefully undid one of the pins, running the freed strands between his fingers. He just as carefully rolled it back up and replaced the hairpin.

Helen took a deep breath, grabbed her shoulder bag from under the bed, removed the box, opened it up and pulled the tress out, handing it to

Rosa, who was sitting like a Buddha, waiting with outstretched palms. She left the book open to the now-empty oval cut into the pages. Rosa stroked the lock as though it were a beloved pet. "Oh well," she sighed, replacing it into the cavity, "it is of no use to me anymore. What else have you got in here now?" She picked through the objects—tried on Anselm's glasses over her own then fingered through the loose pages of the Latin-English dictionary. "Such a beautiful language," she declared with uncharacteristic gentleness. "*Tactus libentia*," she was now reading from the title page, "the pleasure of touch. *Videndi miraculum*, the wonder of sight. *Odorandi potentia*." She lingered over the long *i*.

Helen filled in the pause herself, "the power of smell." The force of the words and of Rosa's compassionate, exquisite recitation of them hit Helen hard. As hard as the distressing sensations she'd been experiencing in Rosa's presence.

Suddenly, without reading the rest, Rosa announced their departure, declaring, "It is imperative that we leave. You mustn't keep us any longer as we have much to do." Günther stood up obediently and helped Rosa off of the bed. The two of them walked out the door and down the hall without saying goodbye, leaving Helen at last to sorrow over the blind old dead man.

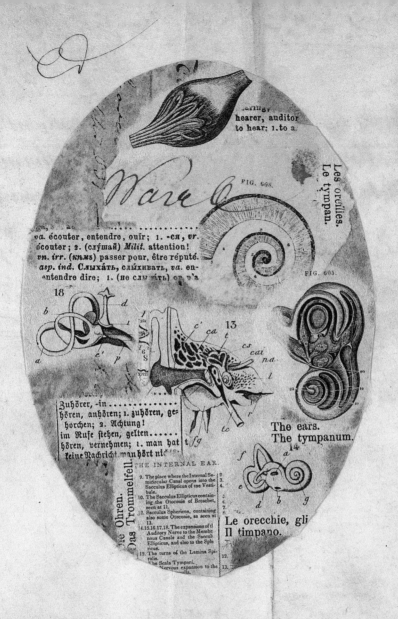

HEARING

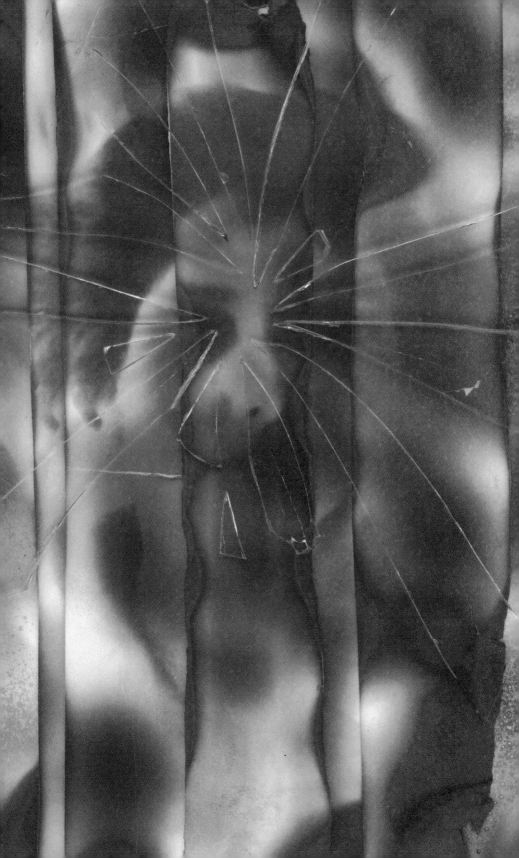

GÜNTHER

Mourners all know that grief retreats in the face of practicalities. Was Helen's loss really Friedrich Anselm, a man as ethereal in life as in death? Or was it the visceral assurance of his library—his books, his pictures, his walls? Or was it the inexplicably intricate caches of whispered clues that materialized when least expected but most needed? Clues to? To Martin's disappearance? Perhaps. But did she care anymore? She hadn't thought of him for—hours? days? eons? Or were they clues to the whereabouts of the Vesalius woodblocks? Maybe. But were the woodblocks really just a single part of an even more complex enigma? And what did an anatomist who lived five hundred years ago have to do with Rosa, Anselm, or herself, for that matter?

And the photograph of Rosa. Together with Rosa herself—a very personal memento mori. Living cells and silver nitrate molecules mixed into a bleak, sobering vision of the immediacy of time's cruelty. She reexamined the photograph for the hundredth time, holding the print carelessly, letting her fingers stain the surface with their oils, their dust. What would it matter if her negligence ruined the print? She stole it, after all; she shouldn't even have it. She stared at it for the thousandth time, but now through eyes freshly contaminated by the remembrance of Rosa's tainting gaze. Rosa, too, said it looked just like her. Helen reached for a book of matches left lying on the bedside table and clumsily managed to strike one alight. She held a corner of the print to the

flame, mesmerized by the curling smoke, the blackening edge. This is how the photo would have been destroyed if she hadn't stolen it.

After several futile attempts to get it to burn, it finally burst into flame, its surface and subject puckering and buckling. Helen watched it burn for the thousandth time. Cinders dropped into her lap; the heat scorched her fingers. In seconds the portrait was completely consumed. She painstakingly brushed the ashes into the palm of her hand, taking care to pick up stray flakes off the floor and the bed, ready to make a place for them in her box. But instead, she abruptly blew them into the air. Rosa's face in blackened powdery clouds. Her face in an ashy fog. Their face. Spiraling. Into the air.

It was time to hunt for a different hotel. This one, bad enough to begin with, was now impossible. No amount of scrubbing would remove the cremated traces from the room. They would always be there, floating, hovering; waiting to be breathed in, threatening to complete the transformation. She had to move, try to work out what to do next. Her first instinct had been to fly back to Vienna to find out what happened to Anselm, but sober reflection forced her to face the fact that she had only known him for a few weeks and that her presence would be unnecessary, and, perhaps even more, misunderstood.

She paid her bill and headed out into the now-sunny streets of Munich. The city that morning had a fresh lively appearance, passersby were cheerful, coats were unbuttoned, reminding Helen of times when she pretended she was in love. This was the first moment of real sun that she'd seen since leaving for Europe six weeks earlier and the weight in her heart lightened just a bit. Stopping to consult her map, she headed back towards the train station and a street of decent-looking hotels that she had passed the night before. Her route took her along busy streets and past stores jammed with activity. She heard her name being called out and turned around, startled.

It was Günther, all by himself, standing by a display in front of a bookstore, waving a book back and forth. She noticed, with surprise,

that he was still wearing his custom official's uniform and remembered that he had worn it the night before.

"Hello, where's Rosa?" she asked.

Günther pulled a long face but said nothing.

"Has she gone somewhere?" Helen persisted.

"Yes," he said, after a minute of thinking.

"Where, Günther?"

"I don't know." The long face pouted childishly.

"I'd like to help," she said, meaning anything but, "but I don't know what she's up to, honestly. Do you have a place to stay?"

He shook his head.

"Do you have any money?"

He shook his head again.

"What are you going to do?"

"I don't know."

Helen was getting impatient. Was she to babysit this man until Rosa showed up to turn her body inside out once again? "Come with me," she said finally. The two of them headed away from the store, but the store owner started yelling and chasing after them.

Helen looked down and saw that Günther still held the book in his hand.

"Did you pay for that?" she demanded.

"No," he said, looking surprised to see it there at all.

She took the book from him and walked back towards the bookseller who was, by now, quite close. She turned the spine towards her to read the title: *I'll Never be Your Bodyguard*. The words rang a bell, but she couldn't place them.

The mix-up at the store straightened out, apologies and explanations exchanged, Helen and Günther again headed down the street. They soon found themselves on a street lined with modest hotels. The first one, called "The Südland," had a charming, welcoming entrance.

The next hotel was only two doors away and the next one after that just across the street, so before committing herself they walked around, sizing each one up. Since nothing could distinguish one from the other,

she asked Günther his opinion in an effort to distract him. He shrugged his shoulders and then pointed to the second hotel, the "Siebert."

The rooms they chose were tiny and quiet, and far more expensive than the room she had had the night before. She checked them both in, after taking Günther's passport from him, and asked the clerk about a good place to eat. She then dragged Günther to the restaurant nearby and they ate outside, basking in a ray of sun as weak and elderly as Günther himself.

Günther picked at his food, alternating occasional nibbles with drags from his ubiquitous cigarettes.

"How old are you?" she asked him.

"Oh, seventy, I guess," he answered morosely.

"Cheer up, Günther, she'll come back."

"No, she won't."

"How do you know?"

"She has all of my money."

"How did she get your money?"

"She always was nasty."

"That was your money in her bag?"

"Nasty, but beautiful."

"All of those marks and schillings?"

"And leva and forints," he added. "She still is beautiful, isn't she, Helen?"

"Yes, beautiful, Günther, but that was a fortune!"

"All of my money."

"How did you get a hold of so much money at so short a notice? You only met her again," Helen thought for a second, "yesterday morning."

"My savings."

"Yes, Günther, a lot of money. Where did you get it?"

"I carry it with me."

"But why? Why not keep it in a bank?"

He looked at her and said, "I am Bulgarian, and you ask 'why not keep it in a bank?' Why not give it away? *Ja,* like I just did. Nasty. Nasty, but beautiful. She still is beautiful."

Helen gave up, finished her lunch, and paid the bill. "Do you want to come back to the hotel, or do you want to finish eating?"

"I'll finish," he said, staring at his plate with a distinct look of revulsion.

"Alright. Don't let him charge you again; I've paid already."

Back in her room, Helen planned her attack on the University Library. With a telephone book borrowed from the receptionist, she looked up the number and the address, and mentally formed the questions that she hoped would help her find answers to the whereabouts of the woodblocks. She had just started writing down possible openings when the clipping that Rosa had left with her the night before caught her eye. Unfolding it again, she reread the brief article about the fire. She picked up the loose, worn clipping of Anselm's obituary and read for the first time the briefer obituary boxed alongside: that of Frau Kehl, aged ninety-one. It noted her birth in Munich, her long residence in Vienna, and listed as her only survivor, her husband, lover, companion, and son: Friedrich Anselm. Helen mused over the wording of the notice and wondered who on earth had written it. Not Herr Thüring, certainly; he was far from the *K*s.

She then studied her map and carefully circled the location of the library. Still unaccustomed to European phone calls, she braced herself and composed the number of the library. After being passed to several departments, she was connected with the curator of the rare book collection, who suggested that Helen come over the following morning, as gossip had reached them about the reappearance of the woodblocks and they were curious to hear anything new. The afternoon was free so she wandered through the streets of the old town, basking from time to time in the fleeting warmth of wind-sheltered havens, and daydreaming in front of window displays heaped with confections and cakes.

As she turned the corner and started down the street leading to the hotel, she could see several black BMWs with official insignias on their doors sitting at the entrance. A large crowd was assembled outside the

lobby entrance, talking animatedly and gesturing to the top floors. Seconds after she first noticed the commotion, the sound of sirens could be heard approaching. She briefly hesitated, considering going away and waiting until the fuss died down, but against her better judgment walked towards the hotel anyway. Several policemen were standing in the middle of the road, turning cars back, causing a traffic jam of unbelievable chaos, as there were no places to turn, and reversing became less and less possible as more cars joined the turmoil. Horns blared and drivers were getting out of their cars, yelling and waving their arms in frustration. As she approached the ever-growing mass of people, glimpses of glass and of a body sprawled upon the ground emerged between shifting legs. She looked up and saw that one of the windows from the second or third floor had been broken, accounting for the shards of glass on the sidewalk and the road.

Helen tried to ease her way between the people and the building, hoping to be able to pop into the lobby without seeing any details of the tragic accident. By this time the wailing sirens had become very loud, the voices around her had risen to be heard over the din, and the blue pulsating emergency lights rebounded staccatically off the windows and walls with each revolution. Two policemen were standing at the hotel door, pushing people away. Helen resolved to retreat and return when the fuss had died down. Being squeezed in so tightly meant that turning around took great effort, but it was nothing compared to trying to fight against the flow of the increasing numbers of gawkers. She clasped her shoulder bag close to her stomach and slipped her arm out in front, using her elbow as a wedge. She'd managed to take two or three steps away when she felt a strong hand seize her shoulder, restraining her from further progress. Twisting to see the source of this hindrance was almost as difficult as putting one foot in front of the other, but she finally realized that a policeman was pulling her back towards the door.

"Pardon me," he said in her ear. "Do not misunderstand. I do not intend—" a surge from the crowd lifted his hand off her shoulder and carried her out of earshot; another wave brought her back "—to be rough." She struggled to turn around again. He was handsome

and mustached, with an imploringly gentle smile. Too gentle for a policeman. Wearing the mustache that Hauptmann Bauer should have had.

The arrival of the ambulance was marked by a sudden hush. He led her into the lobby, asked for her passport, and while flipping through it curtly motioned the clerk to come over and join them. The clerk emerged from behind his counter, carrying the guest registry along with the police form she had filled out. She refrained from asking any questions, imagining that all guests were being interrogated.

"Do you know the deceased?" the policeman asked her.

"I don't think so," she said. "Who was it?"

"Who was the person you were traveling with?" he asked.

"I'm traveling alone."

The policeman impatiently waved his fingers at the clerk who handed him the registry.

"You were traveling with a Günther Mann." His displeasure. She couldn't bear his displeasure.

Helen cursed herself for being so thickheaded. "Now I see what you're getting at. I'm not traveling with him. He's an acquaintance I made two days ago on the train from Budapest to Vienna. I ran into him again just this morning and finding that he had no money and no place to stay felt sorry for him and offered to put him up for a day or two, until he could find a means of returning to his home. I really don't know him at all. He's a customs official," she added, "and he's Bulgarian."

The questions went on and on, giving Helen no time to speculate over Günther's death. The police officer seemed little inclined to fill in the details and Helen sensed that his mood was too dark for her to hazard an inquiry. He asked her where she'd been, why she was in Munich, how much money she had, where she was going next, who her friends were. She asked if she could sit down, was told to stay where she was. The clerk made motions to return to his counter; the policeman gestured for him to remain. Helen began feeling nauseous standing in one place for so long and inched towards the wall where she could at least prop herself up.

She looked out towards the street. The crowd had dispersed and the body had been taken away. She thanked her lucky stars that she didn't have to look at Günther. A dead body engraved onto a piece of paper was not the same thing as crushed and broken flesh and blood. More policemen came into the lobby and talked to the one who had been interrogating her. She was informed that she would have to go to the police headquarters for further questioning. The poor clerk was dragged along as well, but not before he called out to a young boy who came running in and took his place authoritatively behind the counter. The whole party left, with the clerk calling out instructions to the boy.

The ride to the police station was of unparalleled excitement: the siren blared; the driver swung the car in and out of traffic, hopping up onto the sidewalk, needlessly scattering pedestrians as he went. He careened across two lanes, across oncoming traffic, to the station entrance, and stopped with a screeching jerk by pulling up on the emergency brake, throwing all of the passengers into each other's laps and arms.

Their sensational arrival was followed by an endless hour of questions and then the announcement that Helen would have to identify the body. This, she felt, was the moment when they were obliged to explain. They told her perfunctorily that Günther had either leapt out or had been pushed through the window of his room, falling to the street below. His actual death, according to bystanders, had occurred a few minutes later. His age had no doubt contributed to his inability to survive, as the drop had not been severe.

Günther had meant nothing to Helen, but she had pitied him and now she felt genuine regret for his death.

Helen woke up with the sound of shattering glass in her ears. Strong hands lifted her off the bed, gripping her nape and her buttocks, cinching the skin of her neck, cutting into her throat, strangling her breath. She was hurled like a projectile with great force towards the window. Swirling slivers of glass spun about her, weaving a cocoon of twinkling stars as she flew through the window, out into the open air, past the

illuminated hotel sign, and down, down, into the street below, landing with a bone-splintering thump back onto the bed. She lay gasping and sobbing, paralyzed by the fearsomeness of her nightmare, a nightmare that seemed by no means over.

Imprisoned in the airless vacuum of this maelstrom of ricocheting light and billowing winds, she groped for the pillow, the bed sheets, things of substance to anchor her to the earth. The soft glow from the sign, colliding with the surrounding violence, revealed exploding windows and glass shards that flung themselves helter-skelter about the room, onto the bed and floor. The mirror in the bathroom burst into sharp missiles, followed by the light bulbs and the glass in the transom above the door. She put her hands over her ears, trying to block out the fierce clamor echoing all around her. When the tumult abated she dropped her hands and surveyed the room. In the dimness she could see that the glitter of glass covered every surface of the floor and the bed. Glass nested in her hair, and minuscule pieces were lodged into the skin of her face and hands. She wrenched the covers off, carefully patting the sheets, making sure that no glass got into the bed. She then groped for a shoe, shook it out, and with it brushed away a space to stand. Gingerly she placed her feet into the cleared area, slowly and methodically extracting the flakes from her cheeks and forehead, and finding that her fingertips were covered with spots of blood from tiny wounds on her face.

The door to her room quietly opened, admitting both a ray of strong light from the hallway and the silhouette of Rosa who, after taking a second look up and down the hall, came in, neglecting to close the door behind her, sweeping through the glass with loud crunching steps. She was still wearing her wedding dress but now had two black bands on her right arm. She inspected the room and then yanked her veil off, pulling the wig away at the same time. While she was extricating the veil from the hair and the pins, Helen stared at her and wondered why no one else was rushing to the room.

"What happened?" she asked incredulously.

"Exciting, wasn't it?" Rosa absently worked away, still trying to free the wig.

"But what's going on?"

"That's what Günther heard, poor soul, as he fell to his death. Ha!" The wig was free; Rosa let the veil drop to the floor and stuck her wig back on her head.

"How do you know?"

"Why, I was there, my dear."

"Did you push him?"

"No, of course not. I didn't need to." Helen knew instinctively that Rosa was lying; she could lie no better than Helen herself could. She had killed Günther, and she wasn't making much of an effort to hide it. But Helen wanted to see where her game would lead them, what she would get out of the deception. "Why did he jump then?"

"Don't worry yourself about it."

"The police were questioning me for hours. I have the right to know! I had to look at him, too," she shuddered soberly.

"Listen, dear, Günther was pathologically shallow. It is of no consequence why he leapt out that window."

"You stole his money." Helen changed the topic accusingly.

Rosa looked at her with no expression. "So?"

"Rosa, he loved you. Doesn't that mean anything? He loved you for all of his life. He carried a torch for you."

"And I killed him, you think. Well, what better way to go—at the hands of your beloved?" Her sarcasm was bitter. "Your sentimentality is gauche and juvenile. Louis was right when he called you an imbecile."

"Rosa," Helen's voice was wavering, "two dear old men have died. Have you no sorrow?"

Rosa walked over, picked up the coverlet and shook it out, sending more glass scattering. She replaced it and sat down on the edge of the bed. Helen was still cloistered by the ring of shards.

"Your face is a mess," Rosa observed, squinting at her. "Why don't you go wash it off? I can't stand the sight of blood."

"Get out of here, Rosa."

"I don't think so. We have so much left to talk about."

"I'm going to call reception and have someone remove you."

Rosa leaned back on the bed, reclining on one elbow. She beamed and pointed to the telephone.

Helen picked up the receiver expecting to hear a dial tone. Instead she heard a woman's voice—reminding her of the morning in Herr Anselm's study—repeating over and over "Hello? Hello?" In a panic she slammed the receiver down and looked wildly over at Rosa who burst into uncontrollable laughter.

"Show me my picture. Let me see it again." Rosa was suddenly serious and demanding.

"I can't."

"You've lost it?"

"No, I burned it."

"Burned it?" Rosa was incredulous. "When?"

"This morning."

"But why?"

"It should have burned in the house. Who cares, anyway?"

Rosa rolled off the bed, casting her sharp eyes to and fro, nostrils quivering and jowls shaking as though she were on a long-awaited hunt. Dipping down to look under the bed, her corpulent haunches casting massive shadows; sliding out empty drawers, leaving them hanging hungrily open; kicking aside clothing and stray bits of furniture, tangling her feet in the wanton sleeves and legs. Helen watched her, mouth agape in disbelief, as she landed on the bag that held the box. Rosa opened the box and tossed the contents out onto the floor. The box empty, Rosa looked at Helen.

"Where's my picture?"

"I told you, I burned it."

"Where are the ashes?"

Helen raised her arms dramatically, gesturing to the open skies.

"Then there's nothing left of it?"

"Nothing."

"You are sure?" Rosa's intensity was as alarming as her wickedness. Helen met her hard gaze. "Quite sure."

Rosa approached the younger woman, gripped her rigidly by both arms while scrutinizing the fragments of truth revealed on her open brow. Rosa pressed so close that her gigantic breasts crushed Helen's own.

The breasts that Helen wore.

She stood so close that her thick glasses reflected her distorted and watery eyes into Helen's.

The eyes that Helen wore.

Her damp, warm, mortifying breath, so near, so tangible, invaded Helen each time she inhaled.

The death that Helen smelled.

Her fingers, caressing Helen's cheeks, chin, temples, rasped against her skin like fingernails against a chalkboard.

The sound of Rosa's vengeance.

Rosa, still clasping Helen in an imprisoning embrace, freed one hand and tenderly combed strands of Helen's hair back off of her face, back behind her ear. She brushed her lips against Helen's cheek—a woman's kiss: warmer than a mother's, cooler than a lover's, the kind of kiss you would give yourself, if you loved yourself—then whispered, "Are you absolutely sure?"

Helen squirmed: the prisoner needed her freedom. "Yes!" she cried out. "Yes! Yes! I'm absolutely sure!"

Rosa released her and plunged her hand down the front of her dress, wrestling something out from between her breasts. It was her own copy of the photograph in question.

"Here, take this one." Rosa looked around for the box and found it lying on the bed. She tossed the photo in then turned to Helen. "Well, maybe I'll go after all. See you later." She walked to the door, her long dress sweeping a path through the glass. Helen stood watching as she opened the door, flinging a perfunctory wave over her shoulder without turning round. The door closed quietly behind her, closing out the only real source of light. Helen sat back down on the bed, shivering with the experience and, she realized, from the cold air that was blowing in through the holes in the glass. The room was like ice.

When Helen woke up the next morning she scrambled out of bed and then frantically hopped back on it, remembering the glass shards on the floor. But when she looked around the room there was no glass, there were no holes in the windows, the mirror and the transom and the light bulbs were intact. It had been a dream. And what a dream, she thought, sitting back against the wall behind the bed, cradling her head in her hands. No wonder no one came to investigate the noise. No wonder. No wonder Rosa left? Rosa hadn't even been there. It was a dream. Helen got up again and walked over to the window. It was another beautiful day with bright clear skies. People were out and about in the street, cars were honking lazily at each other, a chambermaid was leaning out the window of the hotel opposite, shaking out blankets, singing loudly and off-key, scattering her lyrics to the passersby. Helen held onto herself for a few minutes as she looked out into the street. The memory of Günther was coming back along with the realization that his death had thoroughly driven Anselm's out of her head. He deserved so much more than the few minutes she had given to him.

She walked over to the washroom and turned on the cold water. As she splashed her face, though, her skin began to sting hellishly. She looked up at the mirror to see what the matter was. Her face was covered with tiny wounds.

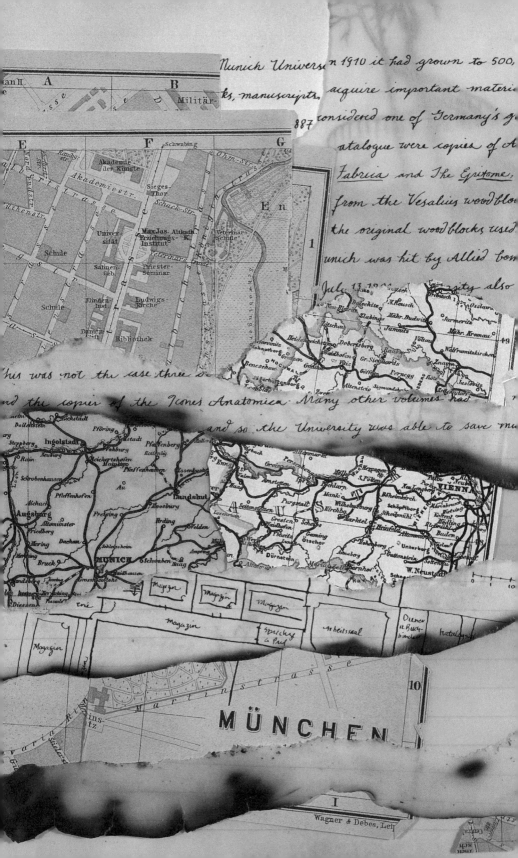

Munich Univers... ...n 1910 it had grown to 500,

...ks, manuscripts, acquire important materi...

887 considered one of Germany's g...

...atalogue were copies of A...

Fabrica and The Epitome,

from the Vesalius wood bloc...

the original woodblocks, used...

...unich was hit by Allied bom...

July 13, 19... ...sity also

...his was not the case three d...

...d the copies of the Icones Anatomica. Many other volumes had...

...and so the University was able to save mu...

MÜNCHEN

Wagner & Debes, Lei...

THE LIBRARIAN

The librarian, Frau Sophie Löwe, sat in a silent display of exemplary posture, her white, patient hands lying on the desk clasped in latent expectation, her hair sculpted into an expert chignon. She had not a strand out of place, no misplaced expressions, and seemed at first to have little to tell Helen. Her muteness contributed to the almost deafening hush: all of the faint sounds that would have been disguised by activities and noises were now running rampant at full volume. Whispers from the outer offices, cart wheels squeaking down the hallway, car horns from distant streets, air blowing in from the vent, the undertones of synchronized breathing—hundreds of lungs, nostrils—from all over the building.

When Helen had been led in to the room by the assistant, Frau Löwe had conceded a slight rise out of her chair just long enough and far enough to grace Helen's outstretched hand with a glancing sweep. It was difficult to say whether or not their hands actually touched or if it was just the air that cushioned Frau Löwe, warmed to the same temperature as her skin, but a gentle rustling like the sound of papers rearranged by a breeze suggested that they had indeed shaken hands. Helen was immediately uncomfortable, feeling herself cold, clammy, creaky and certain that her own dignified features were coarse and clumsy in the presence of this finely wrought woman. Self-conscious, too, she instinctively knew that the minute scars on her face had been noticed but would go unremarked.

Helen, now convinced that the woodblocks must still exist, described her suspicions to the librarian. Frau Löwe's stare, in combination with her smile, gave her a somewhat vacant look, making Helen feel all the more awkward and causing her to stumble over her German. She apologized for her stammering—the composed face nodded understandingly—and explained that she couldn't show the woodcut but could show her the pile of proofs. Frau Löwe picked up the phone and in a subdued bedside tone asked the person on the other end of the line to bring in a copy of the *Icones Anatomicæ* and the first edition of the *Fabrica*. In the intervening moments Frau Löwe informed her that she was not the first person to inquire about these matters.

"I think I am in the rerun of a movie," she smiled. "A man, a newspaper journalist, asked me the very same questions, maybe three months ago. Are you working with this reporter?"

Helen, who had hoped to avoid an explanation of her search for Martin, reluctantly recounted, amidst a trickle of sympathetic murmurs, the circumstances surrounding her investigation.

While they waited, Sophie Löwe described the background of the current library. She explained that the university had actually been founded in Ingolstadt in 1472 and had moved briefly to Landshut in 1800, during the bitter years of war between France and Austria when Napoleon had occupied southern Germany. At this time Germany was subjected to secularization resulting in the destruction of numerous monasteries and the subsequent transfer of books and manuscripts to the universities. Frau Löwe described Landshut as "waking up to a temporary importance" since the university then moved to Munich in 1826. Coming from her mouth, these city names acquired the resonance of history and significance that they had previously lacked. Her account also filled a hole that had been bothering Helen for some time: the question about why the blocks had been moved at all. They were simply following the university. When they were taken to Ingolstadt in 1781 they must have been bequeathed by Dr Leveling or Herr von Woltter, the two men she'd read about earlier, or somehow otherwise housed in the library. Then when the library moved just under twenty

years later, the blocks naturally moved with it, and so on to Munich. Helen asked if there were archives about the donors although she was starting to think that this distant past was a blind, a dead end, that the real story lay closer to the present. Characters like Leveling and von Woltter were crowding the stage, making it difficult to see the real stars, or should she say villains?

"No, sadly, if anything had existed it would have been destroyed in the bombing," Frau Löwe answered. "However, there are numerous published essays describing the history. In 1944 we were the envy of the country. Our library had over a million books, 4300 manuscripts, and far in excess of 4500 incunabula. And we had the Vesalius blocks. We were able to save less than three quarters of the books and half of the incunabula. Thankfully, only a few manuscripts were lost. Today we've worked our collection back up to almost two million volumes.

"The woodblocks were secure in the *Nordkellar,* the North Cellar, and escaped the first bombs that fell on the 13th of July. Part of the library was destroyed during this attack. The real destruction occurred three days later. That's when we lost them finally. Just two years after Vesalius's four-hundred year celebration." She paused to thank the librarian who placed the huge books onto her desk. "But I can't believe that the blocks could have secretly continued to survive all of this time. Their value is too extreme for them to have remained silently underground." She tapped the surface of the *Fabrica* as if expecting the muted response of the leather-covered wooden boards and thick ream of text to confirm her declaration.

"Do you know how much a first edition *Fabrica* would sell for today?" Helen asked.

Frau Löwe rested the palms of both hands on the book's cover while she glanced about the crowded bookshelves that lined the room. She then opened a deep drawer in her desk and pulled out a file crammed with pamphlets. Sorting through them carefully, she shuffled a couple to the side, then returned the others to their place in the drawer. The first one, a French bookseller's catalogue from the 1930s, listed antiquarian books and their prices. After a moment's scanning, Sophie

Löwe turned the booklet over to Helen, pointing to a brief entry; at that time they were selling an edition, missing 2 plates, for 35 francs. She translated from the French: "Beautiful edition with many illuminated initials and a very beautiful portrait of Vesalius; a large quantity of woodcuts representing surgical subjects. This copy is incomplete." Prices for other books listed on the page ranged from 5 to 9 francs. Thirty-five was no doubt expensive.

"I have a more recent catalogue here," Sophie Löwe passed the other booklet to Helen. Several editions were listed, along with a recent auction history. The prices started at a low of £6000 for an edition sold in 1989 to $125,000 for another for sale at the time the catalogue was published. "You can see that if the current price for a book alone is $125,000 then the blocks themselves would be priceless."

"And individual prints pulled from the blocks?"

"Their value would be much reduced. Separated from the book itself would mean that their provenance would be disputable. Of course if they had the text on the back it would be easier to confirm where they came from, but if they were printed without the text? They could be from a later edition, from a printer's proof, from anywhere, do you see what I mean?"

"But why would someone start printing with the blocks and try to pass them off as originals?"

"Again, do you mean original woodcuts from the book or proofs pulled from the original woodblocks?"

Helen had been trying to remember if her print had text on the back. She could only conclude that it hadn't. "Proofs," she said, "pulled from the original woodblocks."

"Done in sufficient quantity they would produce an income, I suppose, but hardly sufficient to make it worthwhile. They would also disrupt the art world, for at least a brief period of time. Perhaps that would be the motivation." Both women looked at each other in silent contemplation of the two possibilities. "Or," continued Frau Löwe, "they could be doing it to hint at the presence of the blocks themselves, to create interest, and thus a market for them."

"Who was the printer of the 1934 edition?" Helen asked. She had forgotten to notice this important detail when examining the book in Anselm's study.

"Bremer Presse, here in Munich." Frau Löwe had flipped to the title page. "Bremer Presse was founded by Willy Wiegand and Ludwig Wolde in around 1911. Herr Wiegand published an essay on the finding and printing of the blocks. Have you read that yet?"

Helen shook her head. "Do you have a copy that I could borrow?" The librarian arranged for one to be hunted down and brought to the office. "I've asked them to look for any other relevant material."

"Do they still exist, the Bremer Presse?"

"No, they were victims, I believe, of bad economic times." She shut the book and thought for a few minutes. "We may have some records of the printing of the *Icones Anatomicæ*. I will go check." She got up from her desk, straightening her narrow-fitting skirt and pulling her matching suit jacket down over her hips. "Feel free to have a look through our copy of the *Fabrica*. It came to us in 1803, during the secularization, from a monastery in Au, close to here, now a suburb, in fact."

The *Fabrica*. At last a chance to dive into this elusive testament. Her hands hovered above the leather-bound boards, fingers itching to storm the pages, eyes hungry to devour the surfaces already scoured by the passing of nearly 500 years, nostrils pinching out all but the reek of dust and paste and rag, ears heeding to the distinct bustle of the past: the pencils, the gouges, the presses, the exclamations of admiration, the cries of disdain, the flames of indignation. She shook her head, wrenching herself out of this flirtation with delirium, and opened the book. As she turned the pages, the thick paper moved the air, filling it with echoes of the searching eyes and possessive hands that had grasped it and cradled it through the years. Evidence of those hands: faint notations in the margins, a misprinted title corrected. She made her way through randomly, now on page 165—*Corporis Humani Ossa posteriori facie proposita*—an illustration of the skeleton, a poignant pose: the skeleton's curved back to the viewer, the knees flexed, the legs apart, the forehead resting despondently on raised, joined hands. Set

against a desperate countryside: rocky, barren earth, a stump, some latent struggling growth.

She returned to the beginning, to the title page that she'd examined in Anselm's *Icones*, the very first one, the raw version. From there to pages of text in Latin, each commencing with attractive illuminated initial capital letters; her gaze at first swung past these but, suddenly arrested by a jarring detail, she looked closer. From page to page, cherubs and putti battled, collected bodies, performed dissections, robbed graves. These initials, possibly cut in Oporinus's own establishment, had been lost. The text itself, dense and incomprehensible to the unschooled, was nevertheless graced with wide borders and subject marginalia notes, creating a most attractive page. One writer had described it as Italian or Venetian in design, rather than German—a compliment in printer's circles. Delving further revealed the clear organization into seven books, the incorporation of the small illustrations into the text, the care and fastidiousness taken to enable the student to cross reference diagrams and legends. She turned to the last few pages and found a magnificent index, each alphabetical section headed by a decorative initial.

Frau Löwe's voice drifted into the room; she'd be on her way back with the archives.

Helen skipped to Book Two, to the muscle diagrams, praying that her own woodcut would seem more familiar in the dim light of age. It was definitely the first, third, or ninth plate. Why couldn't she remember a simple matter of whether the figure faced forward or backward? Did it matter? The introduction to the *Icones* stated that all of the large plates were printed from originals except for the eighth muscle plate. She turned to that one. Definitely not. A despairing skeleton, nearly all its muscle stripped and hanging uselessly from limbs and torso, stood sunken against a stone wall; its sternum and cut-away ribs at its feet. That settled it, her woodblock still existed.

She remembered reading that the eighth block had been damaged before the 1780s, when Leveling printed his edition, so, perhaps, sometime after Maschenbauer of Augsburg got his hands on them. It had been

CORPORIS HVMANI OSSA
POSTERIORI FACIE PROPOSITA.

recut badly by some hack who copied it from the printed example, result-
ing in a backwards impression when it was printed. She also recalled that
Leveling's edition was missing some of the smaller blocks. She twisted
and strained to see if the pages were watermarked, angling the desk lamp
to help her. Not a trace, not on this page, not on the next one. Perhaps the
watermark was a device created in 1934 specifically for the *Icones* from a
crest designed centuries before. Her proofs were watermarked, weren't
they? Or was it just Rosa's notepaper? No, of course her proofs weren't
watermarked; they were printed on whatever scrap the printer happened
to have on hand. It was the notecard that accompanied the box that carried
the mark.

The Semmelweis Vesalius. She'd never had a chance to compare
that. Arteries and veins. On to Book Three. Plate 43 was a study of
veins around the liver, gall bladder, and gut. Turn the page. There it
was, no doubt about it: Plate 44, *Integra Ab Omnibus,* page 268, the
entire vein system, the woodcut at the Semmelweis. Now, if Stefan
Arany had his print authenticated, they could see whether or not it too
had been printed since the war.

Helen's head jerked up with a snap. Sophie Löwe, her back to the
room, spoke to someone from the entrance to her office; she then walked
away again. A couple more seconds' grace of privacy. Leaving the
Fabrica open to the Ninth Muscle plate, the *Nona Musculorum Tabula,*
she turned to the same reproduction in the *Icones.* The 1934 edition was
so rich, so black, so fresh. As if done yesterday. The first edition, faint,
fulvous, fusty. A roll in ancient sheets.

The librarian returned, waving a single sheet of paper as she peered
into an open file folder. "There are no records." She looked up from the
file and peered closely at Helen. "You've been digging! There's dust all
over your face!" Dirt was a safe subject, unlike scars. She handed Helen
a mirror and a handkerchief from her purse and, as Helen rubbed the
Fabrica off of her skin, continued to talk. "Everything was destroyed,
and now it would be virtually impossible to rebuild our records. You do
realize, I hope," Frau Löwe smoothed her still-exquisite hair, "that I
cannot be responsible for these gaps. I was not here at that time. I didn't

start my work here until fifteen years ago. I wasn't even *born* then!"
They both laughed, and Helen sensed that, at last, Frau Löwe and she
understood each other.

The piece of paper that the librarian had carried into the room was
a list of university employees working at the University during the War.
"I doubt if this will be any help, but you asked for archives, and it's all
that we have."

Sophie Löwe moved Helen into a quiet corner, loading her down
with the heavy books, the pamphlets, and photocopies of whatever she
could lay her hands on. Her departure, long after closing time, was
accompanied by the reassurance that she was welcome back the next day
to continue her search.

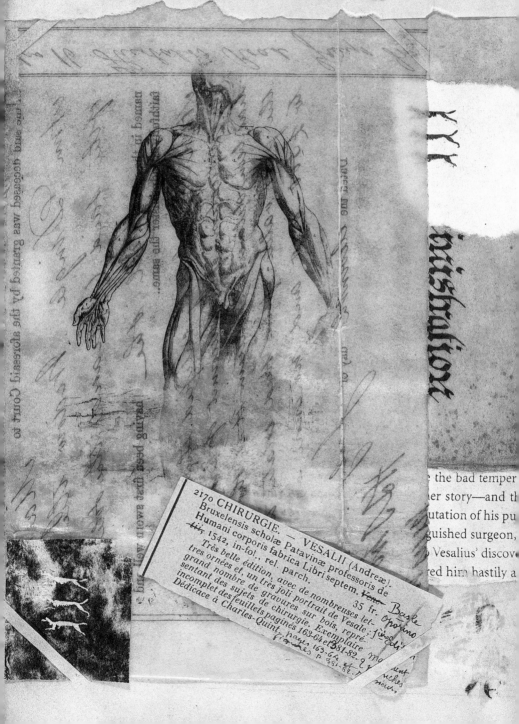

2170 CHIRURGIE. — VESALII (Andreæ).
Bruxelensis scholæ Patavinæ professoris de
Humani corporis fabrica Libri septem.
—, 1542, in-fol., rel. parch.
Très belle édition, avec de nombreuses let-
tres ornées et, un très joli portrait de Vésale ;
grand nombre de gravures sur bois,
sentant des sujets de chirurgie, Exemplaire
incomplet des feuillets paginés 163-64 et 381-82.
Dédicace à Charles-Quint.

the bad temper
story—and th
utation of his pu
guished surgeon,
Vesalius' discov
red him hastily a

THE CUSTODIAN

The dust on Helen's fingers could not be washed off. It stayed encrusted to her skin, like Günther's nicotine had layered itself upon his, a constant reminder of her obsession to find out what had happened to the woodblocks. She disdained the bed that night—what use was it anyway? Beds these days seemed only to invite chaos.

She labored through the German articles, rifling her pocket dictionary, railing against its penchant for leaving out the most essential words. By the time exhaustion had overtaken her enthusiasm, she had concluded that even Vesalius's recent history was confused by shreds of contradiction. The printing of the university's 1934 *Icones* boiled down to a few essentials: there were 615 copies of a numbered edition produced that included Vesalius's explanations of the drawings. It had sold for 280 Reichsmarks. A second version, without the explanations had sold for 240 Reichsmarks. It appeared that at the time of the publication of the *Icones*, a first edition of the 1543 *Fabrica* could be purchased for between 1200 and 1500 Reichsmarks, while an edition of the *Epitome* went for around 3400 Reichsmarks. If 280 Reichsmarks was worth about $100 in 1936, then Stefan Arany hadn't been exaggerating when he claimed that these books were valuable. The French antiquarian bookseller, offering his *Fabrica* just six years earlier for 35 francs— the cost, perhaps, of a fancy dress—had been practically giving away his copy.

In 1893, as she had read before, 159 of the woodblocks were discovered in some part of the library. These, along with a further 68, tracked down in 1932 by Willy Wiegand of the Bremer Presse, brought the total to 227, enabling the printing of the *Icones*. Wiegand's search and the subsequent printing had been instigated by Dr Samuel Lambert, an American physician—Theodore Roosevelt's own doctor—as it turned out.

According to one of the articles, the Bremer Presse had the fine reputation alluded to by Sophie Löwe. In fact, it asserted that they had produced the finest of all the editions ever printed. The article also stated that they maintained the highest level of care for the blocks, returning them to the university in the same excellent state in which they had initially received them. Well, that answered that question. No doubt that the blocks had been sent back to the university.

There were papers scattered over the miserly hotel desk and across the floor, plastered to the wall, stuck on with tape borrowed from a querulous desk clerk. Sentences were underlined once, twice; asterisked if significant; x'd if contradictory. Arrows pointed to pertinent addendums. A cross-referenced traffic jam: disorganized, haphazard, flailing. Personalities and their shadows were interfering with the answers. No! More than that, they were rewriting the questions. Who was in control here? Helen reasserted her authority, gathered up all the pages, and proceeded to deal them out into neat stacks: the history of the library, publication chronologies, description of the printers, treatises on style, the university's list of employees for 1936. Which pile did this go in? No, read through it again. Really too tired, go to bed. Achterberg, D., cataloguing; Addler, P., administration; Albrecht, M., custodian. A huge yawn came, then another one; they never go out alone, always in pairs, these yawns. Aulich, J. M., secretary; Baitz, A., librarian; Beham, H. S., cataloguing; Bergstresser, V., information; Bischler, M., cataloguing; Blauhorn, I., restoration; Brebner, R. T., administration; Cantafio, L., clerk (an Italian?); Dorfman, T., librarian, and so on down the list. Kehl, D. M., custodian. Her steady progress through the names, slowing through the fatigue, now lurched to a stop. Kehl. Related? Kehl. Coincidence? Sensing achievement, she fell asleep.

≻≺ ≻≺ ≻≺

Günther Mann had thoughtfully left a suicide note, so declared the terse anonymous message slipped under Helen's door. The sharp sudden knock that accompanied the note woke Helen out of her already startled sleep. Its mere presence exonerated her of any further involvement; she was free to leave, and not a moment too soon as far as she was concerned. Too much, the collective clamor of Munich—the traffic: horns, whistles, squeals; the people: piercing, guttural, grating. This was supposed to be such a brilliant city—splendid, grand—the envy of all of Germany. But what assaulted her ears was not a tribute to loveliness, but a monument to harshness. Except Frau Löwe who Helen visited once more. The librarian, so tranquil, so placid, so quiet. To hibernate in her peaceful sanctum muffled by the palisade of dusty books. She was being unfair, and she knew it. The sensitivity and irritation resulted from constant replays of the night that had followed Günther's death. Shop windows, neon signs, car windshields, light signals, all would burst into cacophonous fragments of glass as she walked by, yet when she turned to face the damage, everything would be intact, the damage only in her ears. Her world, except in Frau Löwe's sanctuary, was a discordant nightmare that really had nothing to do with Munich's well-groomed presence.

≻≺ ≻≺ ≻≺

"How can I find out more about D.M. Kehl, custodian?" Not brimming over with expectation, Helen's voice.

Sophie Löwe did not ask why, did not even offer a questioning glance. Instead she looked through her telephone directory and dialed a number. She was calling the *Stadtarchiv*, the city registry, had a brief conversation during which she took neat, organized notes, then, the inquiry complete, she passed the notes over to Helen.

"Go to this address—it's not far—ask for this department." Her fingernail shifted from line to line as she spoke. "This man will help you. I can think of no other way to find D.M. Kehl."

Helen had no more excuses to keep her in the library. Lingering over her gratitude, regretting her farewell, she stepped back out into Munich's pandemonium.

"D.M. Kehl. Is he still a resident here in Munich? Do you know if he is alive or not? Have you tried the current telephone book?" The archivist looking over Helen's list clearly lacked the thrill of the hunt. Helen should have said yes, he had been a resident; yes, he was dead; yes, she'd looked; instead, because her mother for some reason was standing next to her—probably because this was a place one hunted for families—she honestly admitted that no, she didn't know and no, she hadn't looked. You won't be here, Mum, she silently told her mother.

"You should exhaust the other possibilities before you come here." The archivist mustered up some warmth for his voice and looked at her sincerely, trying to evict her with sympathy.

"Do you know where I can find a telephone book? Could you lend me one?" He walked over to a metal cabinet and pulled out the directory. She flipped to the *K*s and found the listing for Kehls. There were 42 altogether, one Dieter and six *D*s but no *D.M*s. What was she to do now, call each of these *D*s? She turned and confronted the fragment of her lingering mother. Please go, she pleaded, I'll ask you back next time, I'll invite you specially. Her mother disappeared. Helen shut the phone book with a definitive slap of its soft covers and cleared her voice. "No D. Kehls," she lied.

The archivist, satisfied that he represented the only logical next step, began his own search. He wrote down the sparse details, then disappeared down an aisle, reappearing a few minutes later with a satisfied smile. As he handed his notes to Helen, he told her of the process, "First, I find the address book for the period, in this case you have specified a year, 1936. Then if I find a name, or even if I don't, I try the *Bürgerbücher,* the Citizenship List. There are other places to look, but this was simple. Here is your Herr Kehl. He is a relative perhaps?"

Dietmar Mannfred Kehl. Son of, husband of, father of. Husband of
Inge Maria, father of Helen Theresa. Dietmar Kehl, custodian at the
Munich University Library from 1932 until 1943; born in Munich 1870,
died in Munich 1943. Inge Maria, born in Wilheim 1874, died in Munich
1945. Helen Theresa, born in Munich 1907. Addresses were listed. She
asked the archivist.

"This address here," he pointed, "is the last recorded address. It is
from the *Adressbücher* of 1943." He turned the book around to better read
his writing. "Yes, this is not too far. You can go see the house perhaps. If it
is still there. He was a member of your family, yes?"

Dietmar Kehl, custodian of the Munich University Library, owner
of a house on a street not far from the center. A street that may once
have been quaint and pretty but that was now rebuilt in a frenzy of six-
ties revitalization. Postwar boring. No trace of the Kehls. Helen really
had no choice; she had to return to Vienna and confront Anselm's death.

Just before the Austrian border she got up to pace the corridor. When
she returned she found her compartment occupied by a young man
playing a guitar and a young woman and child who accompanied him
with confident, melodic voices. The child was probably a girl, about ten
years old, but Helen couldn't be positive if it was a girl or a boy. They
sat opposite the guitarist, singing a one-note samba with desperate
gusto. Helen lingered outside, wondering if they were intending to
stay there until she paid them to move. She sank back against the wall
and enjoyed, despite her suspicions, the music, which sounded like it
combined all of the harmonies in the world: the rhythm from Africa, the
velocity from Spain, the minor key from Eastern Europe, and the long-
ing from South America. Suddenly the song ended, and the trio stood
up and walked out of the compartment without so much as a smile or
nod. Perhaps her mere presence ejected them. She watched them as they
walked down the aisle and through the door that led to the next car and
then went into her now deserted compartment and sat down. But it
wasn't empty; they had left that single note for her just as their breath

had left the steam that condensed on the window. She went out and
followed the route they had taken a minute earlier. She could hear the guitar
playing from further down the car. Sure enough, it was a different note
they were playing, completely different than the one they had left behind.

A crazy idea clung tenaciously. What if Dietmar Kehl had sporadi-
cally removed woodblocks from the library until there was nothing left
but an empty crate labelled VESALIUS? Stuck, as it had been, in its corner
since its return from the Bremer Presse, who would have bothered to
open it? Then when the library was bombed, the confusion and debris
would have concealed the crime. No more blocks, ergo, destroyed in the
bombing. But Dietmar died in 1943. So, he had already removed all or
most of the blocks by then. For what? If the library hadn't been bombed
the theft would have been discovered. And what about the 400-year
celebration in 1943? Perhaps the blocks had been put on display for the
celebration. She hadn't thought to ask.

Helen Kehl would have been 37 by the time Munich had been
bombed in 1944, 36 when her father died the year earlier. Friedrich
would have been about 16 then. That seemed right, if she remembered
the photographs accurately. Maybe Helen Kehl and Friedrich Anselm
had smuggled the blocks out of Munich, into Austria, to Vienna.
They'd traveled between Munich and Vienna over one hundred times
by 1965; Thüring's obituary had taken the pains to point this out. And
Anselm went blind by 1967. Was that significant? If they'd been spiriting
these things away two at a time it would have taken them over a hundred
trips. She was losing her mind. Were Helen Kehl and Friedrich Anselm
printing with these blocks? Had they been in Anselm's house all this
time? Had Martin discovered this? Was this why he was missing?

Vienna, mute in a blanket of late fallen snow, welcomed her back with
characteristic indifference. She went directly to Anselm's house, a testi-
mony to the conflagration of her only hopes of finding traces of the
Vesalius woodblocks and, in turn, of course, Martin. The site was roped
off, a threatening sign forbade even thinking about crossing onto the

property, but she picked her way past debris that had been flung haphazardly into the lot, through to the ruins, and stood at the entrance. The doors gaped open, partially burnt and hanging pathetically on their hinges. She could see Anselm greeting her—the way he was the first time they met—proudly throwing back his long white hair, voraciously polishing off the box of chocolates, helping her off with her coat. No matter what he had done, nothing could spoil this memory of him, this simple view of a man who had forced her to question her very existence. He was a twist of her fate, inextricably tangled in her past, present, and future.

She left her bags at the entrance and stepped into the house, walking through, retracing the route from the foyer to the study. Everything was ravaged, for here was the heart of the destruction. Drifts of cinder and ash curled over the toes of her shoes, reminding her of her bizarre encounters on the train, of Anna who burnt her shoes with the magnifying glass and of her strangely empathetic dog. Charred bits of furniture and picture frames were trapped in blocks of ice, sacrificed like flies in amber. Monumental icicles threatened to topple ravaged beams. A winter wonderland, destruction's fantasia.

A scrap of paper, braille, caught her eye; she knelt down and picked it up, running her fingertips over the mute bumps. She stuffed it in her pocket, then stood in the middle of the sickening ruin, surveying the heaps of blackened books, swollen with water like the corpses that float down the Ganges, aghast that anyone could create such a sacrificial pyre. The walls of the neighboring houses loomed impassive on either side, resolute and secure in their uninvolvement. She left the remains of the room, still fingering the pocketed braille, and made her way through to where the courtyard would have been. Several pits had been dug in the narrow patch of earth, the dirt heaped up in mounds along one side. She'd never come here before, had only heard of its existence through Rosa's ghastly tale of the pruning shears and the finger. Stones had been smashed and the water and foam that had spewed over the flames had frozen, leaving a tricky path to negotiate. Stumbling and sliding she made it over to the depressions where she knelt to get a better look. The

cold ice hard against her knees and shins, she reached down to sweep away the light dusting of new snow, to crumble the frozen clumps of earth. The cold crept through the fabric of her trousers, numbing her legs. She stood up stiffly, brushed off her clothes, shivered, then peered into the second pit, wondering what had been buried there, then turned to leave.

Hauptmann Bauer was not at his office when she arrived, still carrying her bags; she hadn't even thought about a place to stay. She waited for an hour, examining the fragment of braille salvaged from the house, listlessly scribbling in her notebook, phoning the newspaper to see if they had any news of Martin. Herlsberg, the editorial assistant, was out, and the editor was busy. She then phoned for a room at the hotel that she had stayed at previously. Finally she left, trailing a despondent cloud, leaving word of where she could be reached.

Had Vienna changed or had she? The walk from the office to the hotel was alive with new sensations; even the snow couldn't hide a vibrancy that she had not observed when last in the city. The air was more complex, replete with an audible, visible urgency. Light was losing its transitory temperament, dawdling later through the afternoon.

Still, it was dark by the time she walked into the lobby of the hotel. By now she was thoroughly cold and tired, but alive to the very tips of every nerve. As the clerk handed her a key the elevator doors opened to the bursting tinkling form of a young girl bundled into a woolen overcoat, knitted toque, and fur-lined boots.

"Sacha, come back!" cried her mother, steps behind.

The little girl ran straight into Helen's arms. "Where are you going?" Helen exclaimed, looking beyond to the reassured face of the mother. "What are these?" she asked the silent, pouting child, jingling the bells that were attached to her collar. The girl giggled and lowered her head as if Helen had been tickling her chin.

"Bells," she answered.

"I can see that," said Helen. "What are they for?"

"I've got more!" The little girl did a pirouette, setting the chimes alive.

Helen laughed. She asked the girl's mother, who was now level with them, "what are the bells for?"

"These," she said pointing to the bells in the front while the girl continued to spin and dance about, "tell us where she is going. And these," the mother turned the girl around and demonstrated the bells on the back, "tell us where she has been." Helen gave the bells one last jangle, committing the simple music to memory, and watched the girl and her mother disappear into the frozen night.

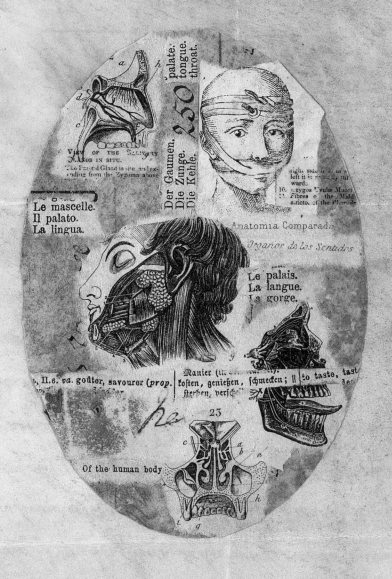

TASTE

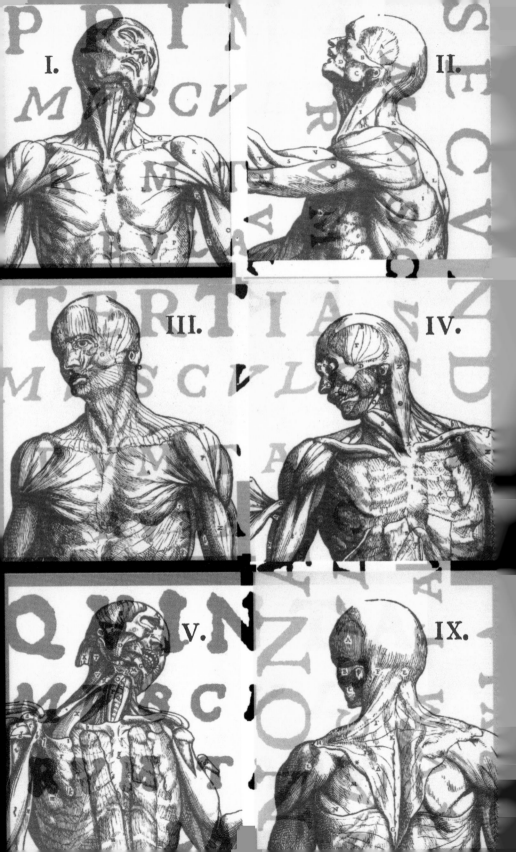

THE INVENTORY

Pacing the floor, a legacy of hotel rooms, a legacy of untold numbers of solitary nights in hotel rooms. If lucky a closet, a bathroom, a room; if not so lucky, a room, a fusty wardrobe. Tonight lucky—skulking into the bathroom, switch on the light, open the cabinet above the sink, turn on the taps, watch the water run, turn them off, tear off a square of toilet paper, needlessly blow the nose, sit on the edge of the tub. Back into the room, open the cupboard door, count the hangers— one, two—up on tiptoes, scan the dusty hat rack, a second pillow, an extra blanket. Shut the door, one time two times, faulty catch, three times. Prowl the perimeter, skirting obstacles: desk, chair, bed, extra chair. Same as the chair Rosa sat in but not the same room, after all. Sit in the chair, imagine squeezing, wedging someone else's broad girth. Why someone else's? Rosa's, be frank. Back out of the chair, open drawers, nothing, not even sawdust. Pick up the telephone. Call who? Hang it up. Call Stefan Arany; she missed him, didn't she? Hand still on the receiver, turn away. Flick on all of the lights in anticipation of turning them all off. Open the inner door, stand in the alcove, test the lock on the outer door, locked tight but turn the key one more time for luck. Sit on the bed, brush the tight pile of the carpet with toes dressed in thin socks. Think of the guest below, looking up, wondering at the cat-like steps crisscrossing the room, crisscrossing. Lie on the floor, ear to the ground, listening to the growl of the hotel's guts.

An inventory of Rosa's interference—nerves and skin scraped raw, inflated, then regenerated; sight dragged kicking and screaming into crippling blindness then painful, naked clarity; nostrils plunged into the most unthinkable of odors, exhumed to recognize the most imperceptible of scents; ears hammered with the shattering cries of grief, now welcoming the bellowing peals of life. *Audiendi delectatio.* The delight of hearing. What's left? She licked the tips of her fingers.

Why this restlessness? There was still so much to do. Nothing had been achieved, nothing. Martin was still missing, Rosa still an enigma, she herself unfinished.

She pulled the Vesalius proofs out of their envelope and counted them once more. One hundred and three proofs, all of them of different plates. She started to sort them into subject matter, but they were already sorted: the skeleton, the muscles, the veins and arteries, the nerves, the viscera, the heart and lungs, and finally, the senses. The seven books of the *Fabrica.* One by one, she laid them out across the room, moving the chairs and bags out of the way. Some of the proofs were huge, some were fragments; their total displacement exceeded the dimensions of the room, backing Helen into a corner of the bed.

The piercing ring of the telephone broke through the deadened air. This was the first time she'd received a call since when? Anselm's, and that wasn't for her. She cleared a path across the bed and silenced the ring by grabbing the receiver. She looked at the black foreboding apparatus with suspicion.

"Hello?" she said finally.

Clicks, hums, distant words broken by the wires into meaningless syllables.

"Hello?" she repeated.

The buzzing rattled and a connection slipped into place.

"Helen?" the male voice on the other line was clear and suddenly very close. "Helen, is that you?"

Martin?

"Martin?"

Where are you? Yes, that was neutral.

"Where are you?"

"At home. Why are you in Vienna?"

Looking for you, you bastard. No, not neutral.

"Here for research. You've been away for awhile. What have you been doing?" Good. Very neutral.

"I was in Vienna 'til Christmas. Sorry I didn't make it home. Hope you weren't worried. I didn't think you would be. I went to Tahiti. Just got back. How've you been?"

He went to Tahiti.

"How did you track me down?"

"Jimmy. He had your number. I must say it surprised me not to find you here. How long have you been away?"

Years and years.

"Since the middle of January. I picked up where you left off. You know, the Vesalius woodblocks."

Cut the enthusiasm. He'll think you're offering Vesalius as a kind of dowry or something. "Will this do, Martin, dear? I have nothing else to give you."

"Oh that." He paused. "Why're you doing that? Nothing to the story. The blocks were destroyed in the war. Stupid rumors. I spend half my life chasing after stupid rumors. When are you coming home? The outside pipe burst, so now there's no water. The city had to come over and turn it off. And the car has a flat tire."

Now or never.

"Things have changed, Martin. I'm not sure that I'm coming home."

There we go again—soft soap. Taken by surprise, articulate your hesitation, your inability to make a decision.

A long pause. The transatlantic dollars dripping down the line.

"What do you mean?"

"I'm not coming back."

"You're going to stay in Vienna?"

She hesitated.

"Have you met someone?"

As if there's no other reason to leave.

"I don't know where I'm going. I haven't worked this out. Your call has come out of the blue. I'll call you in a couple of days."

"I won't be here. I'm off tomorrow."

"Oh."

Another silence.

"To Belize. I'll be back in two weeks."

I'll write you a letter. Another letter. What more can I say? I've changed. It could have worked. But you haven't. I won't do it all.

"Well, we'll talk later. We can get in touch with each other through Jimmy, okay?"

"Yeah, okay."

Another pause.

"Helen?"

"Yes?"

"I missed you not being here when I came home."

Too late, Martin. Too late.

"It's too late, Martin."

She hung up and, kicking the papers out of her way, recommenced pacing the room that now at times seemed insufferably tiny and at times incomprehensibly large.

The next morning she woke to the chambermaid's knocking. It was incredibly late, and she'd slept mercifully well, smothered and comforted by the weight of Vesalius's bodies that she'd left scattered across the bed. It was late but morning late: bright and cloudless, no trace of falling snow. The maid, not hearing any response, opened the door, then silently, discreetly shut it again at the sight of the young woman tangled up in aged sheets of bone, muscle and nerve, stretching her own to shake out the perfect sleep. Yesterday she would have been humiliated at the intrusion, today it pleased her. Partly dressed, she opened the door and scanned the hall, hoping to catch sight of the maid, to reassure her that she could come and clean the room whenever she wanted. There was no

one in sight, but a newspaper had been left outside a neighbor's room. The doorknob sported a do not disturb sign. Helen, miffed that no paper had been left for her, tiptoed over and grabbed it, carried it back to her room, finished dressing, and went out for a breakfast that revitalized her as much as her night.

The newspaper gave a short report of the progress of the autopsy on Anselm's body and the investigation regarding the cause of the fire. It also hinted that the police were reinvolved due to some unusual remains found on the property. She wasn't sure that she had translated "remains" correctly.

Bauer had left a message for her to meet with him; she stuffed the note in her pocket, feeling again the piece of braille, so indecipherable that it might as well be blank, and arrived at his office promptly at the designated time, anticipating further reluctance to return her print, determining how to get it back, how to take the next step.

"A lot has happened in the last week, don't you think?" he asked her with a touch of jaundice in his voice. She realized suddenly what it was about him that bothered her. She recognized a feature they had in common: they shared the same antipathy towards other people, which included each other. So, this was how it felt to be an acquaintance of hers. Unpleasant. Remarkably unpleasant.

His office seemed empty without the presence of the ubiquitous scribbling clerk to deflect his aversion. She looked around to assure herself that he wasn't hiding somewhere. As for herself, her own enmity, well, this had to be the end, the time to be conciliatory. "I haven't gotten over Herr Anselm's death. And his collection destroyed. It's baffling."

"We've been following your progress in Budapest and Munich," he said.

She looked at him startled.

"Not following literally," he dismissed her concern with a shrug. "We know that you met with Herr Stefan Arany of the Semmelweis and with Frau Sophie Löwe at the Munich Library. Have you uncovered

anything of interest?" Helen suddenly realized that she had no idea what Bauer's first name was.

Her news that she had irrefutable proof that the woodblocks still existed fell on indifferent ears. "We know that already."

"But how?" She gave up trying to be friendly; there was no need to try anymore—her curiosity was inflamed and swept their personalities aside.

"They were found when the investigators were going through the remains of the burnt house."

"All of them?"

"We don't know yet but at least two hundred."

"Are they intact?"

"No. This is why the inventory is taking so long to complete. Most of them are burnt beyond identification. They are very difficult to piece together. One thing is certain, the bomb that missed during the raid in 1944 found its target this time."

"It was a bomb?"

"Of sorts." Bauer was now responding to the timbre of Helen's voice, its depth and tones expressing the sincerity of her interest, her right to know. His own voice picked up vibrancy and life, a willingness to set the past meetings aside, to share his knowledge. "The woodblocks were heaped into a pile in the center of the study, and then a bottle filled with gasoline was tossed into the middle of the heap. It had the same effect. The books were set on fire separately. I suspect that it took much longer for the books to burn, but the heat provided by the woodblocks would have sped the fire along. The fire chief has still to supply a complete report."

"They were cut out of pearwood." This fact emerged from some-where.

"Pardon?"

"Oh, nothing. Just that they were cut out of pearwood. I don't know if that makes any difference to how well they would burn."

Bauer shrugged, raised his eyebrows, scratched his jaw, but wrote down the detail all the same.

"And Herr Anselm. What exactly happened to him?" Did she really want to know? He was dead, wasn't that enough? Yes, she did want to, she did have to.

"It looks like he set the fire. An expert pyromaniac, judging from the evidence. Whether or not he intended to stay in the room and perish with his collection is another matter. We may never know if he was overcome by the smoke and passed out or if he deliberately chose to remain. Sad, either way."

"Was anyone else involved?"

"Why? Do you know something you aren't telling me?"

"No, nothing I can put into words, but I saw the house yesterday, the remains of the house, rather. It seems beyond one person, doesn't it? I mean, that was a major fire."

"Well, perhaps. In any case, there wasn't anything so convenient as a suicide note. Not like your friend Günther Mann. That was obliging of him, don't you think?"

"He wasn't my friend; he was an acquaintance." The difference between the words was becoming blurred as the days slid past. Friend, acquaintance, why even bother making a distinction? "I had nothing to do with his death." At the mention of a suicide note, Helen automatically felt the braille fragment crumbling away in her pocket. She reluctantly dragged it out and placed it on Bauer's desk.

"No, of course not." Bauer was saying, inspecting his knuckles, scratching a cuticle. "Tell me. How is it that you were involved at all?"

She pushed the burnt paper closer to Bauer's field of vision. He took it, at first roughly, naturally, and then carefully as bits fell away onto the desk. "What's this?"

It's my gift, you fool. Watch it. Things are going really well. The old Helen back again. He's not Martin, you know. You have nothing to lose by being patient, nothing except this scrap of Anselm.

"It's a scrap that I picked up off the floor yesterday at Herr Anselm's home. I don't know what it says; I can't read braille."

Bauer pulled an envelope out of his desk and put the piece of paper into it. He painstakingly labeled one corner. He opened his mouth about

to say something, no doubt to chastise her for disturbing an off-limits site. But he too changed his mind, saved his breath. She could see his struggle.

Helen recounted meeting Günther, leaving out, once more, the more unbelievable aspects. Bauer nodded. "We still haven't been able to track this Rosa Kovslovsky down. Why didn't you let us know that she showed up in Budapest and in Munich? Why didn't you mention her to the Munich police?"

Helen threw her hands up in a gesture of ignorance. Who knew the correct response? She changed the topic back to Friedrich Anselm's house. "I read the paper this morning. If I understood correctly, there has been an unusual discovery that involves the police. Is that true?"

Bauer looked at his watch, straightened his cuffs, picked off a piece of lint and carefully dropped it in the wastebasket. Helen watched him with interest. There was no mistaking a fidgeter.

"Yes," he said finally. "Human remains."

"Do you know whose?"

"No, it's too early."

"Can't you tell me anything else?"

"I don't want to unduly alarm you; we haven't finished the investigation."

"You must be able to tell me something else."

He sighed. "There have been two bodies discovered so far. We are continuing to dig through the courtyard to see if there are any others. The initial test pits indicate that there may be several more." He came to a stop, but Helen urged him on. "One of the bodies is that of a young woman. The first hypothesis is that she was about in her early to mid-twenties when she died; this would have been, it seems, around fifty years ago. The second one, another woman, is much more recent, certainly since the beginning of the year. A woman in her eighties or nineties. I'm not even sure if they've pin-pointed it further. Say, I shouldn't be telling you this." He sat up straight and opened up a drawer. He peered in it, closed it, then picked up the telephone and

asked if there were any messages. Satisfied with the response, he hung up the phone.

While Helen watched him nervously deal with his discomfort, her mind zigzagged back and forth through various cadaverous possibilities. An old woman, murdered? Dead anyway while she, Helen, was at Anselm's perhaps? Just before, just after? And the young woman? Fifty years ago would have been roughly around when Anselm and Rosa had been medical students, at the end of the war or just after. Of course, the two bodies could belong to women she hadn't heard about, other players in the works. Or complete strangers; they could be complete strangers.

"How did they die?" she asked.

"It's too early to tell; they haven't supplied me with that information. Except that there is no evidence that either woman died by obvious causes."

"Were they murdered?"

"We cannot say yet. Another thing."

"Yes?"

"Wilhelm Stukmeyer is still missing. Do you know anything about this?"

"Why would I?" she asked cautiously. Rosa's pearl in Wihelm's mouth; Wihelm's pearl in Rosa's mouth. God. When was this going to stop?

"No reason. I just thought I would ask." He yanked on his earlobe. "Stukmeyer sounds like a phony name."

"You haven't found his body in the courtyard, have you?" She was terrified of his answer.

"No. No, we haven't." The simple *no* left too much unresolved.

"May I ask just one more question? Can you tell me if the old woman was missing a finger?"

Bauer skimmed through the first two pages. "Yes. The third finger of the right hand. How did you know?"

"Frau Helen Kehl. Friedrich Anselm's governess. Her obituary was carried in the newspaper the same day that Friedrich's appeared."

Helen winced at her inadvertant slip of the Christian name, but Bauer was writing frantically and hadn't seemed to have noticed. "Which newspaper? What day? I suppose you realize that this will delay your departure from Vienna?"

Helen nodded. She hadn't realized, but it wouldn't make any difference, would it? Except money, of course. Worry about that later.

"And the other woman. Do you have any thoughts on her identity?"

Helen shook her head. It didn't bear thinking of. But of course she thought. Rosa? Anselm's revenge? Far worse than either of them had hinted of? She began to shiver. No, it definitely didn't bear thinking about. She wrapped her arms around her body and hugged herself hard, squeezing some immobility back into her uncontrollable nerves. And the possibility that there were others. And she stayed there, in that house. No, it didn't bear thinking of. And she had trusted Anselm. No that wasn't fair, they didn't know. They didn't know who did it. They didn't know who did what. Yet.

"Now, about your husband," Bauer consulted a loose sheet on his desk, "Martin Evans."

"What about him?" Helen was pulled from the thoughts she was trying to avoid.

"We've had no luck tracking him down. His name is now on the missing persons list. We've interviewed the staff at the newspaper, spoken with Mr Singleton, and of course we've talked to you. His picture has been telexed to police headquarters in Germany, Italy, Hungary, France. There is nothing else for us to do. But wait."

Helen rested her chin on one hand and stared hard at Bauer. He'd been straight with her; she'd return the favor. "I've found him."

"You what?"

"I found him. He's at home. He lost interest in the article and cleared off for a sunny vacation in Tahiti. He called me last night." They both sat silent, contemplating the open pits in Anselm's yard. Relieved that Martin was not in one of them; concerned for whoever else might be.

Bauer scowled. "Well," he said. "Well." He rubbed his eyes and

yanked on his cuffs. He pulled an envelope out of his top drawer and tossed it across the desk to her. "Here, this is yours," he said. "Just don't try to pass it off as the real thing." He smiled.

"I guess you'll call me when you need me?" asked Helen, taking the envelope, disdaining the chance to immediately open it up and see which one it was. "Maybe I could try to sell this? I'm going to run out of money soon. That's a joke," she added, seeing the smile disappear. "I hope this can be finished quickly."

Bauer shook his head. No, it can't be rushed? Or no, he didn't know? Or God, what a screw-up? "We'll be in touch," he said at last.

She stood up. "Thank you, Hauptmann Bauer. I'll be at the Stadtpark for the next couple of days, and after that, I don't know. I just don't know. But I'll tell you."

She walked to the door of his office. "Oh yes," she waved the envelope. "Thanks for this."

ROSA'S FAREWELL

How could Helen wait longer? Her trip to Vienna wasted, her future in shambles; it was time to go. Time to look at time stretching ahead interminably without resolve; time for her to return to her life trapped in the shadows cast off by others. And who knew how far Rosa would follow her and to what end. But what was she thinking of: return to those fettering shadows? How about the reality that she had never freed herself of them. Here she was now, a prisoner to Helen Kehl, a dead woman who had shown off a ring and lost a finger for her efforts. Who had traveled thousands of miles tracing and retracing the same steps to help a man steal history. (Or was it the other way around, he helping her?) Who had abandoned the ring, the very thing that bound her to that same man; passing that very ring to her, binding her almost as irrevocably. They shared a name, her and Helen Kehl. But she, Helen Martin, shared her body with Rosa. (Or was it the other way around?)

Was Helen Kehl buried in Anselm's back yard? Bauer said buried very recently, in the last few months. And if Helen Kehl was buried there, who was the other woman? Fifty years ago, he'd said. She'd been buried fifty years ago. And there might be others. But if Helen Kehl? Who was the other woman? Someone else caught up in this crazy web? Someone else altogether? A young woman. Christ, get a grip! You don't know everything about Anselm's life. Face it, you don't know anything

about his life. You only know what he, that blind conductor, wanted you
to see.

Still. A young woman.

Rosa. She was young once. Everybody said so. I never swallowed
that garbage about her transformation. Never believed a word of it. But
if not Rosa, who? Who lies in the garden? Who lay in the garden for
fifty years awaiting the arrival of Helen Kehl?

And Rosa, the one here, the one now, in spite of her mammoth
presence had never seemed quite. Real.

Anna. Anna with the dog. She was involved. Her dog dug up Helen
Kehl's finger. She traveled on the same trains, following in the footsteps
of Rosa, who followed in the footsteps of Helen Kehl and Friedrich
Anselm. Anna was Rosa's sister, at least that's what she had assumed.
Or did someone tell her that outright? And, just as Helen Kehl ensured
herself a legacy of identical decadent youths, so did Anna fortify her-
self with a parade of indistinguishable terriers.

With the precious woodcut nestled safely in the crook of her arm,
her thoughts incoherent but unrepentant, she walked back to her hotel,
taking the long detour past Anselm's house. She had to see it one last
time before it was pulled down and completely eradicated. An army of
workers was crawling over the ruins, toppling dangerous beams, shovel-
ing out and screening the soot and charcoal into clear plastic sacks.
Another industrious team was excavating the courtyard, dividing the
narrow patch of land into even squares. A group of bystanders, timidly
clustered, stood—barely breathing, scarcely moving—watching the
activity. Helen joined them for a few minutes, grateful that she'd had a
moment to wander through unhindered.

Her conversation with Bauer nagged her the rest of the way back
to the hotel. He had been worried about telling her about the bodies.
Not because he wasn't permitted to say, but because he didn't want to
"unduly alarm her." Why would he think she'd be alarmed? He couldn't
know just what not knowing was doing to her. Of course. He meant
Martin. He hadn't known when he said that, that Martin had reap-
peared. She walked in through the hotel door, picked up her key, and

climbed the stairs up to her room. There was something else. Something really obvious. Besides, of course, how odd it was that Helen Kehl appeared to be buried in Anselm's yard. Something in the back of her mind continued to nag. The obituary! Helen Kehl's obituary! Newspapers didn't print obituaries for people who were buried surreptitiously in courtyards. They only carried them for people who were officially dead. Unless. Well, unless she was officially dead and then. And then? And then snuck out of the hospital? The mortuary? Like Vesalius in his student days, sneaking bodies. Only his were cut down from the gallows. Was her death so very different? A judgment, a sentence, a punishment?

She telephoned the newspaper and managed, this time, to reach Herlsberg.

"Martin called me last night. He's back in Canada."

"*Ja?* We know."

"How long have you known?"

"Oh, what is today? Tuesday. We've known for one week, maybe more."

She was silent. What could she say?

"We didn't know where you were. We naturally tried to find you."

Liars; she'd left her—no, she'd forgotten. She was going to call them. And never did. At least, not until yesterday. Herlsberg was forgiven.

"Sorry about that. I left Vienna for a week or so." Then she remembered Bauer. "The police didn't know."

Herlsberg was silent despite traces of faint breathing.

She continued. "I have a favor to ask you."

"*Ja?*"

"You ran an obituary of Friedrich Anselm, the art collector. And on the same day another obituary of Frau Helen Kehl." She fumbled through her papers as she spoke, searching for the date. "Could you tell me who submitted the obituaries? Or would they have been written by staff?"

"Maybe staff, maybe someone else. I'll call you back?"

"Yes, that would be really helpful. Oh, Herr Herlsberg? The dates they were submitted, as well." She gave him her number and rang off.

If Herlsberg looked this up right away, he'd call her back right away. If he put it in some in basket, it could take days. She hauled out the box Rosa gave her to have another look at it, to see if she could squeeze anything else out of it. She really should take the finger bone over to the police station. And the ring. Rosa's photo was sitting on the top of everything else. A reminder that she hadn't looked into the box since that night. Helen shivered at the memory of Rosa's embrace. She'd put that out of her mind; there are things that just can't be considered. On the surface it appeared to be the simple matter of another's close presence. But this was nearer than close. Like the beginning of her life and the end of her life tightly clasping her in its arms. This fantasy had to stop. Each time she thought of it, day or night, waking or sleeping, her brain threatened to explode, her stomach churned, her nerves consumed themselves. Helen smothered Rosa's picture under her hand. Asphyxiate it, strangle it; it won't be a threat any longer. She'd burned the first one, and this had taken its place. Only this one, if one were to believe Rosa, was far worse. It wasn't some far-away, long-ago, beautiful dreamy-eyed girl student. It came from Rosa herself.

The phone rang.

Helen shut the lid and picked up the phone.

"It's Herlsberg here."

"Yes?" So soon?

"*Ja.* I've got your information. Herr Hermann Thüring, the obituarist, submitted Friedrich Anselm's obituary about two years ago. Staff have kept it up to date."

"Two years ago?"

"This is normal, you know. For famous people."

"And Helen Kehl's?"

"That is more difficult. No one can find any source for her obituary. I've asked and looked in the files. Composition says that their records state that it was phoned in. They thought perhaps someone in editorial. Is there a problem with the obituary?"

"No, not that I know of, but you wouldn't normally just print an . . ."

"Because if there is," he interrupted, "I must apologize for the paper. An obituary is a serious matter. It must come through an official process."

"Do you have the date that it was phoned in?"

"Two days before it appeared. There was a note that it had to, if possible, run adjacent to Friedrich Anselm's."

"But Friedrich Anselm died the day before his obituary appeared. In fact, the night before."

They were both silent for a moment.

Herlsberg broke the silence. "It appears that there has been a terrible mistake. We must find out what we can about Frau Kehl. Can you help me? Do you know anything? *Is* she dead?"

"The police have uncovered some bodies in Anselm's yard. It's possible that one of them is Frau Kehl."

"You mean we don't know for certain if she really is dead?"

"No, not yet."

Helen let Herlsberg moan about his newspaper's reputation for a few more minutes, then called Bauer's office. She'd stay on the telephone for the rest of the day if it meant she didn't have to think about Rosa anymore. Bauer was out of his office, so she left a message for him to check with the newspaper about the obituary. There was no one else to call so she went out and walked until Vienna's streets, not Rosa's breath, ran through her veins.

Helen woke up with the taste of her life in her mouth. Not just the remains of memory but the complete archives, as if she had never ever throughout the years, brushed, scrubbed, rinsed, scraped, or picked. As though every scrap and shred of every word spoken, every word swallowed had lodged itself between teeth, under tongue, waiting for this moment. She lay in bed, eyes clamped tight, choking on the bitterness of her regrets and her losses, the sourness of her scorn and her grievances, the fermentation of her distresses and shames. These were familiar flavors; they'd insinuated themselves in some form or other many times

over the years, but never so collectively; they'd never ganged up on her before.

There was something else though, something not so commonplace, something much more complex. She swallowed then ran her tongue along her gums, the divisions between her teeth, along her lips. The identity of this new taste, these new tastes rather, rushed through her suddenly like a hot flush through the cheeks, and once recognized, they overpowered everything else. She savored honeyed souvenirs of laughter and enchantment; where had they been all this time? She devoured ambrosial remnants of amity and intimacy, and full substantial meals of contentment and tranquillity. But the best tastes of all were the reminders of provokingly delicious kisses: cool, fresh and exquisite; fiery, thrilling and delirious. Proof that she had loved, promise that she could love again.

She reluctantly severed the new sensations, "I know you're here, Rosa," she said without sitting up, without even opening her eyes.

"Yes, I am, my dear. Look at me."

Helen opened her eyes but couldn't see anyone. Rosa's keeping her distance. Rosa's not breathing over her, gloating over her. She sat up and looked around the room. Sitting in the corner was an elegant, spare, old woman with long thick grey hair and a complexion showing only the faintest traces of the ravages of age.

"Where's Rosa?" Helen asked.

"I'm Rosa," she said calmly. "Take a good long hard look. You'll see me again in a few decades. But for now, I'm here to say good-bye. We no longer have to meet."

"But." Helen was speechless.

"Think about it," said Rosa. "Friedrich is dead, he no longer has power. He has given you what you want; he has given me what I want. You can go on and pursue your life and I, well, although I'm now old, I am free from both his curse and my past."

"How do you know what I want?"

"How do I know? It was written all over you. It still is because you still don't know what you have, what you've been given. Speaking of

giving, I have something for you. From Friedrich." She leaned forward and tossed an envelope on the bed. An envelope redolent with a pleasing mix of time, roses, knowledge.

Enclosed was a black and white photograph of Friedrich Anselm, standing in the middle of his study, surrounded by the collection that he had loved so much. The photograph showed him posed in front of the high wall of his study, the one that had been covered in framed prints. His arms were outstretched, embracing the room; his head was thrown back, incautiously merry. The sole source of lighting was the weak Vienna sun coming in through the skylight above him. So that's how he guaranteed that he would go with his collection, she thought to herself; he planned it that way; he photographed himself. She looked on the back. Someone, not he, for it wasn't his hand, had simply written: Friedrich Anselm, Vienna.

Rosa spoke while Helen studied the photograph. "He asked me to give this to you."

"When was it taken?"

"A few days ago."

"He didn't take this by himself. Do you know who helped him?"

"Yes, I do," she smiled again. "I did. Nice work, isn't it? Much better than anything he was able to produce."

Helen couldn't bring herself to accuse Rosa of helping to kill Anselm. Rosa took care of that herself. "Yes, I helped him kill himself, if that's what you're thinking. Sometimes there are no options. Like with Günther."

"So you did kill Günther?"

"Yes, of course I did. You knew that: you can read my lies as easily as I can read yours. He was the last thing linking me with those dreadful weeks in Vienna after Friedrich had taken my photograph. I had to."

"And Peter Ganz? Who killed Peter Ganz?"

"That was pure Friedrich. He had a profound evil streak. Not even I penetrated to the depths of his maliciousness. And only the devil would find my life beyond reproach. He and our Buzzard Princess ran

rampant through those years after the war. You must have guessed that
it was he who had the Vesalius blocks?"

Helen nodded. Well, she hadn't guessed, really, she'd been told, but it
had come as no surprise. There were only so many possible conclusions.
Rosa continued, putting it into so many words:

"They brought them back to Vienna, two or three at a time. Almost
a hundred trips. He bragged about it to me. And it wasn't the only thing
he did. On the surface he was a respectable, admired collector of art; in
his depth he was a wicked man who would do anything to turn the
world of art on its ears. He perpetrated so many thefts, forgeries, what
have you, that it will take years to straighten it out. One thing I can say,
museums and galleries are going to have a miserable time dealing with
anything bought from him or with his assistance. And it is worse now.
All of the evidence is burnt. But he told me everything. I hated him; I
hated him with all my heart. You want to protest. You want to tell me to
admit that I loved him. It's not so very different, you know. If you're
capable of one, you're capable of the other. Over the years I've tried
many things to free myself; I've stopped at nothing. In my world you
can only fight evil with evil."

Helen started to object; Rosa shushed her.

"No, it's quite true. But the weapons used on our battleground
were none other than wits and time. Both of which we had plenty to
spare. I rode that same route—Munich to Vienna, Vienna to Munich—
trying to devise a way to trap him. Fifty years I've done this. My sister
Anna, you met her, she rides with me, rode with me, but always as an
echo, never a companion. Ehrlach, he was my landlady's son. He was
crazy about me. But too young. A child. Not such a child now—he
became a doctor to try to salvage me. Now Louis is too far gone him-
self." Her voice trailed on, lost in its memories.

"Peter Ganz. You were asking. Friedrich wanted to stop the authen-
tication of the print. You must have told him you were going to see
him?"

Helen nodded.

"Friedrich and Helen had started reprinting the *Fabrica* plates on a

press at the University. They had after-hours access but their work still captured unwanted interest. They'd perfected about twenty of the plates when they gave up, hoping to resurrect the press someday in a securer location. Then they began filtering the prints out—very slowly. Just one of each. I took off with one—the *Nona*—yours. When I saw you on the train, you looked so much like me, but you had lost so much, even more than me. For although I lost my health and beauty, I continued to live. You—when had you ever lived? I felt so sorry for you. And yet, I knew you could help."

Through all of this Helen remembered that she hadn't yet looked at her print. She made an involuntary start towards the envelope, then sank back into the bed, not wanting to break the thread of Rosa's explanation.

Rosa sighed. "I've never seen Friedrich so shaken up. He never dreamed the day would come when I'd find a way to get back at him. He was sure he had thoroughly put me out of the picture, so to speak."

"What does the braille say? The braille in the box?"

"To you, it doesn't say a thing. But for Friedrich it told our story from the beginning to the end. That was his secret; my gift to him. For you the box tells the story of the beginning. That's your secret. That's my gift to you. And that's why you don't need it anymore. You don't, do you? You haven't needed it for a while.

"Peter Ganz." She swept a stray hair off of her face. "I don't know how he did it. But it was brutal and vicious. But then I can't talk, I did cut off Helen Kehl's finger, after all."

"How did Helen Kehl die? Old age?"

"We could say that, or we could say she couldn't live without Friedrich. I'm sure the autopsy report will be quite complete once they finish digging her up out of Friedrich's courtyard."

"So it is her there?"

"Oh, you know about this already? Yes, it is her."

"And who else?"

"You'll find out when you need to. No sense me telling you everything."

"Is it your sister Anna?" Helen couldn't let her go.

Rosa stretched stiffly. Thin limbs on a potent frame.

"Is it you?"

"Good-bye Helen." She stood up and held out her hand. Helen, grasping it for the last time, was brought back sharply to the first time they met, the first time they shook hands, and the horrible clamminess that the contact had coated onto her palm. The penetrating frigidity was still there but the clamminess had gone; the skin slid like silk, dry and almost static.

Helen watched her walk away, turn around and wave, and then leave, shutting the doors quietly behind her. When the last of the footsteps disappeared down the hall another familiar sound replaced it: the unmistakable trot of paws, the click-clack of delicate nails on tile, the tinny jangle of tags around a furry neck, accompanied by labored breathing, suppressed giggles and the creaks of tiptoeing. Helen sat immobile as these sounds too passed, then she got out of the bed and went over to the shoulder bag that held the box Rosa had given her so many weeks ago. As she picked it up the pearls and the tooth fell off one by one and rolled crazily about the floor. The glass cover fell off the top, shattering on the bedside table. The booklet inside it crumbled into powder. Helen opened up the box—its inside was burnt black and it held charred bits of paper and the blackened, ruined remains of the dog tag, ring, glasses, and magnifying glass. She stepped towards the bedside light to better examine it and stepped on one pearl and then another—each disintegrated underfoot, leaving only a faint residue of white on the carpet's strands.

She reached into the bag again and pulled out the notepad that carried the beginning of her next letter to Martin. Instead of looking for a pen, however, to continue it, she removed the sheet and slowly ripped it up. Opening the window, she flung the pieces into the night and watched them flutter, mixing with heavy flakes of unexpected snow. With a deep sigh of relief she leaned further out the window and caught one of the flakes on her tongue. It melted slowly like the kisses so recently remembered, thawing her completely, irrevocably. She settled

back onto the bed then flung herself off and ran over to the envelope that held the print. The muscle man had faded into the yellowed paper, leaving barely a trace of his presence. He was gone; he'd left like the others, leaving nothing behind. Like her stay in Vienna, nothing left. Nothing but a whole world that she could have never dreamed existed.

BIBLIOGRAPHY

Although this is a work of fiction, the history of Andreas Vesalius is a true one. For anyone interested in reading more about his work, the following books are invaluable:

Ball, James Moores. *Andreas Vesalius: The Reformer of Anatomy*. Saint Louis: Medical Science Press, 1910.

Cushing, Harvey. *A Bio-Biography of Andreas Vesalius*. New York: Schuman's, 1943.

The Four Hundredth Anniversary Celebration of the De Humani Corporis Fabrica *of Andreas Vesalius*. New Haven, CT: The Historical Library, Yale University School of Medicine, 1943.

Ivins, William M., Jr. "What about the *Fabrica* of Vesalius?" in *Three Vesalian Essays to Accompany the Icones Anatomicæ of 1934*. New York: The Macmillan Company, 1952.

Lambert, Samuel W. "The Initial Letters of the Anatomical Treatis, *De Humani Corporis Fabrica*, of Vesalius," in *Three Vesalian Essays to Accompany the Icones Anatomicae of 1934*. New York: The Macmillan Company, 1952.

Lind, L.R, ed. and trans. *The Epitome of Andreas Vesalius*. Cambridge: The M.I.T. Press, 1949.

O'Malley, C.D. *Andreas Vesalius of Brussels: 1514–1564*. Berkeley: University of California Press, 1964.

Roberts, K.B. and J.D.W. Tomlinson. *The Fabric of the Body: European Traditions of Anatomical Illustration*. Oxford: Clarendon Press, 1992.

Rollins, Carl Purington. "Oporinus and the Publication of the *Fabrica*," from *The Four Hundredth Anniversary Celebration of the* De Humani Corporis Fabrica *of Andreas Vesalius*. New Haven, CT: The Historical Library, Yale University School of Medicine, 1943.

Roth, Moritz. *Andreas Vesalius Bruxellensis*. Berlin: Druck und Verlag von Georg Reimer, 1892.

Saunders, J.B. de C.M. and Charles D. O'Malley. *Vesalius: The Illustrations from his Works*. Cleveland: The World Publishing Co., 1950.

Singer, Charles and C. Rabin. *A Prelude to Modern Science: Being a Discussion of the History, Sources and Circumstances of the 'Tabulæ Anatomicæ Sex' of Vesalius*. Cambridge, England: The Wellcome Historical Medical Museum, 1946.

Vesalii, Andreæ. *De Corporis Humani Fabrica Libri Septem*. Basel: Johannes Oporinus, 1543.

Vesalii, Andreæ. *Andreæ Vesalii Bruxellensis Icones Anatomicæ, Ediderunt Academia Medicinæ Nova-Eboracensis et Bibliotheca Universitatis Monacensis*. Munich: Bremer Presse, 1934.

Wiegand, Willy. "Marginal Notes by the printer of the *Icones*," in *Three Vesalian Essays to Accompany the Icones Anatomiæ of 1934*. New York: The Macmillan Company, 1952.

My research also included the following publications:

Bachmair, Heinrich, F.S. "Ein neuer Vesal. Zur Veröffentlichung von 'Andreae Vesalii icones anatomicae' durch die Bremer Presse." in *Zeitschrift für Bücherfreunde*. 40. 1936.

Buzas, Ladislaus. *Geschichte der Universitätsbibliothek München*. Wiesbaden: Dr. Ludwig Reichert Verlag, 1972.

Clair, Colin. *A History of European Printing*. London: Academic Press, 1976.

Herrlinger, Robert. "Das Schicksal der hölzernen Druckstöcke zu Vesals anatomishem Lehrbuch." in *Münchener Medizinische Wochenschrift*. 1951.

Maggs, B.D. and E.U. *Manuscripts and Books on Medicine, Alchemy, Astrology & Natural Sciences*. London: Maggs Bros., 1929.